WEEGEE'S NEW YORK

WEEGEE'S NEW YORK

335 PHOTOGRAPHS 1935 – 1960

Introduction by John Coplan

SCHIRMER ART BOOKS

The publisher would like to thank
Mrs. Wilma Wilcox
for helping to make this book possible.

Schirmer Art Books is an imprint
of Schirmer/Mosel Verlag GmbH, Munich.
For trade information please contact:
Schirmer Art Books, 112 Sydney Road, Muswell Hill, London N10 2RN,
England, or Schirmer/Mosel Verlag, P.O Box 401723,
80717 München, Germany,
Fax 089/338695

A CIP catalogue record for this book is available
from the British Library

Printed in Italy

ISBN 3-88814-874-X
A Schirmer/Mosel Production

"... is not every spot of our cities the scene of a crime? every passerby a perpetrator? Does not the photographer – descendant of augurers and haruspices – uncover guilt in his pictures? It has been said that "not he who is ignorant of writing but ignorant of photography will be the illiterate of the future. But isn't a photographer who can't read his own pictures worth less than an illiterate? Will not captions become components of pictures?"

Walter Benjamin[1]

WEEGEE THE FAMOUS

Weegee was a forceful photographer with a unique style and personality, but among those photographers currently judged as serious artists, this maverick almost defies acceptance. The images Weegee brought back from another world deeply trouble us. A gritty, raucous and self-advertising voyeur (who called himself "the famous"), he prowled the nights as a press photographer, making the lives of "the tenants of the city"[2] his subject matter. Much of his seedy, squalid imagery explores human degradation. He reserved his sharpest sarcasms for the rich, whom he portrays as vacuous and greedy, and his exposure of the concrete horrors of the poverty, filth and violence of big city life, especially in New York in the late '30s and '40s, insists that life just about batters people senseless.

Weegee was born Arthur Fellig in the Austro-Hungarian Empire in 1899. In his early days he used a police radio to get to events ahead of his competition. He adopted the name Weegee, a phonetic rendering of "Ouija," the board device which is assumed to predict events, as a way to promote his uncanny ability to be where the action was about to happen. The three macabre photographs *Death of a Peddler* served to magnify Weegee's claim to foresight (plates 51–53).

No other art form rivals photography's capacity to be meaningless, to topple into a void. As a hedge against vacuity, ambitious photographers cloak themselves in a knowledge of art. But Weegee was an innocent, a primitive who described strong emotions and guilelessly jabbed at ours. In his autobiography, 'Weegee by Weegee', he discusses his early days as a fiddle player in a silent movie theater:

"I loved playing on the emotions of the audience as they watched to silent movies. I could move them either to happiness or sorrow. I had all the standard selections for any kind of a situation. I suppose my fiddle playing was a subconscious kind of training for my future in photography."

Indeed, without literal music, his photos did supply their own willful jazz. He blew hot almost as if to escape his feelings of nullity.

His photographs are always immediate, of action caught on the sly or just after it happened. He was a street photographer out for a scoop. His concern was for the life of the city, people at work, at play, asleep – and in death, particularly as the aftermath of criminal activity. These are the categories in which he blocks out his imagery and to which he continuously returned, territory that had deep psychological fascination not only for his audience, but obviously for him. But he was not only out to get memorable chance images; they had to have a consistently archetypal character. All Weegee's passion was centered on getting close to his material, to snatch the explosive moment out of the air. Nothing else counted. There is a frantic edge to Weegee's imagery. He worked at a pointblank range and at a desperate pitch, the better to catch people in the raw.

The only other photographer of note that Weegee apparently had some awareness of was Lewis Hine, whose work is grounded in reformist social judgments, an attitude antithetical to Weegee's apolitical stance. I would imagine, too, that he would have sensed that Hine, above all, was a visual idealist. There was nothing Weegee could have used in the beautiful faces of immigrant kids, or toiling workers bathed in Hine's sweet rapture. People don't so much work as scavenge, grimace, or screw up, in Weegee's tacky, rundown circus.

His own tawdriness led him to where few other photographers were willing to go, and gives a terrible edge of remorseless tension to some of his images. Take one from hundreds: the photograph of the psychopathic copkiller who has been arrested, savagely beaten up by his captors, and caught by Weegee's camera at the moment of being booked, fingerprinted and photographed (plate 91). The bedraggled, abject and beaten criminal, eyes puffed and almost closed, hunches head downcast. Two plainclothes detectives stand with their burly backs to the camera, dwarfing the killer. A huge, out-of-focus hand of the police cameraman cranking

his camera fills the left top corner. It's a portrait of a brute cuffed by other brutes on our side of the law. Weegee's use of flash in this photograph creates a luminous ovoid shape from the dark visual field, a clear center whose edges fade. This effect gives a startling nearness to the image. We momentarily feel that we ourselves are there observing the scene.

Weegee successfully evades isolating people's movements. His photographs, including those taken in daylight, give a continuous sense of implied movement. This potential for movement, perhaps the expression of a face about to change, the rhythmic movement of feet, or the syncopation of various glances, is one of his graphic strengths. It keeps his photographs continuously alive. It's usually hard to guess the next motion of a person in a still photograph, but the behavior in Weegee's seems instinctively charged with animate and continuous reflex; or is it, perhaps, that he startles it into being? In 'Cop Killer' the blurred hand of the camera operator seems to be in motion, the detective who took the fingerprints is turning his head, the detective in the foreground has his hands on the criminal's jacket, and is about to push him forward. Finally, the culprit himself, who is holding the palm of his hand upwards after the fingerprinting, is about to straighten and drop his arm. Such incipient movement endows Weegee's photographs with unforgettable vibrancy and urgency.

Weegee had an esthetic predilection for artificial light. He liked the way in which an object is highlighted and flattened by a freeze action of flash, and slowly dissolves into a saturated black background. He called this "Rembrandt light." This effect is only partly due to his equipment. He used a 4-by-5-inch Speed Graphic with a synchronized flash attached to the chassis, or capable of being hand-held nearby, with the exposure preset to 1/200 of a second, stopped down to f 16, focused to a distance of ten feet. The fast shutter speed and synchronized flash were ideal for Weegee's style of candid photography, which demands split-second judgment combined with equally fast reflex action.

His images are snapped rather than compositionally planned. The flash automatically vignetted his subjects, well within the frame. This means he worked without a preconceived notion of composition or its decorum. He focused in on an event, and if an image failed to compose itself, he used the enlarger to crop

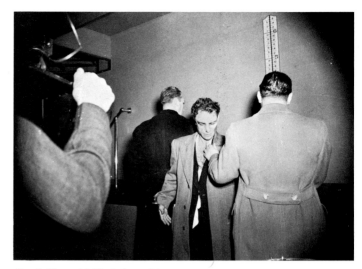

Copkiller, 1939 (plate 91)

and bring the image closer by eliminating superfluous detail, especially in the background, which he often burnt to a deep, flat black. Thus, Weegee's images are unleavened by tonal gradations. They have the expressive qualities, rawness, and punchy visual impact of a woodcut, in comparison, say, to an etching. Weegee's sense of graphic design is modulated by the fact that his photography was primarily made for reproduction. His images had to survive the printing processes used by tabloid newspapers, in which the coarse black screen dot turns gray when the ink is sucked into cheap newsprint. Moreover, it was tough for an independent to sell photographs during the Depression, especially to newspapers which employed their own staff photographers. Picture editors are primarily journalists who will not buy a print unless it looks catchily newsworthy. Weegee spent long hours with police reporters at police stations waiting for stories to break. The Black Maria was his studio. He knew as well as the editors the "what, why, when, how, where and who" of journalism, and that a photograph must tell it quick, especially if it is to be peddled to the tabloids, whose story headings are simplified and sensational. Weegee's photographs make no concessions to what photographers call print quality, or the idea of a photograph as a beautiful object (though later in life Weegee evidently reprinted some of his best photographs to make them look more arty).

Most photographers differentiate themselves from one another on a style basis, in terms of specific, predetermined and recognizable ways of composing their images. This can hardly be said of Weegee, whose style

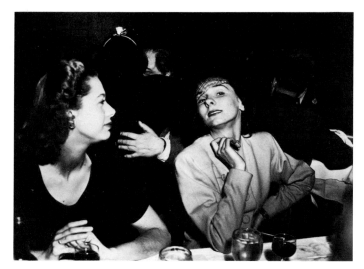

Women in a restaurant, ca. 1943 (plate 239)

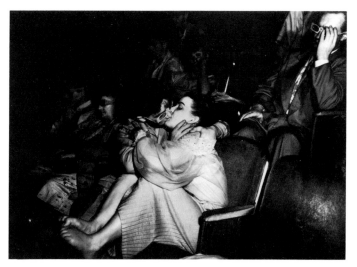

Lovers at the movies, ca. 1940 (plate 164)

is dominated by a raunchy casualness that is uniquely his. By virtue of culture (Austrian Jewish), education (the streets) and temperament (neurotically insecure), Weegee developed an expressionist edge.

The use of infra-red photography in reconnaissance flights to expose a concealed enemy is well known. Similarly, Weegee used infra-red film in his photographs of high-society cafe life to strip away the artifice of his subjects' elegance or pretensions. With infra-red, a woman's makeup is separated from her face, it floats on the surface like a mask, and concealed pimples or facial defects are uncovered. Veins normally hidden rise to the surface of the skin, and suavely dressed and neatly groomed men look tigerish as the film reveals capped or artificial teeth in their grinning mouths (plate 219). The infra-red also penetrates the skin of their freshly shaven faces and brings out hidden stubble.

It is not unusual for candid photographers to want to conceal their presence. Ben Shahn, for instance, used a right-angled viewfinder to disarm his subjects. But he shot people in public places, going about their ordinary lives in daylight. Weegee's voyeurism is more furtive and unfair. Infra-red film could be shot in near-total dark, which concealed his presence. He penetrated the protective gloom to expose people's intimate secrets: shamelessly entwined lovers in a movie theater, who feel doubly safe from observation as the rest of the audience watches a 3D movie wearing colored glasses that blank out all except the image on the screen (plates 163, 164). Or children picking their noses, or sucking their fingers, entranced by a movie. Weegee

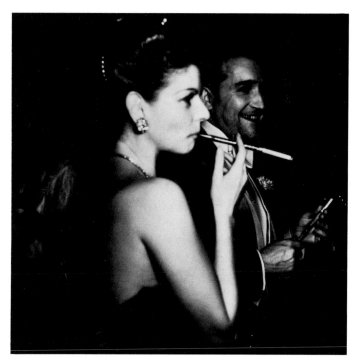

Premiere at the Met, 1943 (plate 219)

also prowled Coney Island beaches on warm summer nights to secretly photograph couples making love. One of his most extraordinary photographs is of a lone young woman sitting at night on top of the lifeguard's watchtower, apparently gazing out to sea (plate 46). As Weegee's book 'Naked City' makes clear (where her image is juxtaposed with two others taken at the same time and place), there are lovers on the sand below her perch. So she, like Weegee, is a voyeur, who sits in the night listening to the muffled cries below her. What is the dictionary definition of voyeurism?:

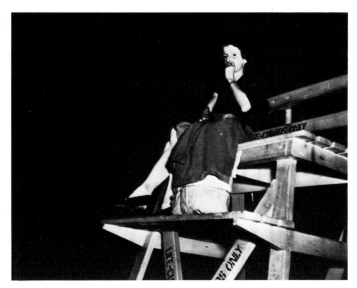 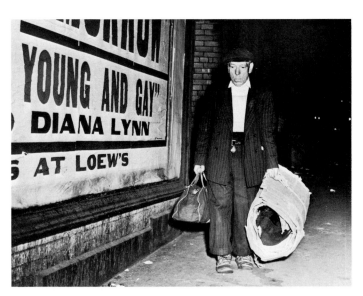

Girl watching lovers at night, Coney Island 1940 (plate 46) Tramp with bed roll, ca. 1940 (plate 132)

The obtaining of sexual gratification from secretly looking at sexual acts. This image brilliantly mirrors his malignancy.

Weegee also exposes the terrible disorder and chaos of life for the poor. Sometimes his camera catches transients scurrying around the deserted city at night, hugging the shadows, bedding-roll in hand, searching for a safe haven to sleep in (plates 131, 132). Or sleeping anywhere they can, on a bench or in a shop door. Or grimy children of all ages and both sexes pitifully huddled together in a disorderly mass, sleeping like young animals on a tenement fire escape to avoid the summer heat of their squalid rooms (plate 193). In a photograph shot vertically from above, a flabby and nearly naked man sleeps on a mattress on the fire escape below (plate 148). He is transformed by Weegee's merciless lens into the image of an aging, helpless child.

A series of macabre photographs also exist, those taken through the bars of a police cell at night, of a hugger mugger pile of men sleeping on the ground like so many sacks thrown together (plates 154–159). One's immediate impression is of a cell full of brutalized political prisoners in some police state. In actuality, it's a torpid mass of Saturday night drunks sleeping off their alcoholic stupor.

Because Weegee was dependent on selling his photographs for a livelihood, he was as close to a photojournalist as any photographer ever got to be. Weegee had the instincts to nose out a story for himself, which he would juice up by extravagant, callously written

witticisms à la Raymond Chandler, such as 'Covering Murders Gets Messy' (a photo of himself having his shoes shined), or 'Special Delivery' (a corpse under a letter box). Although Weegee began as an evidentiary photographer, his captions often imposed upon the documents he stored up the accents of a certain kind of pulp fiction. This lent to his several books, supported by his own narrative texts ('Naked City', 1945; 'Weegee's People', 1946; 'Weegee by Weegee', 1961), the character of hardboiled fables.

Sometimes his presence at the scene of a photograph became an active element in introducing a grotesquely humorous touch, as in the picture of a drowned man at Coney Island beach, in which we see serried ranks of hypnotized spectators watching an ambulance team, headed by a doctor, attempting to resuscitate the swimmer (plate 38). Kneeling at the side of the supine figure is a pretty companion, his wife or girl friend, clad in a swimsuit. It is a moment of high drama. Is the man dead or alive? Yet, at the very moment Weegee takes his photograph of the scene, the woman turns and flashes a coquettish smile at the camera. Let us admit that this could well be an accident – but not the inspired bad taste, or rather, the human knowledge that wanted it published.

Weegee's sardonic edge cuts everywhere. It is sharpened in his best known photograph 'The Critic', an encounter between two heavily bejewelled matrons on their way to the opera, as they pass a scruffy and dishevelled woman. She hisses at them in fury. (Plate 213. The woman on the left, Mrs. George Washington

Kavanagh, was noted for having had her face lifted so often that she was unable to change her expression – her face was frozen into a perpetually smiling mask.) In the '50s, Weegee shifted his attention to tricky distortions and manipulated photographic cartoons, among the finest of which are a series on Khrushchev, whose pudgy round head is variously transformed into a droll, longnosed Frenchman, a Disney-like Roman emperor, an aristocratically smiling New Englander, a Russian peasant with a jaw-breakingly crooked smile and, finally, an egghead. Weegee obviously identified with the peasant in Khrushchev and admired his cantankerous und unpredictable public behavior.

Weegee was a hustler incarnate, who lived off his wits, and by his abilities to solicit and wheedle. At the same time, he knew that he was incorrigibly unpresentable in either high or art society. But he nevertheless had some contact with society. And it dawned upon him that he, Weegee, could become an object of exotic curiosity to this upper-class stratum of people, that his slobhood could be engaging in much the same way that he made his subject matter the object of their curiosity. It is a strange idea, but not at all inconsistent with his character. After all, the flash-bulb is literally a booster of light, and here he used it to catapult his subjects into fame, even if it was a very ephemeral type of media celebrity. Unlike so many of the punks he photographed, he would become a perpetrator *with* a name. He, too, could be transformed into a fit subject for the kind of brazen exposure he visited upon others. Weegee the Famous promoted himself as a colorful braggart and made himself into the pet of the cultured set (he was included in a show at the Museum of Modern Art, and was given assignments at "Vogue", etc.). A trespasser in society, he clamored his way upwards with real savvy into Hollywood as *the* news-photographer – the greatest. But his fame was only in the news sense; and not for his cultural accomplishment, which had to wait a decade after his death in 1968 to be recognized.

There is a demonic edge to Weegee's quirky endeavor that bears discussion. Many of his photographs are morally dubious, not just because of their evident prurience, or his anti-social attitudes or even his outrageous hucksterism – it's that he sold for money images that exposed and exploited the involuntary, naked emotions of people he photographed without their permission, often by deliberately spying. One does sense animus in Weegee. Sleep, self-absorption, and

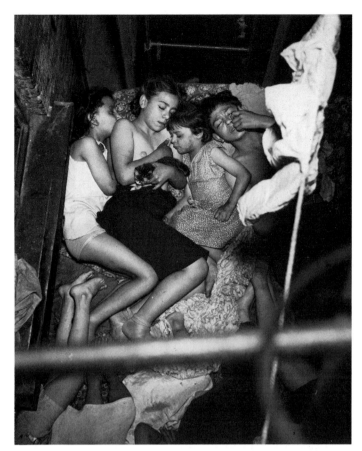

Children sleeping on a fire escape, 1938 (plate 193)

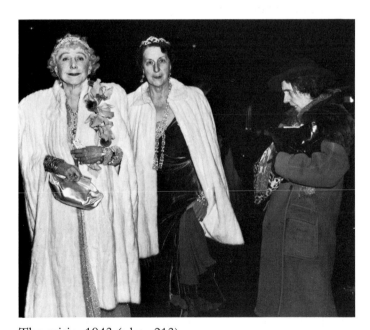

The critic, 1943 (plate 213)

unawareness were continuing obsessions, and people shocked, in terror, convulsed with pain or blown out of their minds were his special targets. In the moment he comes across them, after seeking them out instinc-

11

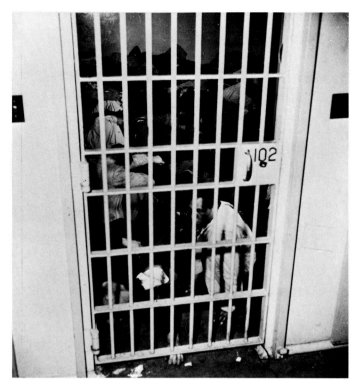

In the "cooler", ca. 1942 (plate 154)

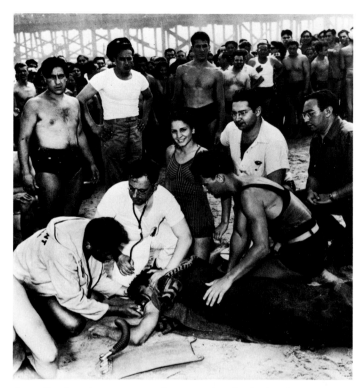

A smile for the camera, Coney Island 1940 (plate 38)

tively, it's as if he knows that in capturing their images, he has a supreme power over them. They cannot prevent his act. His distressed subjects were literally the most completely vulnerable people imaginable at that moment – in extremis, torn by grief, or totally helpless. This is what makes Weegee's work pitiless. It blazes away with its own kind of totally unsolicited awareness, thereby bringing off what photographers claim for the medium, but which it so rarely accomplishes – the rhetoric that unmasks.

Weegee belongs to a very American photographic vein, *to tell it like it is*. But the extremes to which he was willing to take this rhetoric make the viewer's complicity in it apparent. To view a typical Weegee is to have the stakes in the photographic contract very much upped, both emotionally and morally. Diane Arbus and even Les Krims, who surely owe him a great deal, allow us to recognize that self-indicting shiver which Weegee was the first to explore. Once we give public permission to the photographer to invade other people's lives, how can we object to his zeal in the matter, especially when it is slapped into form without any hypocrisy whatsoever?

The element of journalism in Weegee, as I said, mixes with his expressionist intent. There are a number of journalistic photographers who are equally involved

in the critical moment, simplifying the image to make it more telling. It could be that with Weegee, we are not really dealing with a photojournalist at all, but one who instead used photojournalism as a cover, unconsciously or not. There is a large and recognizable sector of his work in which Weegee is not a detached reportorial professional. Weegee was aware of his whole enterprise as being surreptitious und contraband. This gave him a thrill. Thus, there is a contradiction in his apparent nerveless willingness to look upon appalling scenes and drink them in passively, without any apparent tremor. In one sense his images were no less or more than ghoulish still-lifes to him, but on the other hand, it was his very insistence on focusing on these lurid moments for his own personal satisfaction which gives them their exceptional resonance. Finally, our awareness of Weegee's excitement promotes these images of ostensibly banal horror to a level of artistic horror which is capable of moving us. Weegee does not apologize. This private eye had a vital insensitivity that is precious. This is his fascination.

1. Walter Benjamin, 'Kleine Geschichte der Photographie' (in "Literarische Welt", Sept. 18, 25, and Oct. 2, 1931), translated by Phil Patton and republished as 'Walter Benjamin's Short History of Photography' in 'Artforum', Feb. 1977, pp. 46–51.
2. Ibid.

BIOGRAPHICAL NOTES

Weegee (Arthur Fellig) was born on June 12, 1899, in Zloczew, Austria (now in Poland). German and Polish were his native languages. His father immigrated to the United States in advance of the family and settled in New York's Lower East Side. He sent for the family, including Weegee's brothers, in 1910.

Weegee's father sold crockery from a pushcart. He was an educated man who had a hard time starting life again in America. Later in life he became a rabbi. Weegee attended a nearby public school. He was an excellent student, he learned English rapidly, and became a rabid candlelight reader. Weegee eased the family's poverty by making a dollar or two a day selling candy to young sweatshop workers after school hours. Weegee insisted on quitting school at fourteen to help support his family, first trying his hand as an itinerant tintype operator, then as an assistant to a commercial photographer, and once more as an itinerant street photographer making portraits of children on a hired pony that he named "Hypo".

At eighteen he left his family. He lived in Bowery flophouses, worked at a variety of short-term laboring jobs, and searched for a photographic job. Eventually, he became a passport photographer. This lasted for three years.

Around 1924, Weegee joined Acme Newspictures (United Press International Photos) as a darkroom technician, filling in during emergencies, particularly at night, as a news photographer. He took fiddle lessons and became skilled enough to accompany the lady piano player at a Third Avenue theater. The arrival of talkies killed this extra-curricular musical activity and income.

Restless to become a news photographer in his own right Weegee left Acme in 1935, and began to free lance under the name Arthur Fellig at Manhattan Police Headquarters. He rented a room nearby, and picked up police emergency signals and fire alarms on his own radio. Weegee roamed the nights and specialized in supplying photographs to the tabloid press of car crashes, fires, and violent crimes, especially gangster liquidations by Murder, Inc.

In 1938, Weegee obtained official permission to install a police radio in his car. Because he was the only press photographer to be granted this privilege, he continued to beat his rivals (and often the police themselves) to the scene of a crime or fire, obtaining scoop after scoop. He adopted the name Weegee, a phonetic rendering of the Ouija board, a device which is assumed to foretell events, as a way to publicize his ability to be where the action was about to happen. There is no definite record when Weegee first began using his pseudonym for his photo credit. Several photographs exist dated 1940 in his own handwriting and rubber stamped on verso "Arthur Fellig." He probably began the systematic use of Weegee after he was retained by the newly published tabloid *P.M.* late in 1940. Several years later he stamped many of his photographs "Weegee the Famous".

In his ten years photographing from Police Headquarters, Weegee claimed to have covered some 5,000 murders, used up ten press cameras, and five cars. There is no doubt that Weegee took the most famous photographs of a violent era. Though he was extremely squeamish, hating the sight of blood, Weegee was, to use his own words, "spellbound by the mystery of murder"; consequently, many of his best photographs are tableaus in which he maintains a discrete distance from the corpse and catches the bewildered of horrified reactions of onlookers.

Weegee first began using infra-red flash and film as a result of being refused permission to photograph. This technique enabled him to work unobserved.

Weegee's first book, *Naked City,* published in 1945,

became an immediate success, going through several editions. He was retained by Vogue, and the Museum of Modern Art acquired several of his photographs. Hollywood purchased the title of *Naked City* and made it into an Academy awardwinning film. Weegee left New York for Hollywood in 1947 to be a consultant for the film, and to gather material for his book *Naked Hollywood,* from time to time playing small parts in various movies. He returned to New York in 1952, and began to work on his series of photo caricatures of public figures including Kennedy, Khrushchev, DeGaulle, and entertainment personalities. He made several short color films.

In his last years he travelled extensively and worked in Paris, Germany, Belgium, Russia and London (for the *Daily Mirror*) on a wide variety of photo, film, lecture and book projects. He went back to Hollywood several times, eventually returning to New York.

He died in New York on December 26, 1968.

SELECTED BIBLIOGRAPHY

Books by Weegee

Naked City, Duell, Sloan & Pierce, N.Y., 1945.
Weegee's People, Duell, Sloan & Pierce, N.Y., 1946.
Naked Hollywood (with Mel Harris), Pellegrini & Cudahy, N.Y., 1953.
Weegee's Secrets of Shooting with Photo Flash (with Mel Harris), Designers 3, N.Y. (?), 1953.
Weegee by Weegee, Ziff Davis, N.Y., 1961.
Weegee's Creative Photography (with Gerry Sheck), Ward Lock, London, 1964.

Films by Weegee

Weegee's New York, 1948, 16 mm, 20 minutes, color, sound.
The Idiot Box, C. 1965, 16 mm, 5 minutes, b/w, silent.
Cocktail Party, C. 1950, 16 mm, 5 minutes, b/w, silent.

Films on Weegee

Stoumen, Lou. *The Naked Eye,* 1957, 16 mm, 71 minutes, b/w and color, sound.
Jourden, Erven. McCoy, Esther. *Weegee in Hollywood,* C. 1950, 16 mm, 10 minutes, b/w, sound.

Books on Weegee

Weegee, Stettner, Louis. Alfred A. Knopf, N.Y., 1977.

Articles on Weegee

Blumenfeld, Harold. "Weegee the Photographer Dies; Chronicled Life in Naked City," *New York Times,* December 27, 1968, (ill.) [obituary].
Fondiller, Harvey; Rothschild, Norman; Vestal, David. "Weegee, a Lens on Life 1899–1968," *Popular Photography,* N.Y., v. 64, no. 4, p. 93–100, April 1969 (ill.).
Berg, Gretchen, "Naked Weegee", *Photograph,* N.Y., v. 1, no. 1, p. 1–4; 26–28, Summer, 1976 (ill.) [Interview, 1965.]
Westerbeck, Colin. "Night Light: Brassai and Weegee", *Artforum,* N.Y., v. 15, no. 4, p. 34–45, December 1976 (ill.) [Text incorrectly transposed in reverse order bottom right column p. 42 and p. 43; correct sequence begins first column p. 43.]
Goldman, Judith. "Weegee the Famous", *Quest/77,* N.Y., v. 1, no. 4, p. 69–74, September/October 1977 (ill.).
Coplans, John. "Weegee the Famous", *Art in America,* N.Y., vol. 65, no. 5, p. 37–41, September/October 1977 (ill.).
Quindlan, Anna. "He Was There", *New York Times Magazine,* p. 40–43, September 11, 1977.
Lifson, Ben. "Weegee: Aquainted with the Night", *Village Voice,* N.Y., p. 101, October 24, 1977.

PLATES

Fires	1– 37	At the Circus	202–212
Coney Island	38– 50	Society	213–227
Sudden Death	51– 65	Musicians	228–238
Crime	66– 96	Bars	239–263
Paddy Wagons	97–113	Soldiers	264–274
Night People	114–132	Onlookers	275–297
A Place to Sleep	133–161	Strippers	298–306
At the Movies	162–176	Celebrities	307–333
Children	177–201	Self-Portraits	334–335

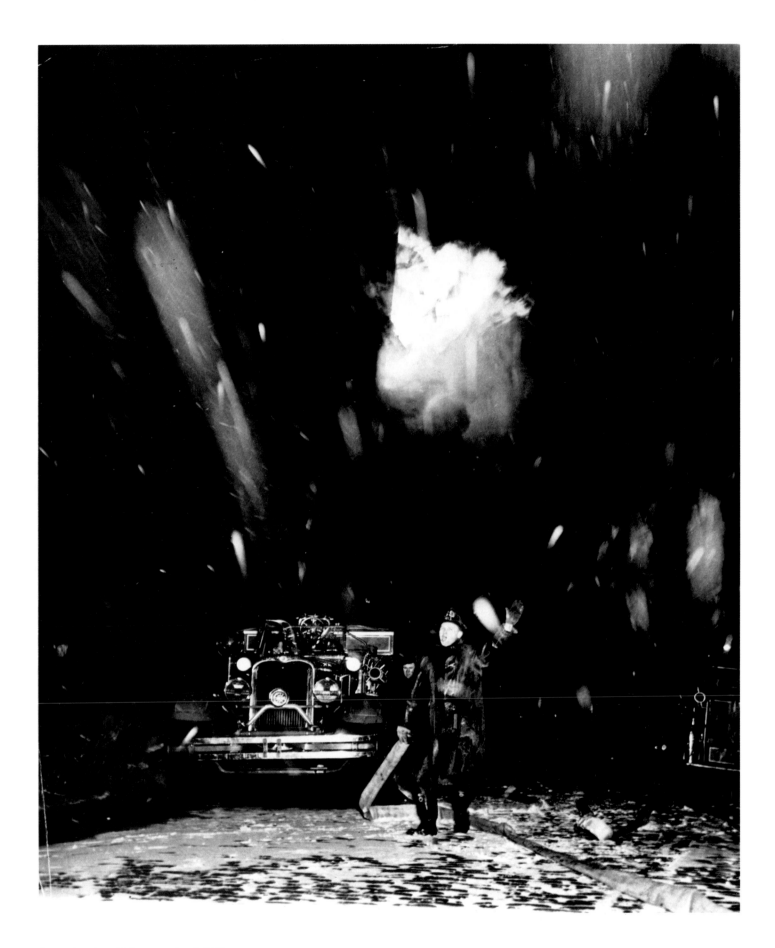

Feuer in einer Winternacht, 1947
A winter's night fire
Incendie, une nuit d'hiver

1

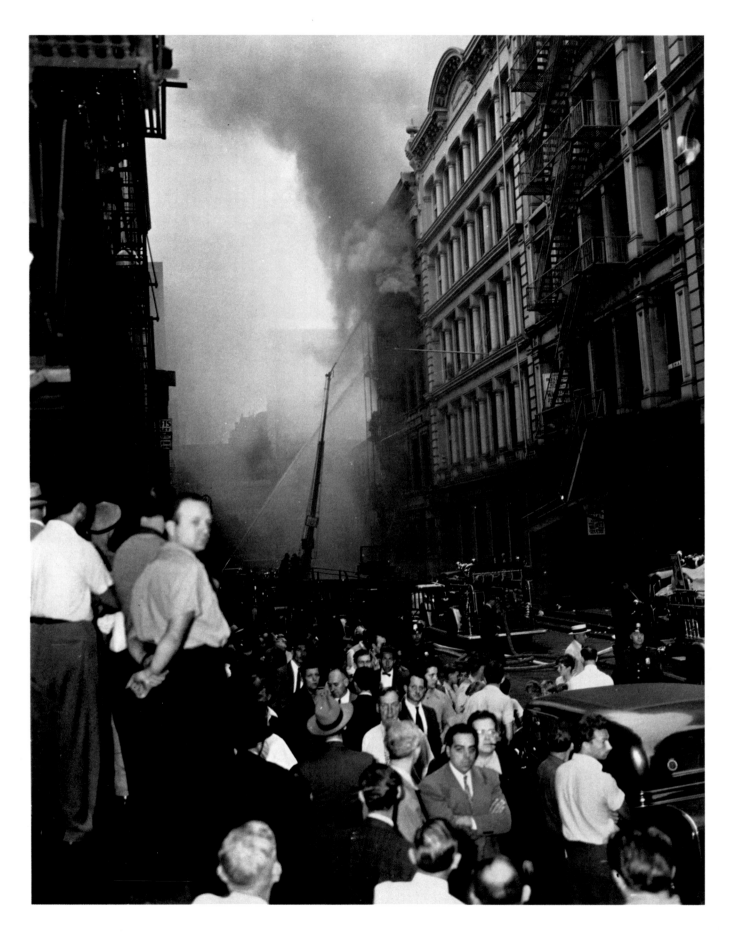

Feuer an einem Sommerabend
Fire on a summer's evening
Incendie, un soir d'été

2

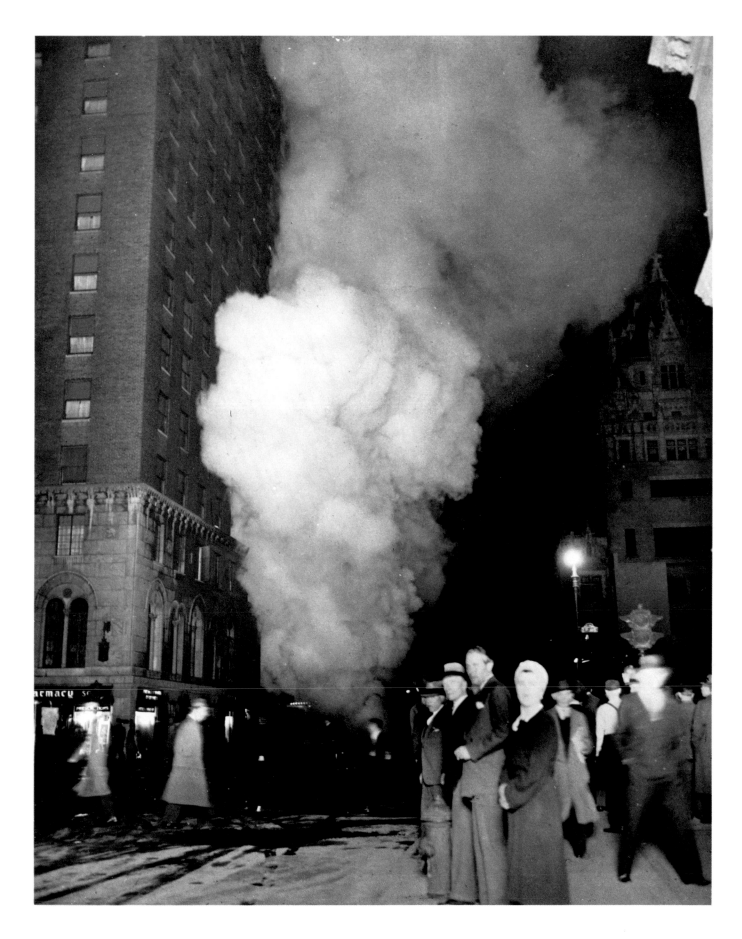

Feuer
Fire
Incendie

3

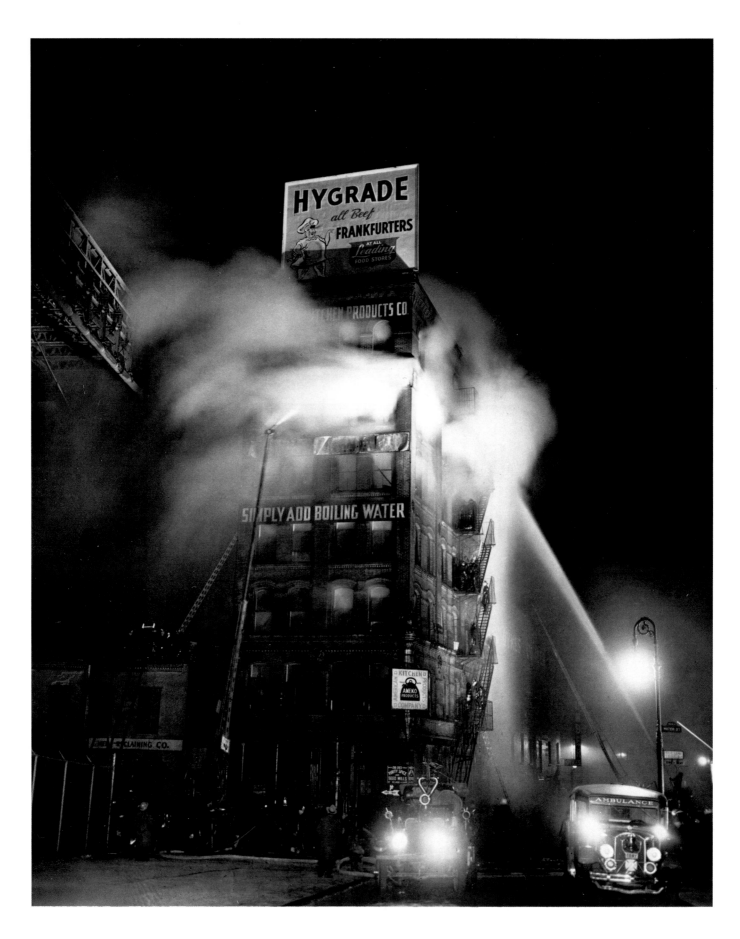

"Simply add boiling water"
"Simply add boiling water"
"Simply add boiling water"

4

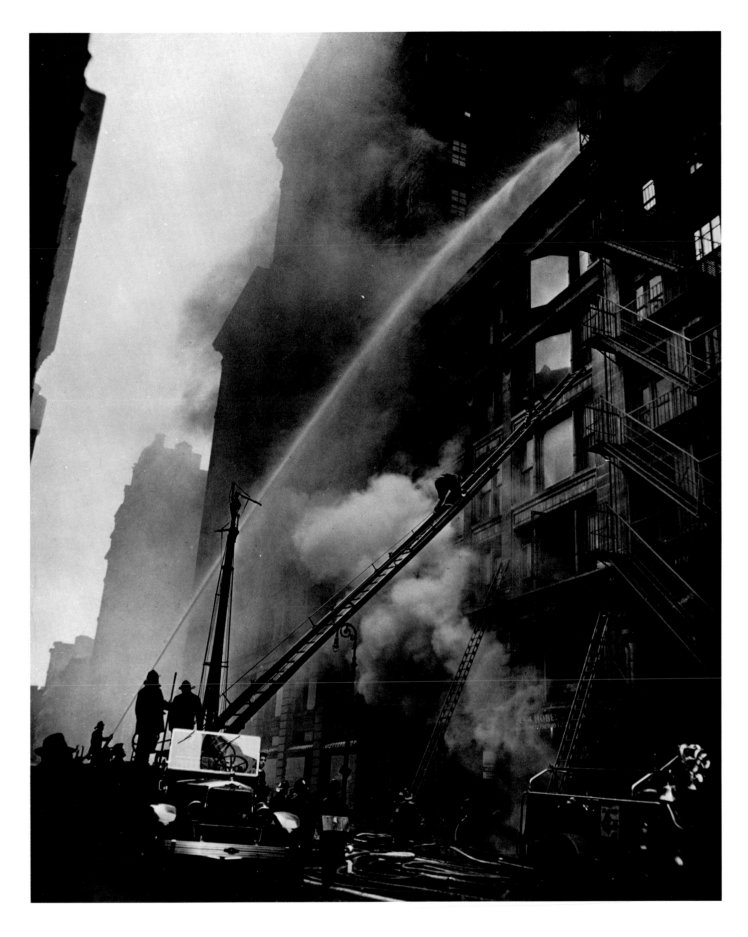

Feuer
Fire
Incendie

5

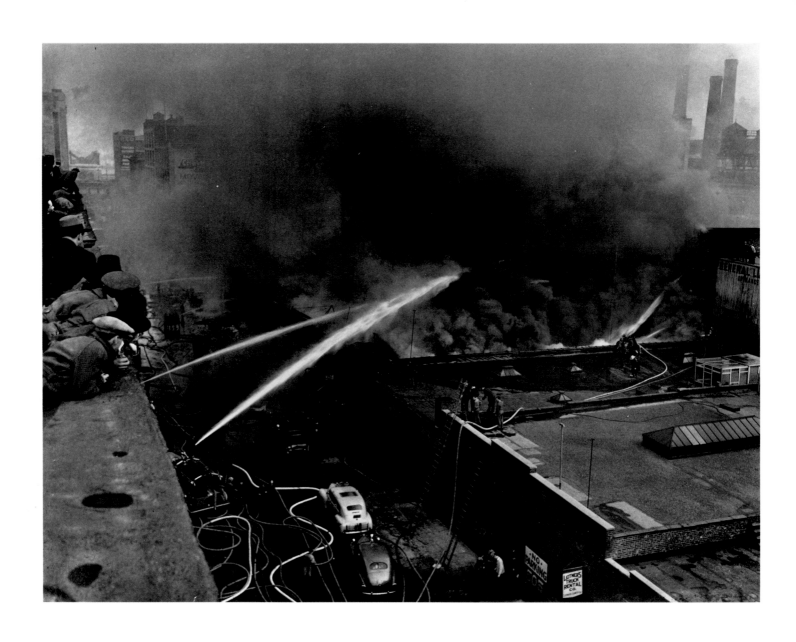

Großbrand
Conflagration
Embrasement

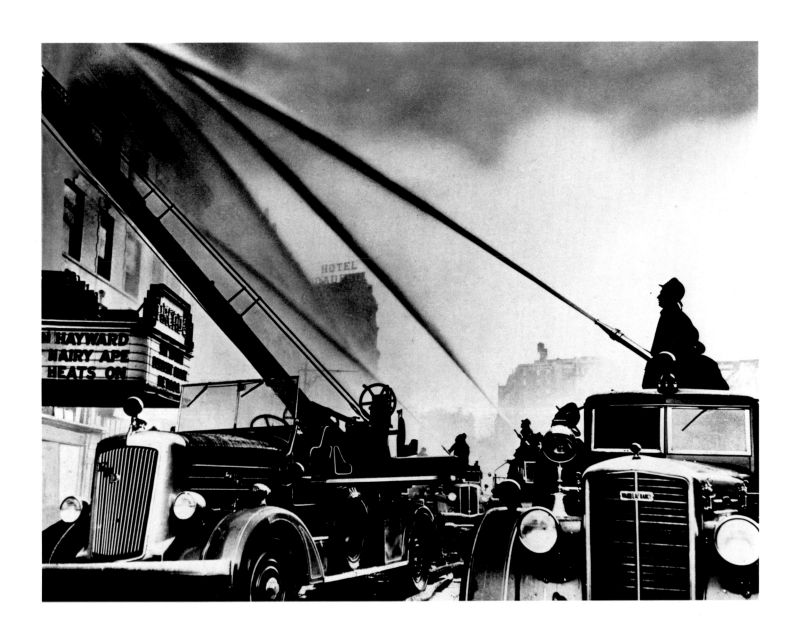

Feuer in einem Broadway-Theater
Fire in a Broadway-Theatre
Incendie dans un théâtre de Broadway

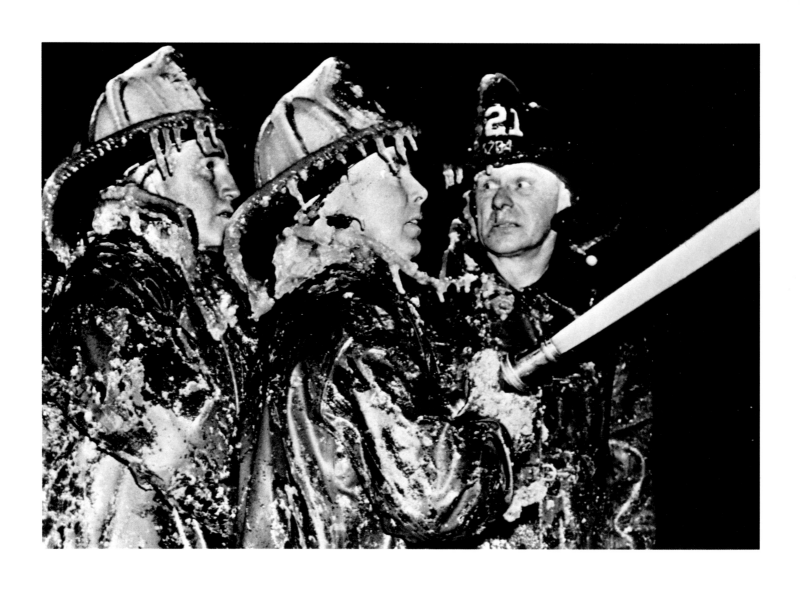

Einsatz im Winter
On duty in winter
De service en hiver

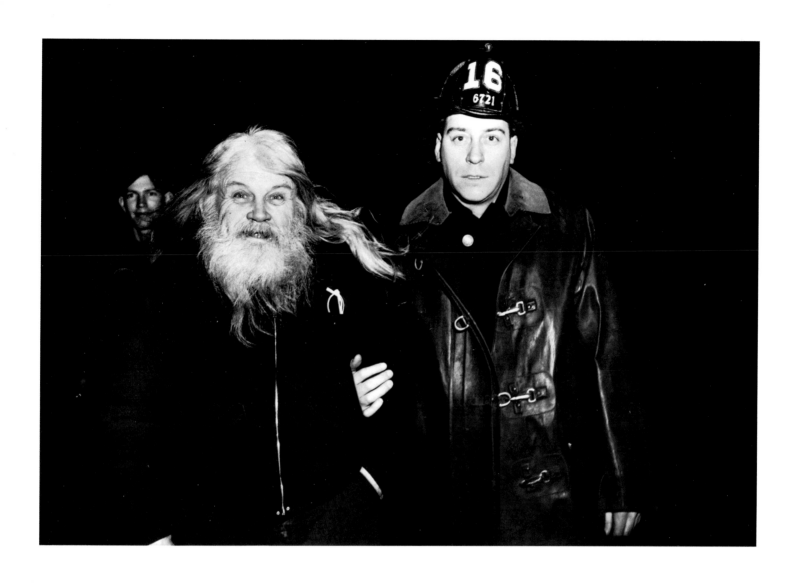

Geretteter Mieter
Rescued tenant
Locataire sauvé

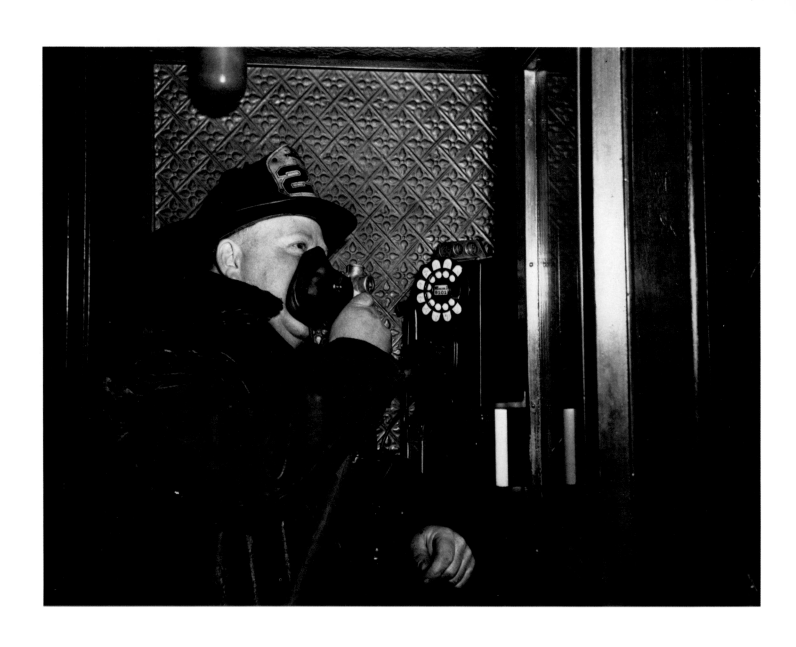

Atemholen in der Telefonzelle
Getting "air" in a phone-booth
Reprendre souffle dans la cabine téléphonique

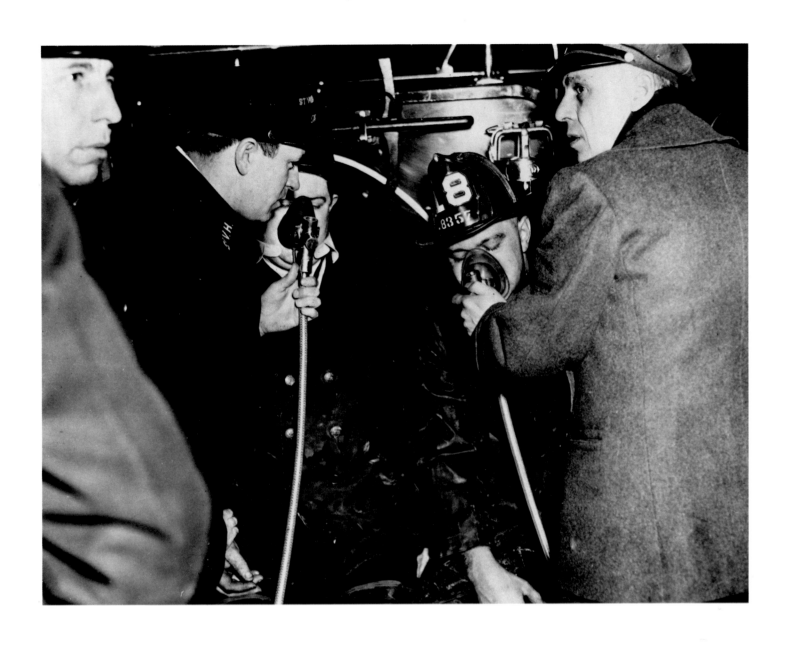

Hilfsaktion für Kollegen
Helping a buddy
Aide à un collègue

11

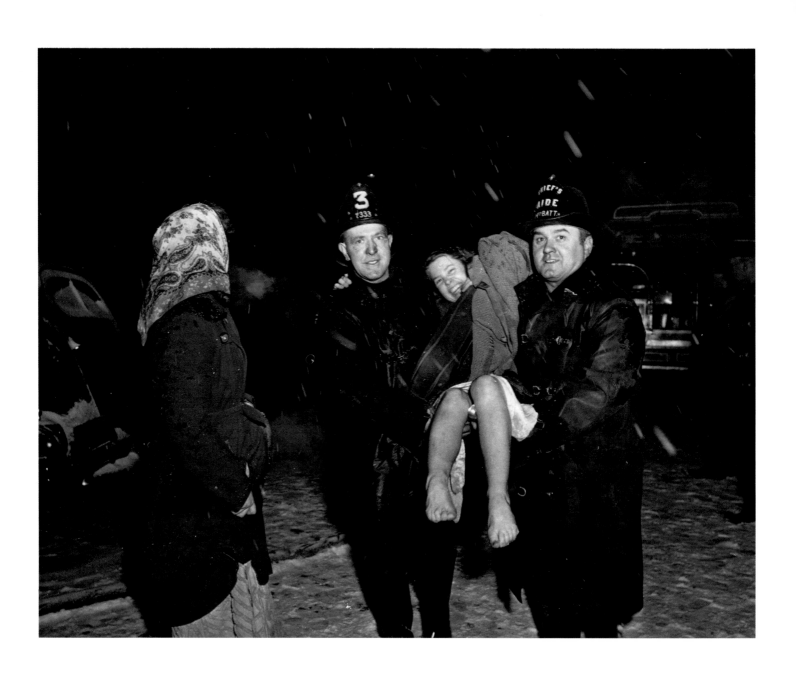

Gerettet mitsamt der Geige, 1945
Even saved the violin
Sauvée avec son violon

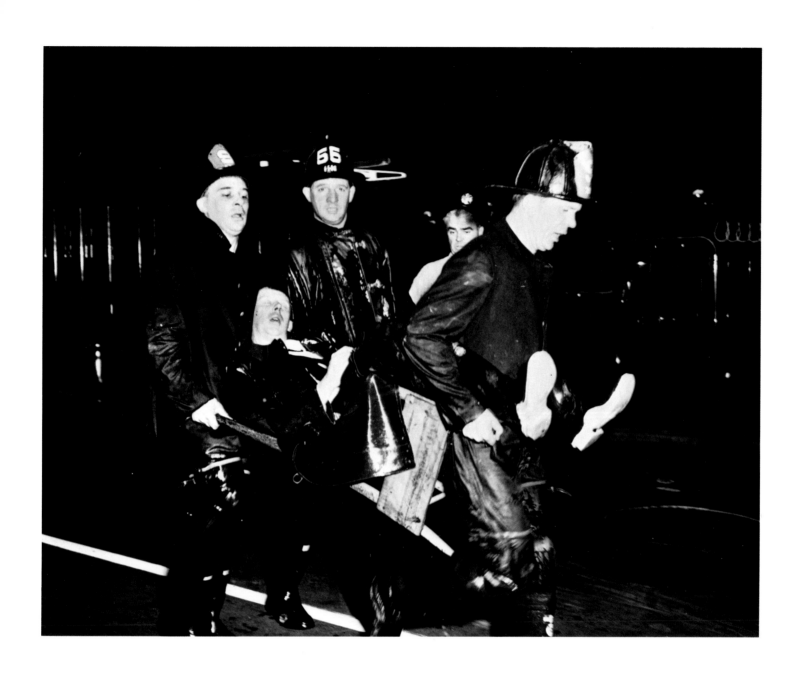

Ein Kollege wird gerettet, 1945
Saving a buddy
On sauve un collègue

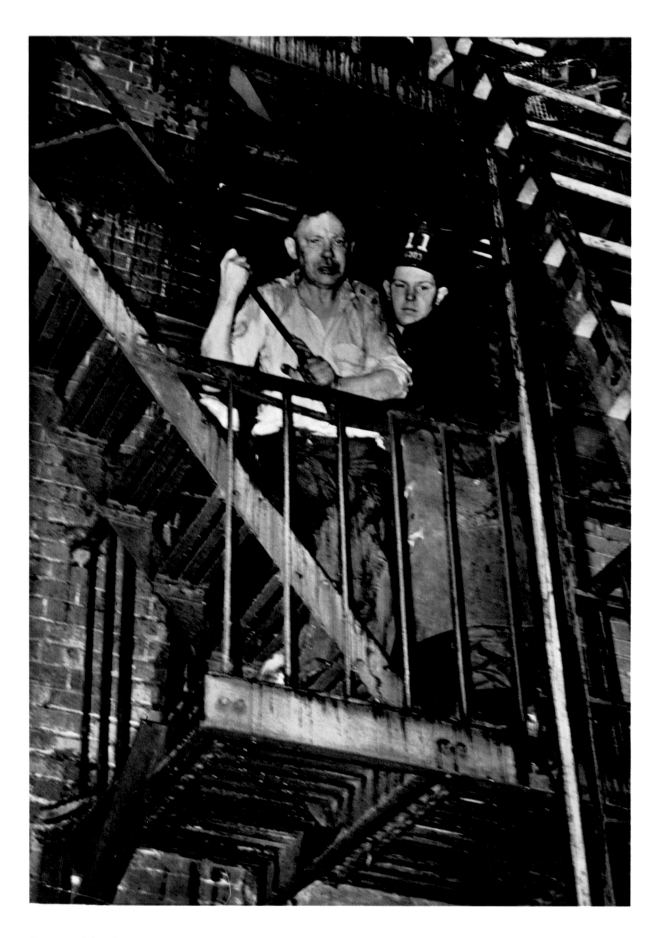

Rettungsaktion I
Rescue operation I
Sauvetage I

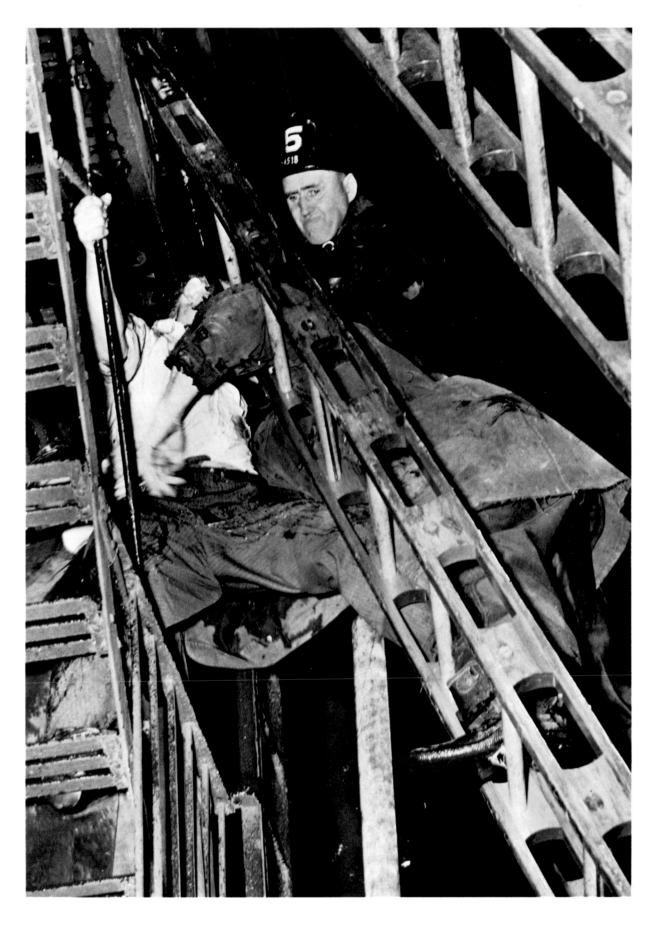

Rettungsaktion II
Rescue operation II
Sauvetage II

15

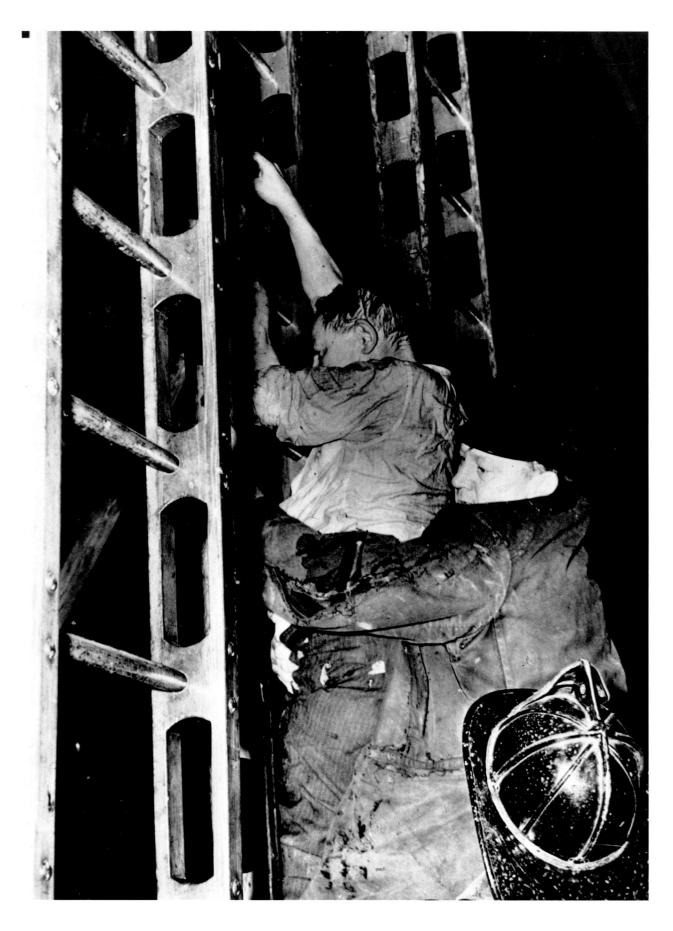

Rettungsaktion III
Rescue operation III
Sauvetage III

16

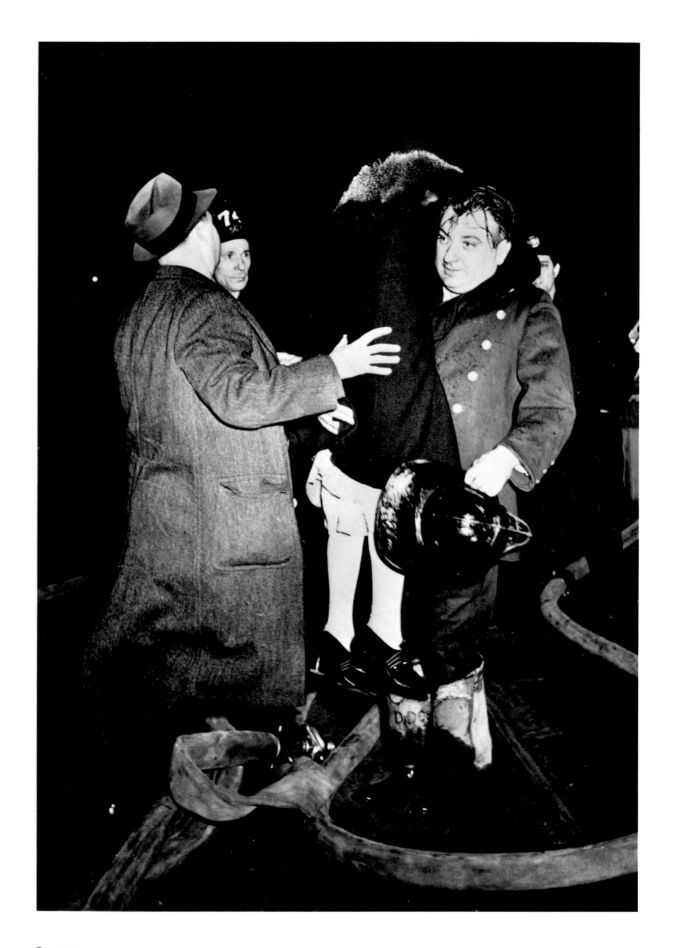

Gerettet
Rescued
Sauvée

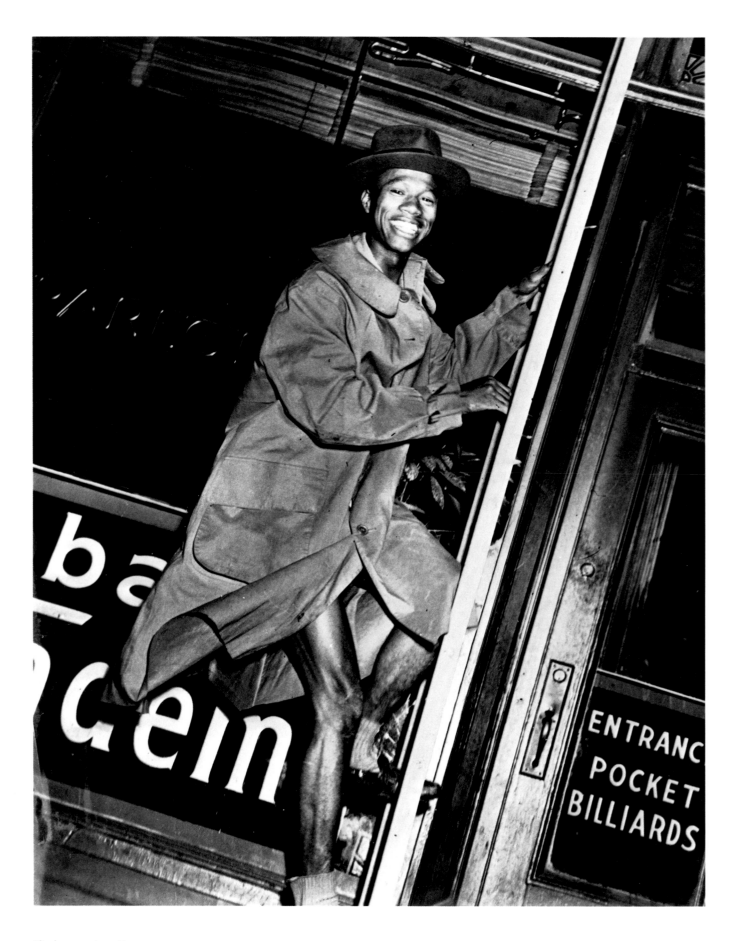

Flucht vor dem Feuer
Fleeing the fire
Fuite devant le feu

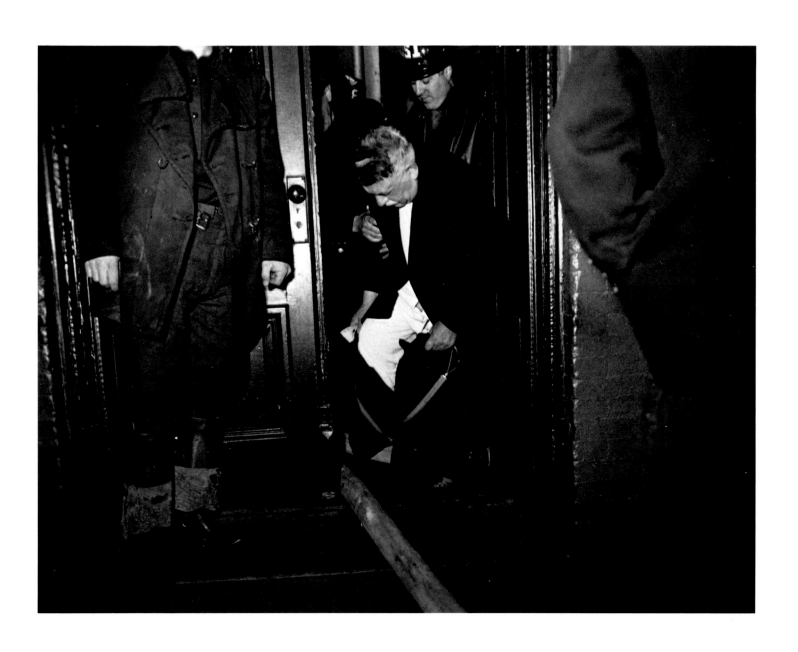

Im Schlaf überrascht
Caught by surprise
Surpris pendant le sommeil

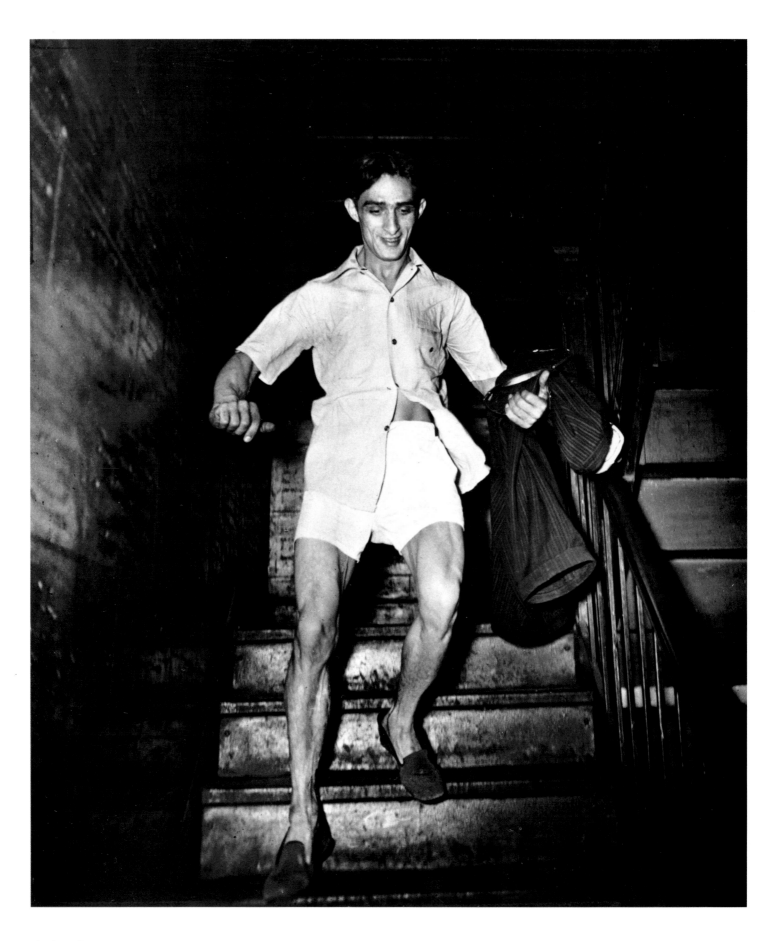

Flüchtender Mieter
Fleeing tenant
Locataire en fuite

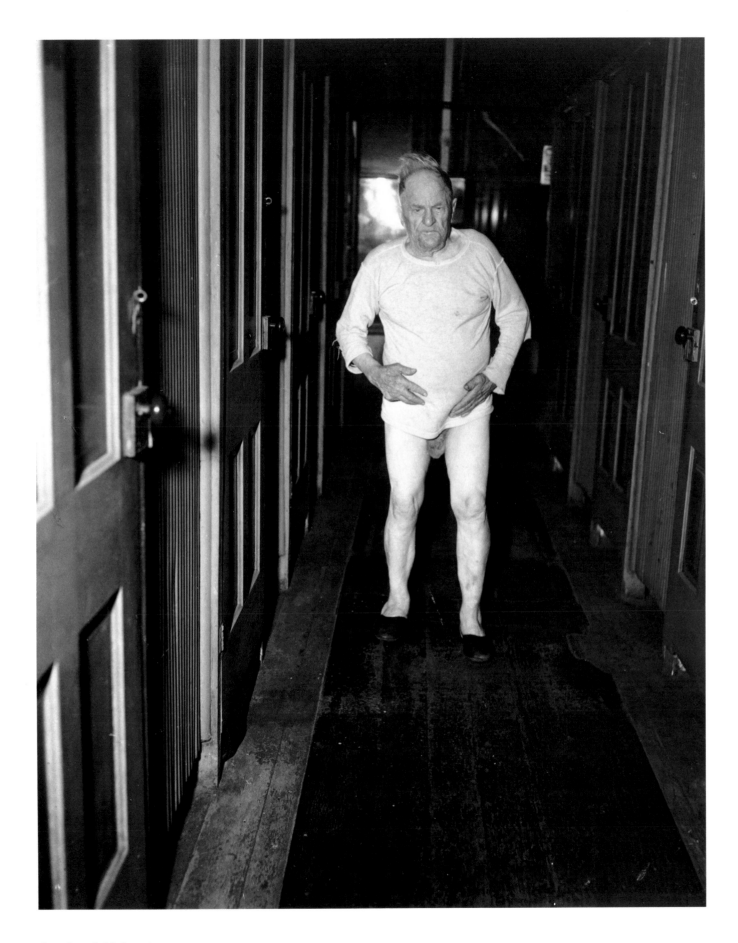

Aus dem Schlaf gerissen
Unpleasant awaking
Arraché au sommeil

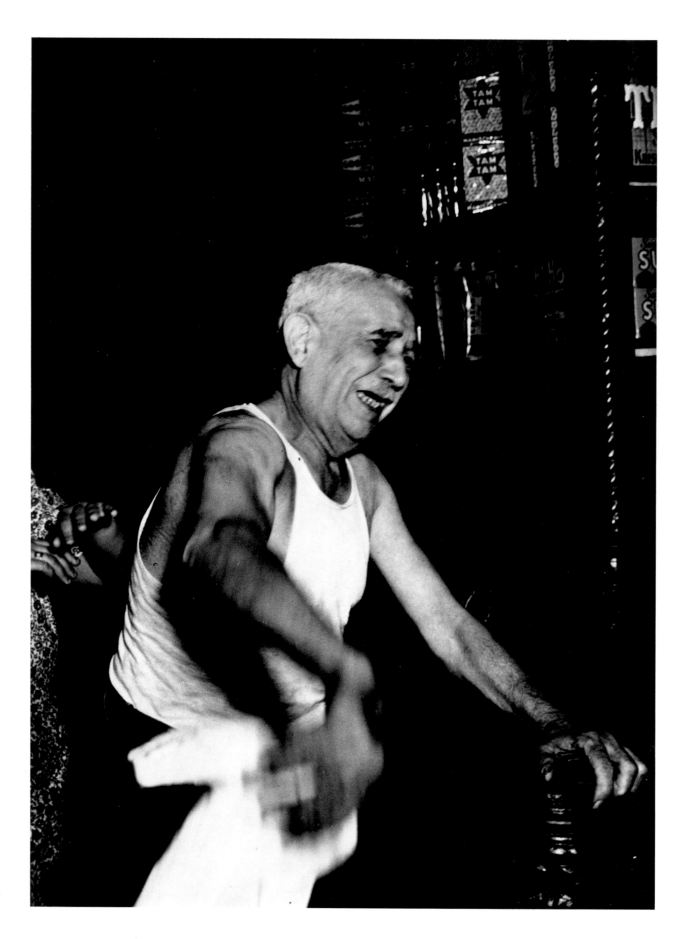

Jammernder Hausbesitzer . . .
Lamenting landlord . . .
Propriétaire qui se lamente . . .

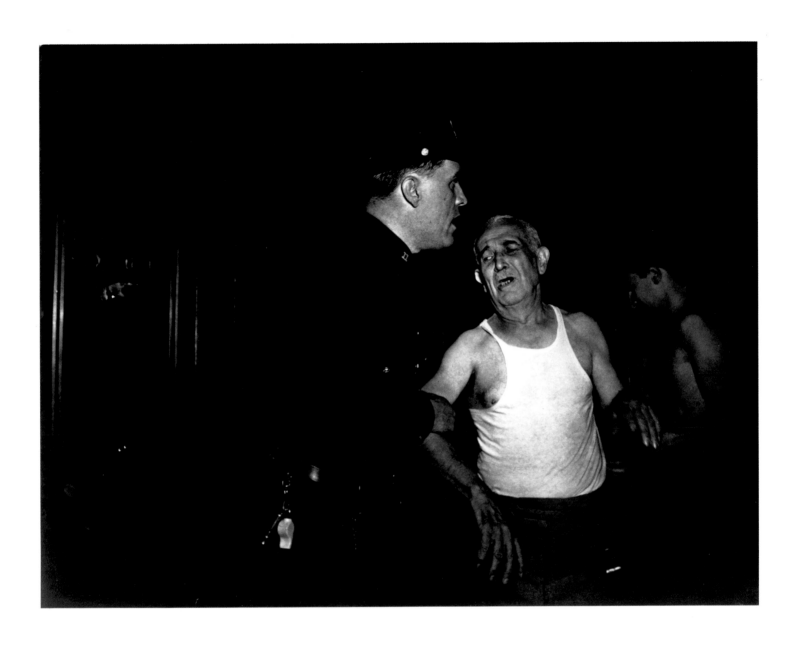

. . . sein Eigentum verbrennt
. . . his property is burning
. . . sa propriété flambe

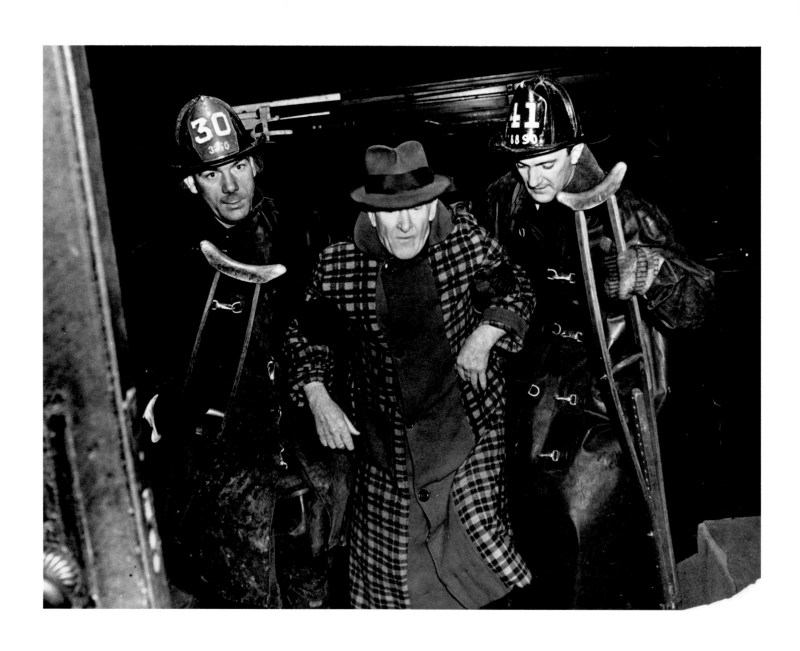

Freundliche Helfer
Friendly helpers
Aides aimables

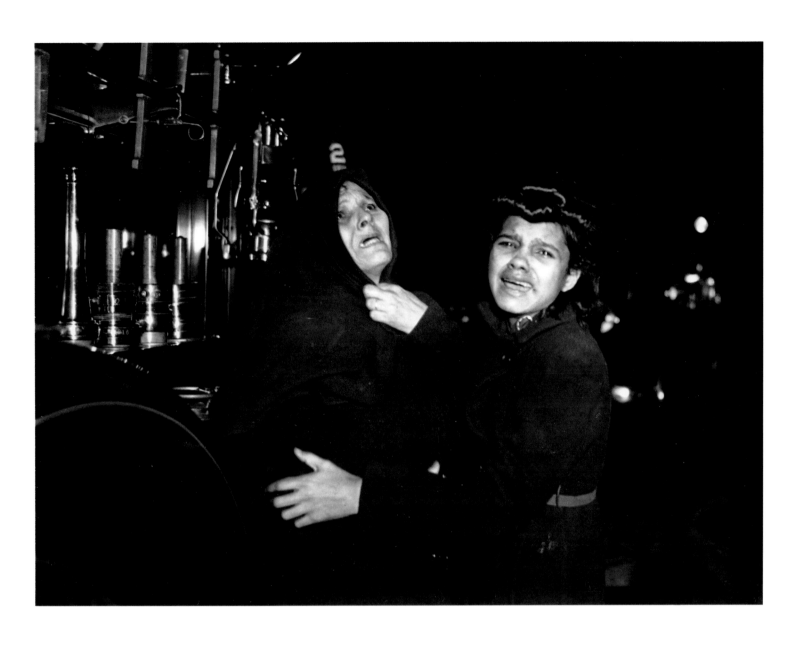

Feuer in Harlem — ihre Kinder sind noch im brennenden Haus, 1942
Fire in Harlem — her kids are still in the burning building
Incendie à Harlem — ses enfants sont encore dans la maison en flammes

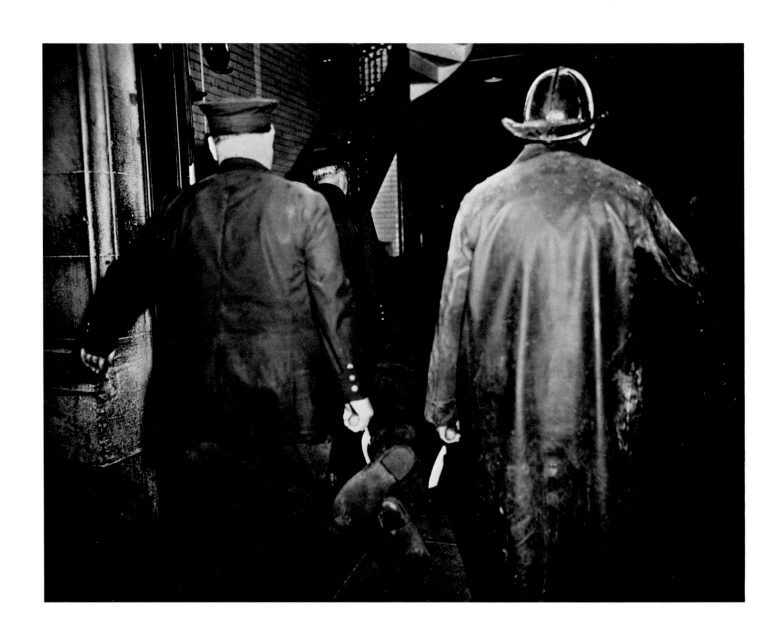

Auf dem Weg ins Leichenschauhaus
On the way to the morgue
Sur le chemin de la morgue

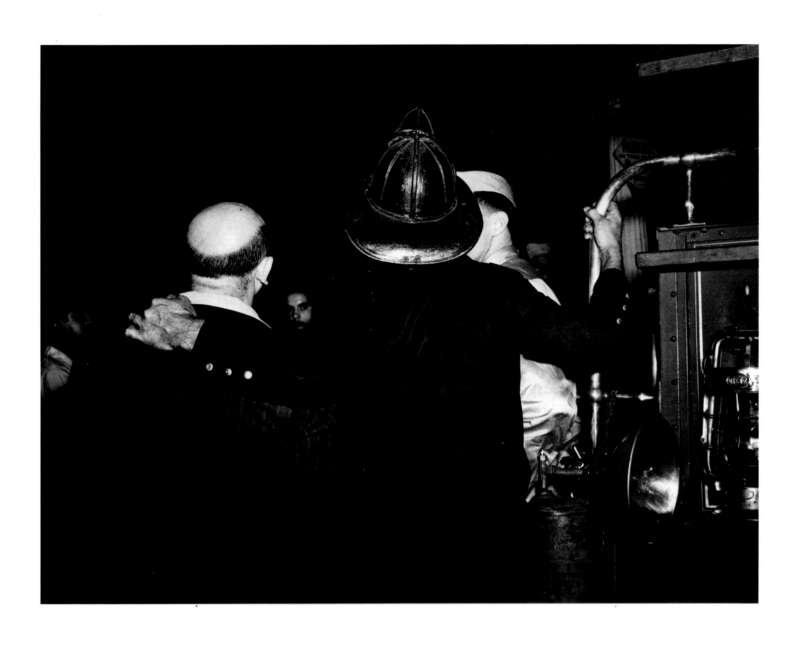

Beobachter eines Brandes um fünf Uhr morgens
Watching a fire at five o'clock in the morning
Observateurs d'un incendie à cinq heures du matin

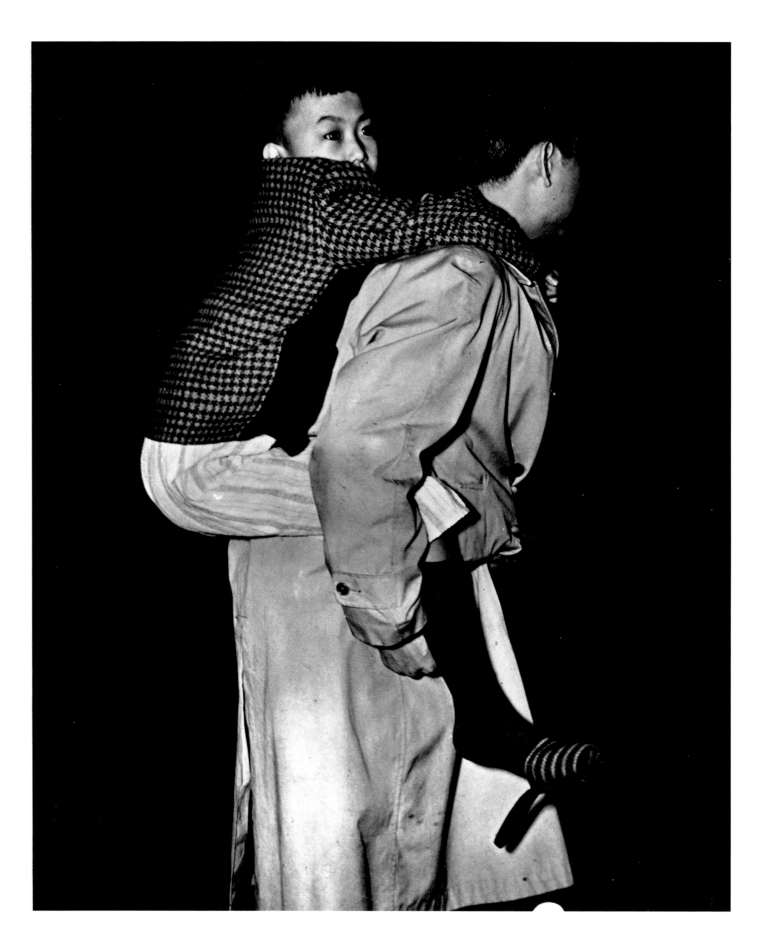

Vater und Sohn in Chinatown
Father and son in Chinatown
Père et fils à Chinatown

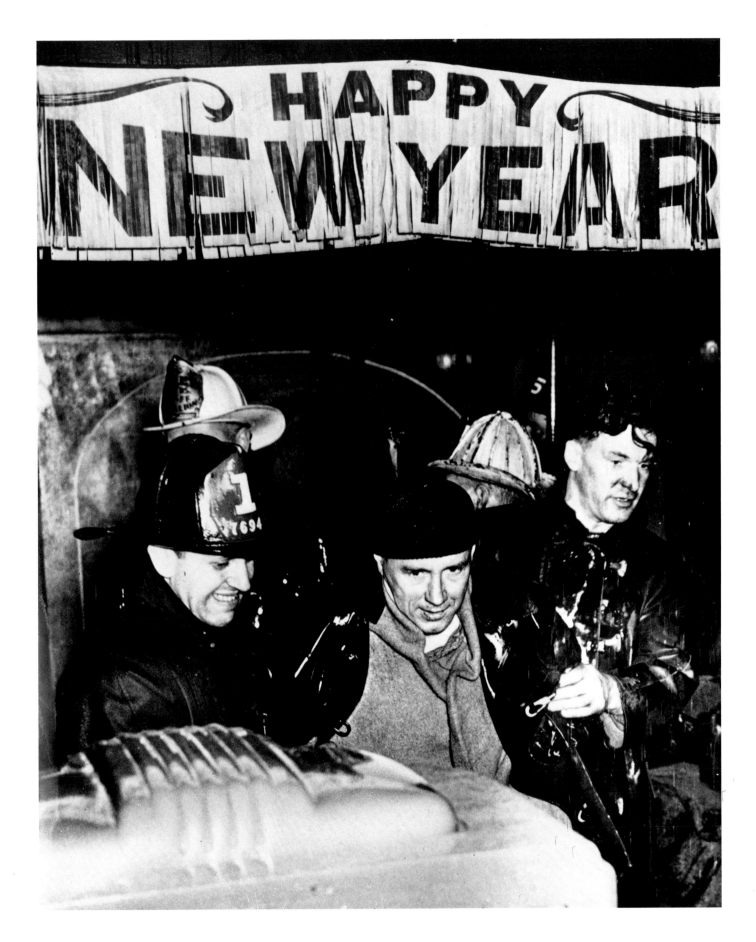

"Happy New Year"
"Happy New Year"
"Happy New Year"

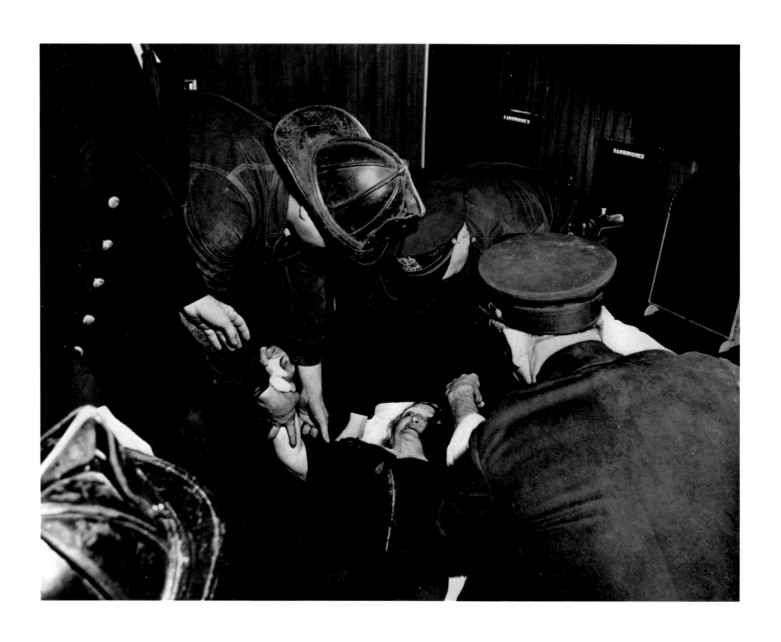

Hilfreiche Hände
Helping hands
Mains secourables

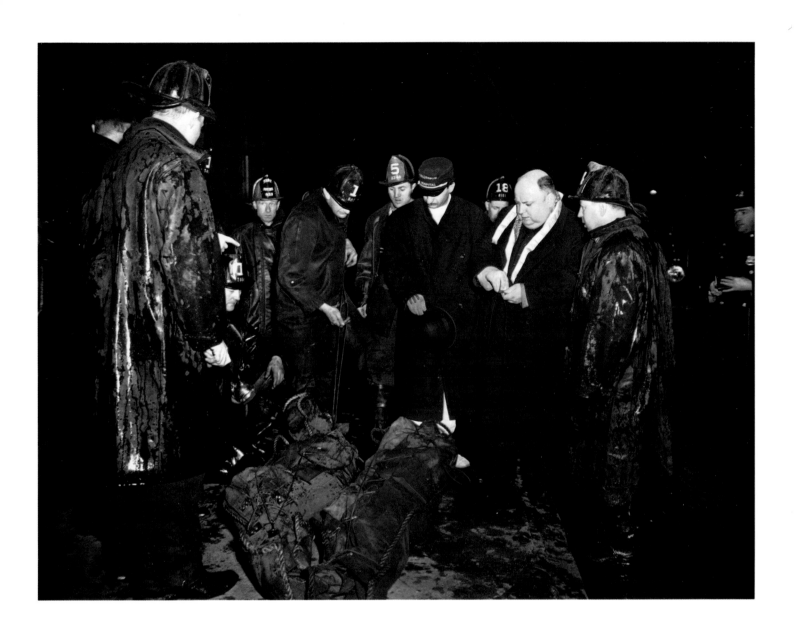

Die letzte Ölung
The last rites
Extrême-onction

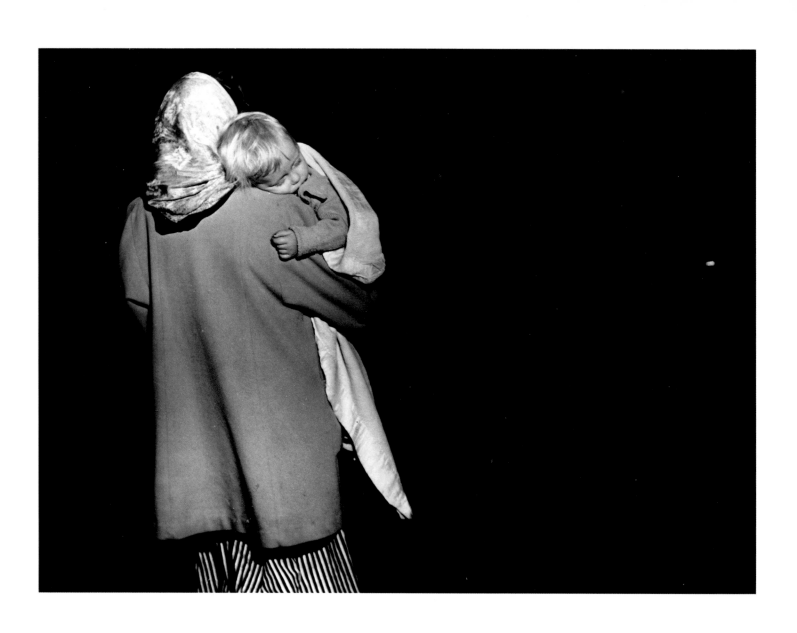

Gerettete Mutter mit ihrem Kind
Mother and child saved
Mère sauvée avec son enfant

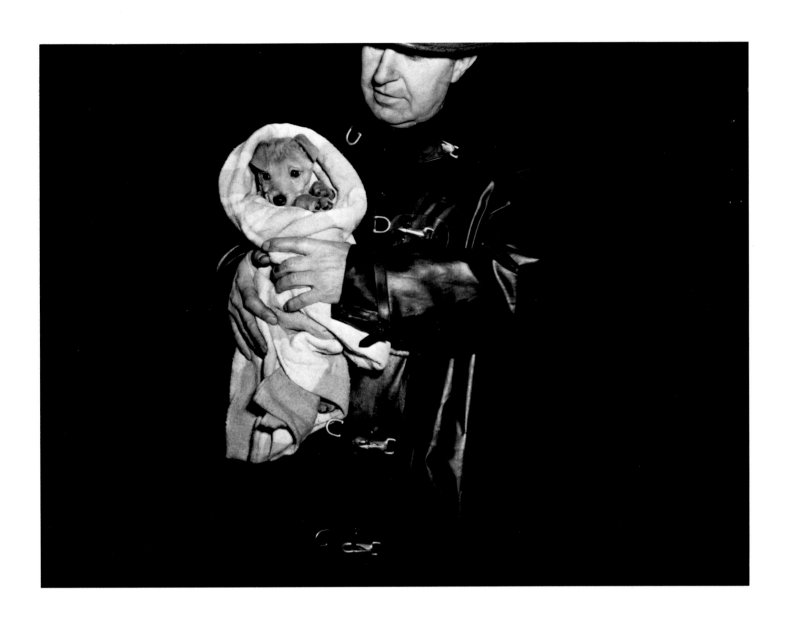

Geretteter Hund
Rescued dog
Chien sauvé

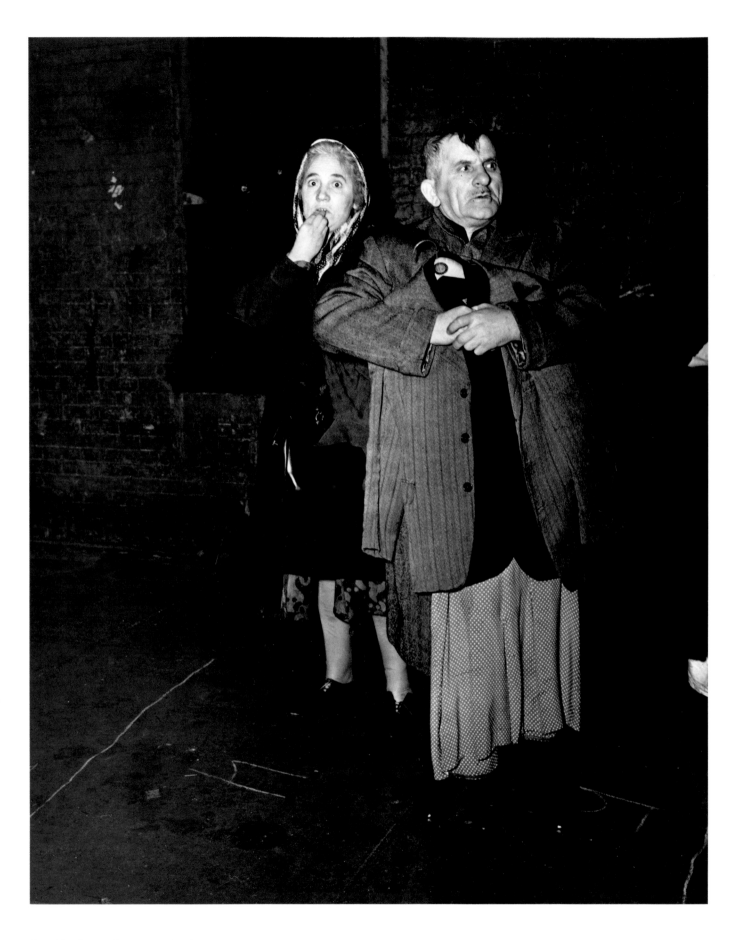

Die Kleider sind gerettet, 1943
The clothing has been saved
Les vêtements sont sauvés

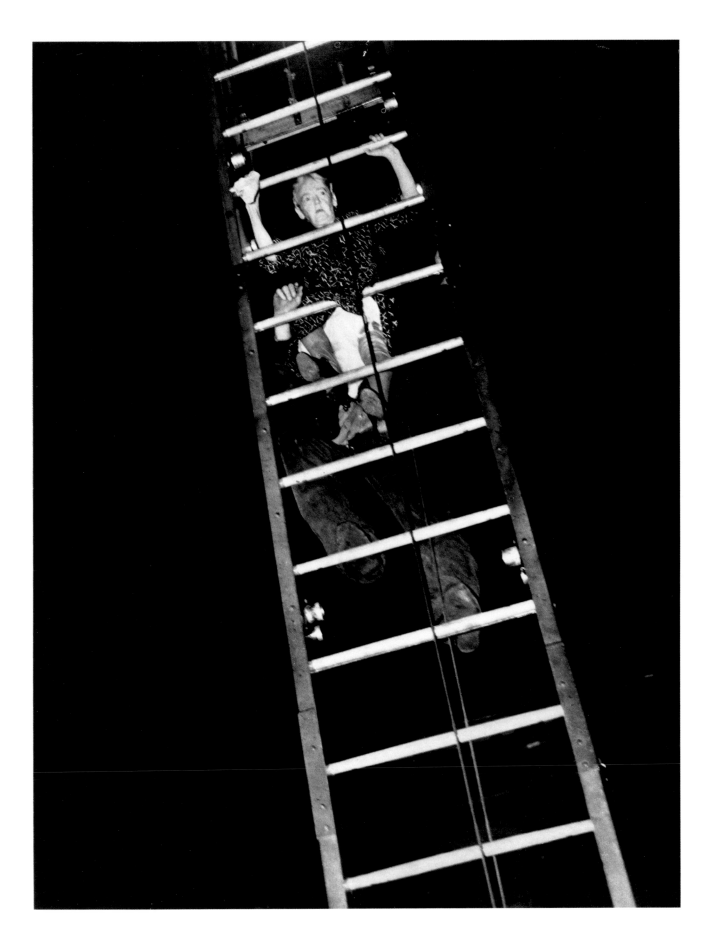

Rettungsaktion, ca. 1940
Rescue operation
Sauvetage

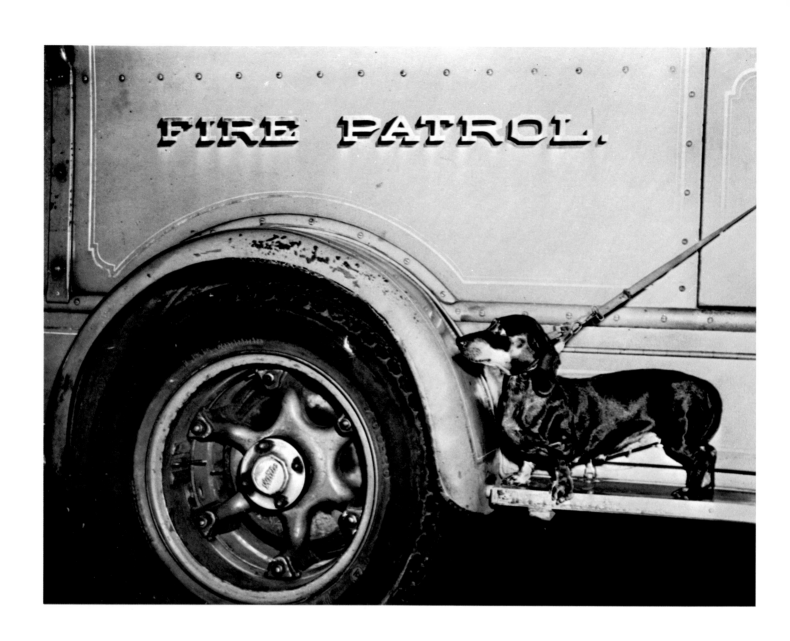

Maskottchen
Mascot
Mascotte

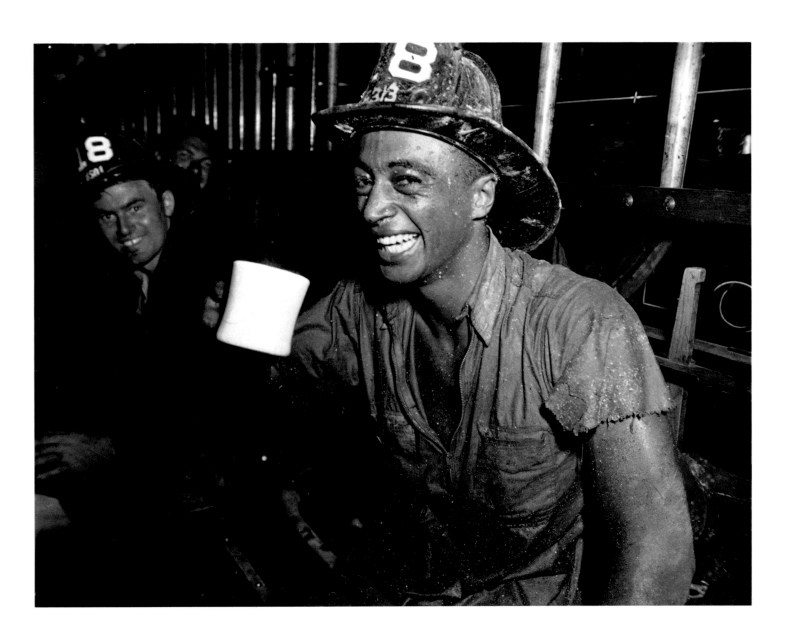

Erfrischung
Refreshment
Rafraîchissement

Strand von Coney Island
Coney Island Beach
La plage de Coney Island

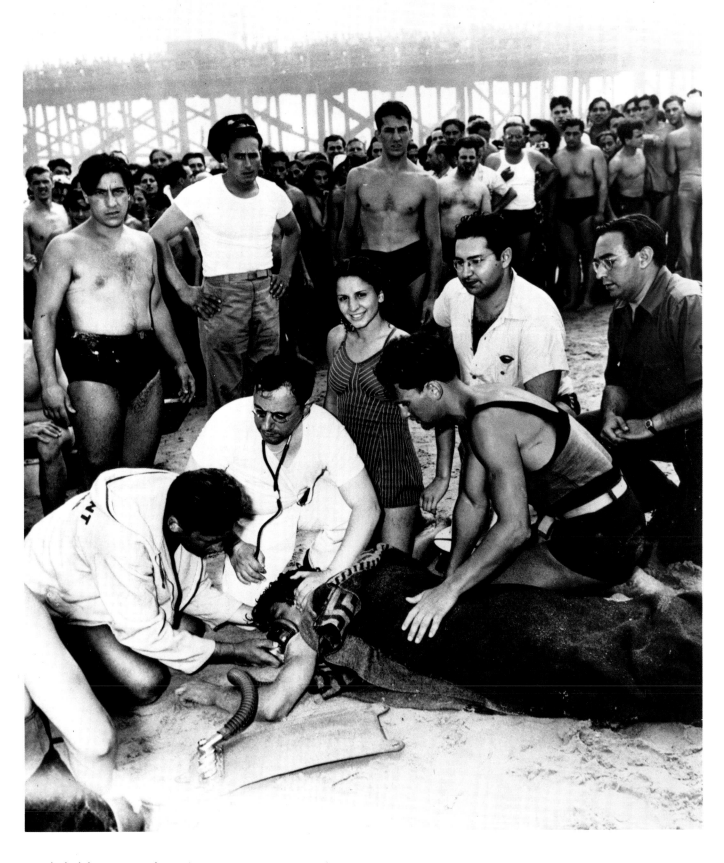

Wiederbelebungsversuch, 1940
Life-saving attempt
Tentative de réanimation

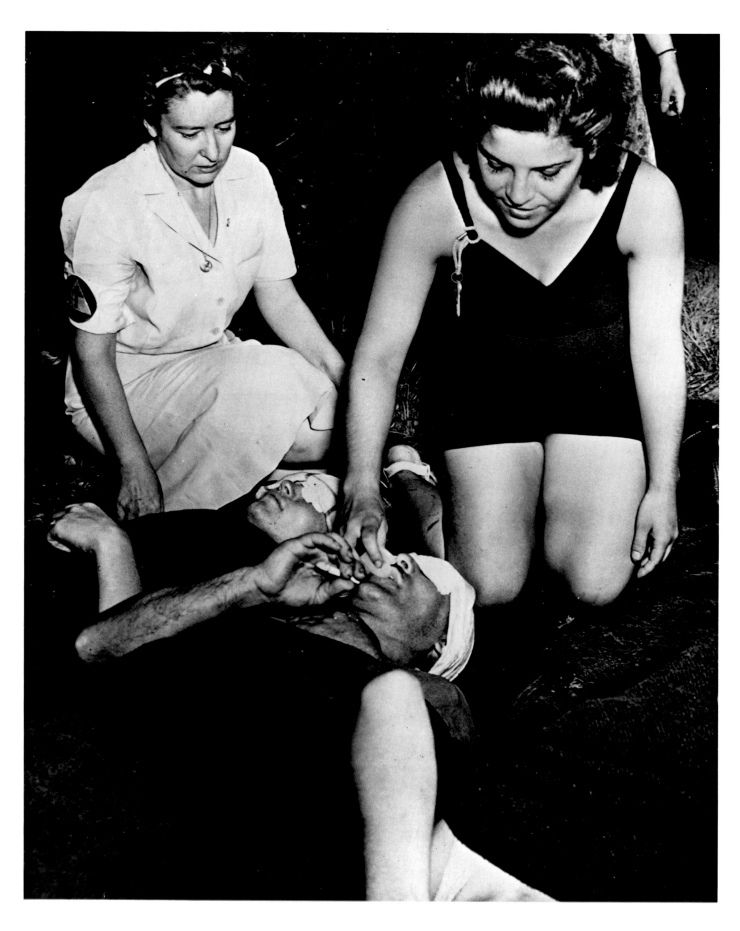

Erste Hilfe
First aid
Premiers secours

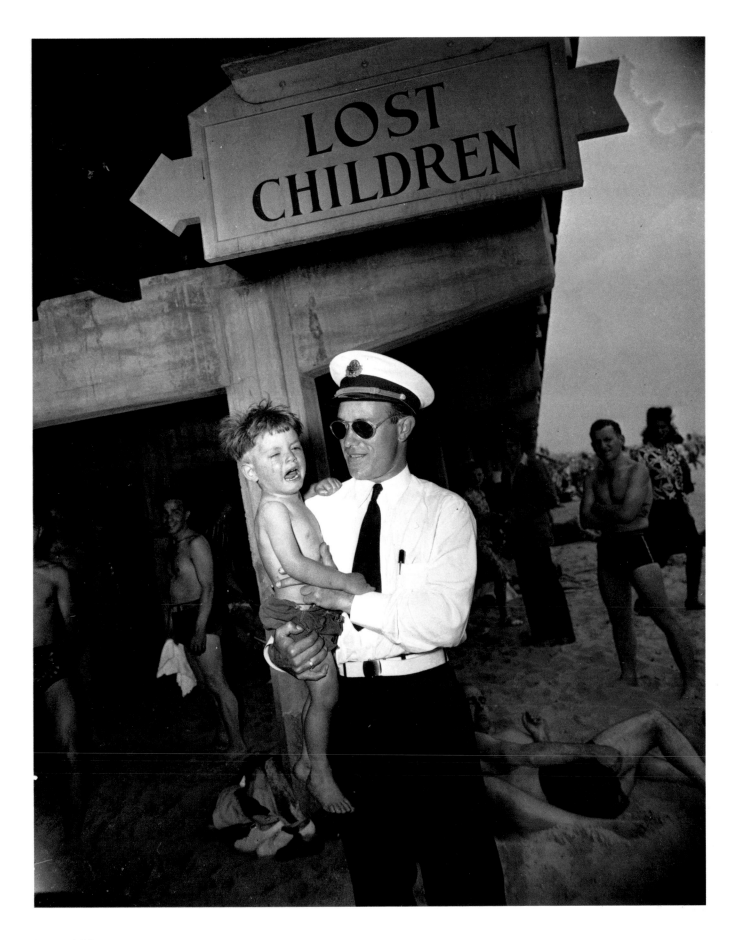

"Lost children"
"Lost children"
"Lost children"

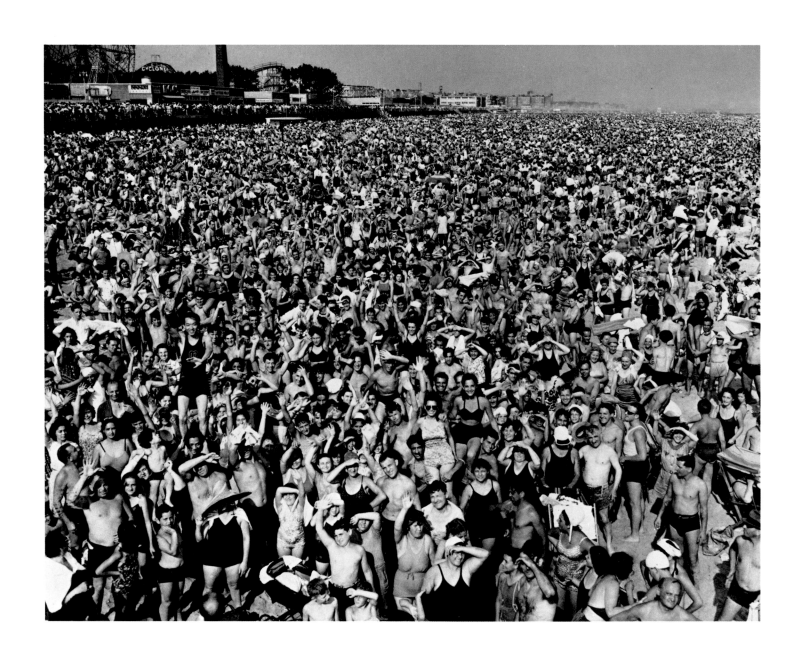

Coney Island am 28. Juli 1940 um vier Uhr nachmittags
Coney Island, 28th of July 1940 4 o'clock in the afternoon
Coney Island, le 28 Juillet 1940 à quatre heures de l'après midi

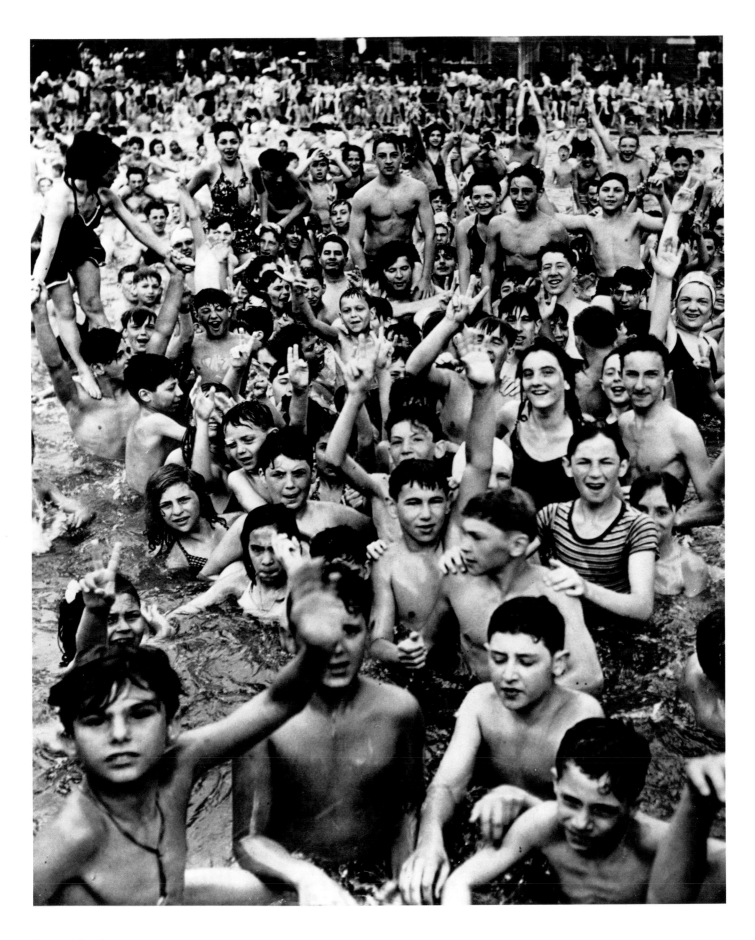

Coney Island
Coney Island
Coney Island

42

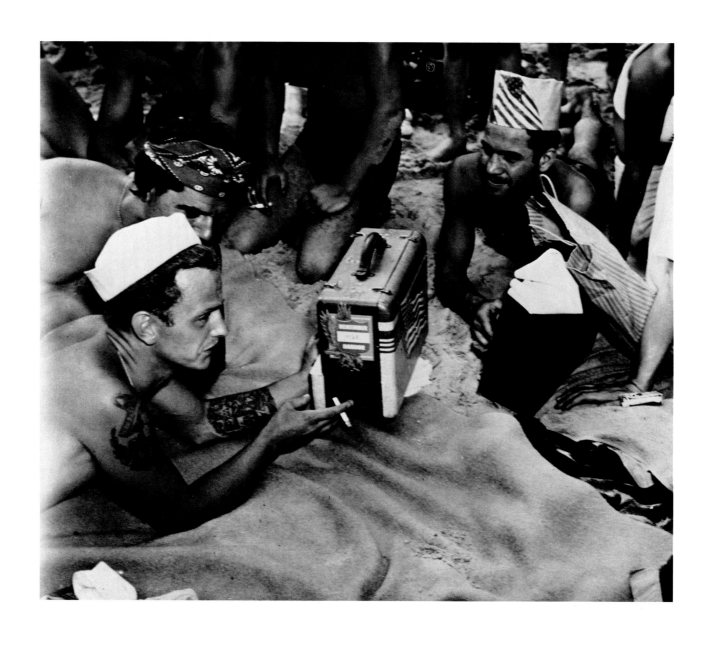

Matrosen am Strand
Sailors on the beach
Marins sur la plage

43

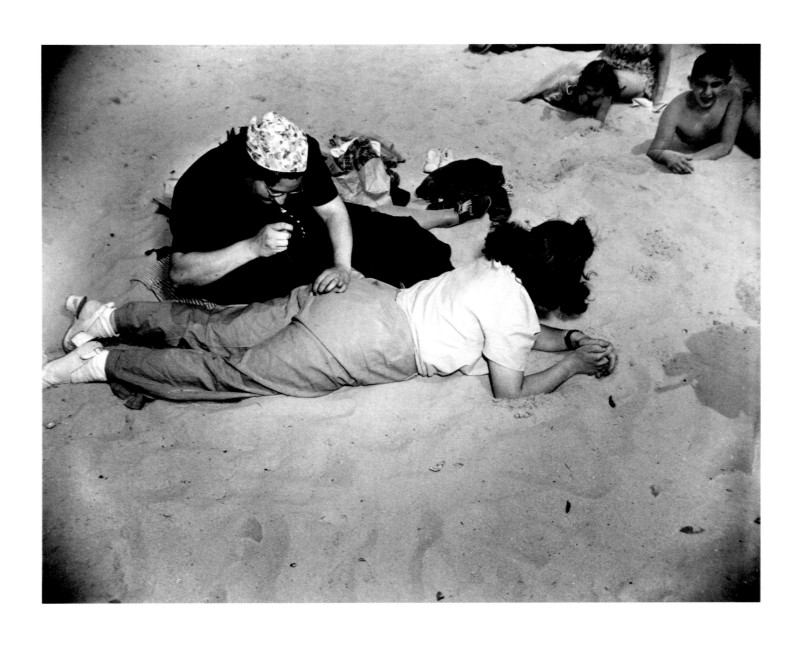

Ausbesserungsarbeiten, 1940
Needlework
Reprises

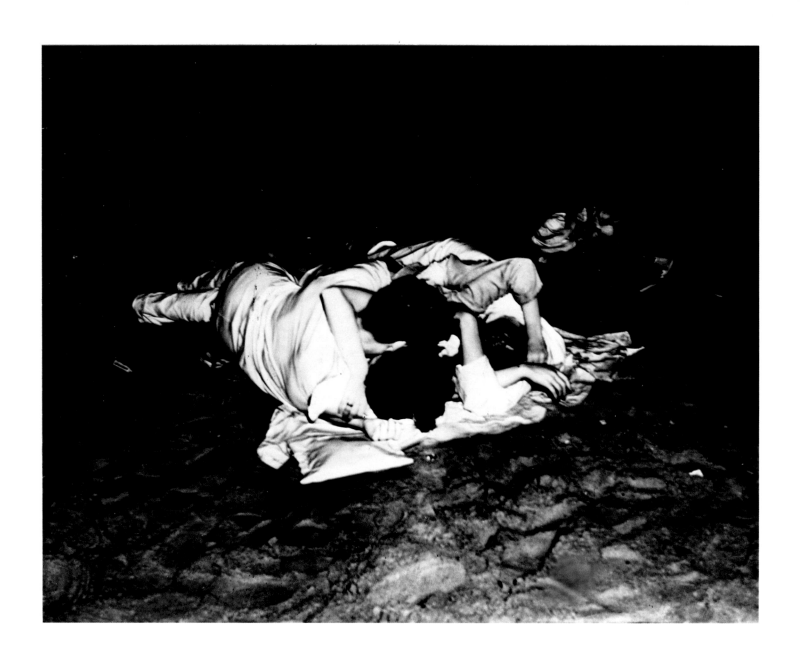

Liebespaare am Strand, 1940
Lovers on the beach
Couples d'amoureux sur la plage

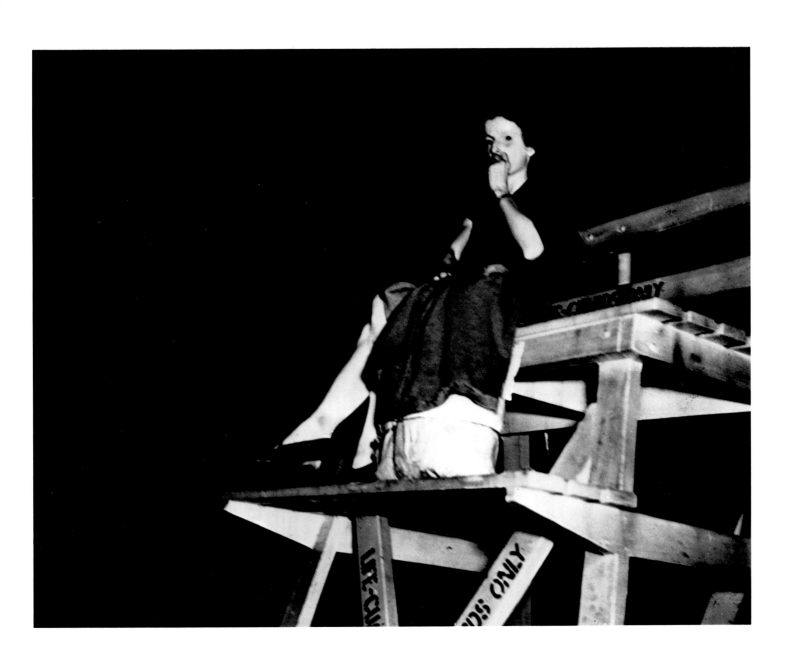

Mädchen beobachtet nachts Liebespaare, 1940
Girl watching lovers at night
Une fillette observe les couples d'amoureux la nuit

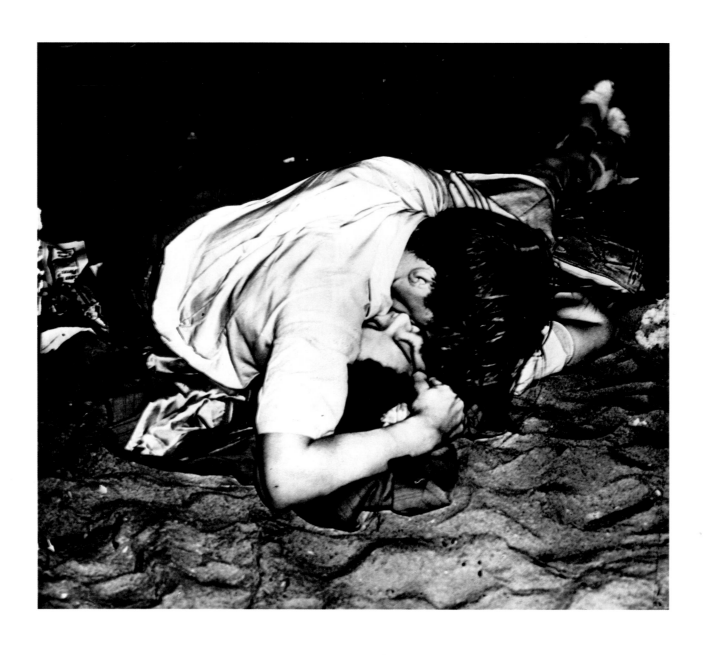

Liebespaar am Strand
Lovers on the beach
Couple d'amoureux sur la plage

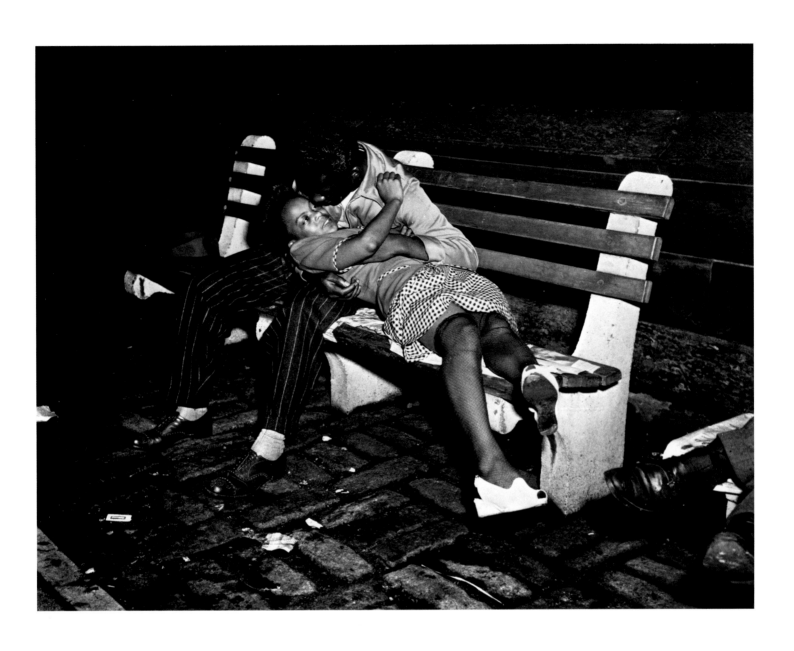

Liebespaar
Lovers
Couple d'amoureux

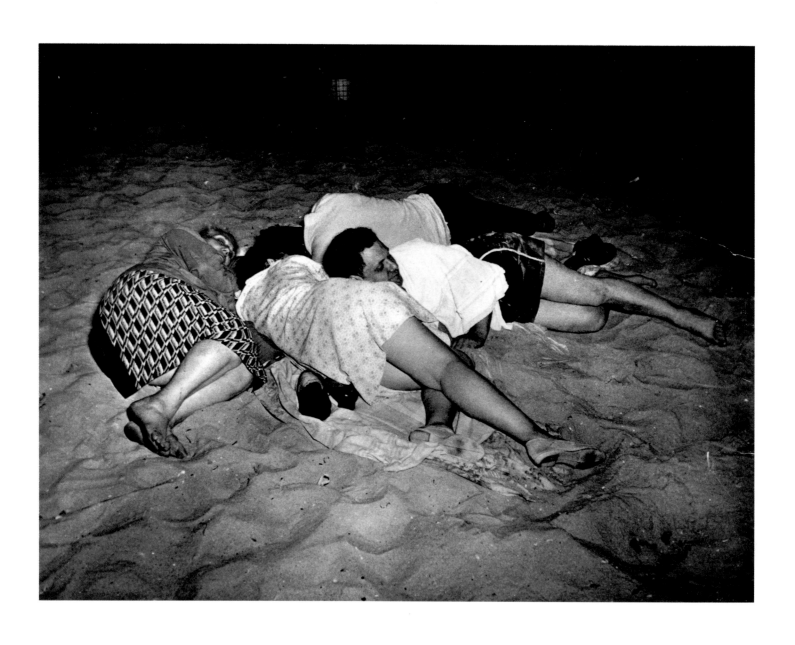

Übernachten am Strand
Sleeping on the beach
Passer la nuit sur la plage

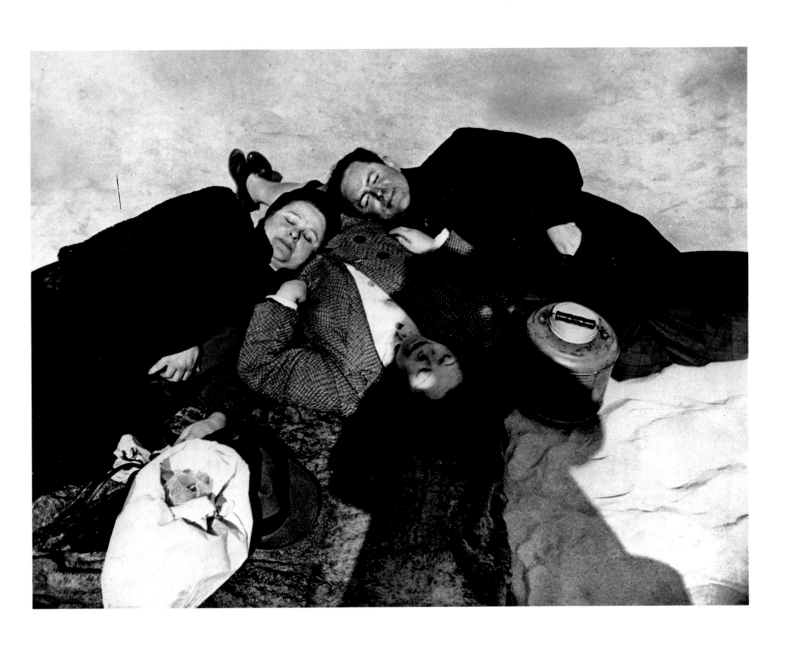

Frühes Sonnenbad, 1940
An early sunbath
Bain de soleil matinal

50

Unfälle
Accidents
Accidents

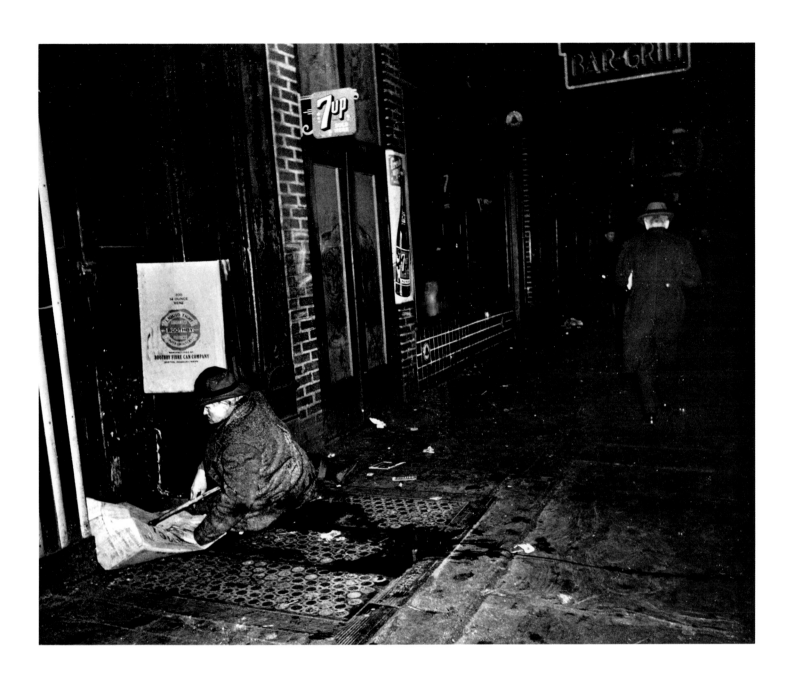

Stadtstreicher an der Lower East Side . . .
Tramp on Lower East Side . . .
Clochard à Lower East Side . . .

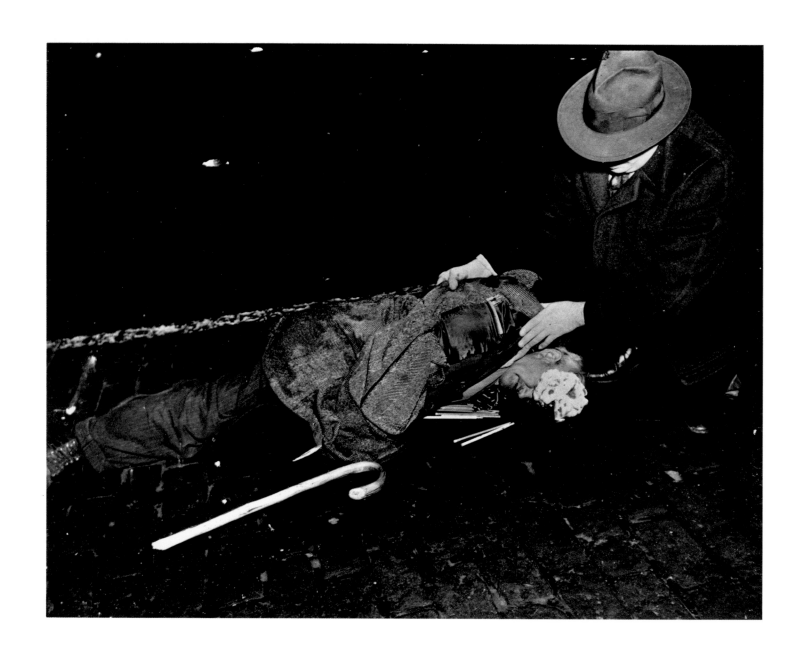

. . . wird von einem Taxi angefahren . . .
. . . is hit by a taxi . . .
. . . est renversé par un taxi . . .

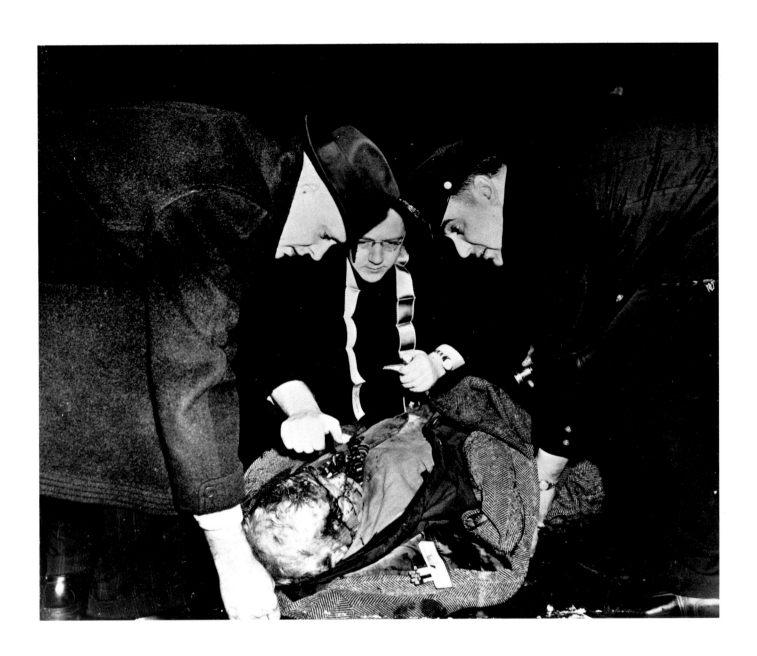

... erhält die Sterbesakramente
... and is receiving the last rites
... reçoit l'extrême-onction

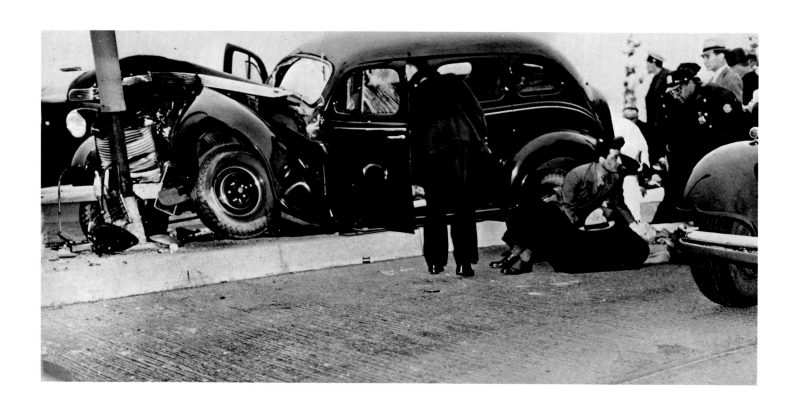

Tödlich verunglückt bei einem Zusammenstoß
Killed in a car crash
Mortellement blessé dans une collision

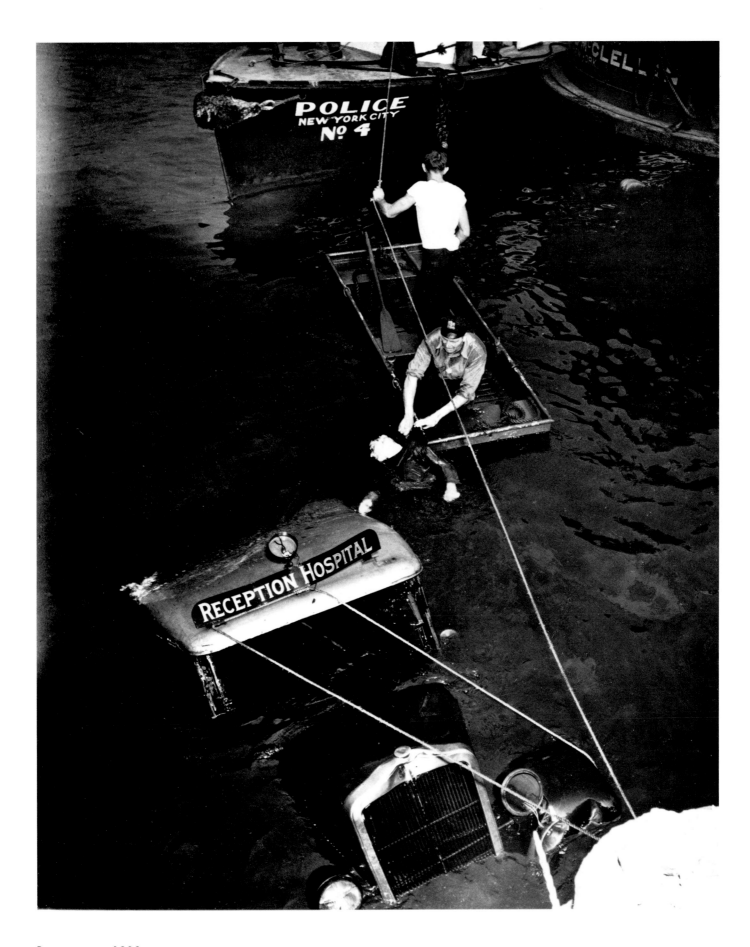

Bergung, ca. 1938
Rescue
Sauvetage

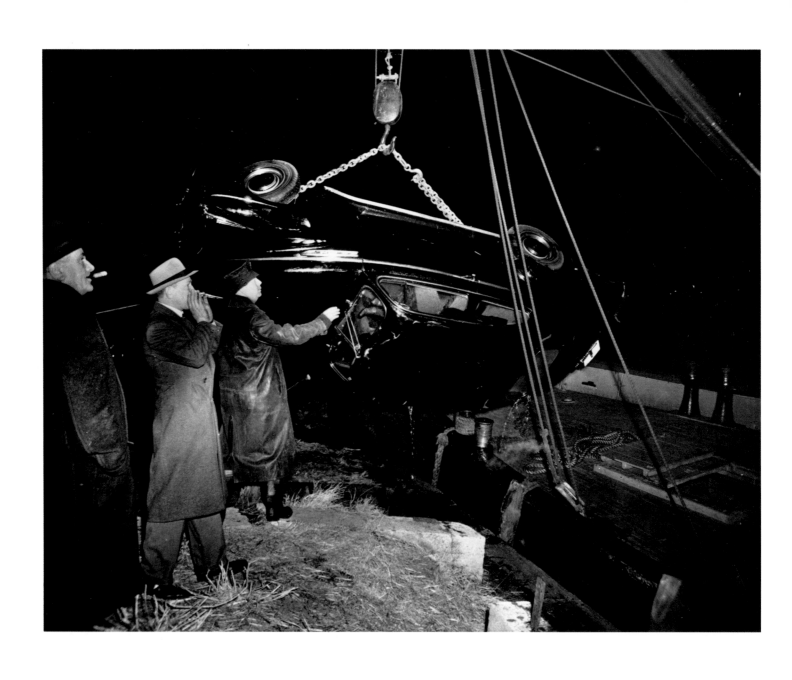

Bergung aus dem East River, ca. 1937
Recovery from East River
Sauvetage de la East River

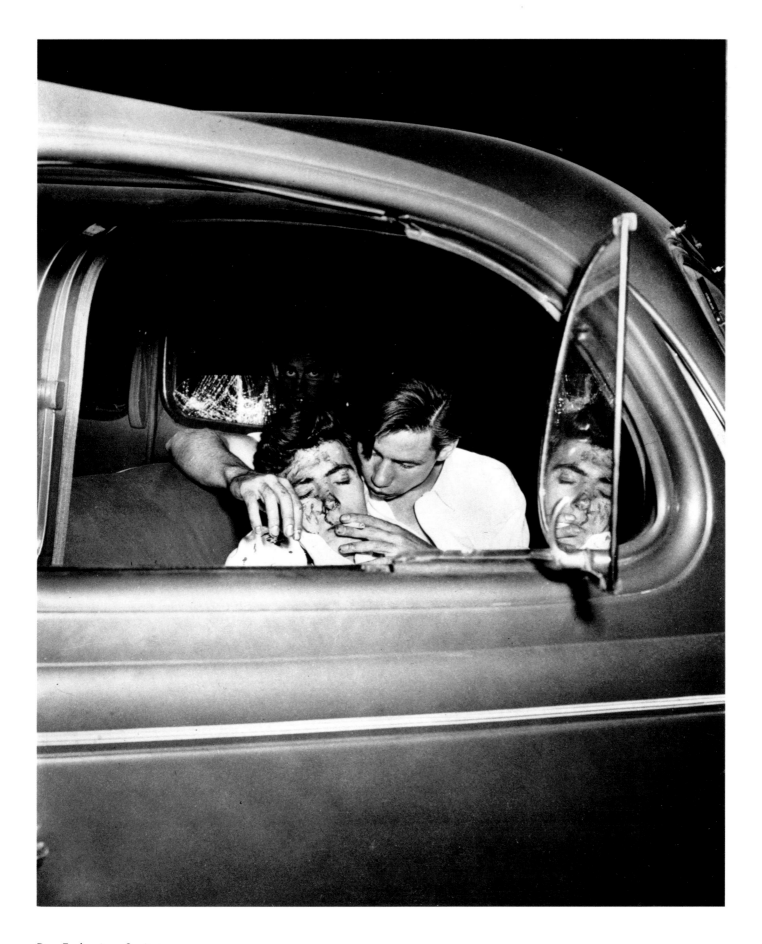

Das Ende einer Spritztour
The end of a joyride
La fin d'un petit tour

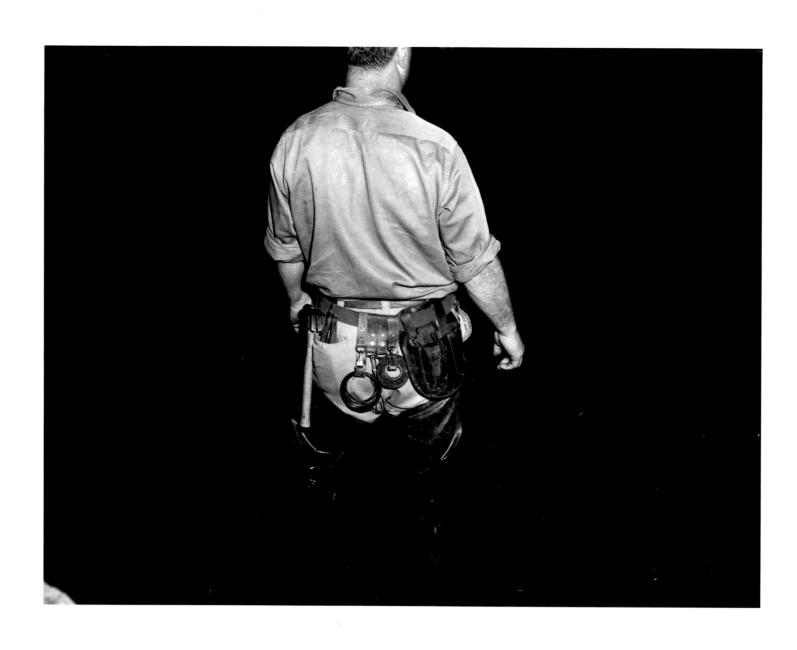

Einsatz im East River
On duty in the East River
En service à East River

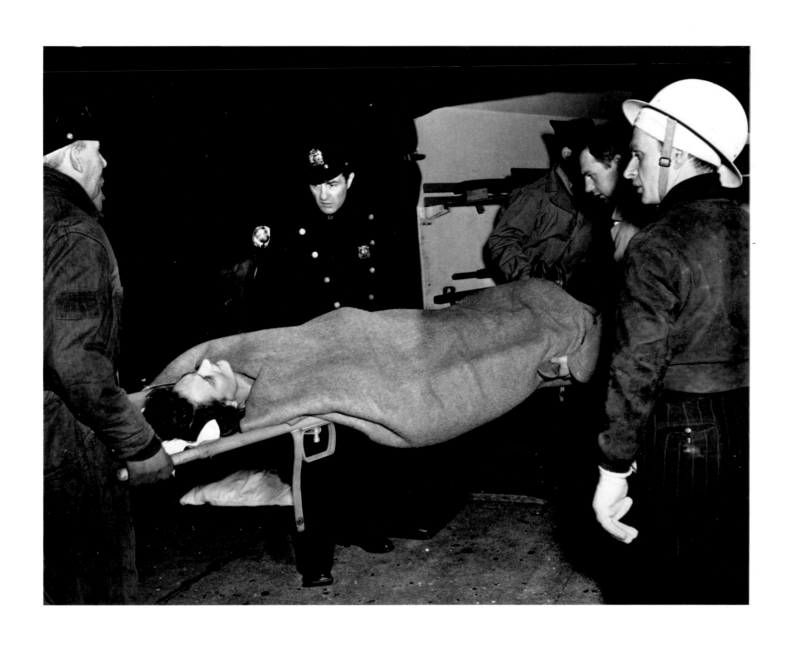

Ambulanz, ca. 1943
Ambulance
Ambulance

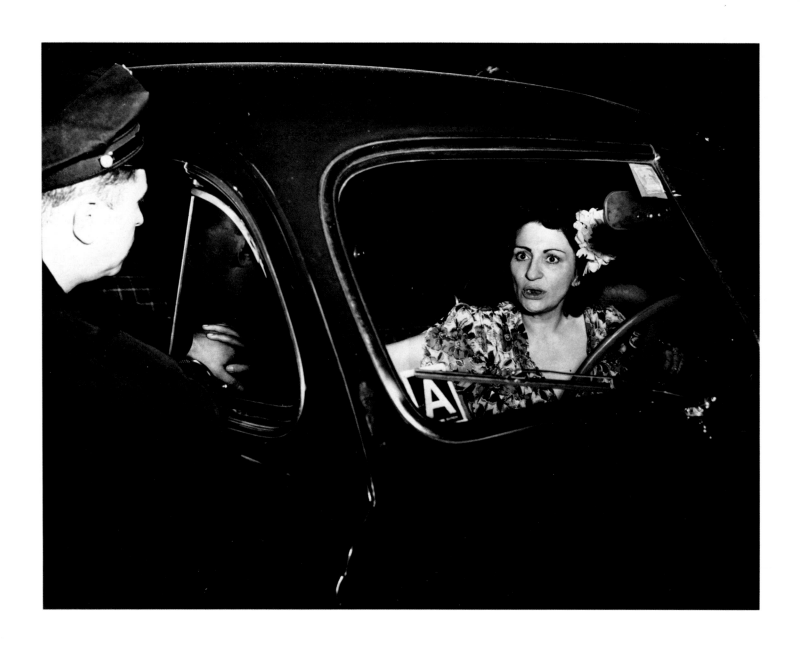

Unfallschock, 1940
Shock
Sous le choc de l'accident

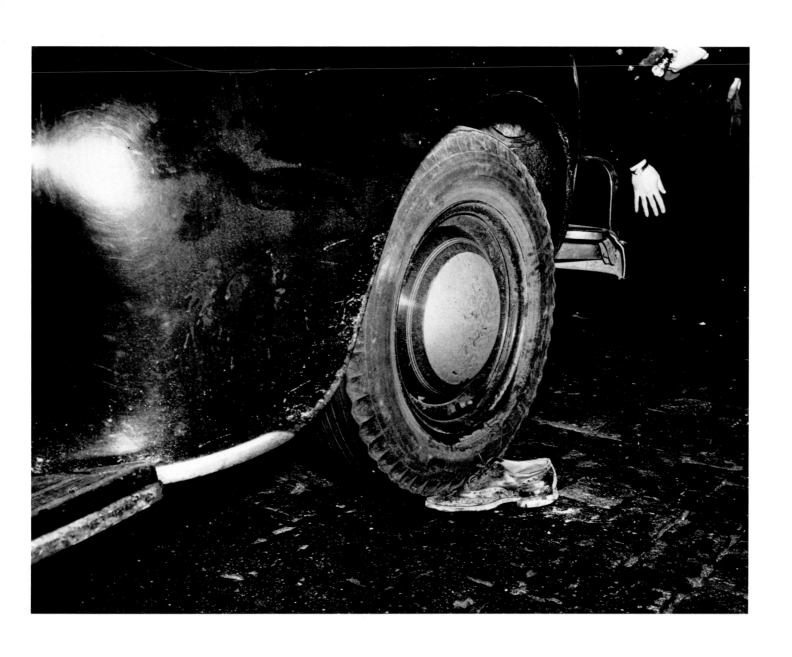

Verkehrsunfall, ca. 1938
Car accident
Accident de la circulation

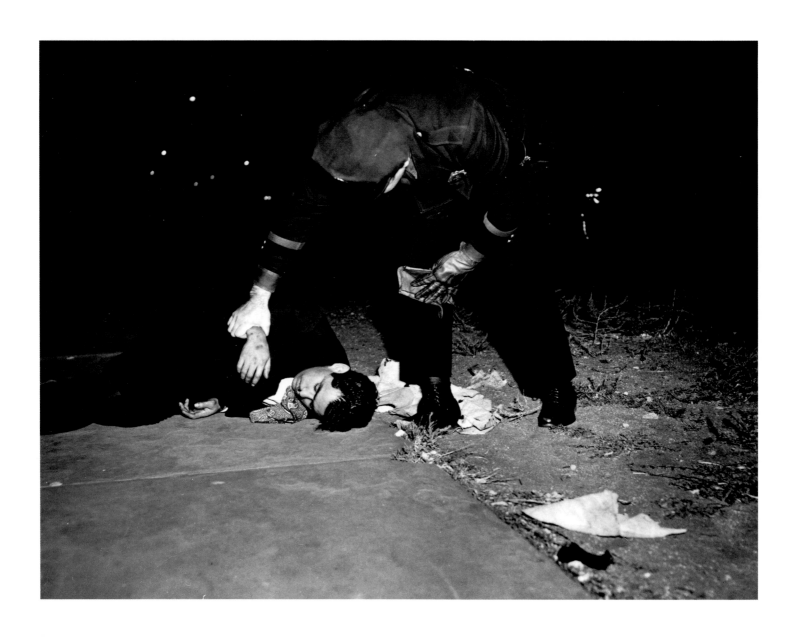

Tot?
Dead?
Mort?

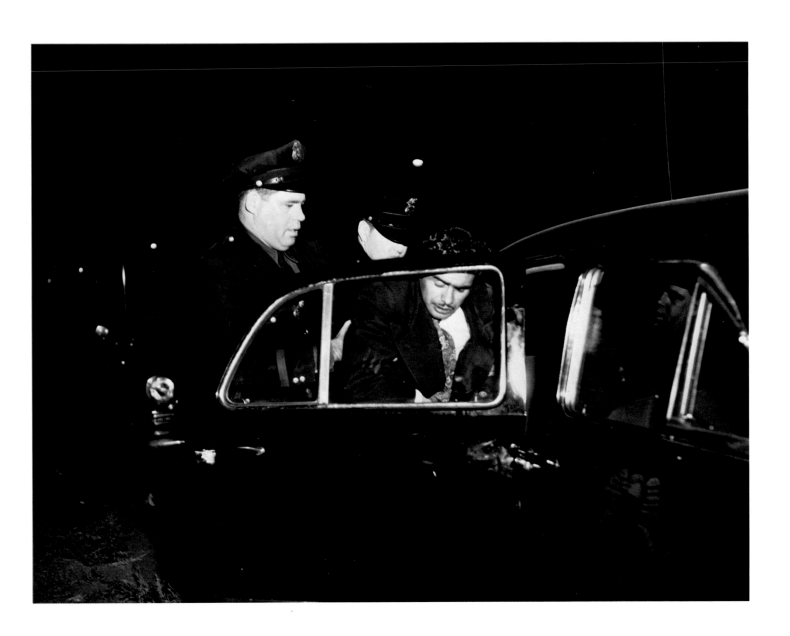

. . . nein, er lebt noch
. . . no, he's still alive
. . . non, il vit encore

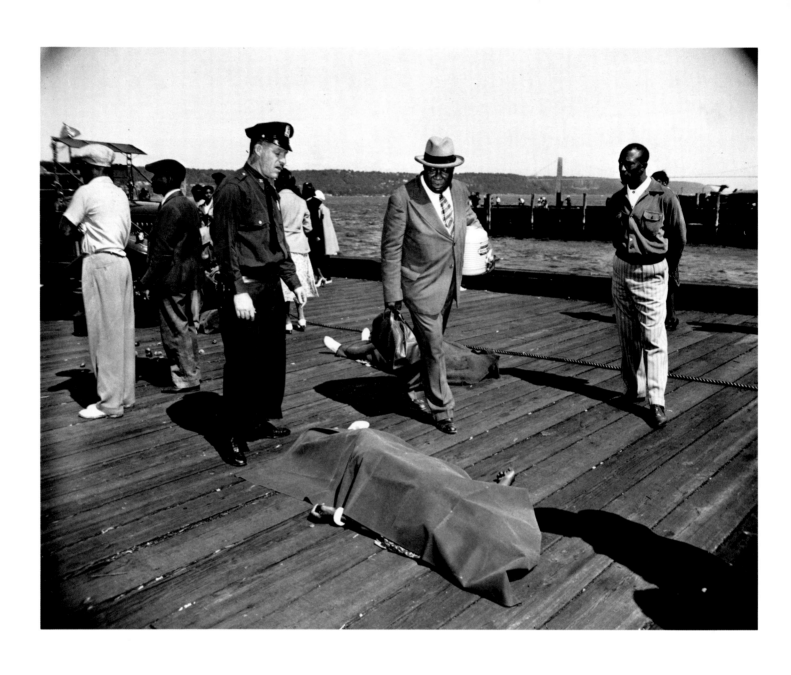

Auf einem Vergnügungsboot zu Tode getrampelt
Trampled to death on an excursion boat
Piétiné à mort sur un navire de plaisance

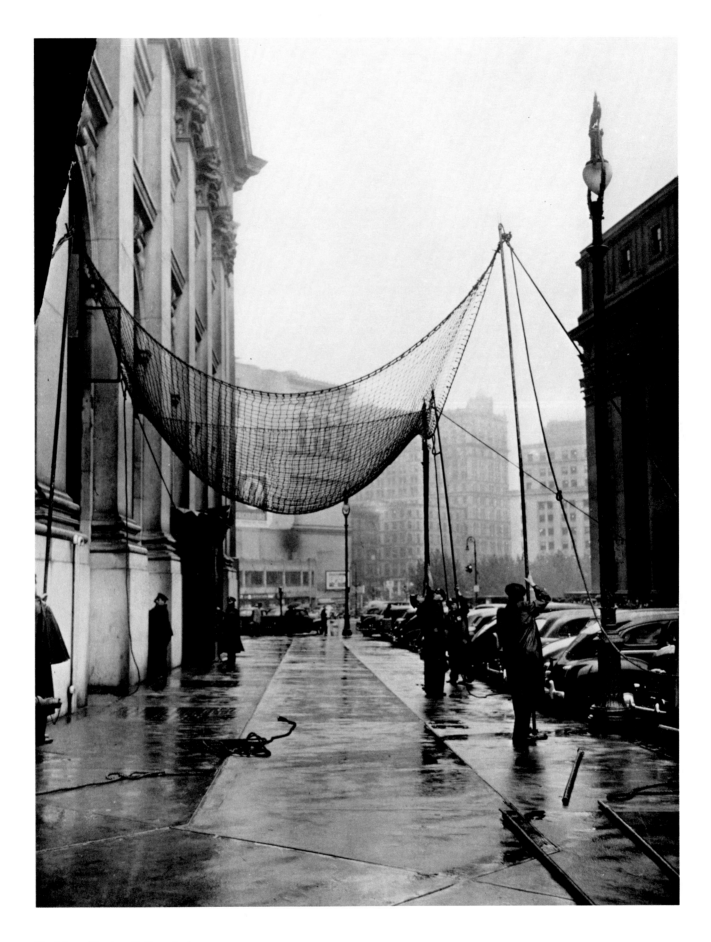

Ein Netz für den Selbstmörder
A suicide net
Un filet pour celui qui veut se suicider

Verbrechen
Crime
Crimes

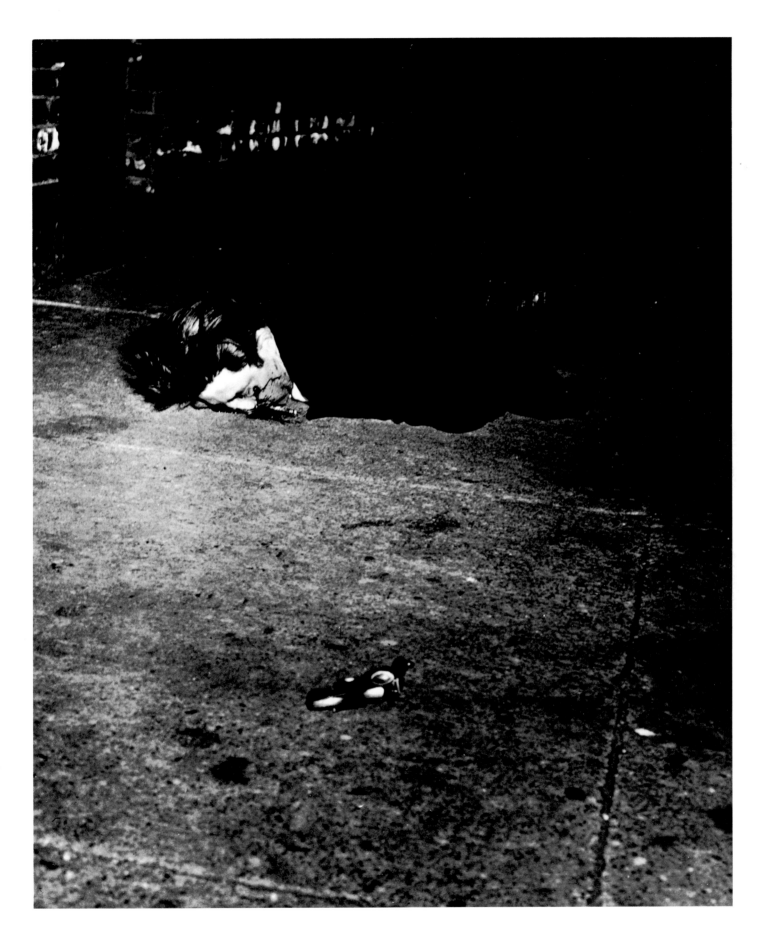

Leiche mit Revolver, ca. 1940
Corpse with revolver
Cadavre avec révolver

66

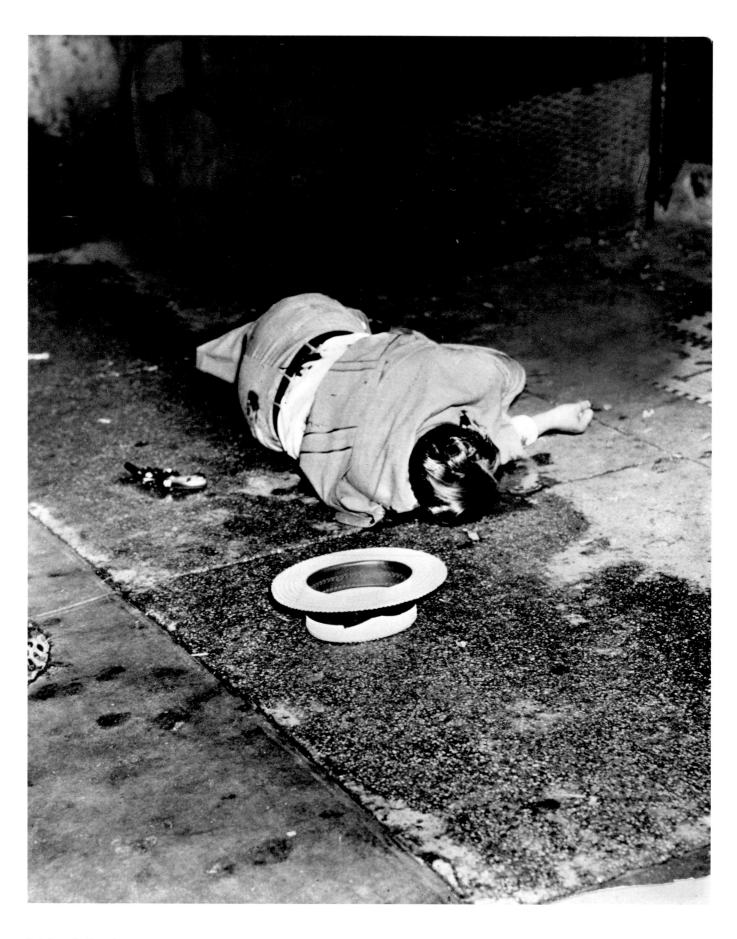

Leiche mit Revolver
Corpse with revolver
Cadavre avec révolver

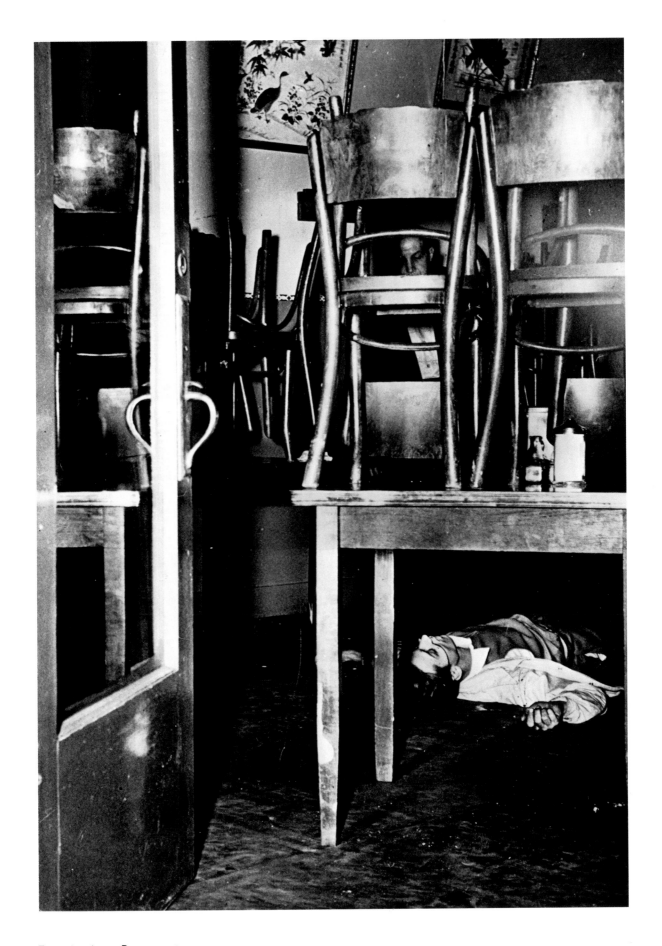

Toter in einem Restaurant
Dead man in a restaurant
Mort dans un restaurant

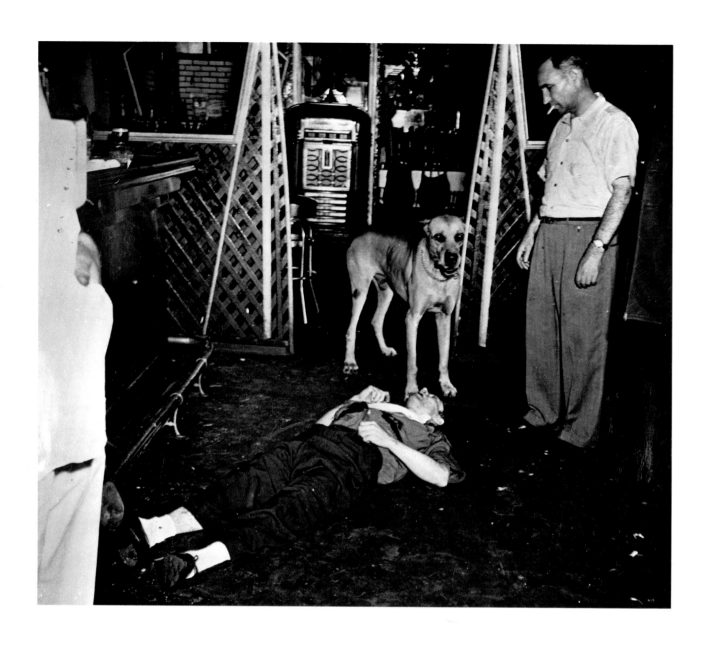

Toter in einer Bar
Dead man in a bar
Mort dans un bar

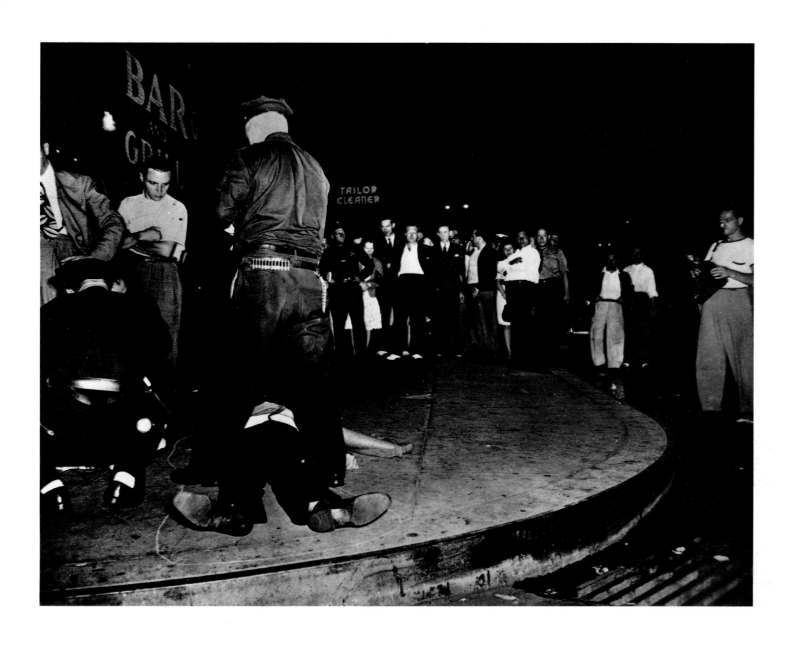

Toter auf der Straße
Dead man in a street
Mort dans la rue

70

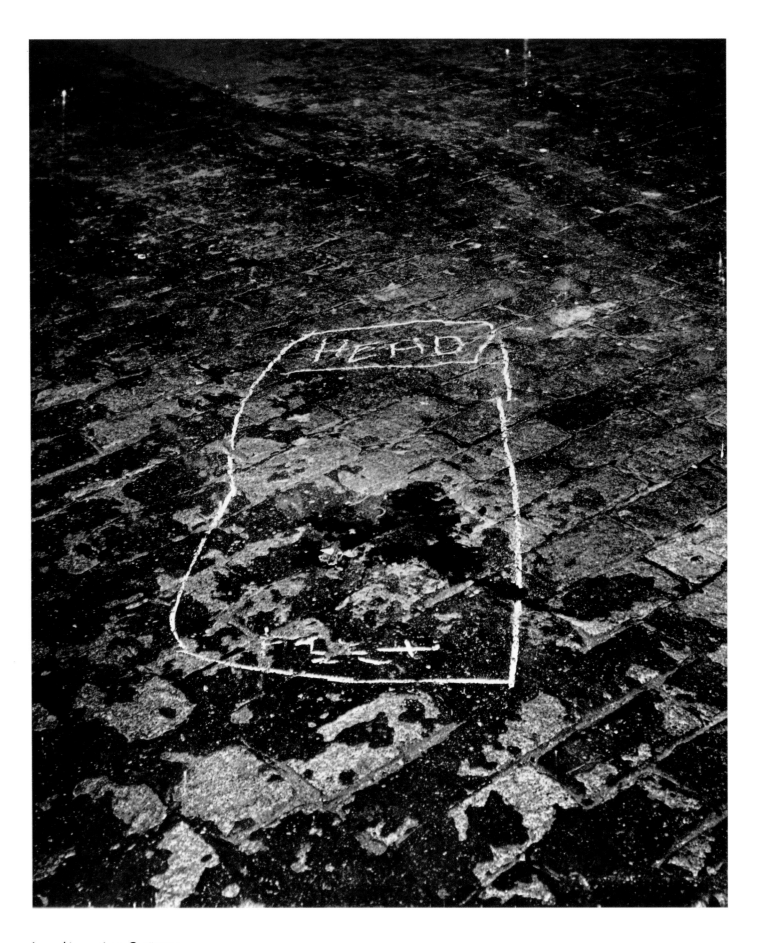

Lageskizze eines Getöteten
Outline of a murder victim
Croquis signalant la place d'un mort

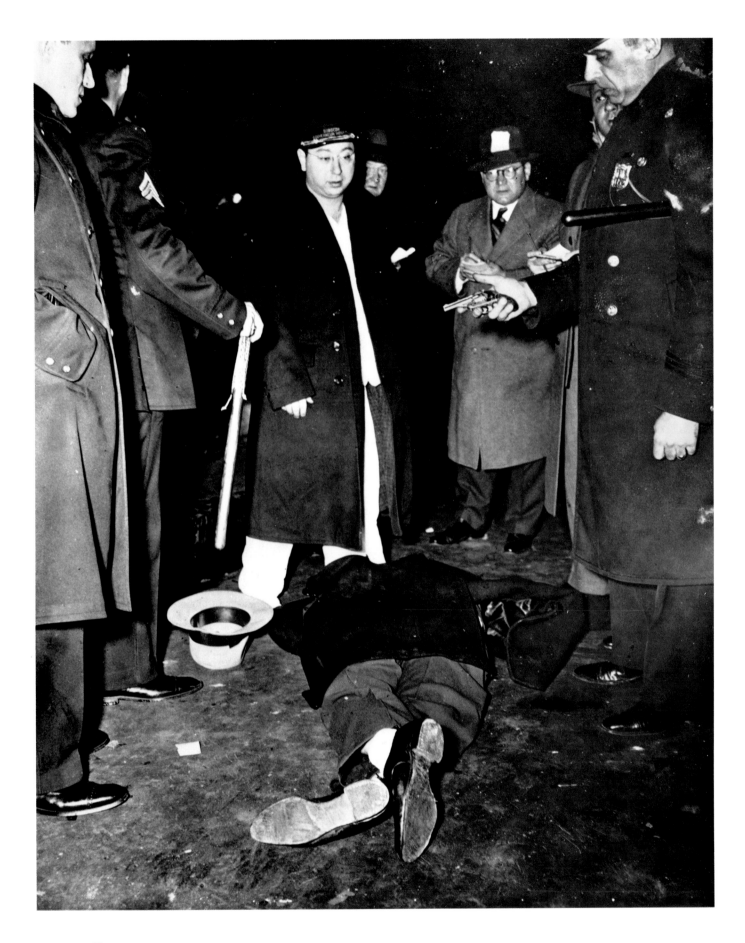

Die Tatwaffe
The murder victim
L'arme du crime

72

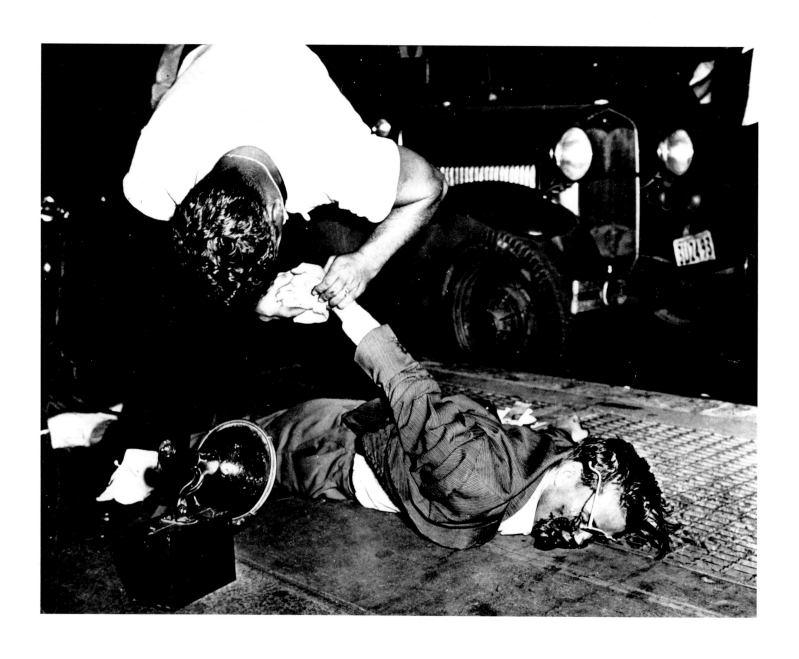

Erkennungsdienst, 1943
Identification squad
Identification

73

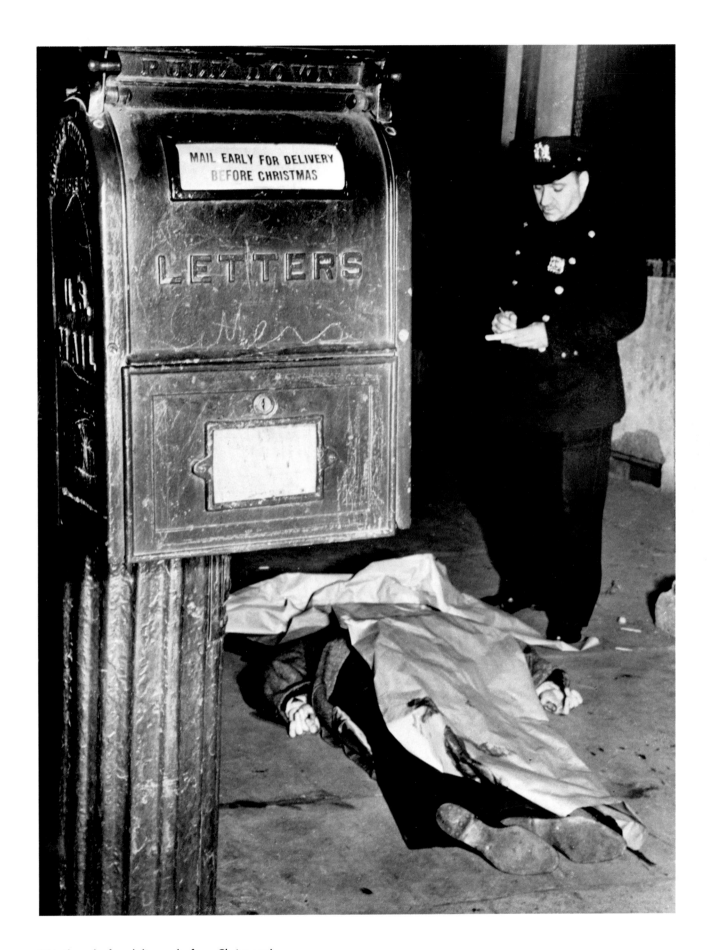

"Mail early for delivery before Christmas'
"Mail early for delivery before Christmas'
"Mail early for delivery before Christmas'

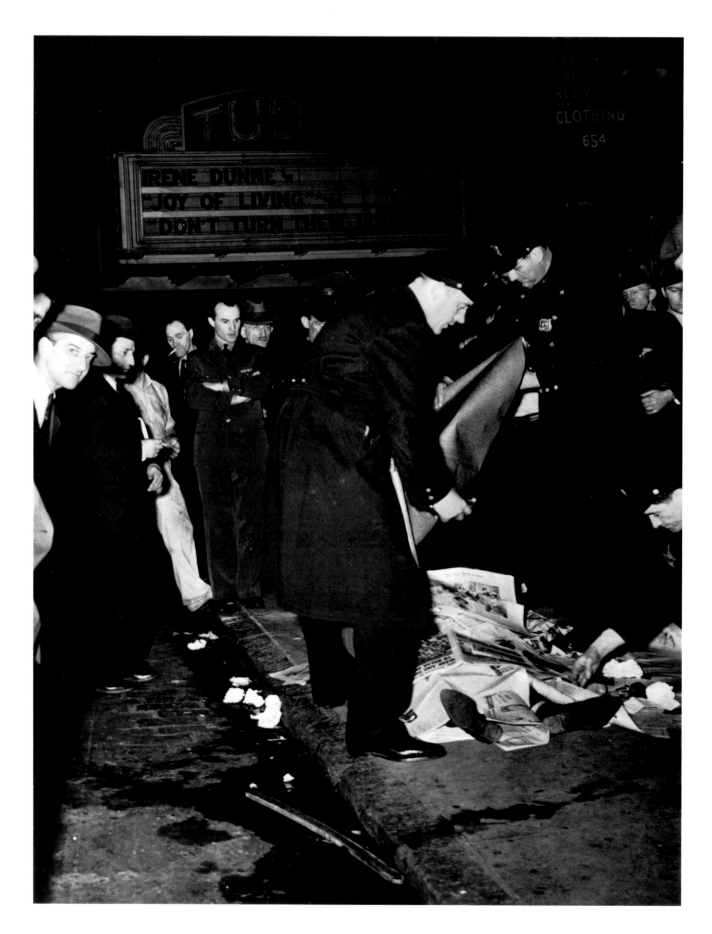

"Joy of Living" 1946
"Joy of Living"
"Joy of Living"

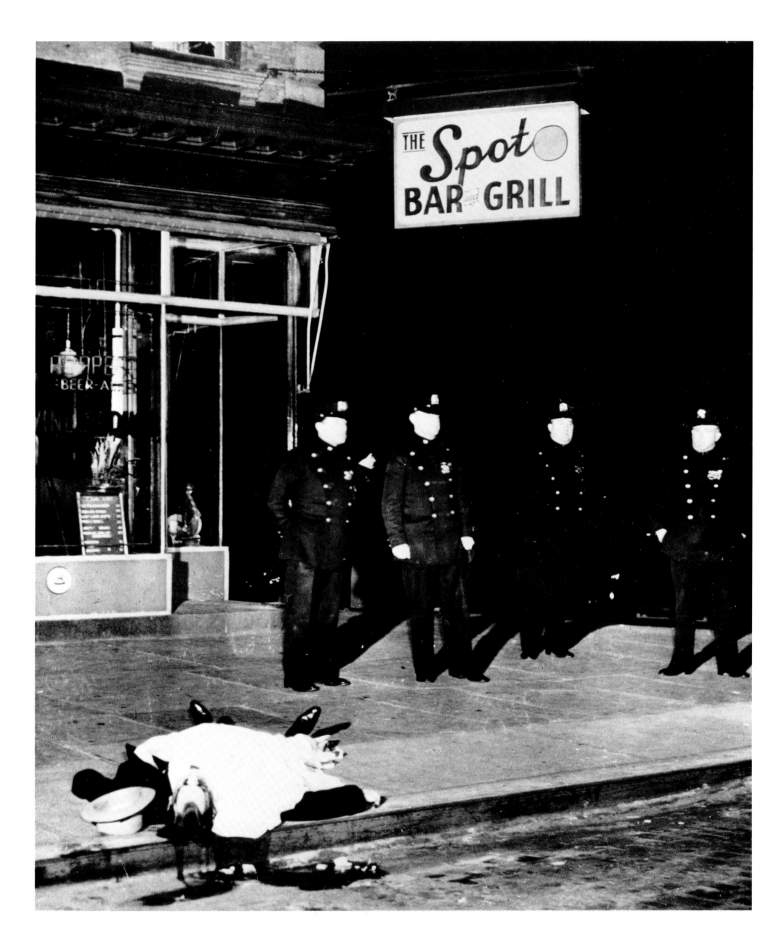

An Ort und Stelle, ca. 1940
On the Spot
Sur les lieux du crime

76

Ein Haufen Polizisten
A bunch of cops
Une foule de policiers

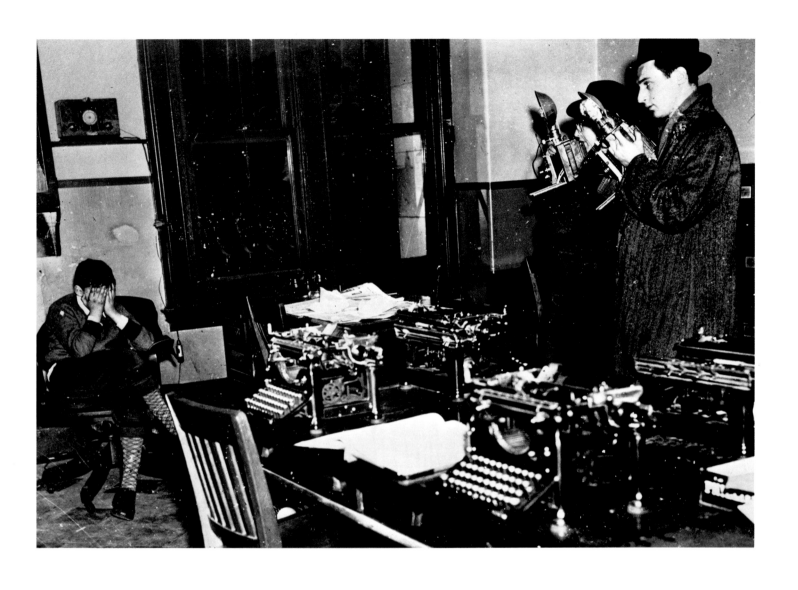

Jugendlicher Täter und Pressephotographen
Juvinile delinquent and pressphotographers
Jeune délinquant et photographes de presse

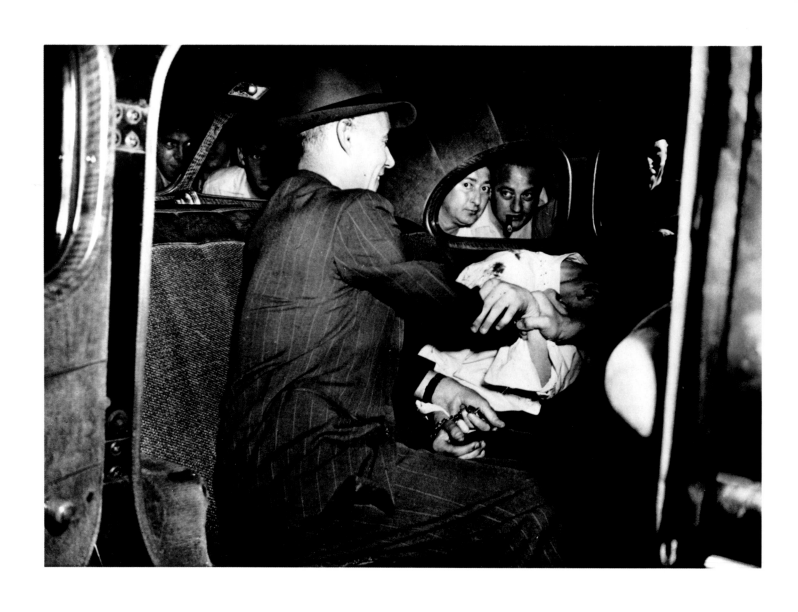

Anlegen von Handschellen
Putting on the handcuffs
En train de mettre les menottes

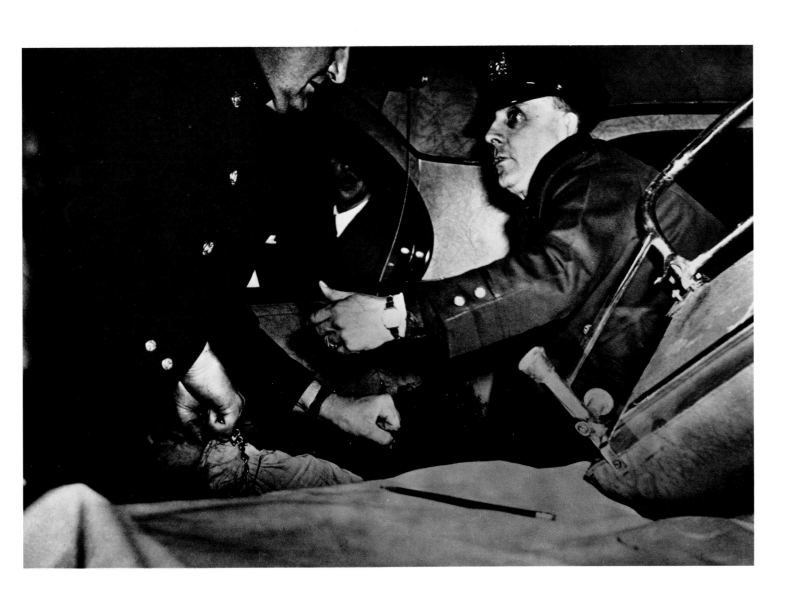

Ein Festgenommener leistet Widerstand
Resisting arrest
Celui qu'on arrête oppose une résistance

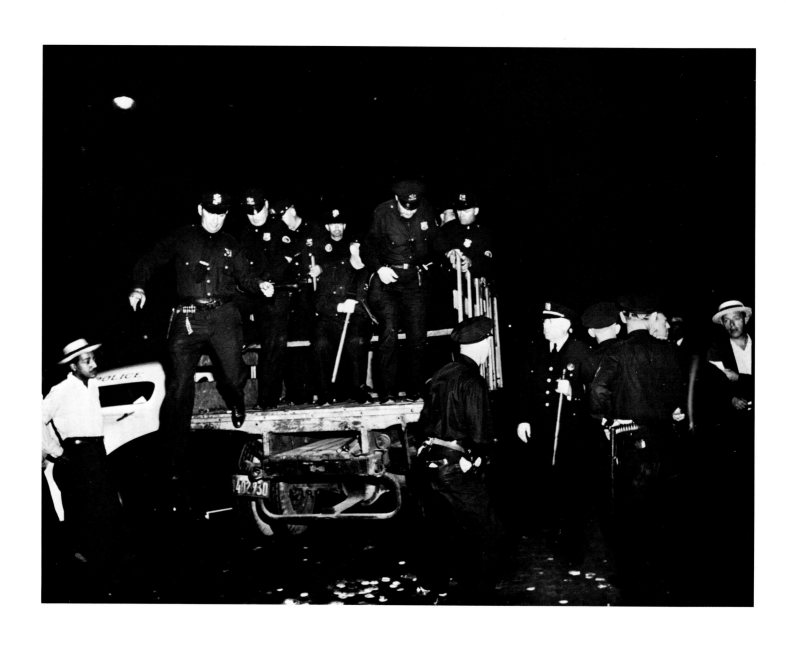

Polizei-Einsatz in Harlem
On duty in Harlem
Service de police à Harlem

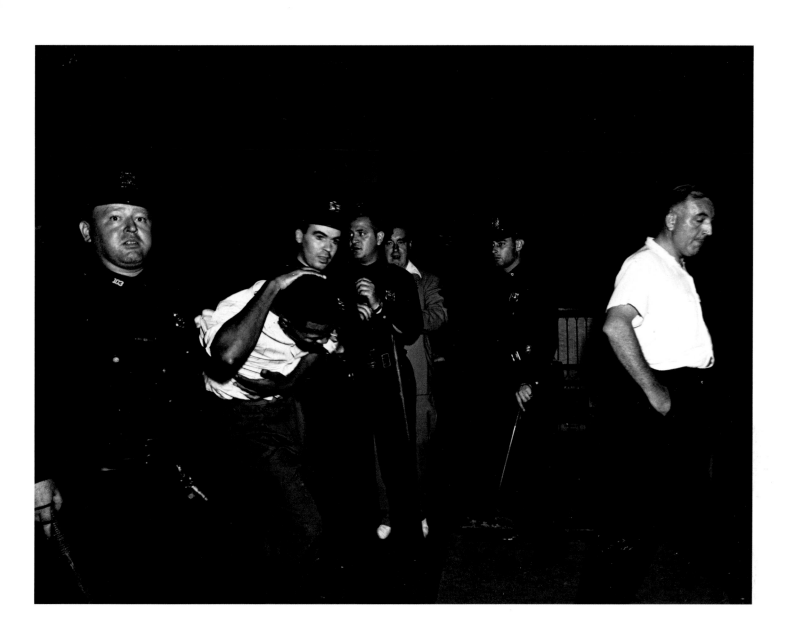

Festnahme
Making an arrest
Arrestation

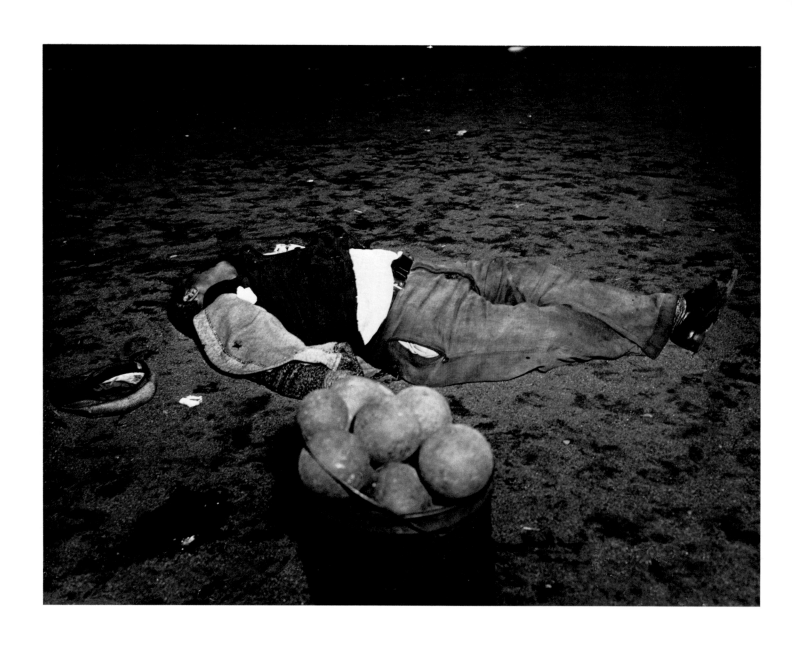

Beim Boccia-Spiel ermordet, 1938
Murdered while playing boccia
Assassiné pendant qu'il jouait au boccia

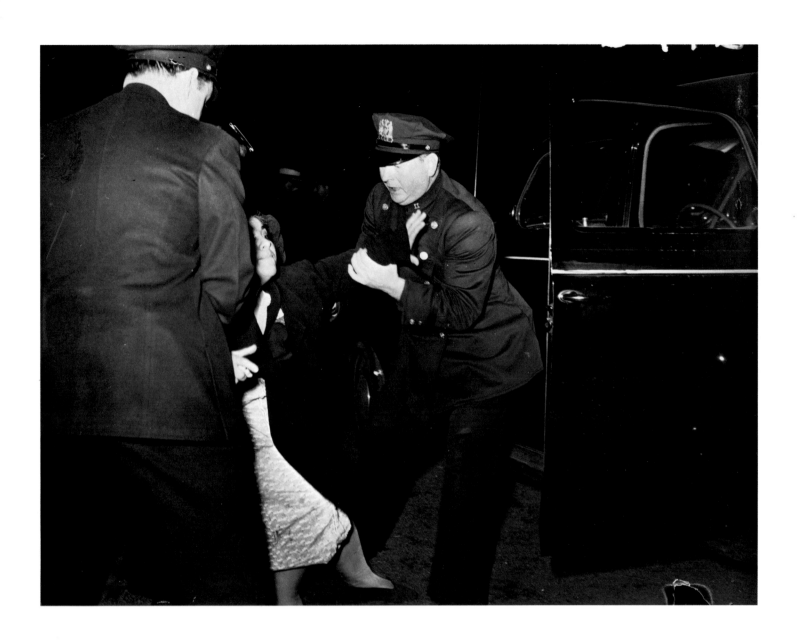

Die Frau des Ermordeten
Wife of the victim
La femme de la victime

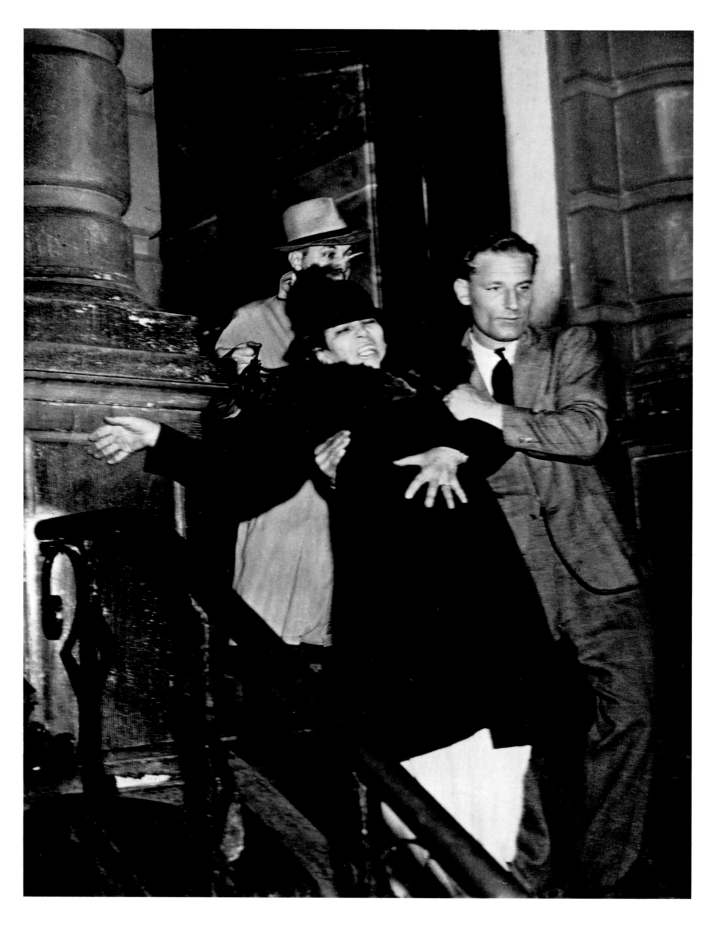

Verhaftung, 1947
An arrest
Arrestation

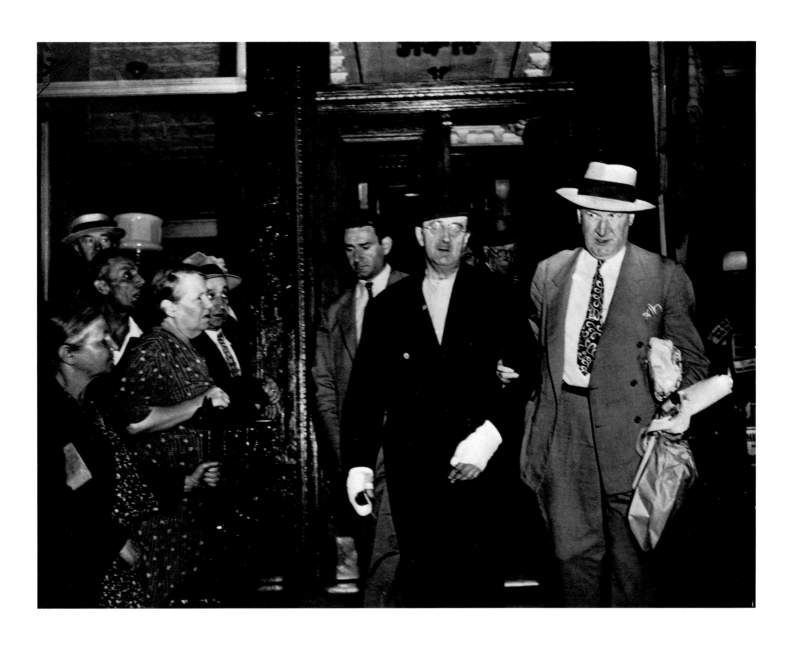

Alan Downs — tötete seine Frau
Alan Downs — killed his wife
Alan Downs a tué sa femme

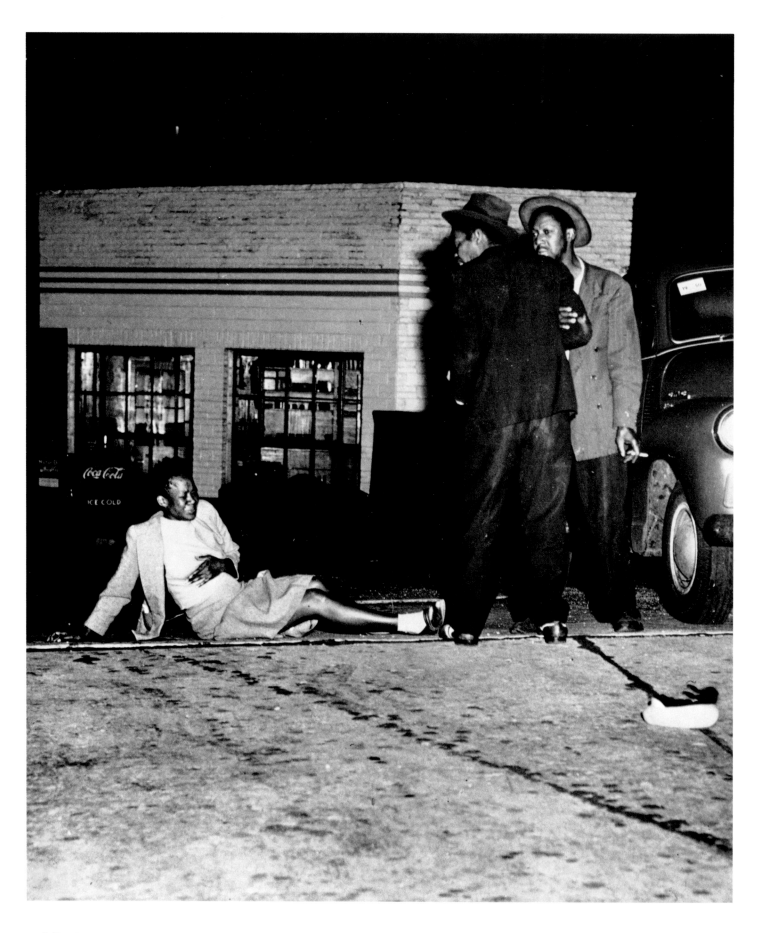

Unfall oder Verbrechen?
Accident or crime?
Accident ou crime?

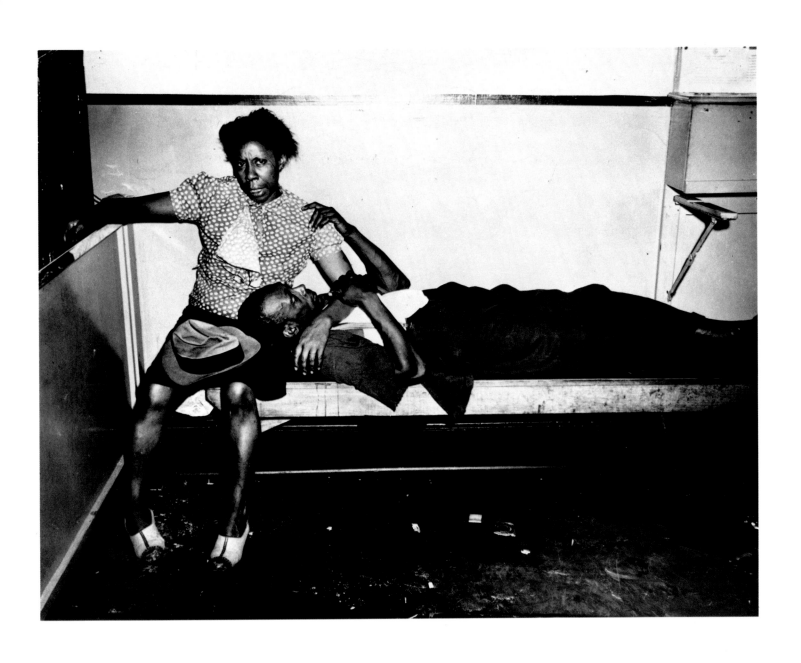

Er hat getötet, ca. 1940
He killed someone
Il a tué

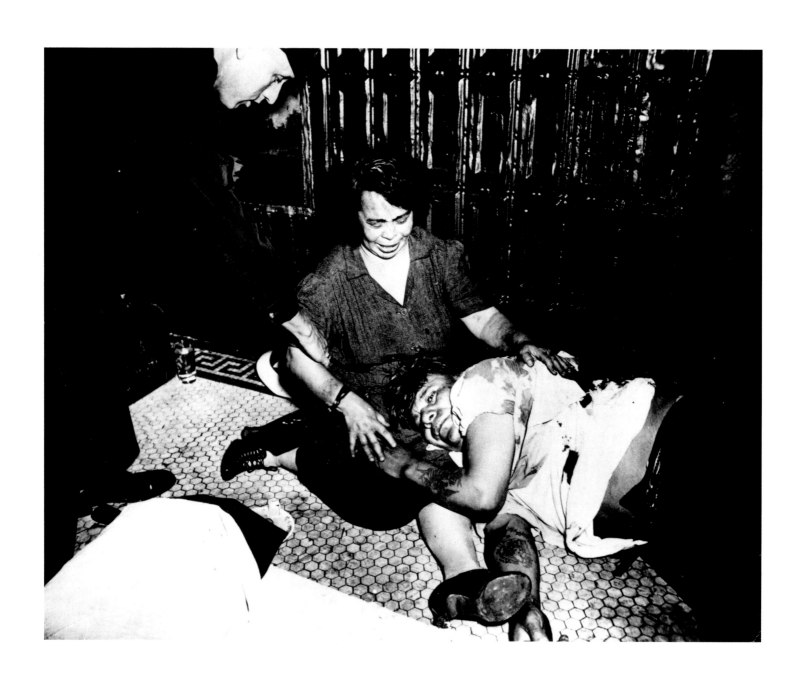

Ihr verwundeter Ehemann wird wegen Mordes an einem Verwandten verhaftet, 1938
Her wounded husband is arrested for killing a relative
Son mari blessé est arrêté pour meutre d'un parent

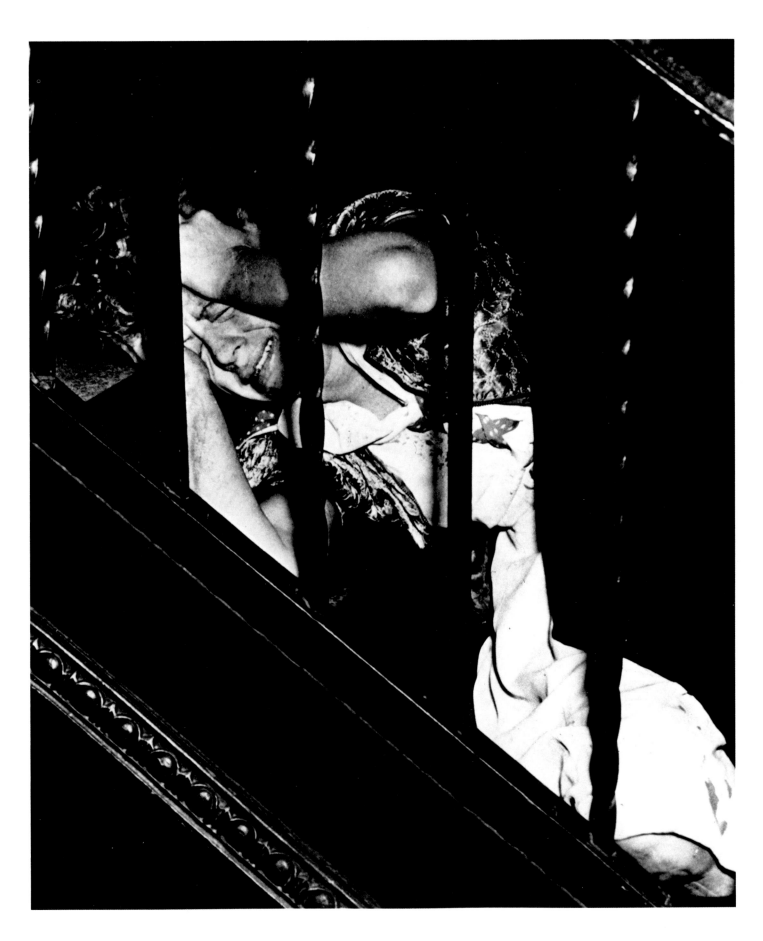

Ihr Mann wurde ermordet, ca. 1941
Her husband was killed
Son mari a été assassiné

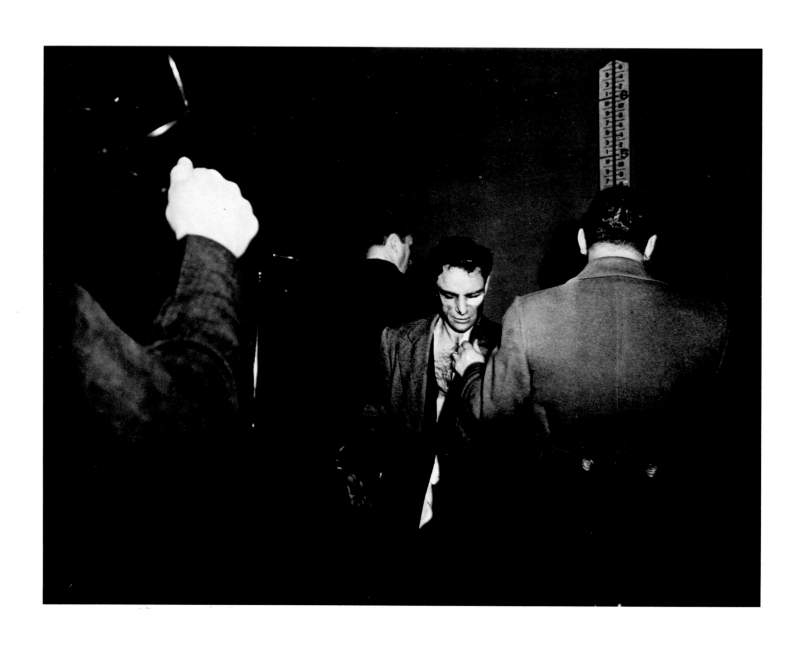

Polizistenmörder, 1939
Copkiller
Assassin de policier

Gegenüberstellung
The lineup
Confrontation

92

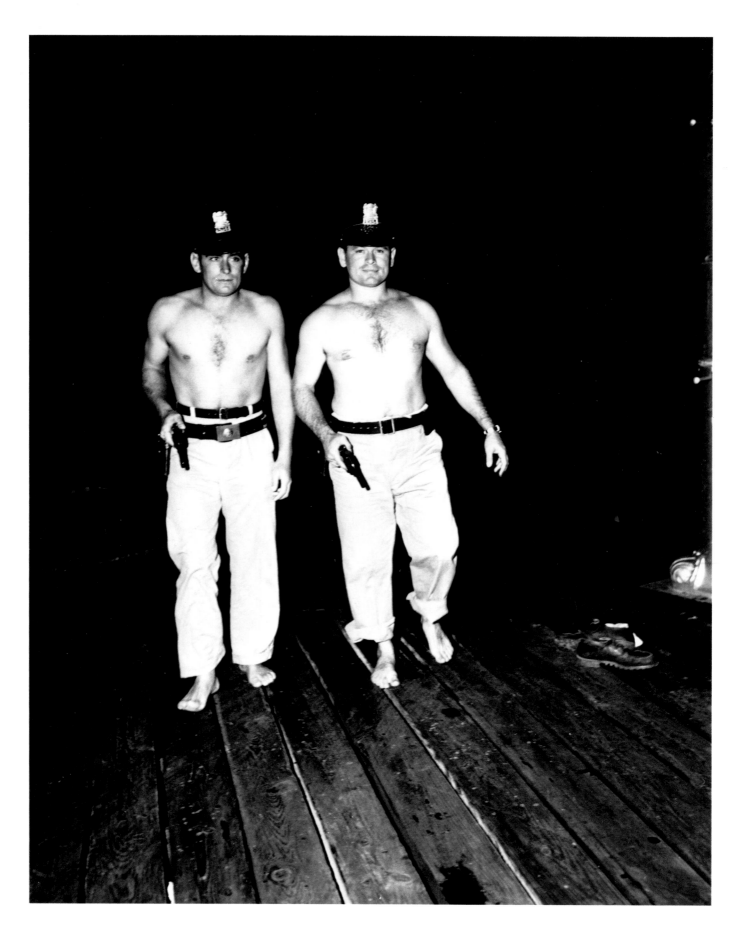

Nächtlicher Polizei-Einsatz
Night time operation
Service policier nocturne

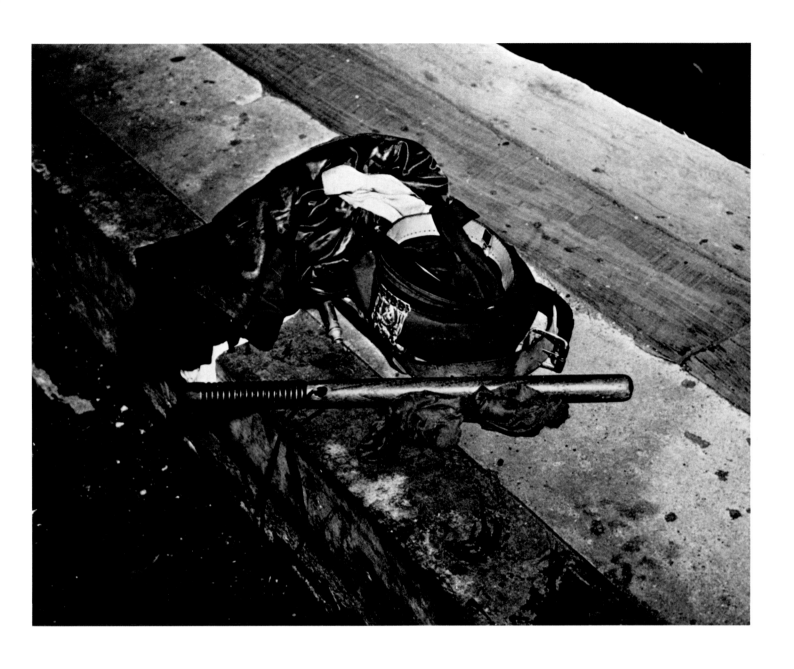

Rettung eines Ertrinkenden am East River
Saving a drowning person from East River
Sauvetage d'un noyé à East River

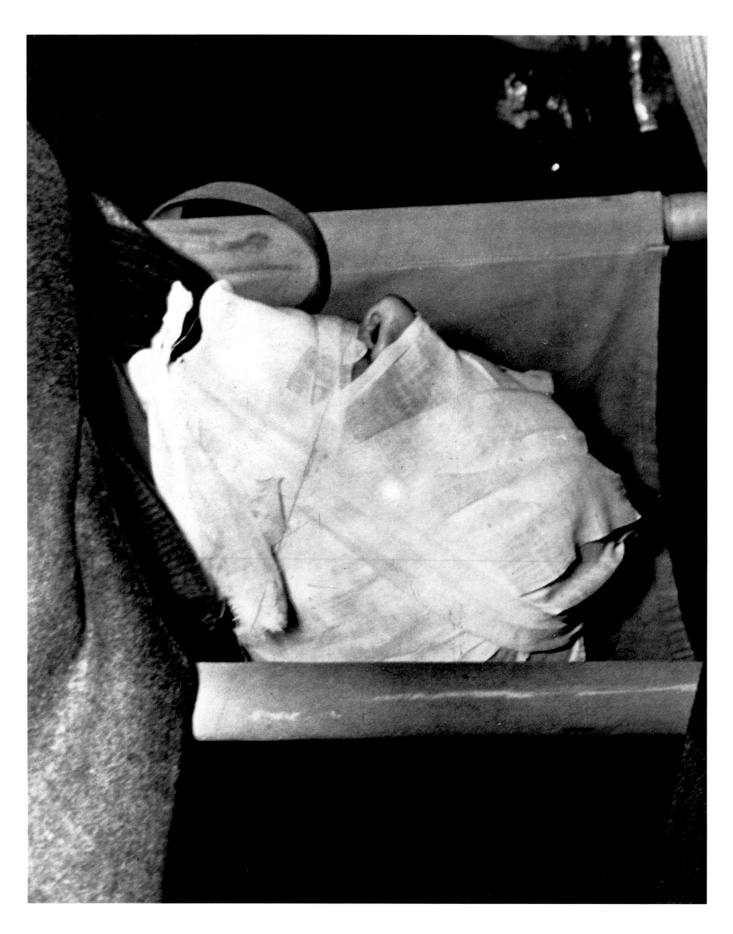

Transport eines Schwerverletzten
Transporting a severely injured person
Transport d'un blessé grave

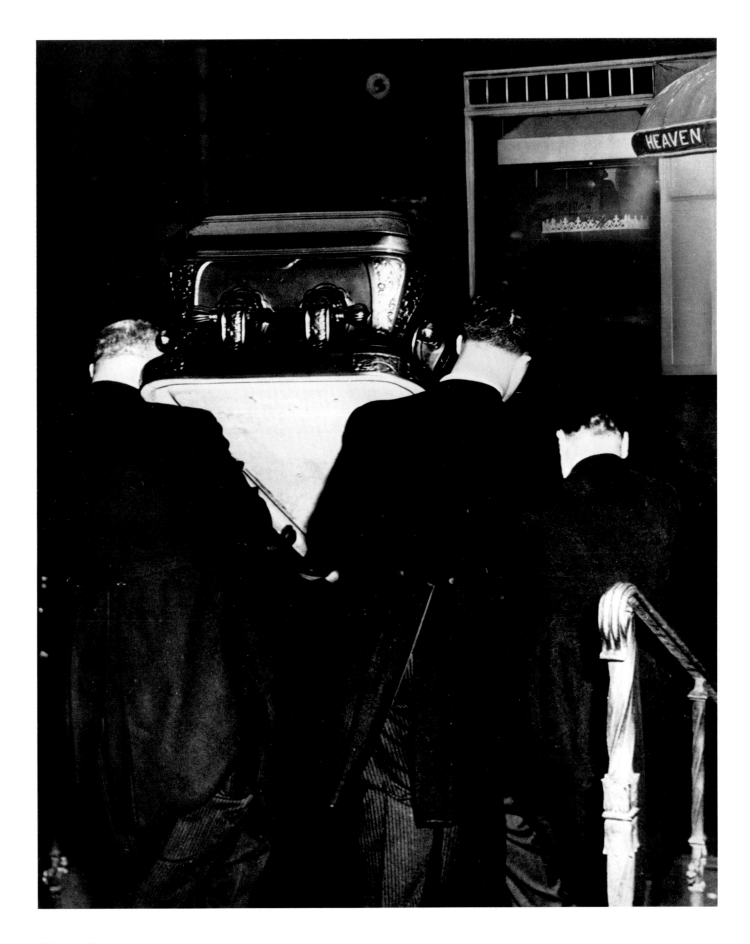

"Heaven"
"Heaven"
"Heaven"

96

Grüne Minna
The Paddy-Wagon
Le panier à salade

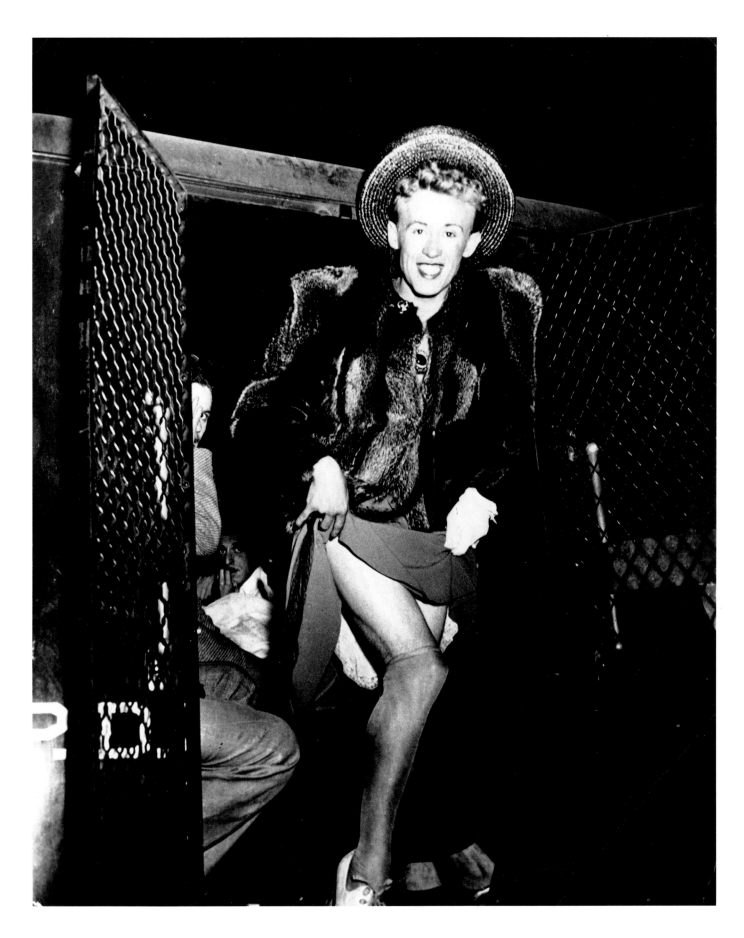

Transsvestit, ca. 1940
Transvestite
Travesti

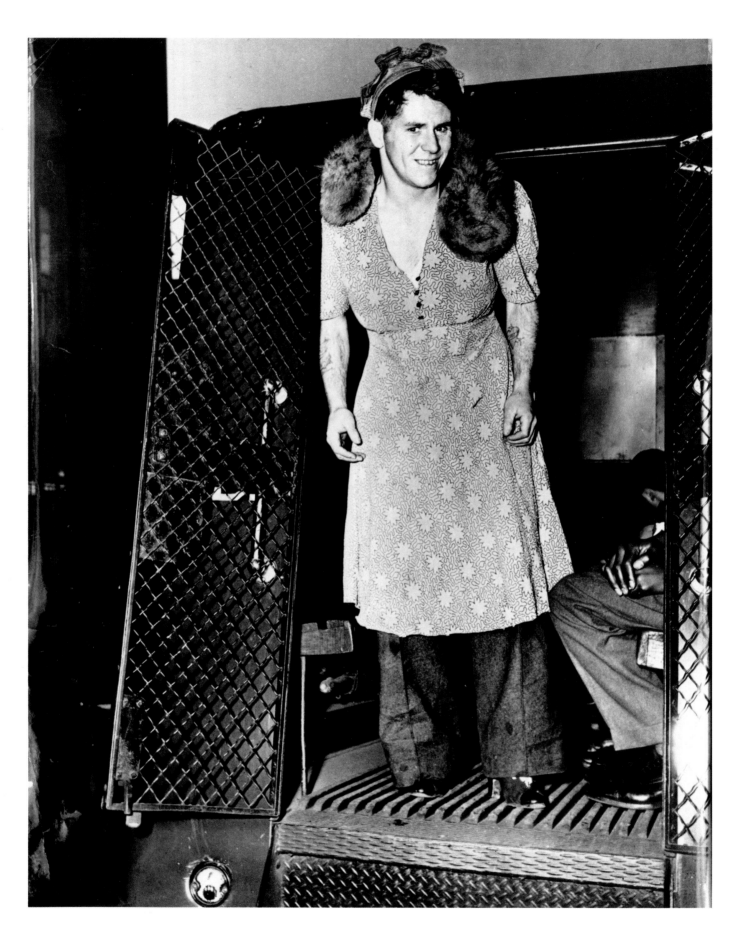

Als Frau verkleideter Dieb
A thief dressed up as a woman
Voleur déguisé en femme

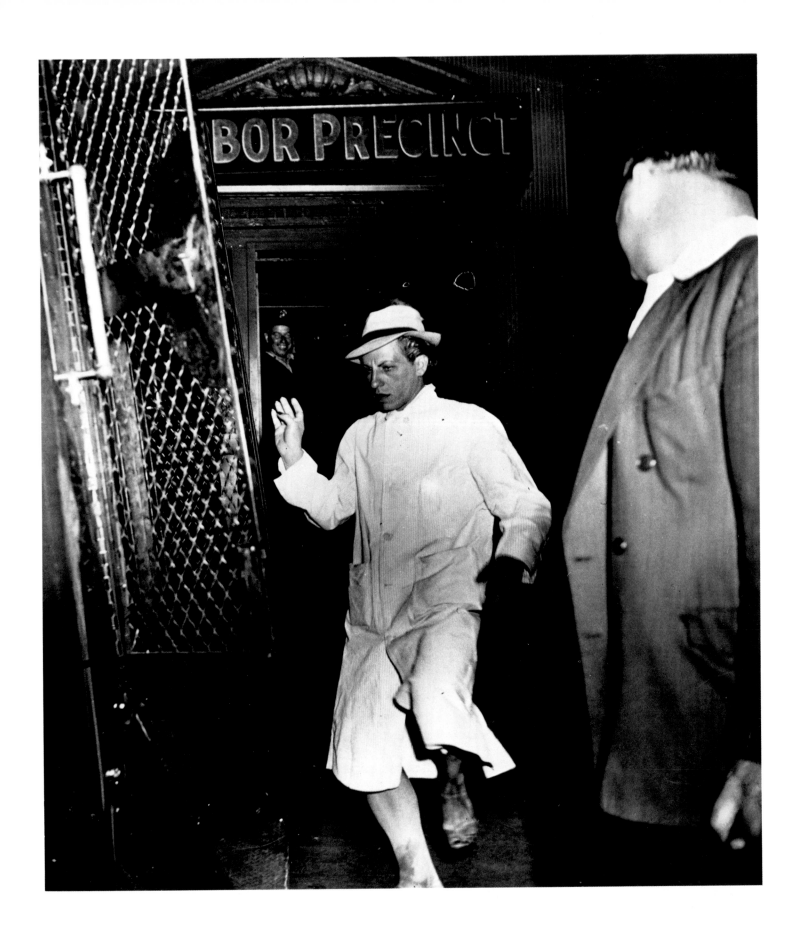

Transvestit
Transvestite
Travesti

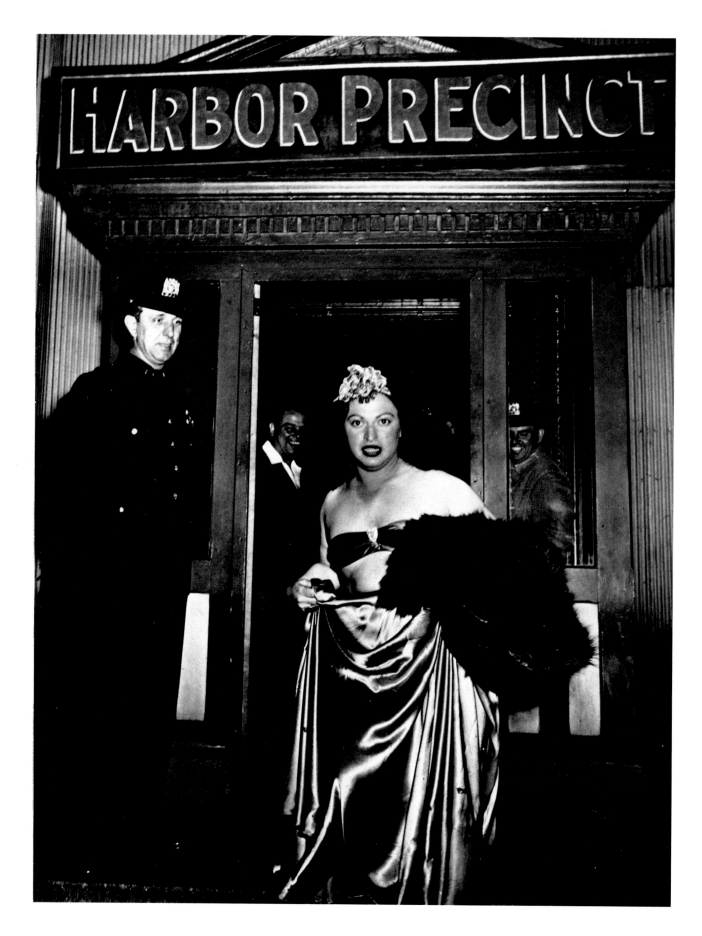

Transvestit . . .
Transvestite . . .
Travesti . . .

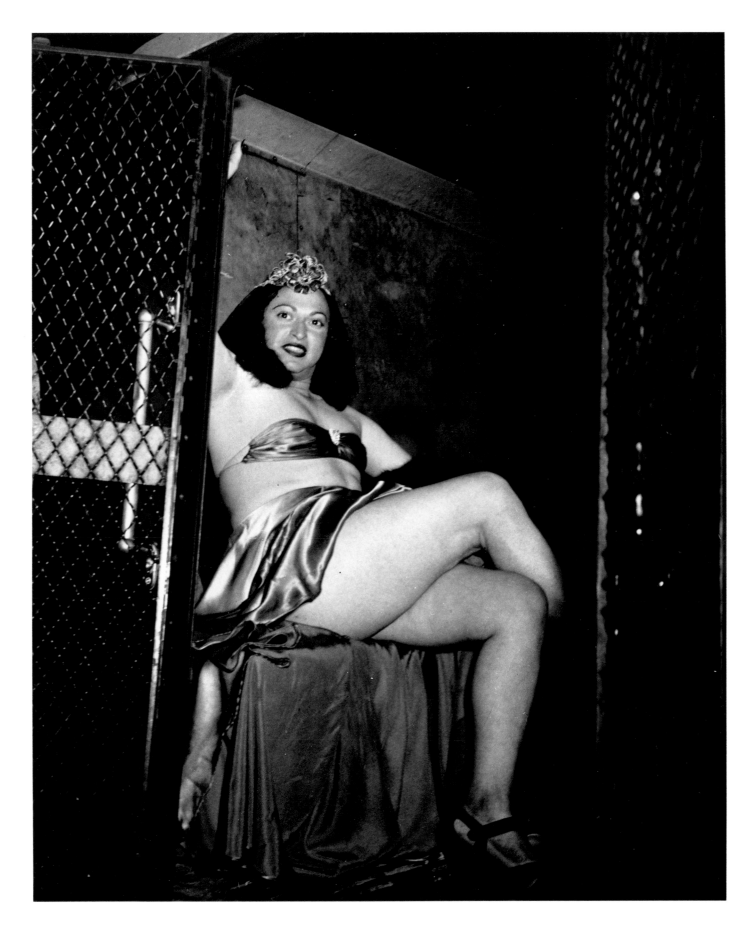

... in der grünen Minna, 1940
... in the paddy-wagon
... dans le panier à salade

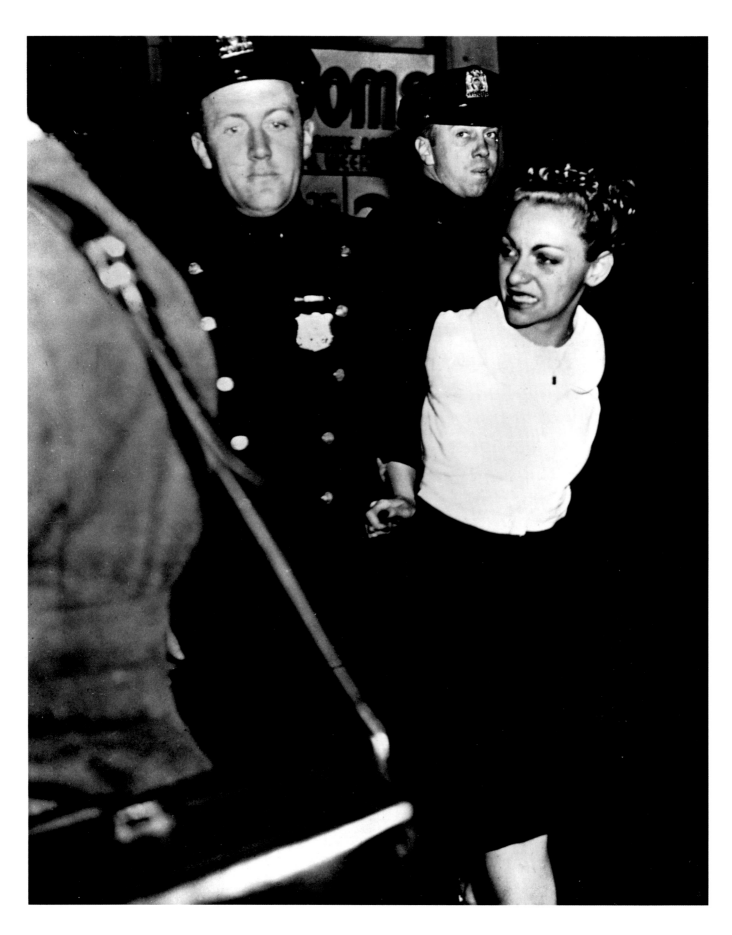

Festnahme
Arrest
Arrestation

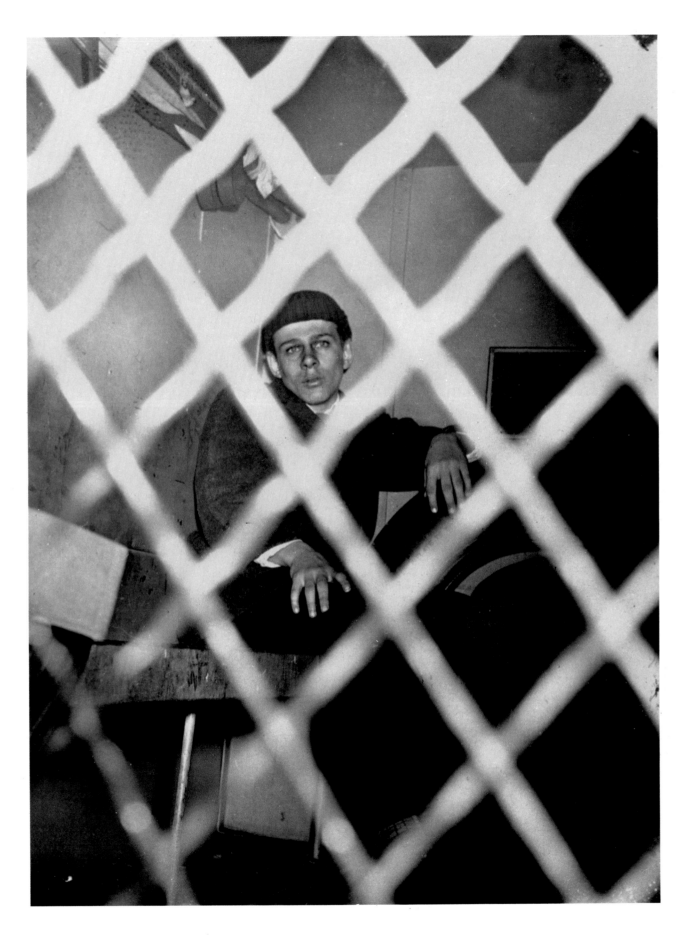

Halbwüchsiger, der ein vierjähriges Mädchen erwürgt hat, 1944
Teenage boy, arrested for strangling a four years old girl
Adolescent qui a étranglé une fillete agée de quatre ans

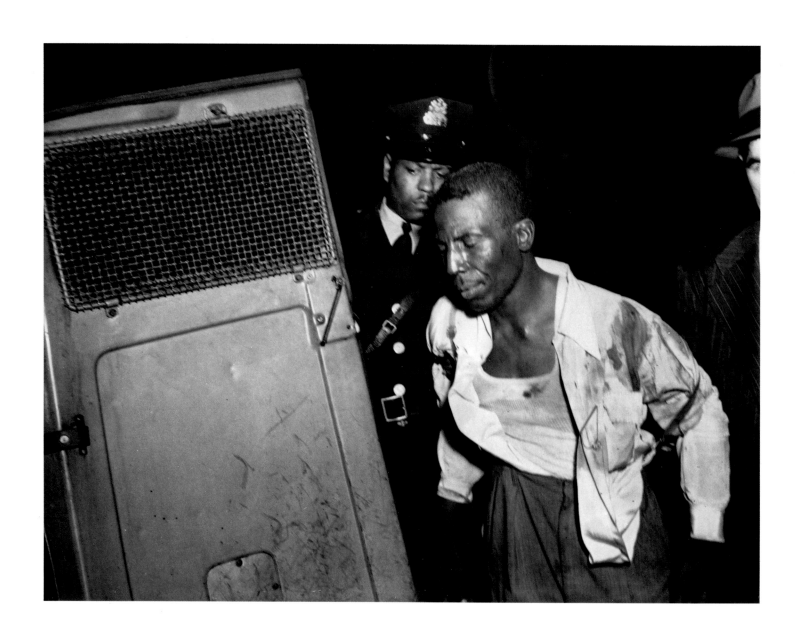

Festnahme
An arrest
Arrestation

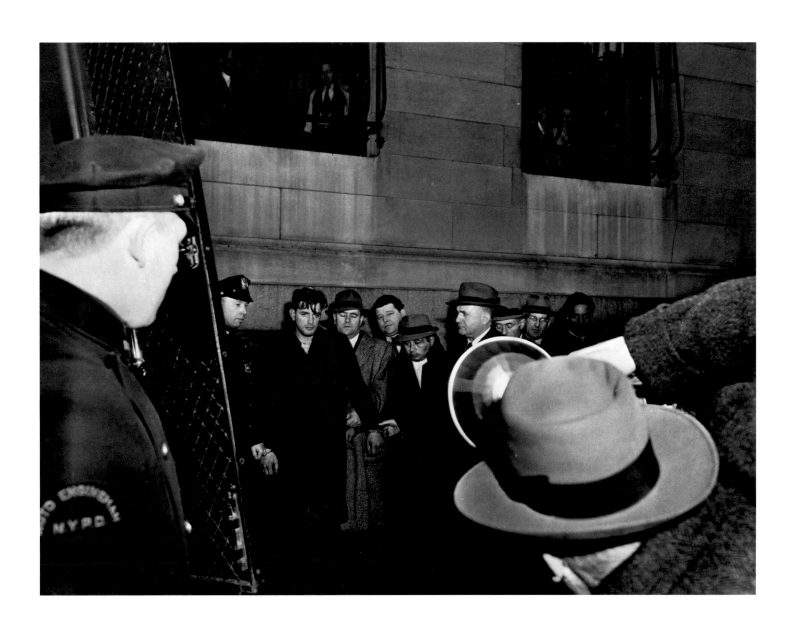

Schlangestehen für den Haftrichter
Waiting in line for the night judge
Faisant la queue pour passer devant le juge de nuit

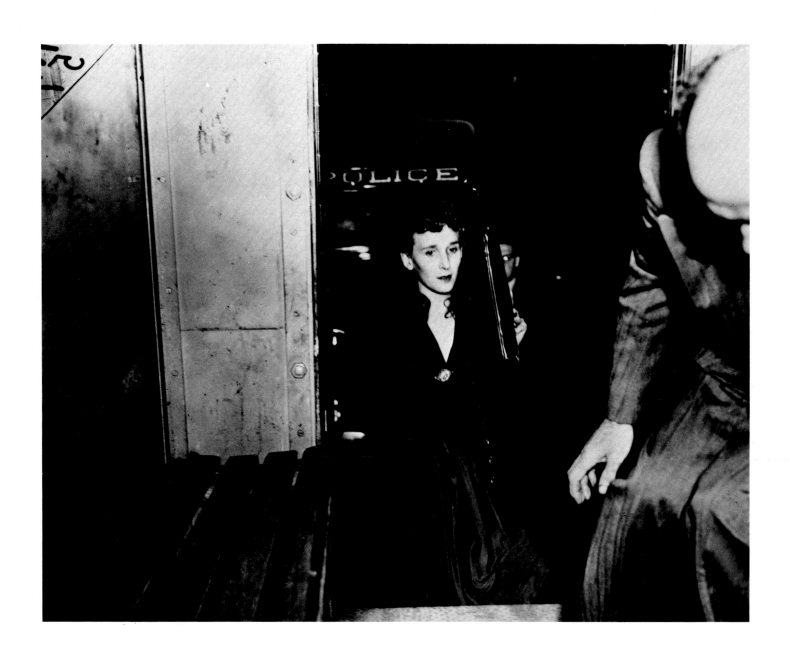

Festnahme
An arrest
Arrestation

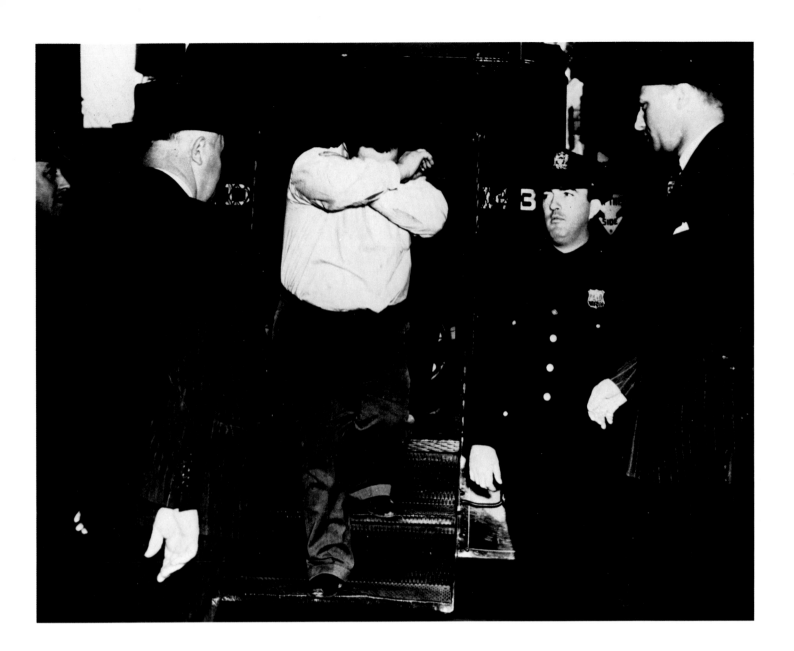

Festnahme
An arrest
Arrestation

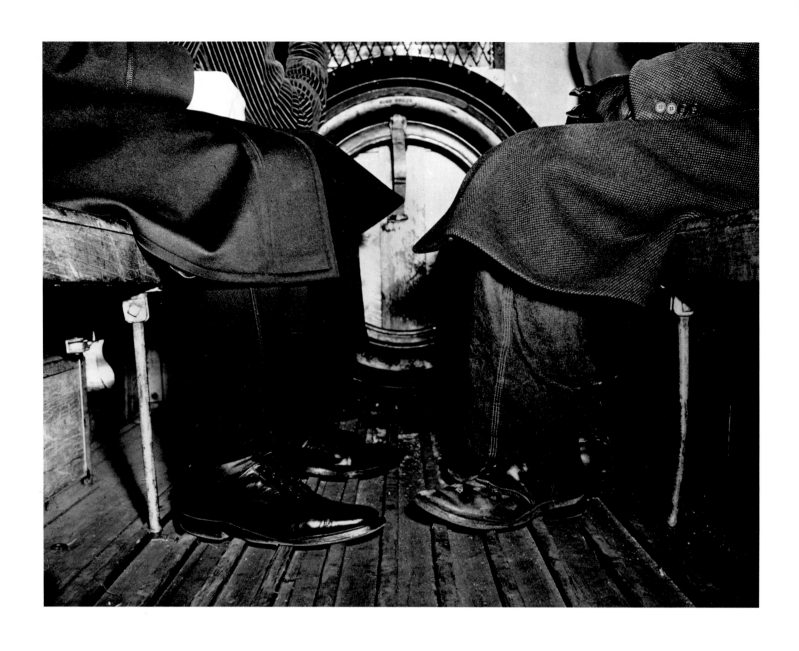

In der grünen Minna
In the paddy-wagon
Dans le panier à salade

108

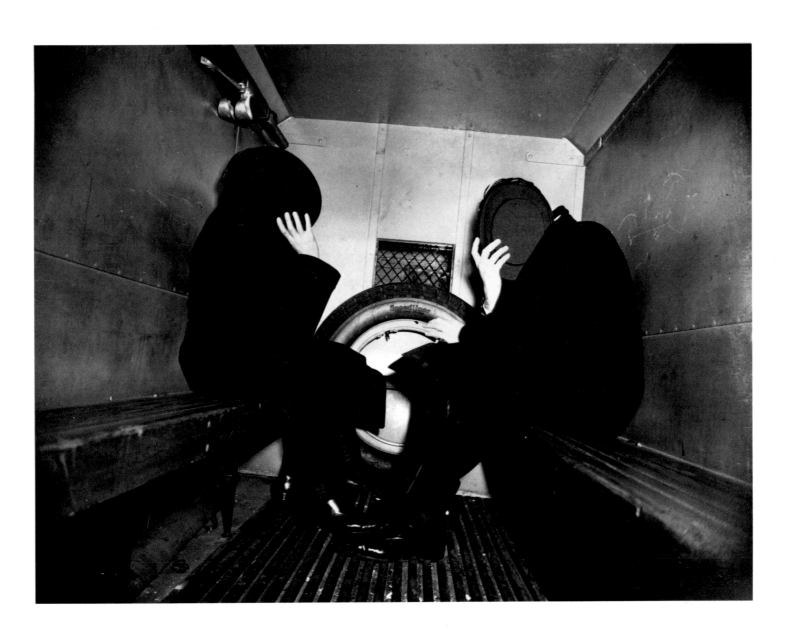

Abtransport
Being carried away
Départ

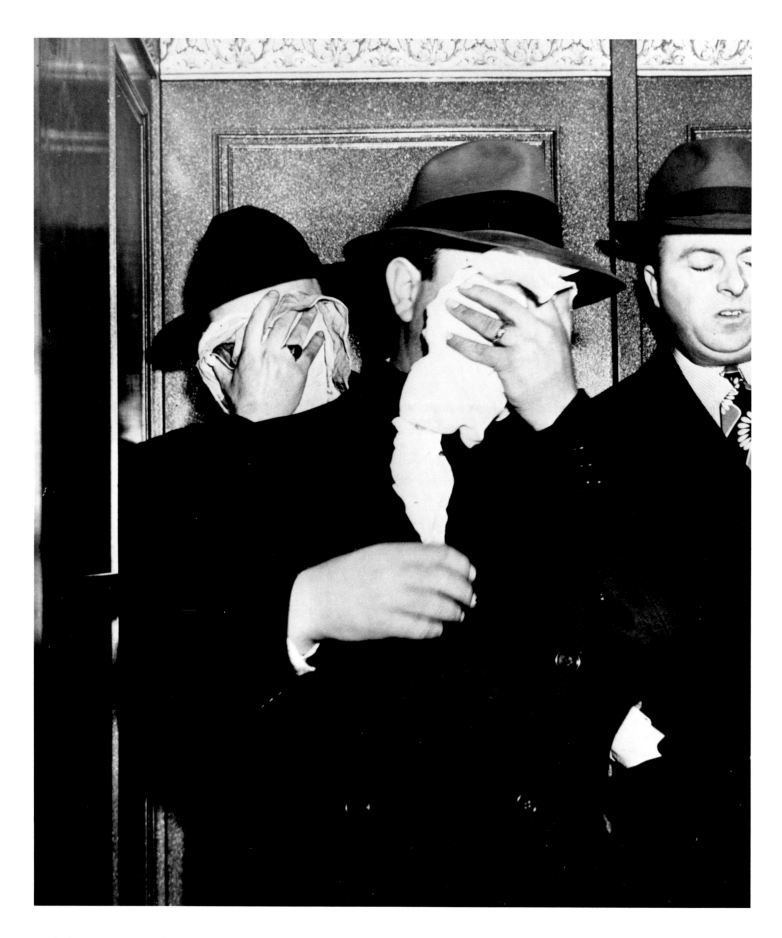

Verhaftet wegen Bestechung von Basketball-Spielern
Arrested for bribing basketball-players
Arrêtés pour corruption de joueurs de basketball

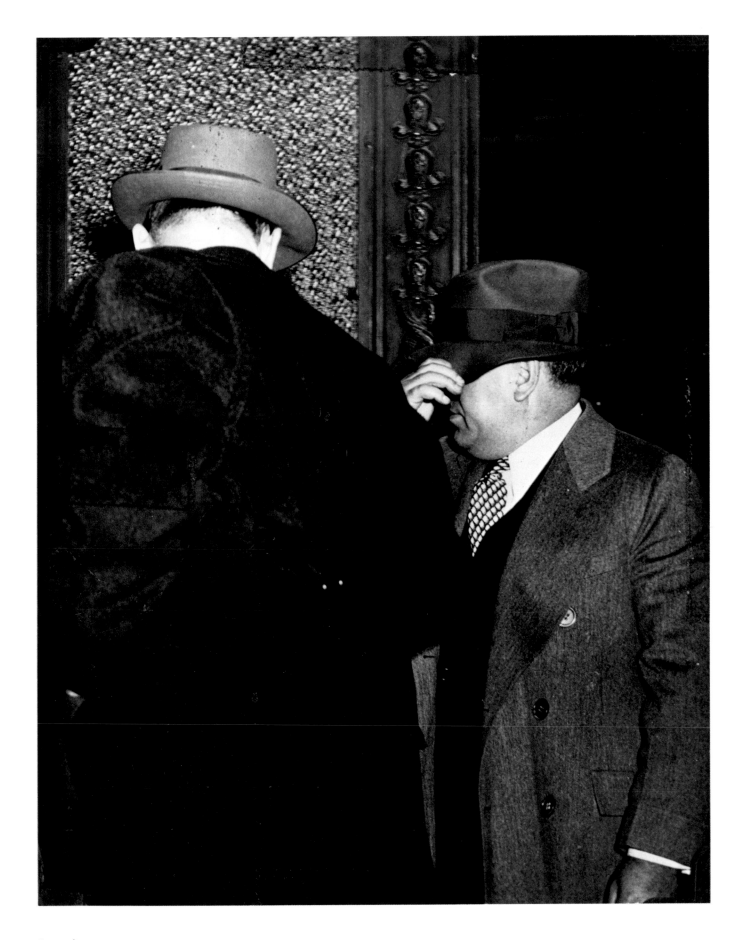

Festnahme
An arrest
Arrestation

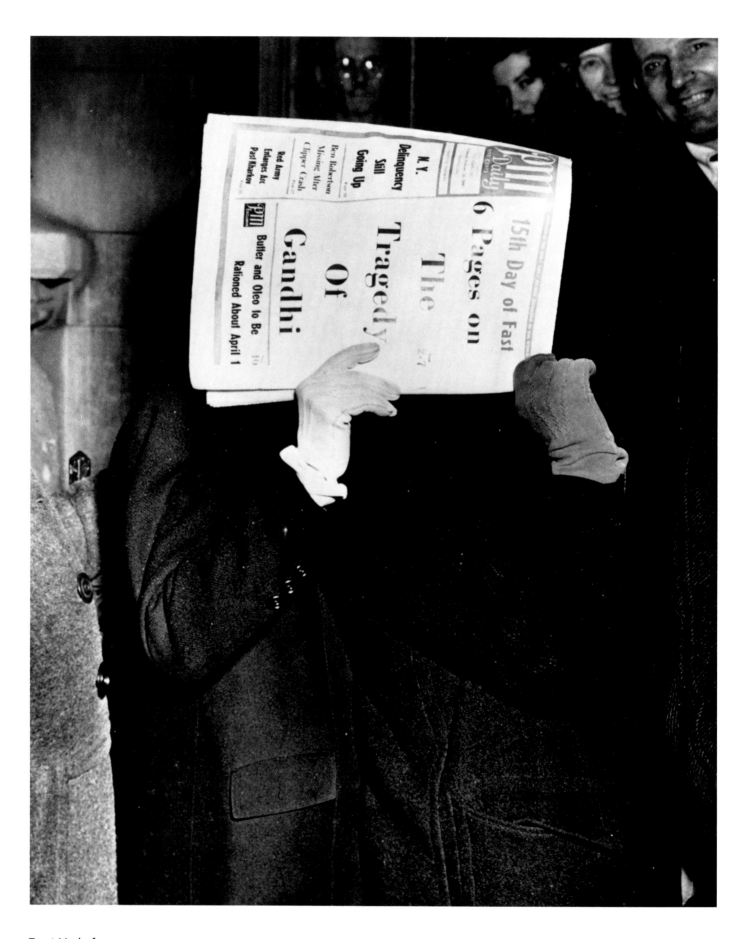

Zwei Verhaftete
Two arrested
Deux personnes arrêtées

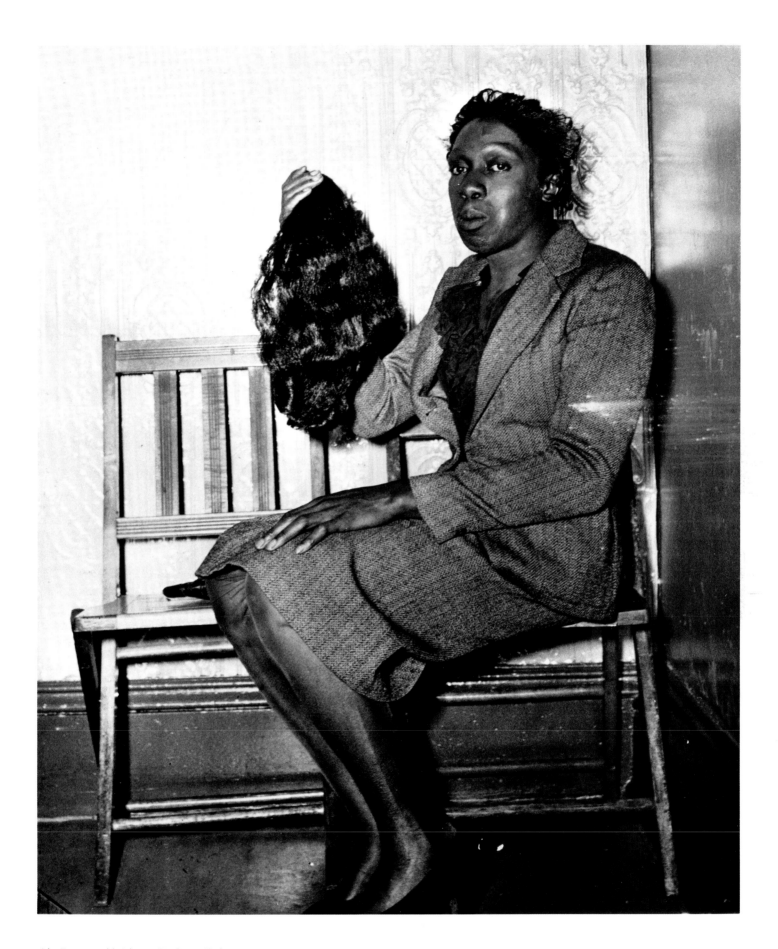

Als Frau verkleideter Dieb im Polizeirevier
A thief dressed up as a woman, in the police station
Voleur déguisé en femme à la station de police

113

Nachttypen
Night People
Figures Nocturnes

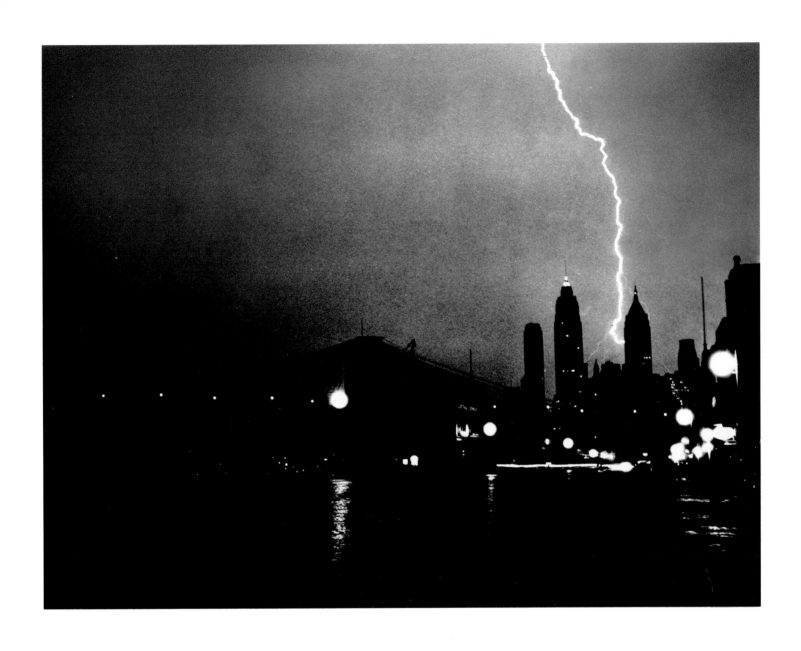

New York bei Nacht, ca. 1940
New York at night
New York la nuit

114

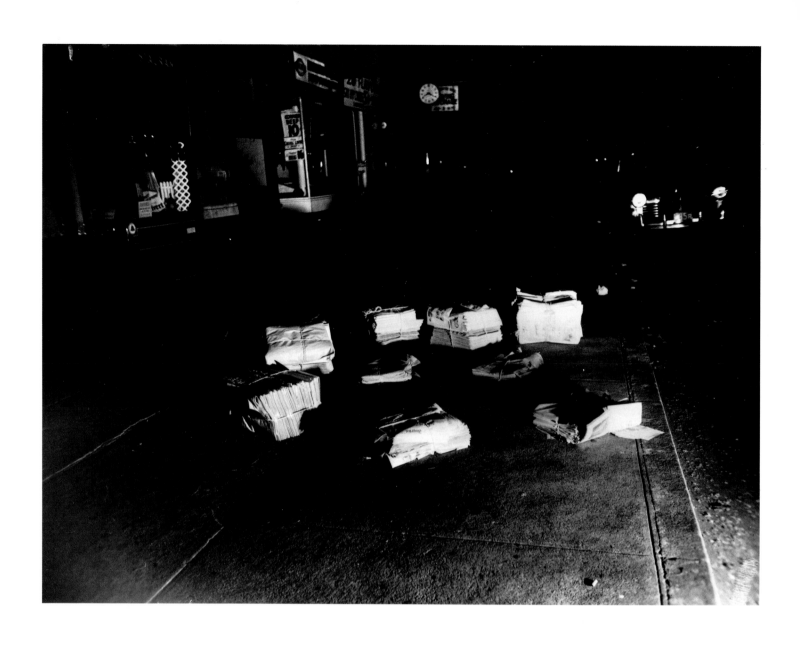

Nachtausgabe des *Journal American*
Late night edition of the *Journal American*
Edition de nuit du *Journal American*

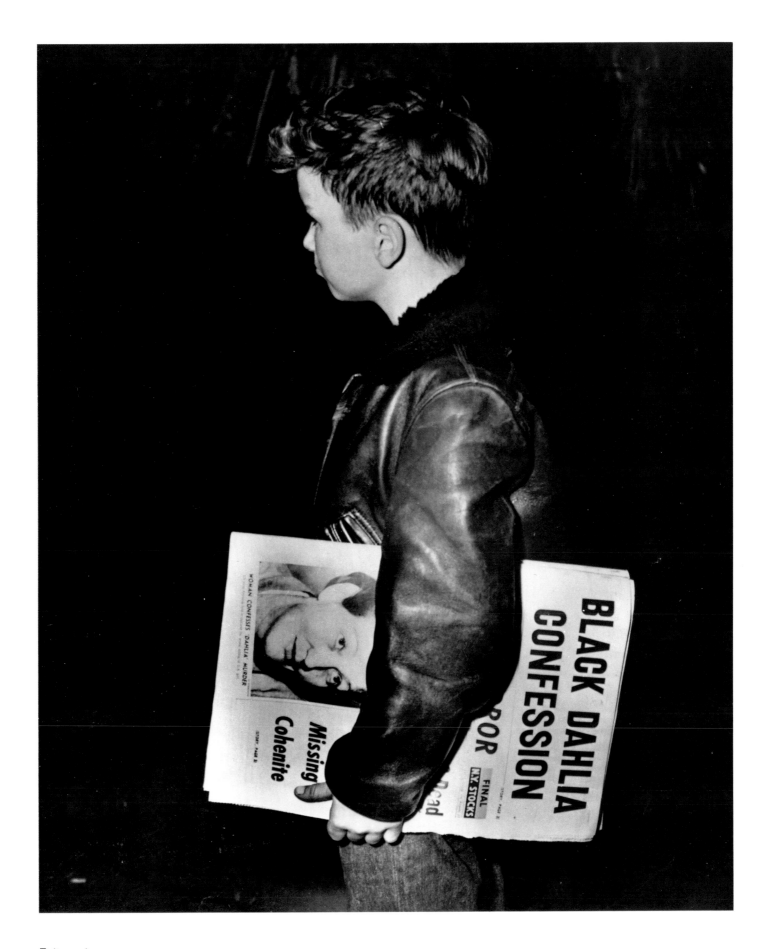

Zeitungsjunge
Newspaper boy
Jeune vendeur de journaux

116

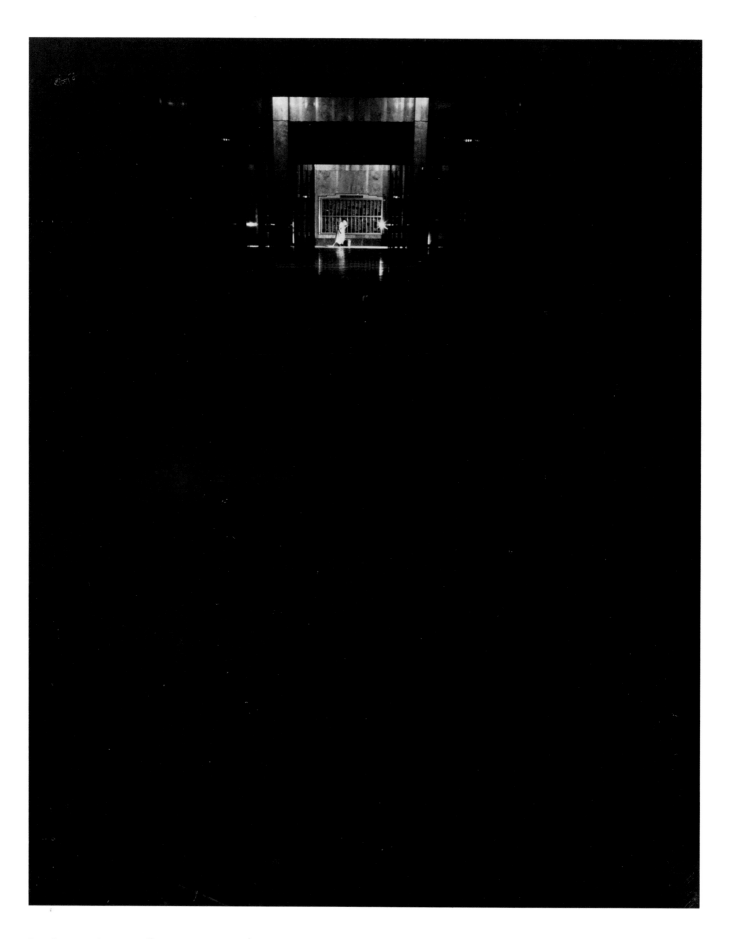

Putzfrau im Sixty Wall Street Tower
Scrubwoman in Sixty Wall Street Tower
Femme de ménage à Sixty Wall Street Tower

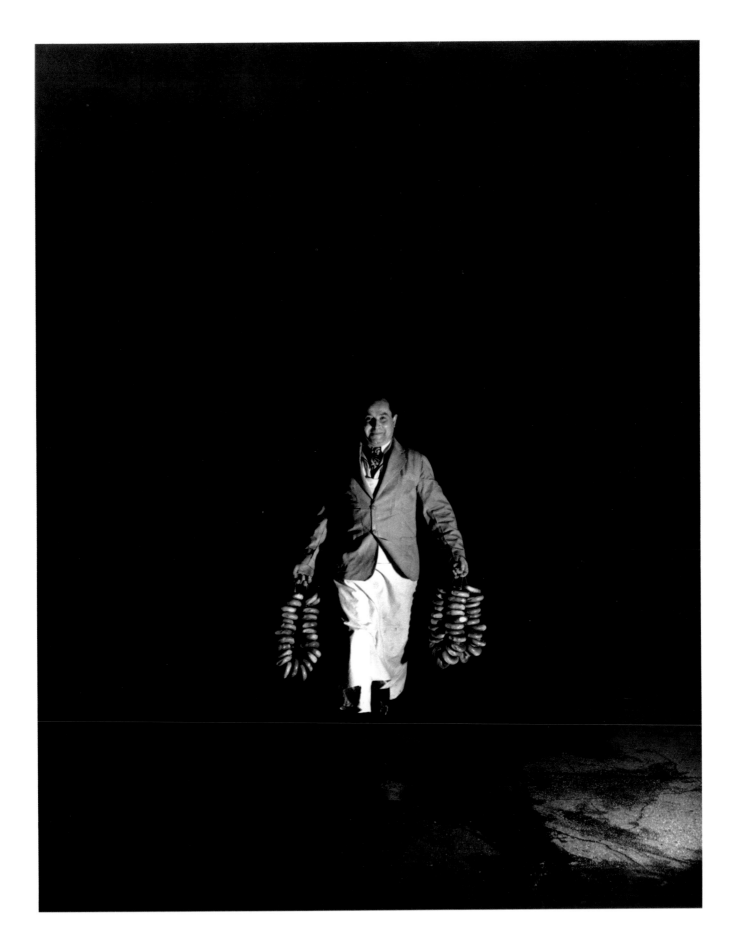

Brezenmann, 1940
Pretzelman
Homme aux bretzen

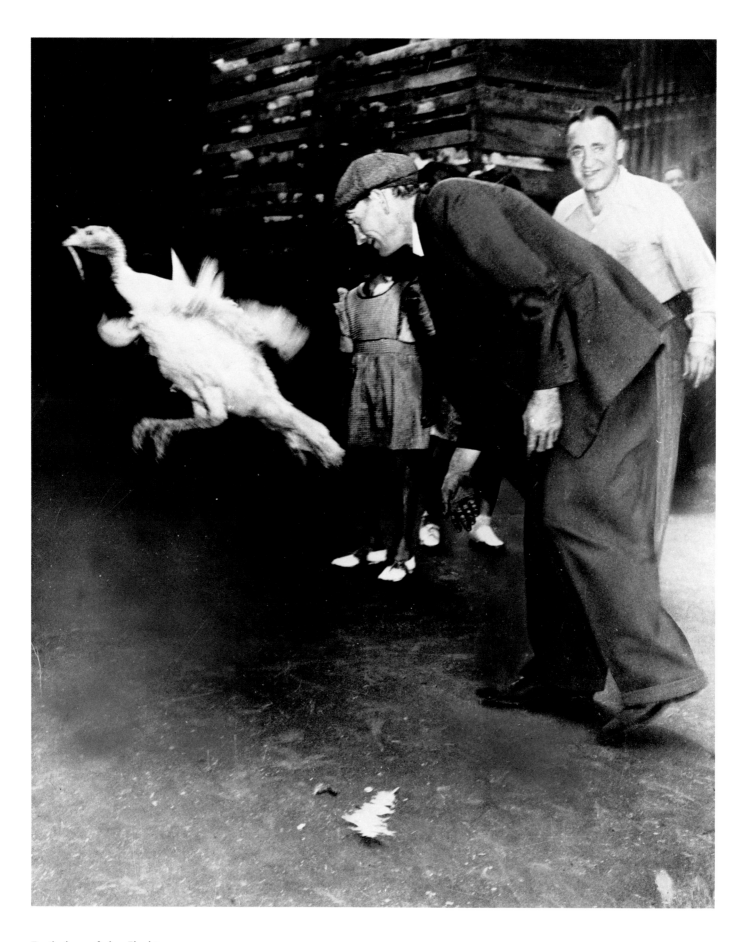

Truthahn auf der Flucht
Turkey on the run
Dindon en fuite

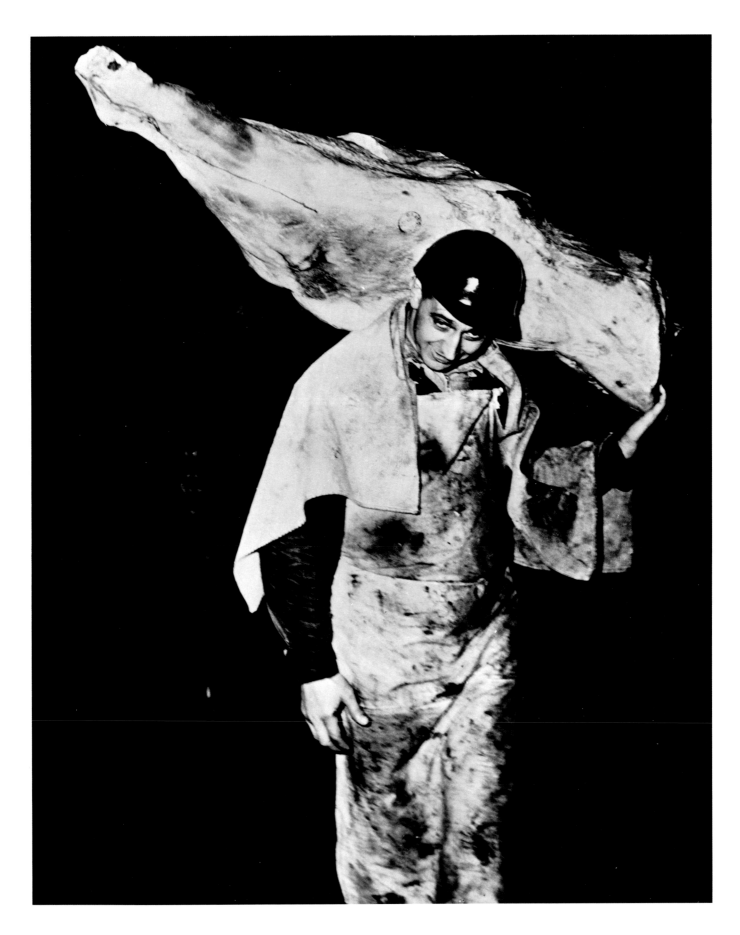

Auf dem Weg zur Fleischbank in der 1st Avenue/46th Street, 1942
On the way to the meat counter, corner 1st Avenue/46th Street
Sur le chemin de l'étal de boucher, 1st Avenue/46th Street

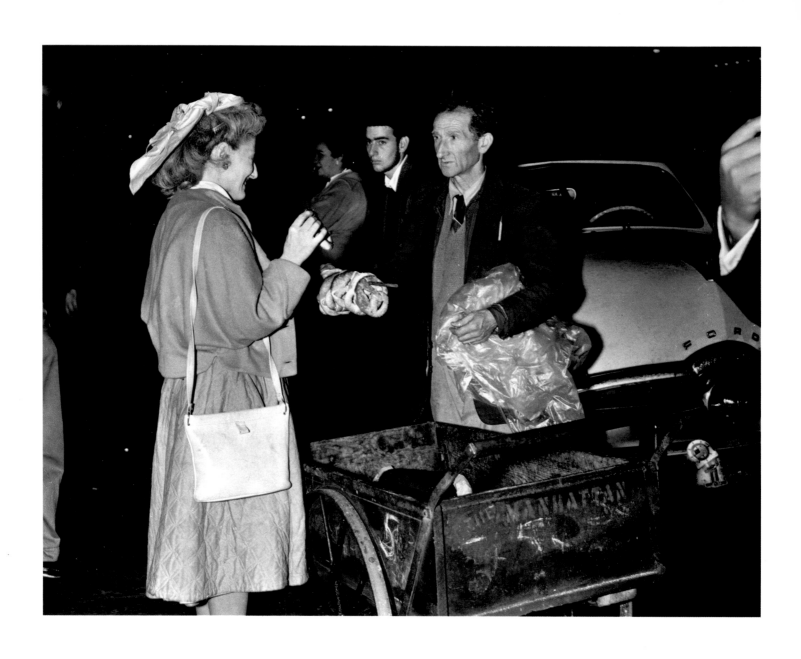

Brezenmann
Pretzelman
Homme aux bretzen

121

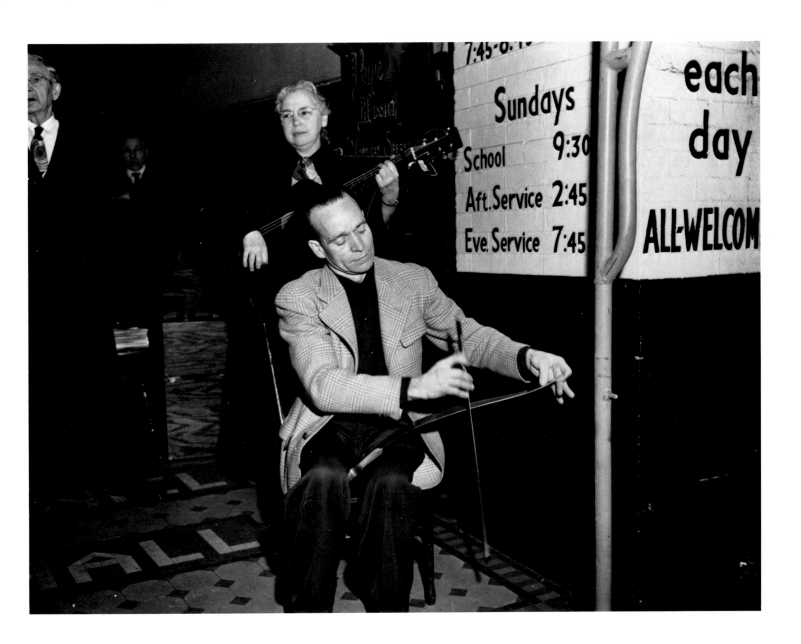

Singende Säge
The singing saw
Scie qui chante

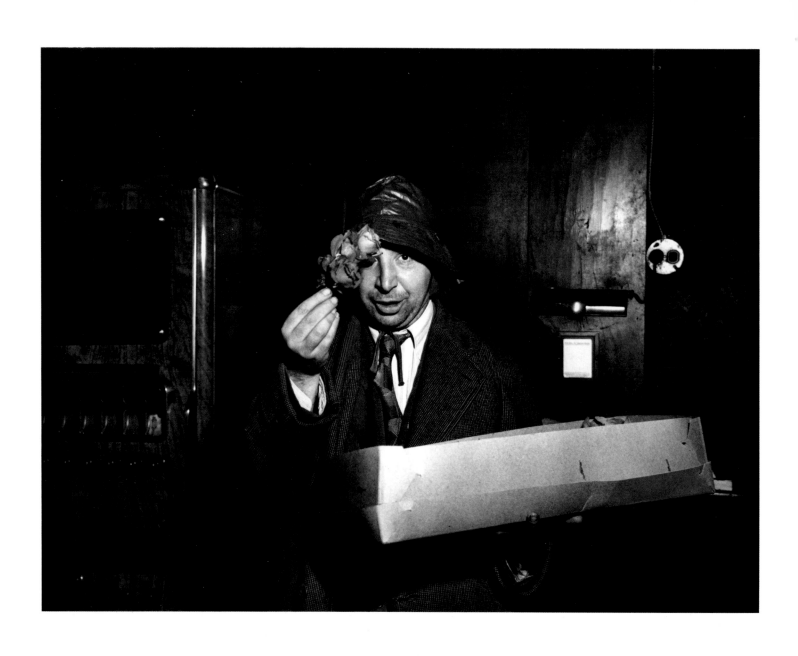

Blumenverkäufer, 1941
Selling flowers
Vendeur de fleurs

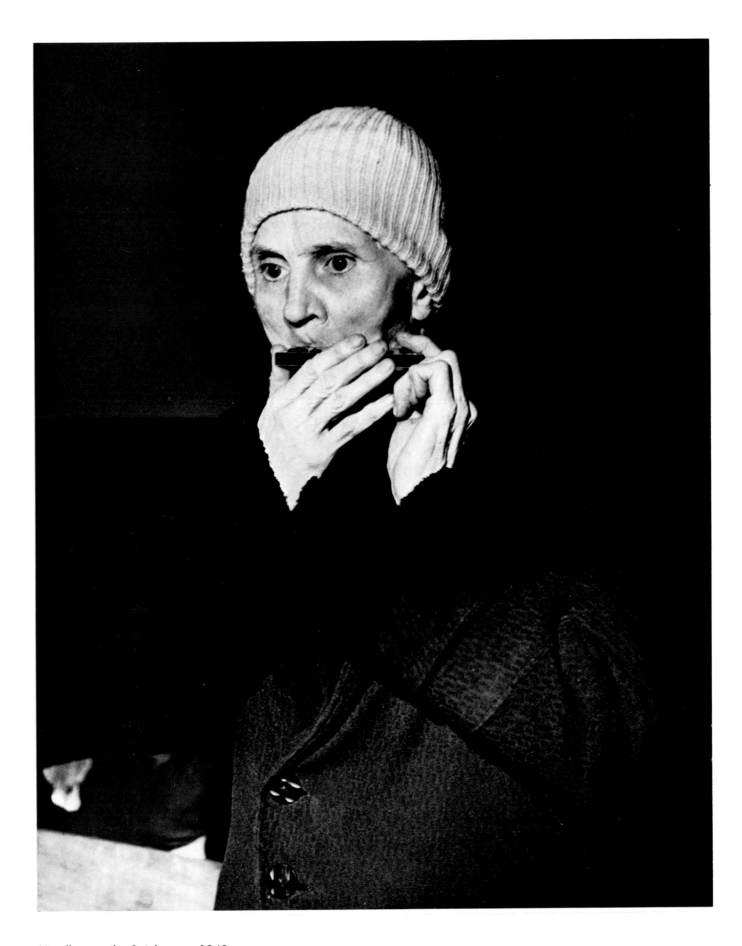

Mundharmonika-Spieler, ca. 1942
Harmonica-player
Joueur d'armonica

124

Gemüsehändler, 1946
Vegetable dealer
Marchand de légumes

125

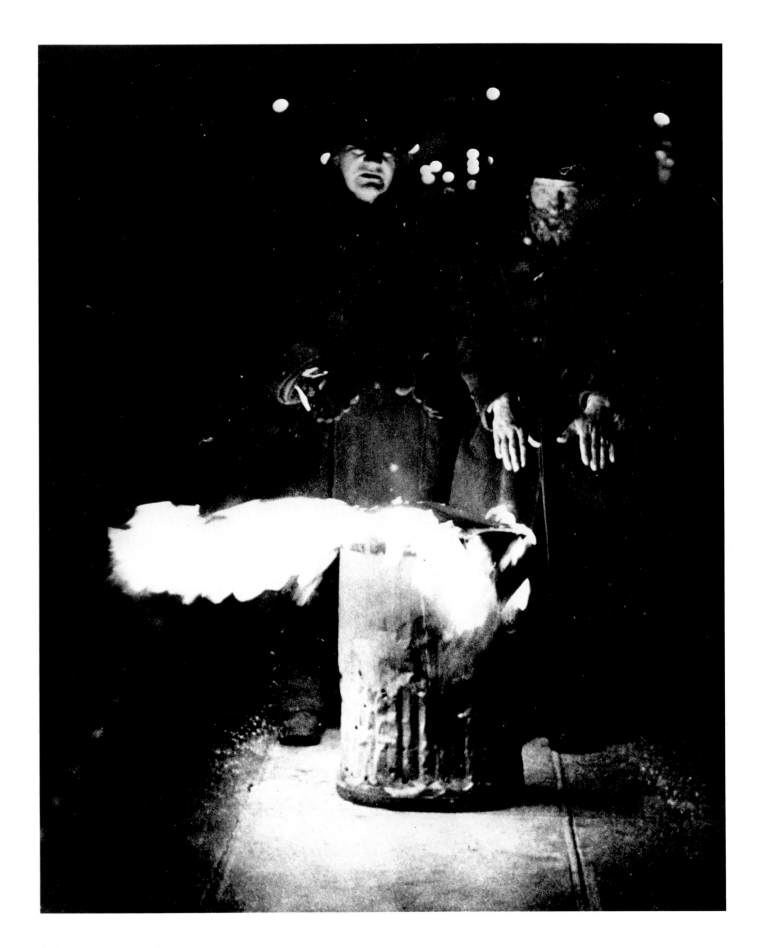

Aufwärmen, ca. 1938
Warming up
En train de se réchaufer

126

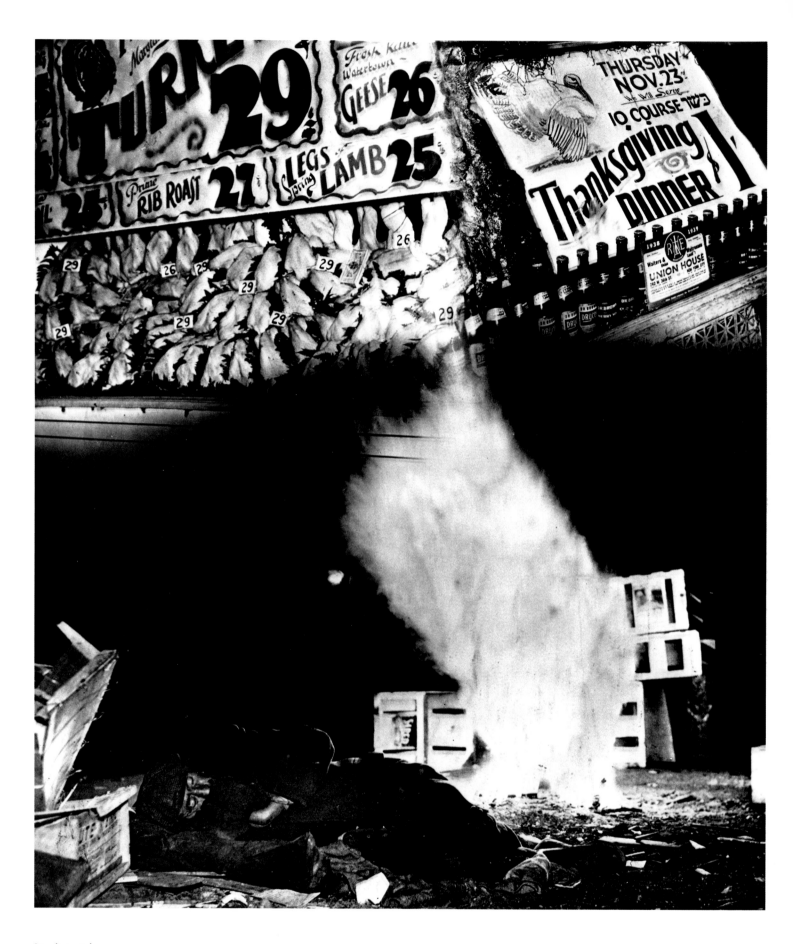

Stadtstreicher
Tramp
Clochard

127

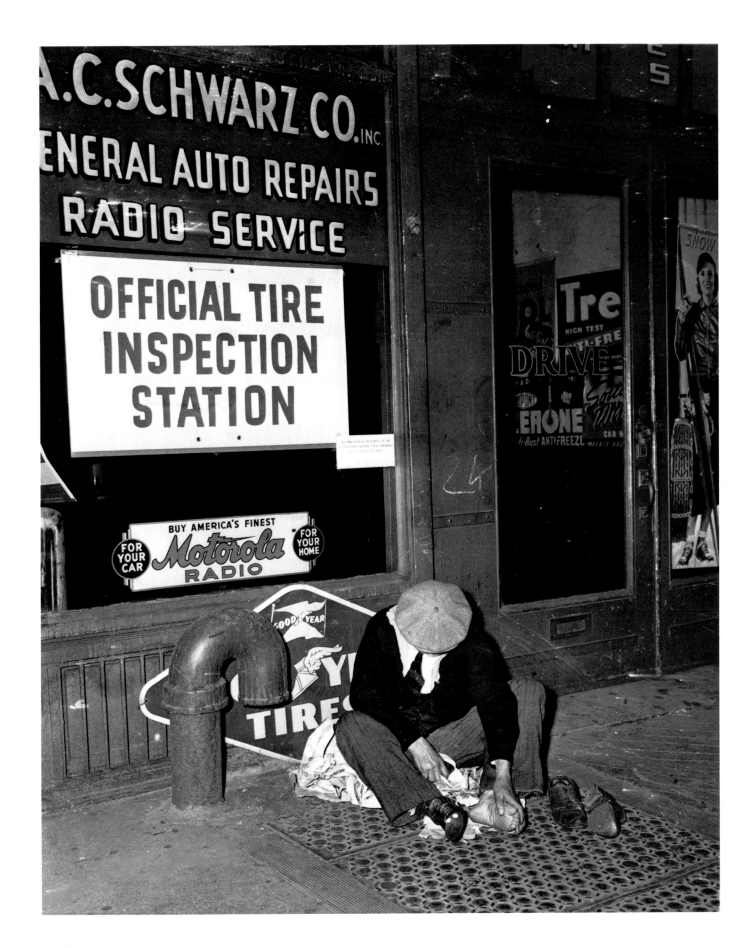

Stadtstreicher
Tramp
Clochard

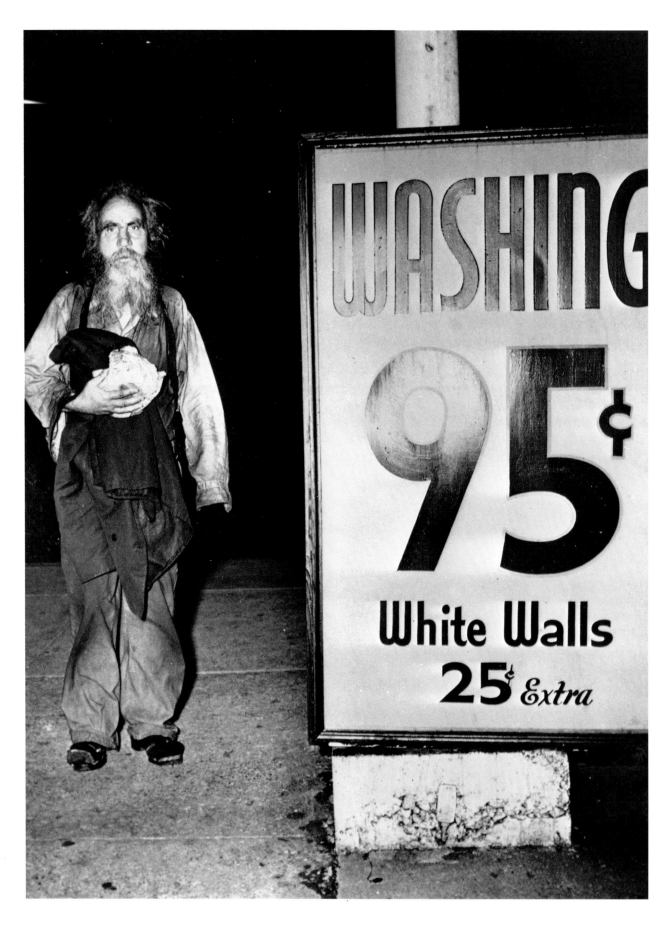

Öffentliches Bad
Public bath
Bain public

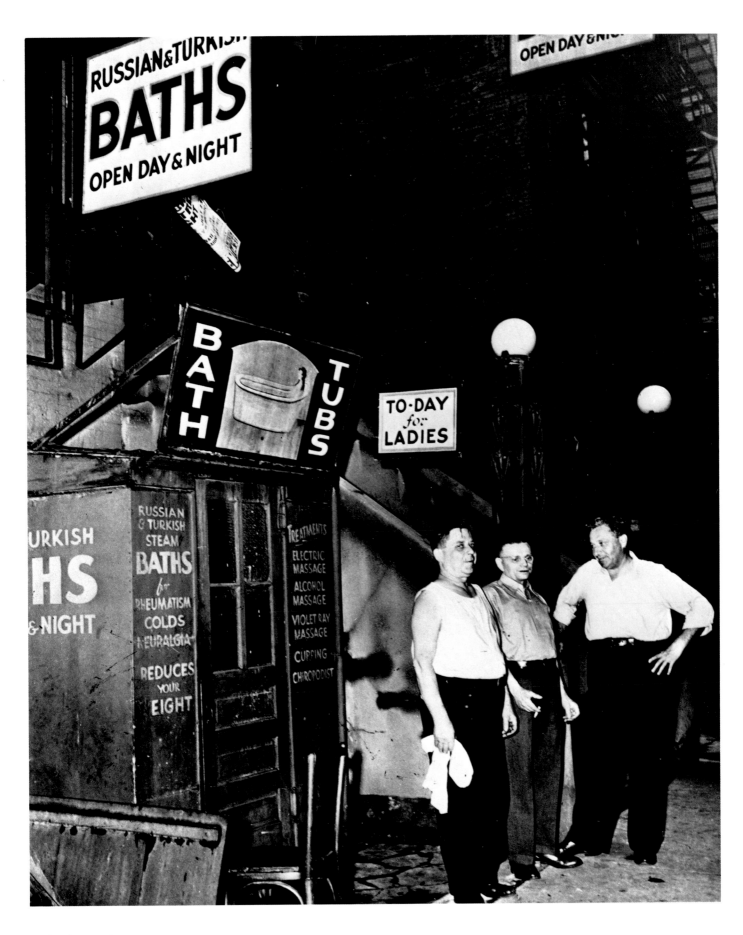

Türkisches Bad
Turkish bath
Bain turc

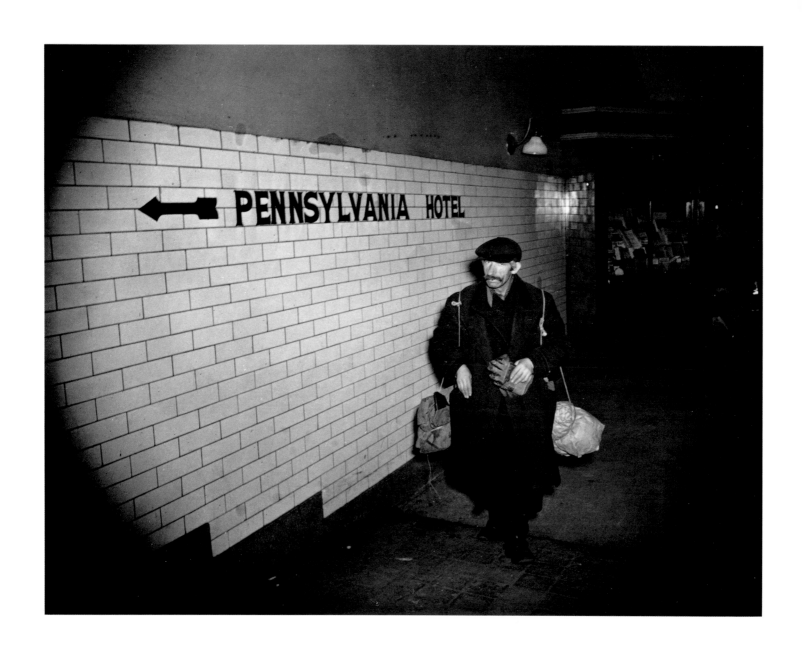

"Pennsylvania Hotel"
"Pennsylvania Hotel"
"Pennsylvania Hotel"

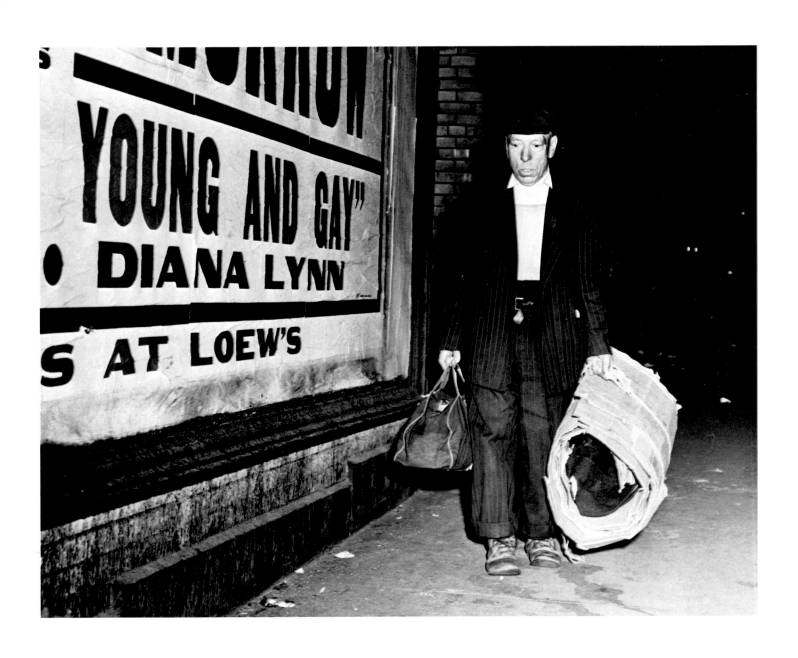

"Young and gay"
"Young and gay"
"Young and gay"

Schlafende
Sleeping
Dormeurs

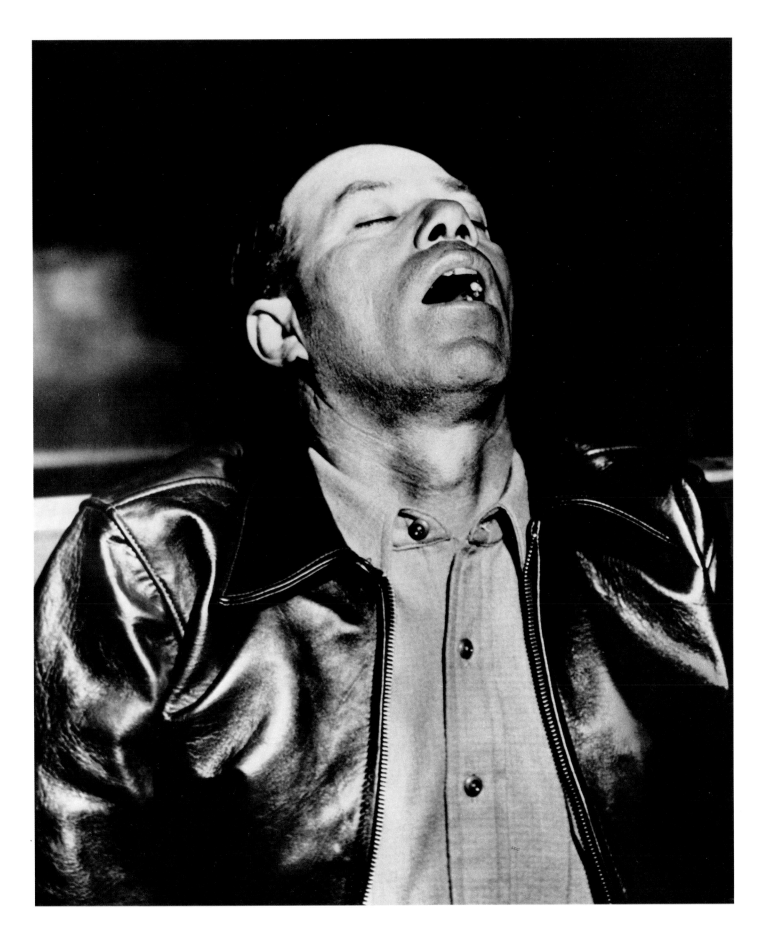

Schlafender
Sleeping
Dormeur

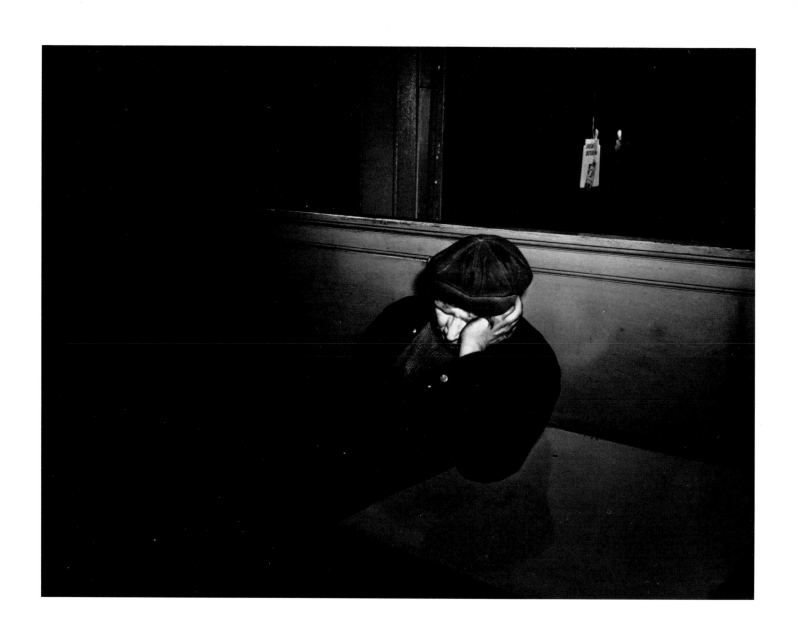

Schläfer in einer Bar, 1939
Sleeping at a bar
Dormeur dans un bar

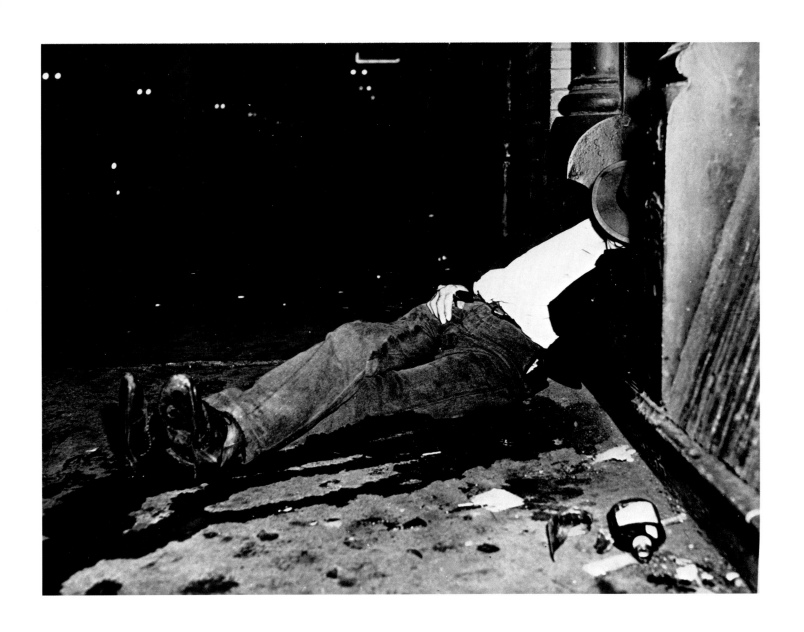

Betrunkener in der Bowery
Drunk in the Bowery
Ivrogne dans la Bowery

135

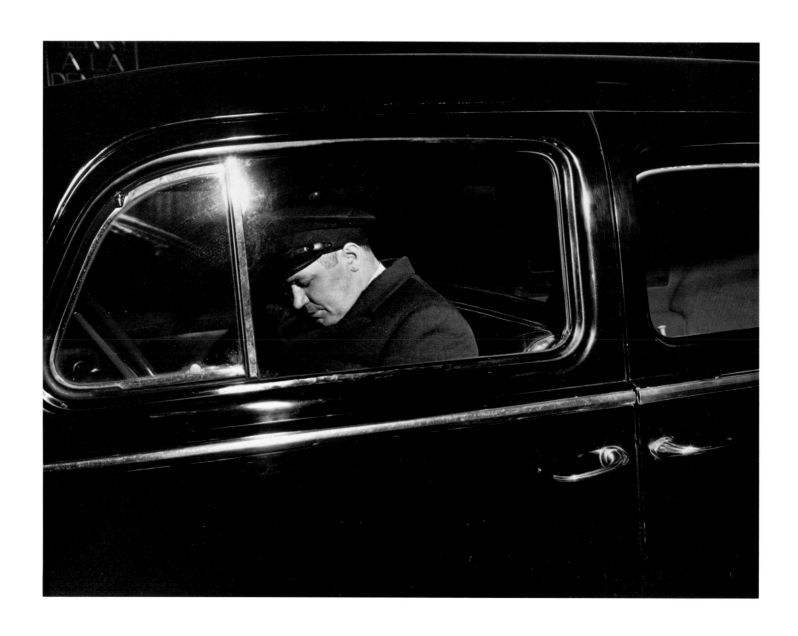

Nachtdienst
Nightshift
Service de nuit

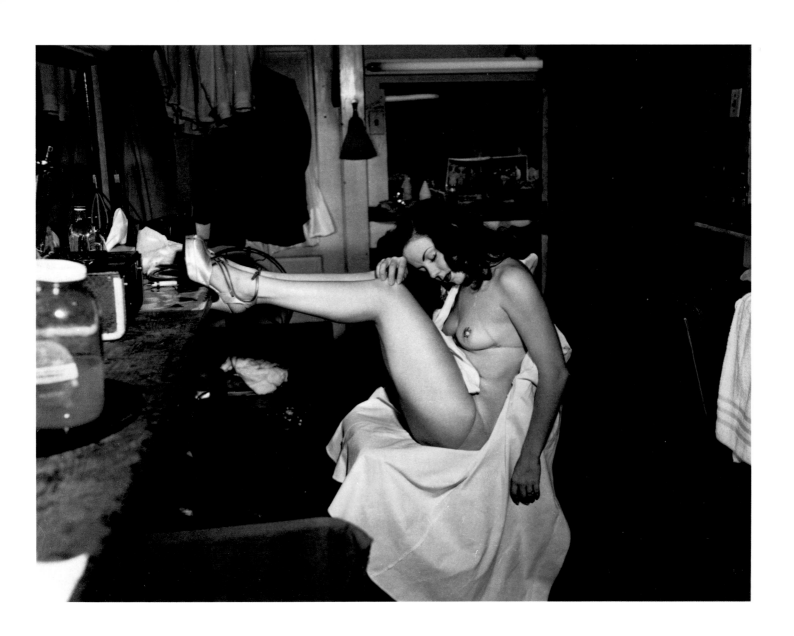

Zwischen zwei Auftritten
Between performances
Entre deux entrées en scène

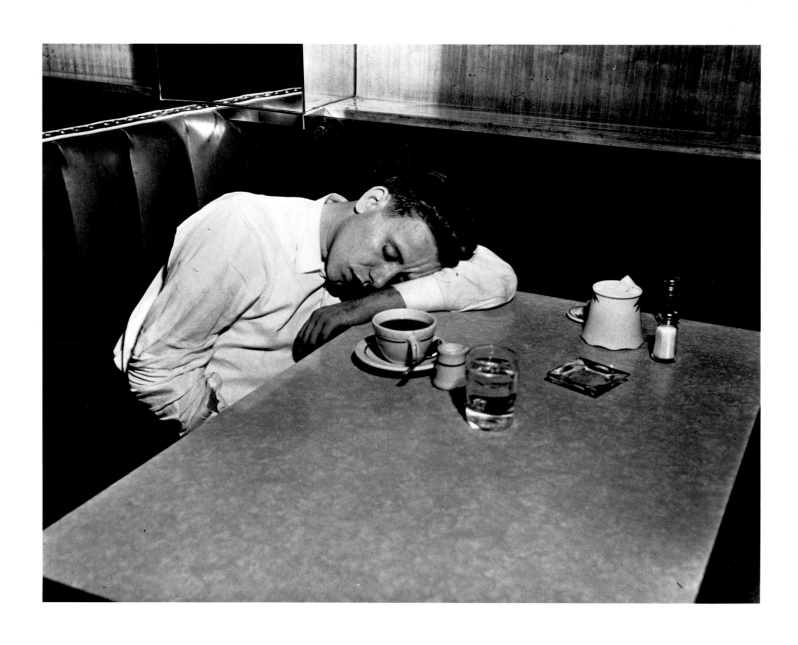

Schlafender in einem Café
Sleeping in a café
Dormeur dans un café

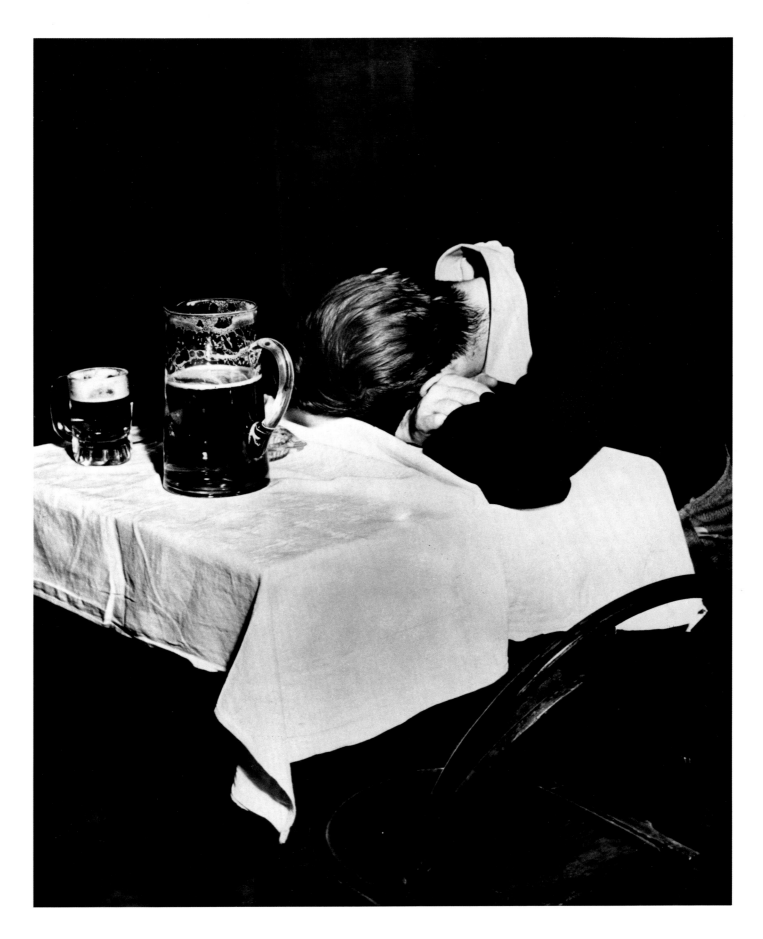

Schlafender in einer Bar
Sleeping in a bar
Dormeur dans un bar

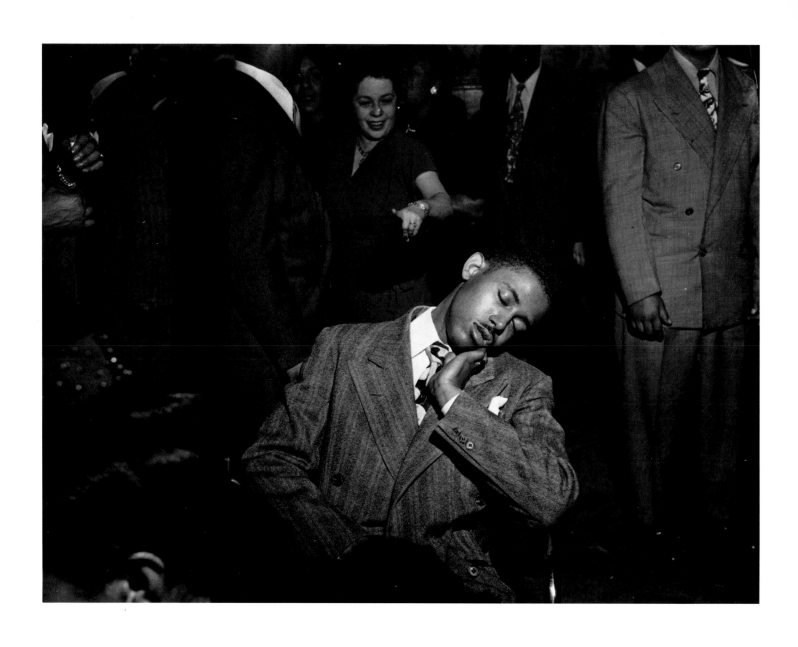

Während der Vorstellung eingeschlafen
He fell asleep during performance
Endormi pendant la représentation

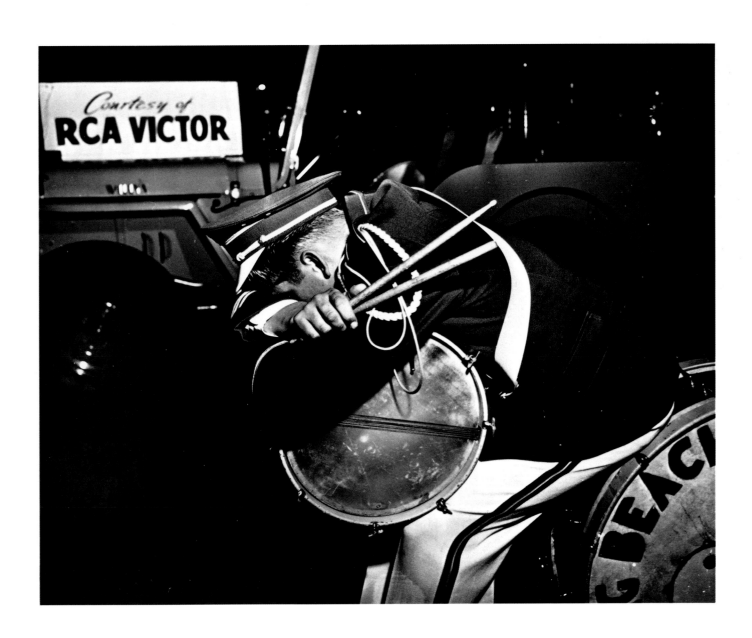

Eingeschlafener Musiker
Musician — fallen asleep
Musicien endormi

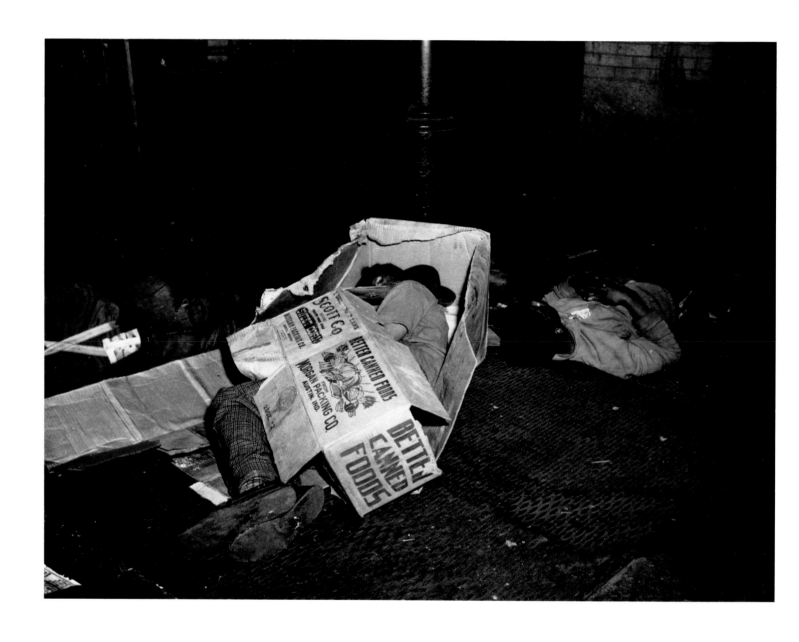

Obdachlos
Homeless
Sans abri

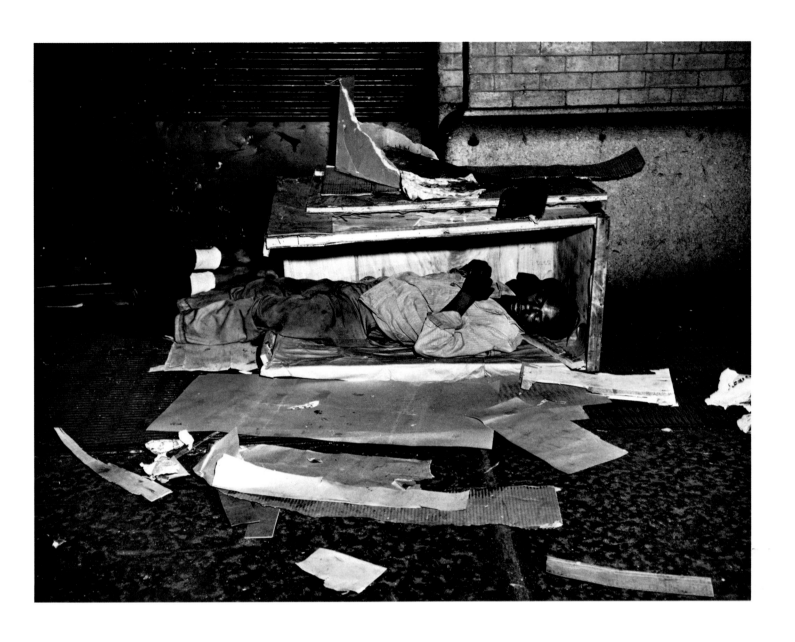

Obdachlos
Homeless
Sans abri

143

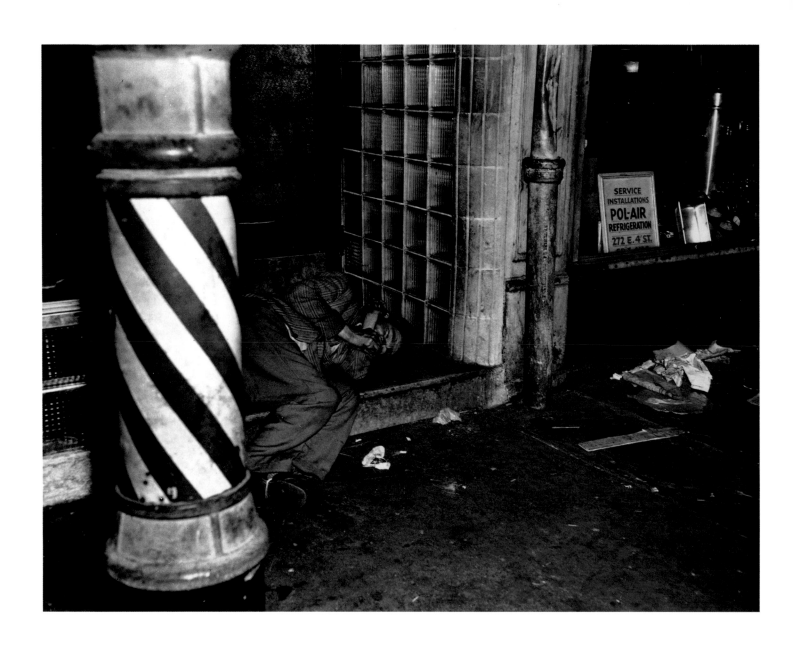

Obdachlos
Homeless
Sans abri

144

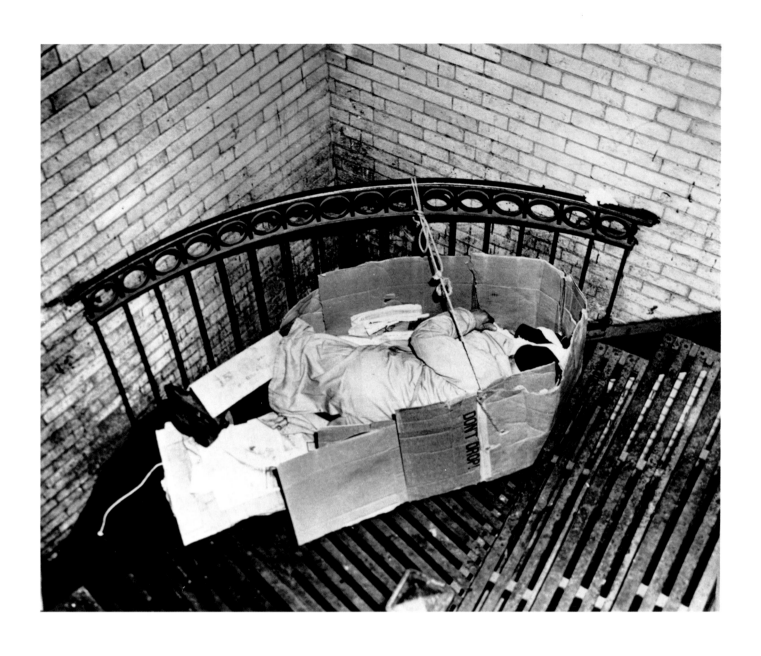

Nachtlager auf der Feuertreppe, 1938
Night's lodging on a fire-escape
Quartier de nuit dans la cage d'incendie

145

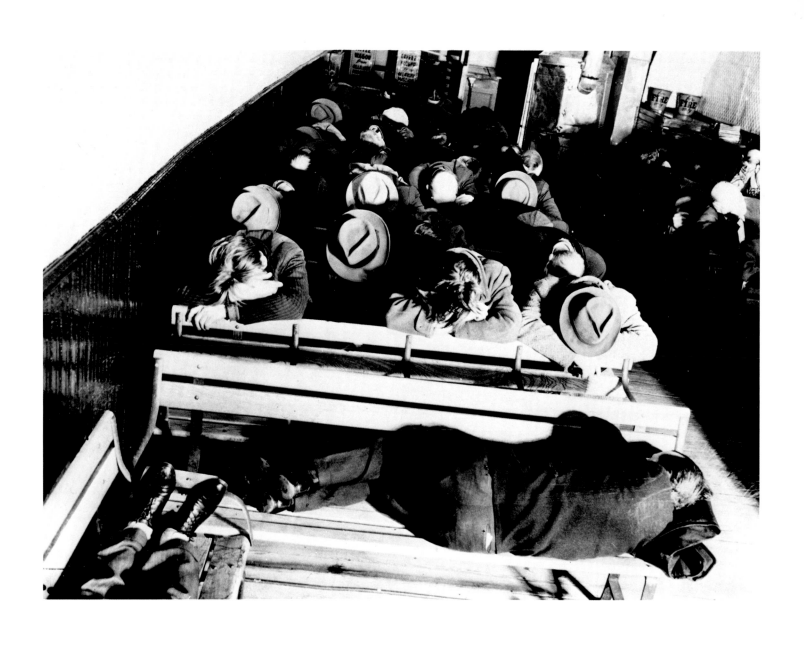

Nachtasyl in der Bowery, ca. 1938
Night shelter in the Bowery
Asile de nuit à la Bowery

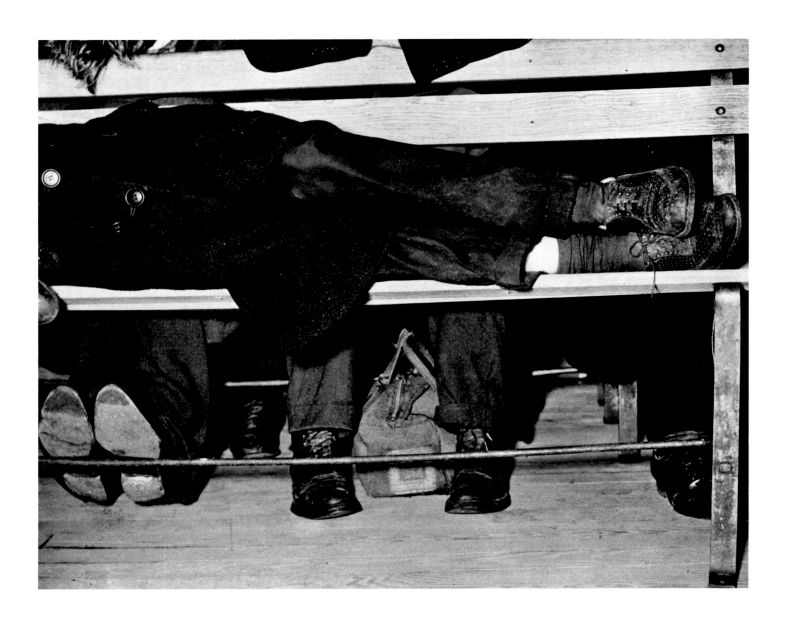

Nachtasyl, ca. 1938
Night shelter
Asile de nuit

147

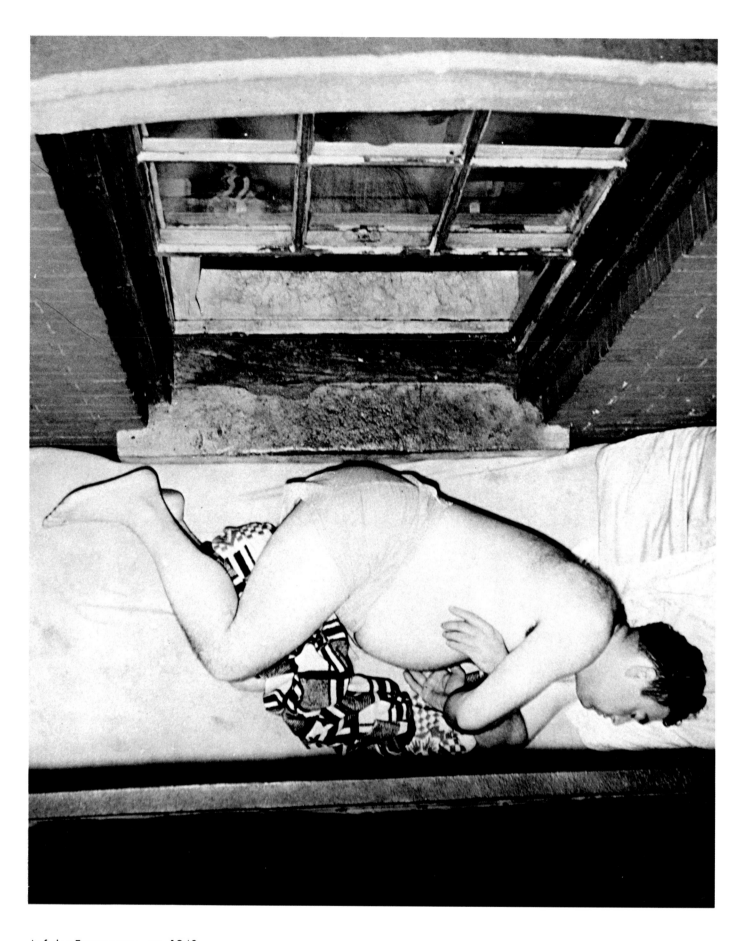

Auf der Feuertreppe, ca. 1940
On the fire-escape
Dans la cage d'incendie

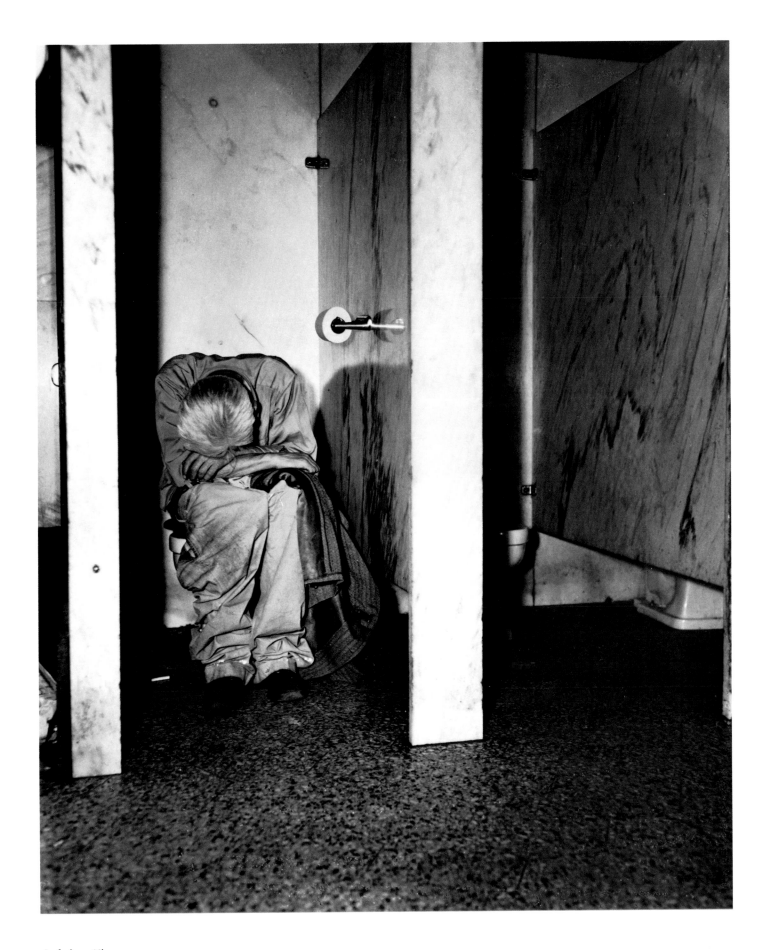

Auf dem Klo
On the toilet
Aux toilettes

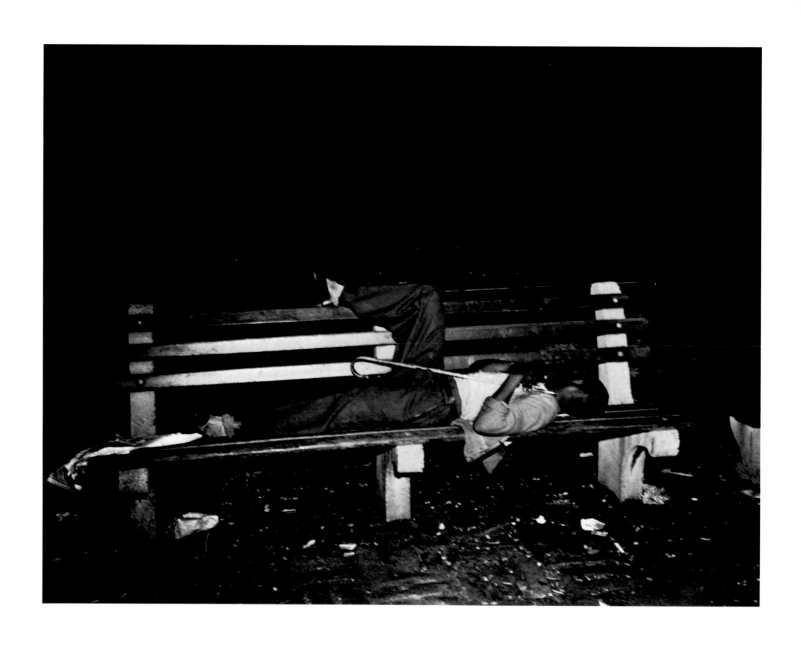

Auf einer Parkbank in Greenwich Village
On a parkbench in Greenwich Village
Sur un banc du parc à Greenwich Village

150

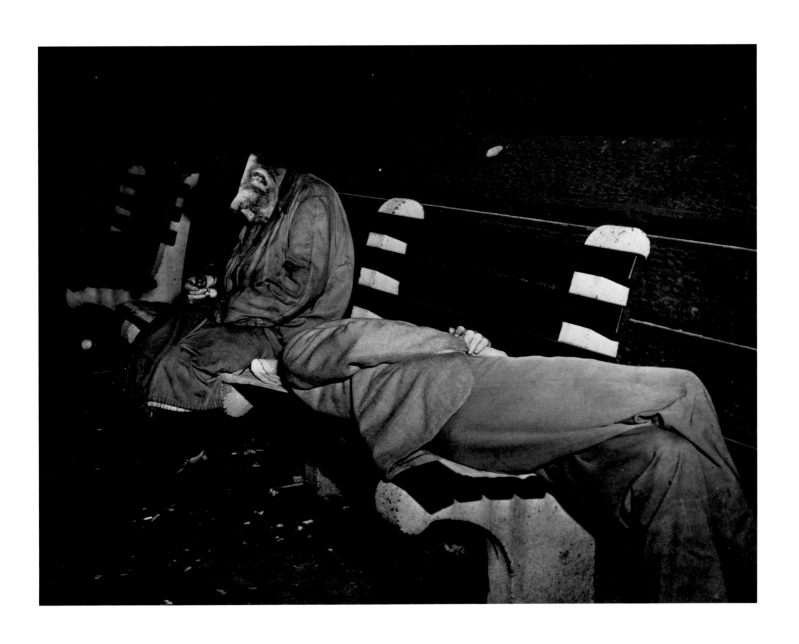

Im Bryant Park um fünf Uhr früh
Bryant Park, 5 o'clock in the morning
Dans le Bryant Park, à cinq heures du matin

151

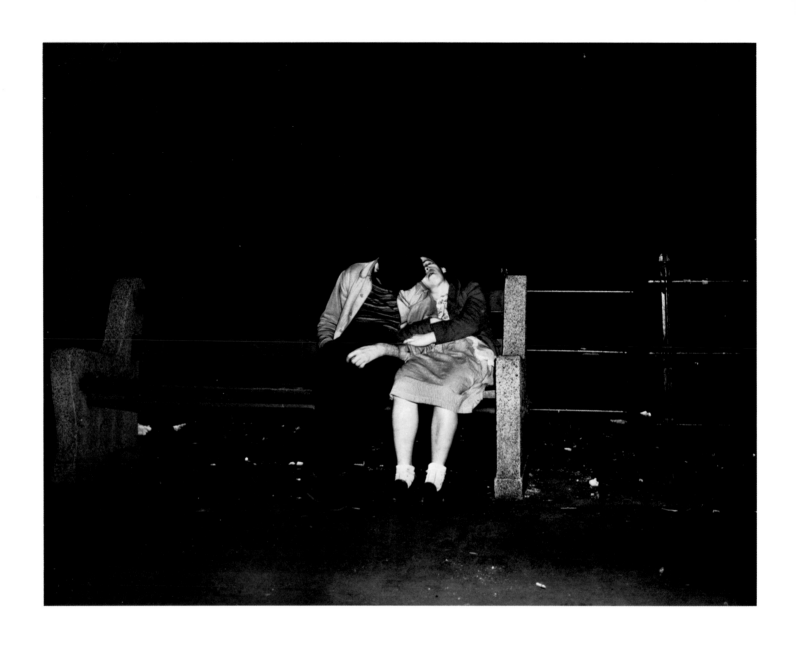

Eingeschlafenes Liebespaar
Lovers — fallen asleep
Couple d'amoureux endormi

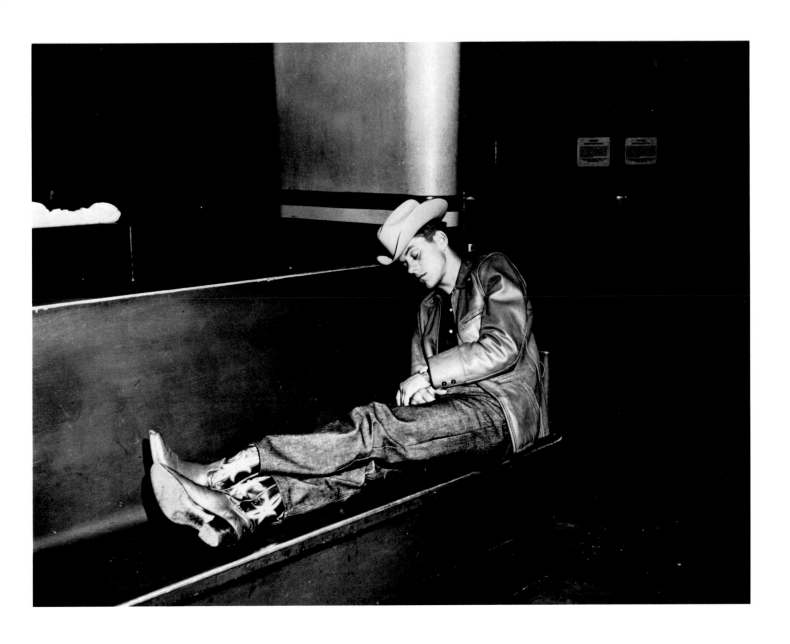

Im Wartesaal
In the waiting-room
Dans la salle d'attente

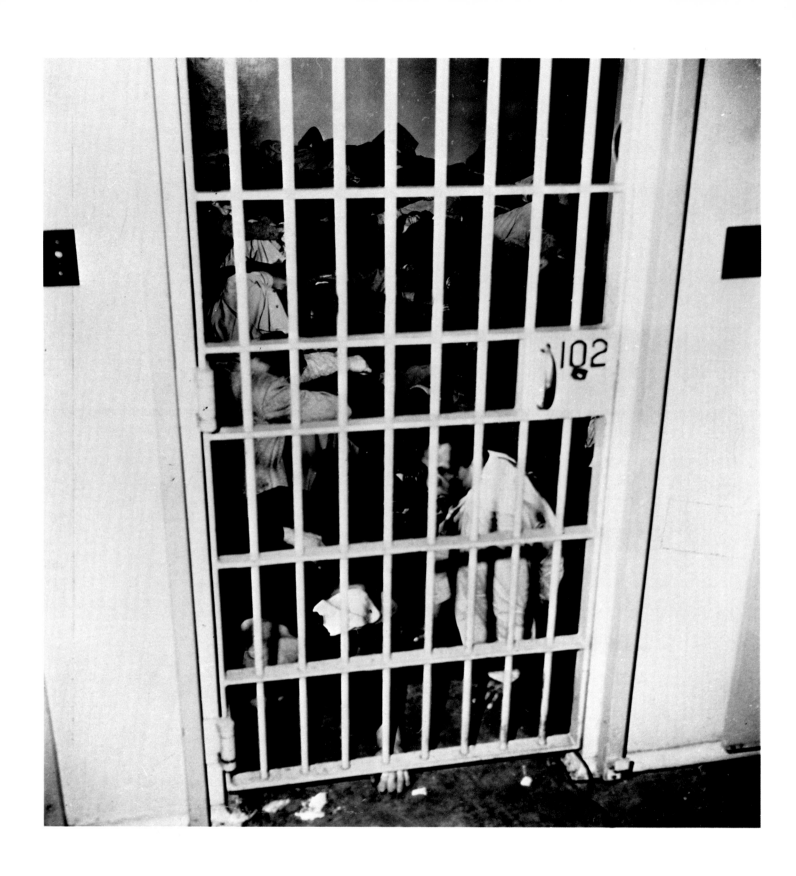

Arrestzelle, ca. 1942
''Cooler''
Cellule de la maison d'arrêt

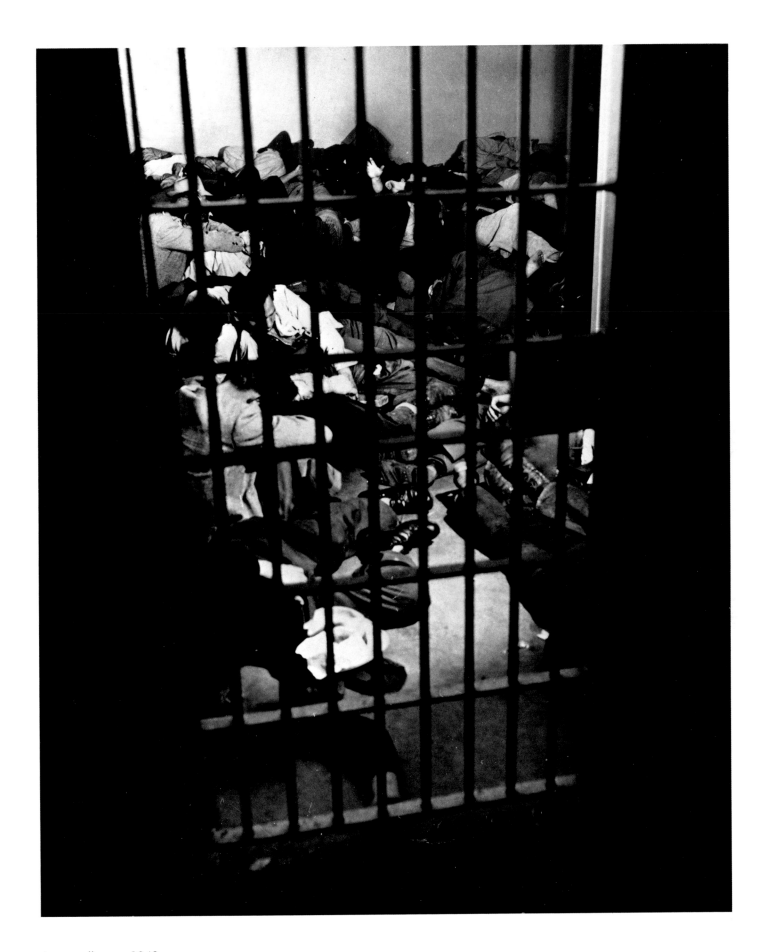

Arrestzelle, ca. 1942
''Cooler''
Cellule de la maison d'arrêt

155

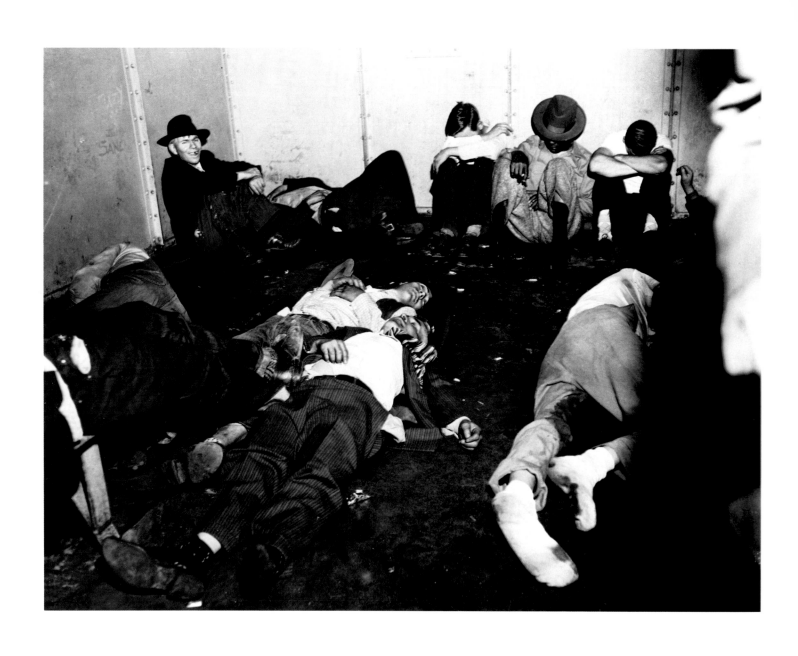

Arrestzelle, ca. 1942
''Cooler''
Cellule de la maison d'arrêt

156

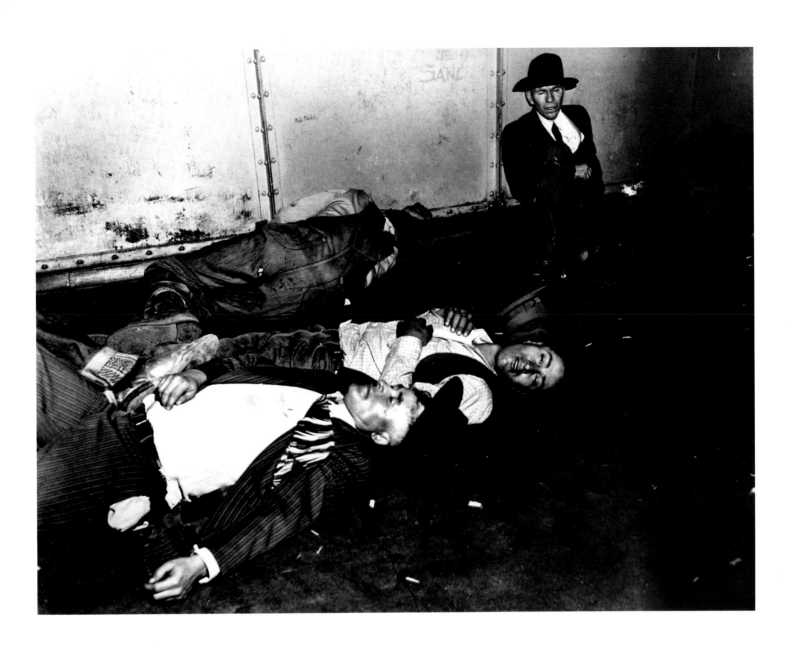

Arrestzelle, ca. 1942
"Cooler"
Cellule de la maison d'arrêt

157

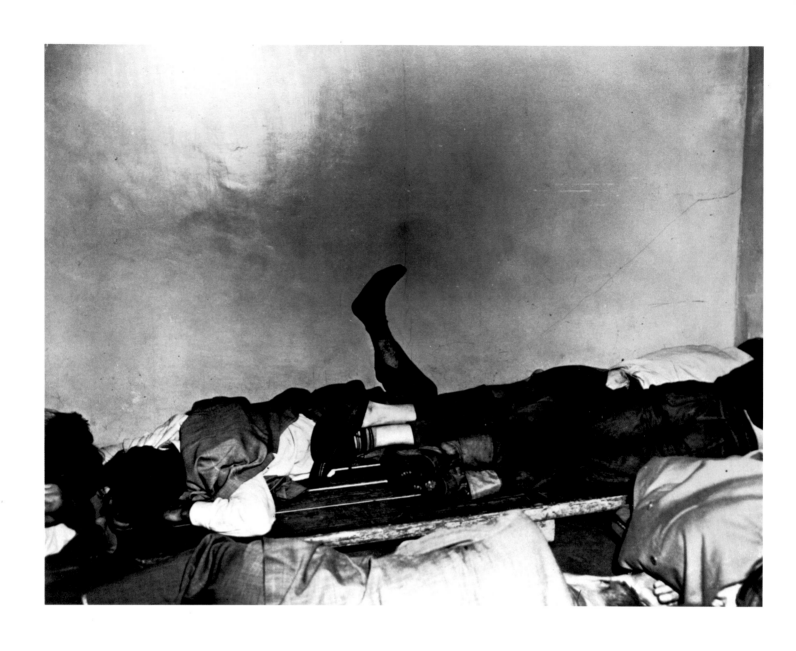

Arrestzelle
"Cooler"
Cellule de la maison d'arrêt

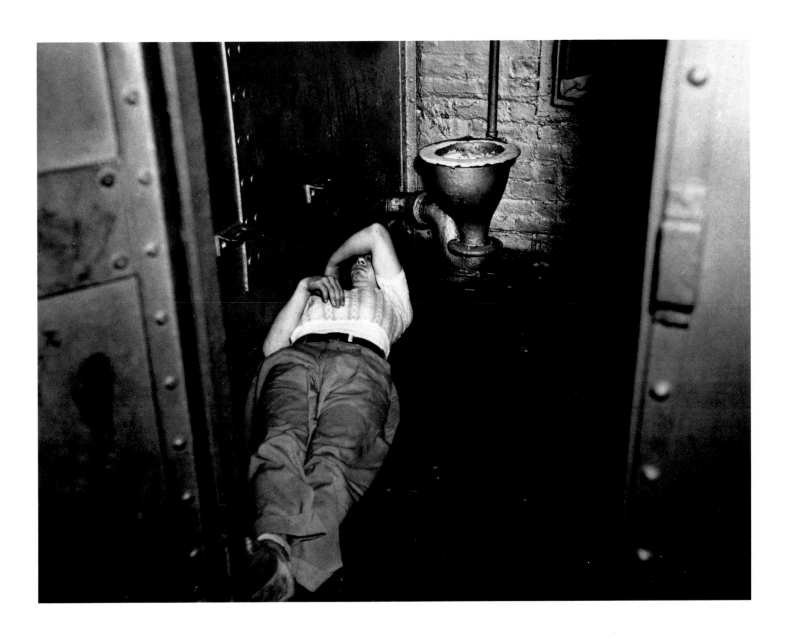

Arrestzelle
"Cooler"
Cellule de la maison d'arrêt

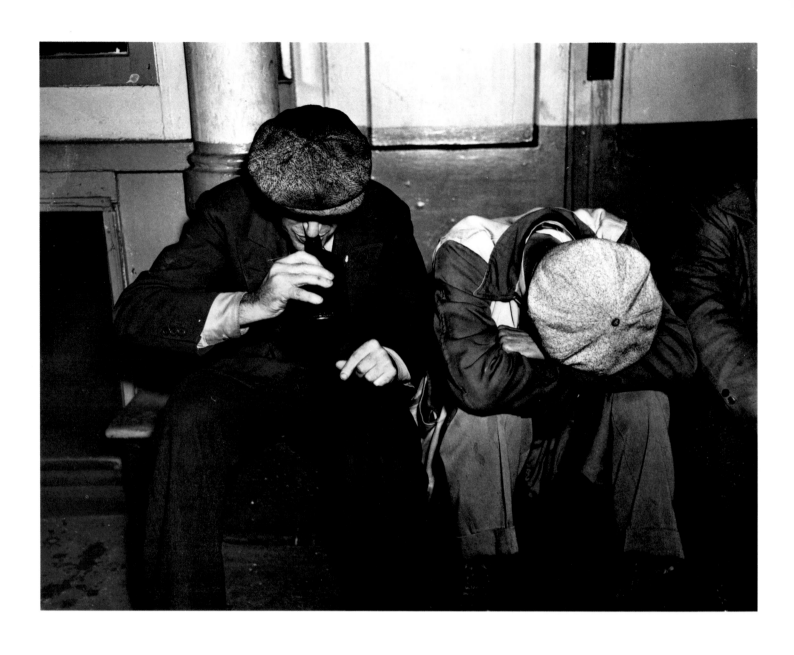

Nachtasyl
Night shelter
Asile de nuit

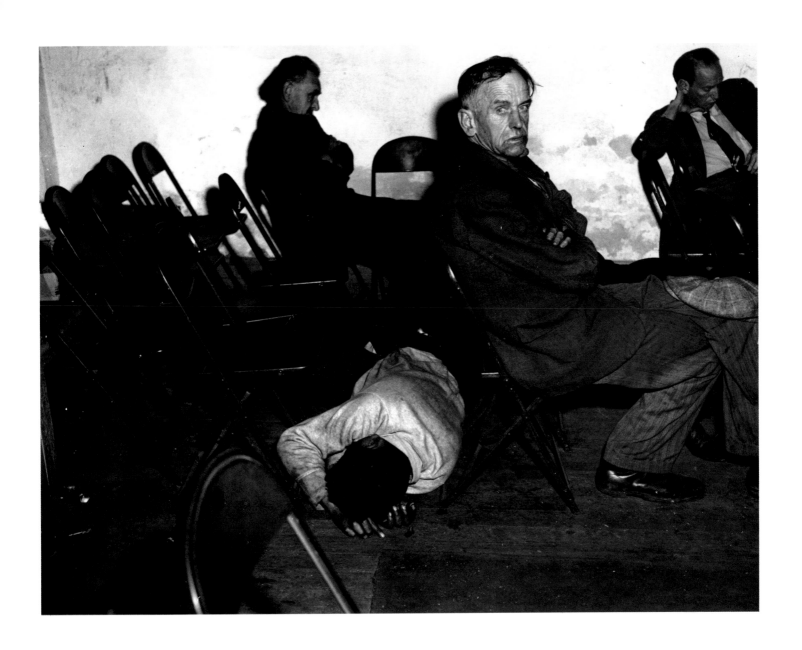

Nachtasyl
Night shelter
Asile de nuit

Im Kino
At the Movies
Au Cinéma

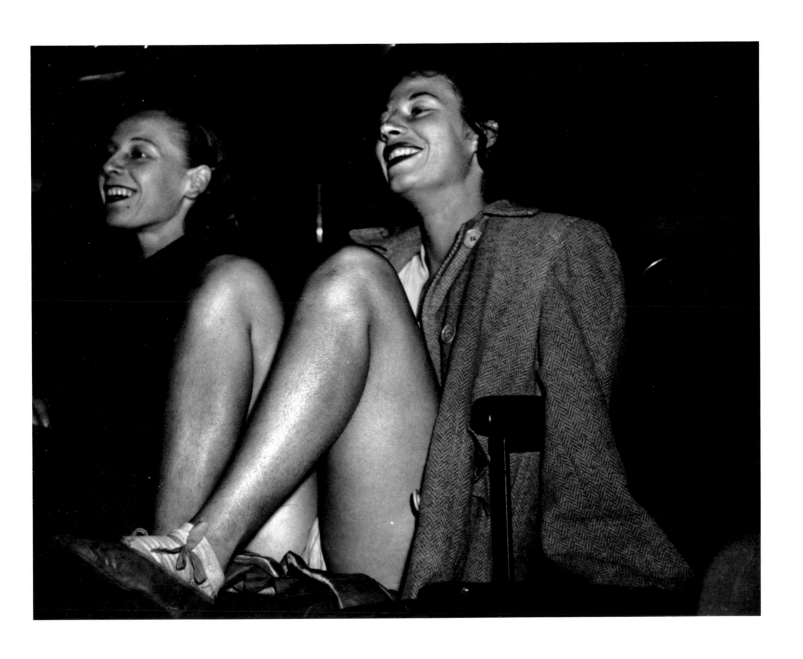

Im Kino
At the movies
Au cinéma

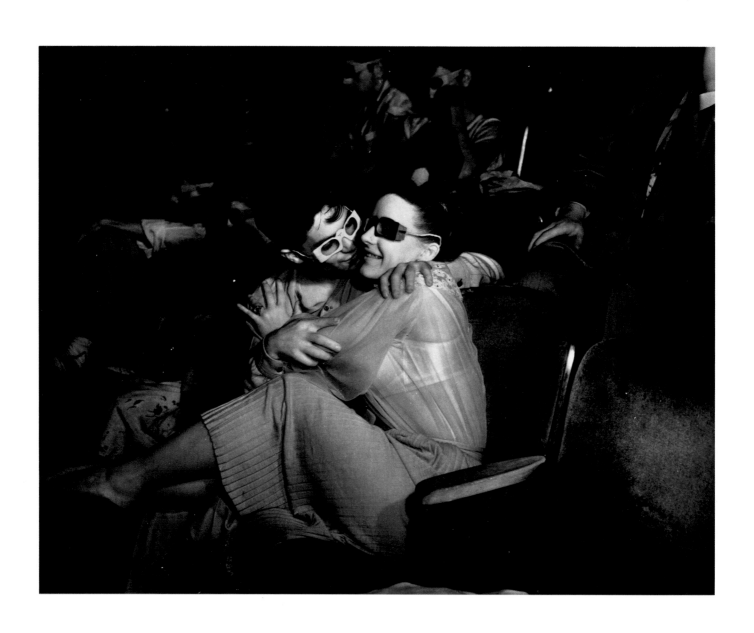

Liebespaar im Kino I
Lovers at the movies I
Couple d'amoureux au cinéma I

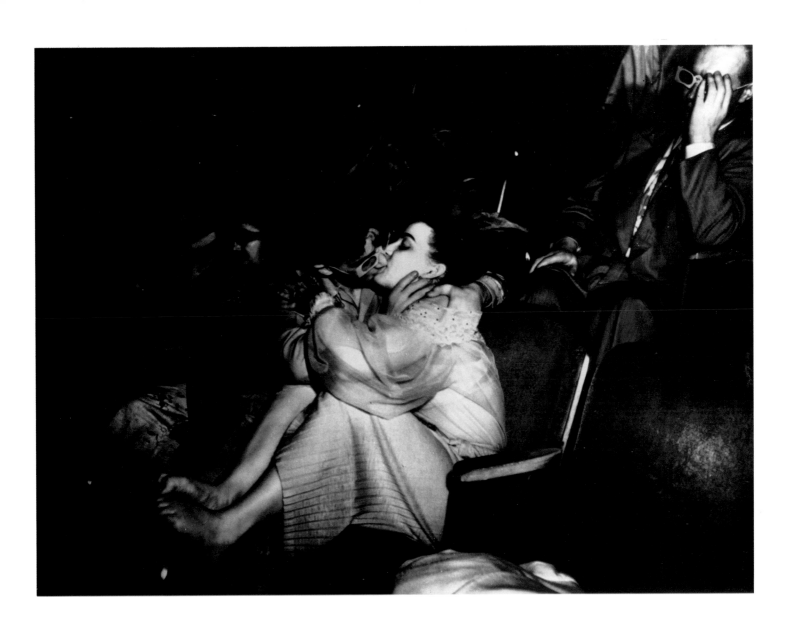

Liebespaar im Kino II, ca. 1940 (Infrarot-Aufnahmen)
Lovers at the movies II (infrared-photographies)
Couple d'amoureux au cinéma II (photographies aux infrarouges)

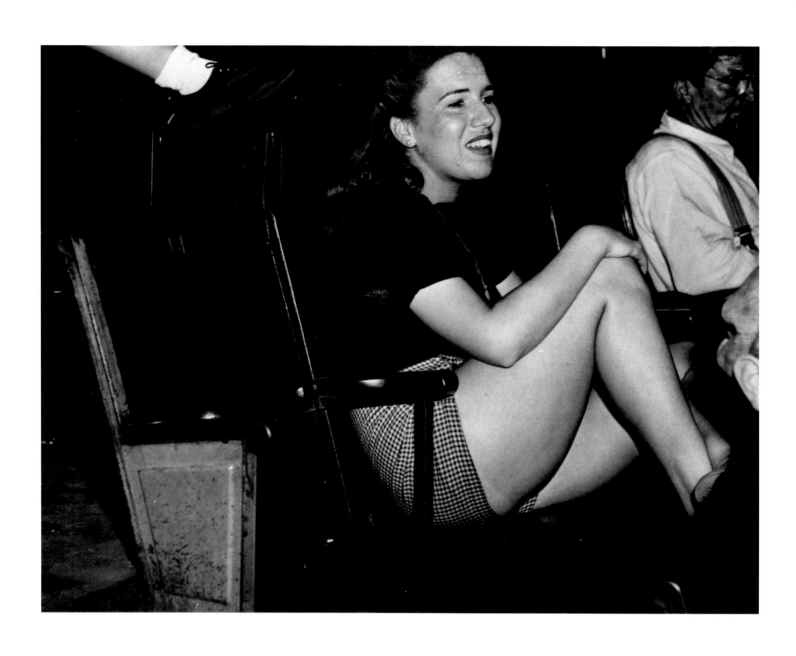

Im Kino
At the movies
Au cinéma

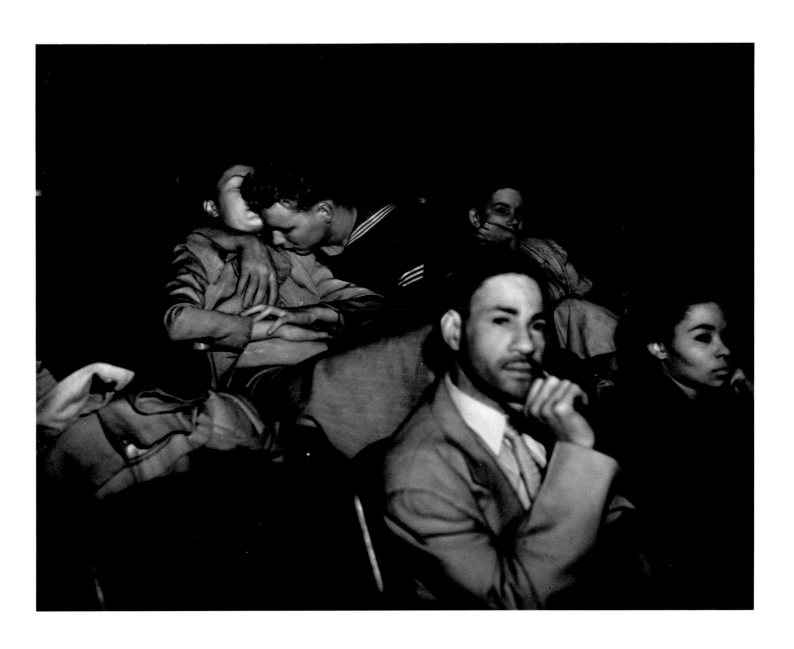

Liebespaar im Kino (Infrarot-Aufnahme)
Lovers at the movies (infrared-photography)
Couple d'amoureux au cinéma (photographie aux infrarouges)

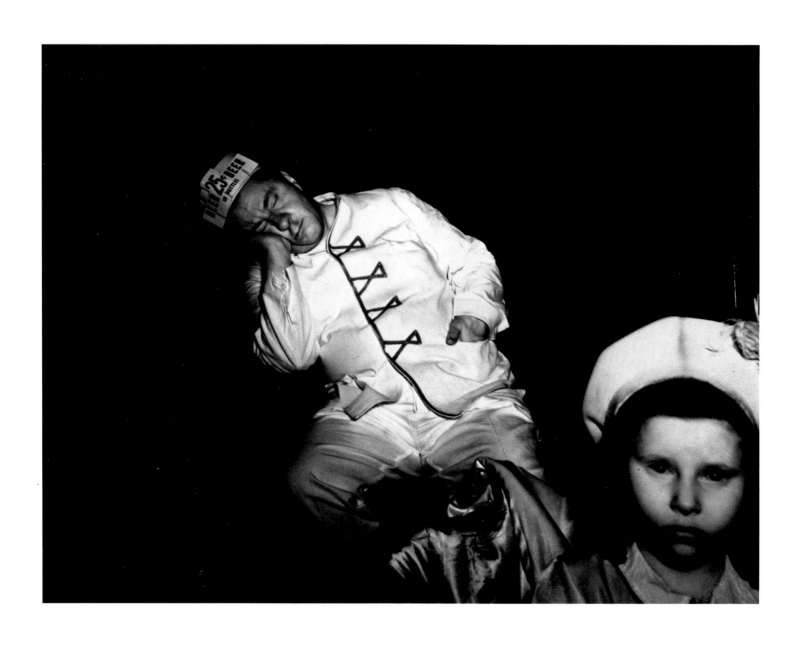

Im Kino (Infrarot-Aufnahme)
At the movies (infrared-photography)
Au cinéma (photographie aux infrarouges)

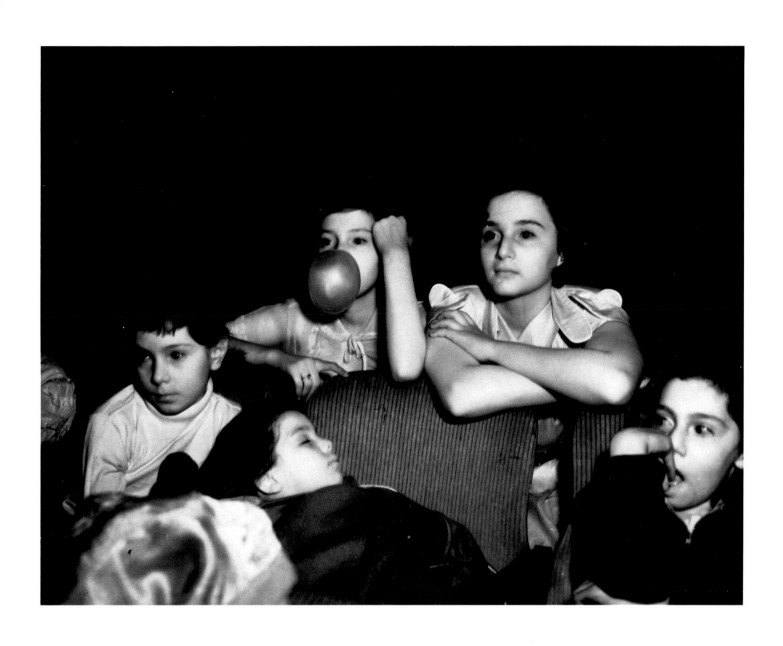

Kindervorstellung, ca. 1940 (Infrarot-Aufnahme)
Children's performance (infrared-photography)
Représentation pour enfants (photographie aux infrarouges)

168

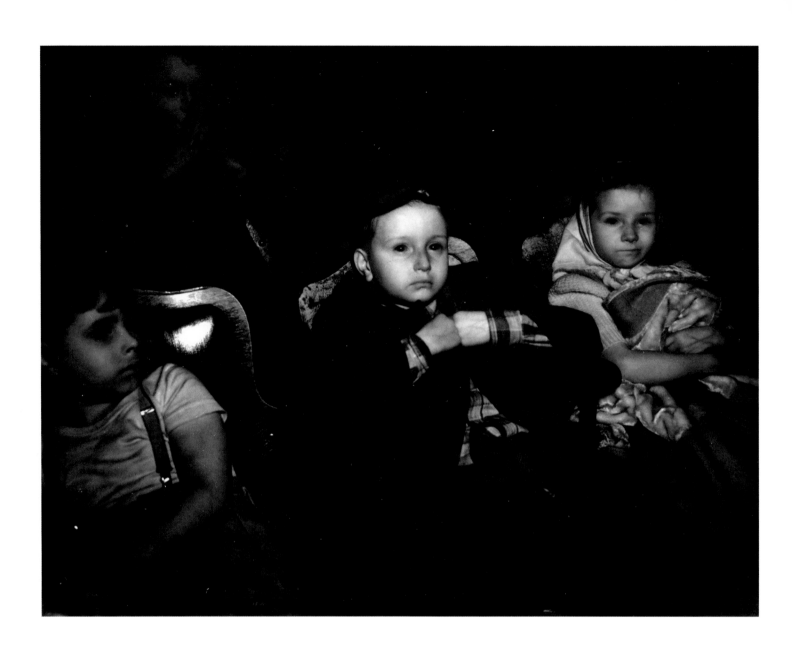

Kindervorstellung, ca. 1940 (Infrarot-Aufnahme)
Children's performance (infrared-photography)
Représentation pour enfants (photographie aux infrarouges)

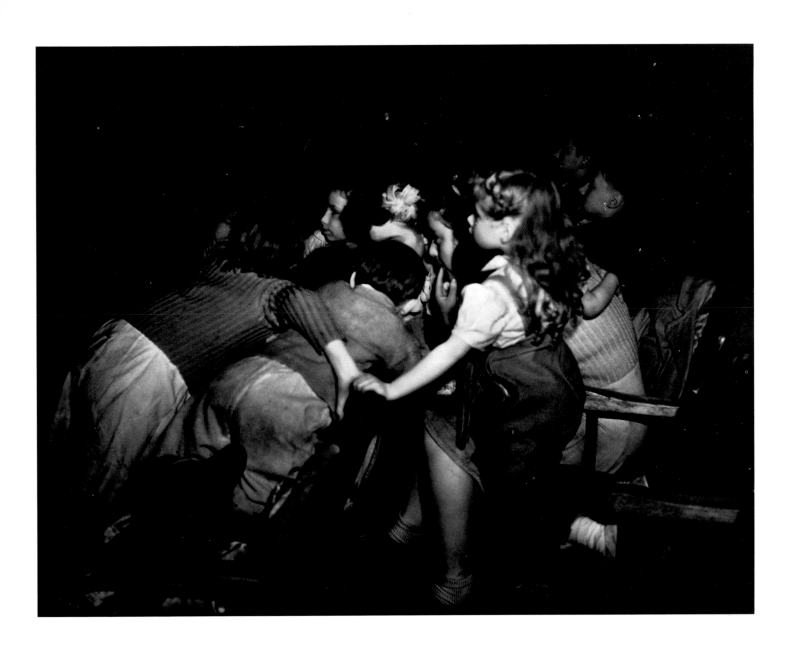

Kindervorstellung, ca. 1940 (Infrarot-Aufnahme)
Children's performance (infrared-photography)
Représentation pour enfants (photographie aux infrarouges)

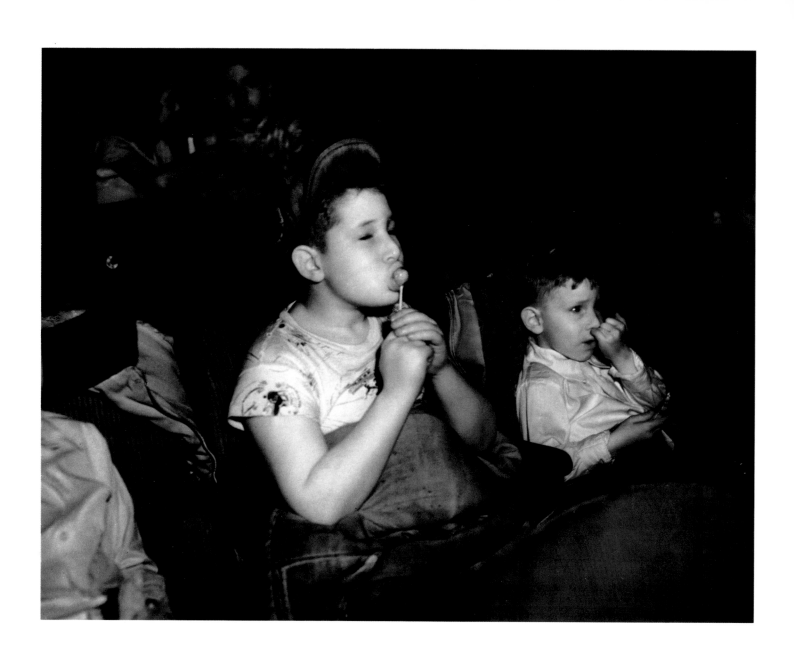

Kindervorstellung, ca. 1940 (Infrarot-Aufnahme)
Children's performance (infrared-photography)
Représentation pour enfants (photographie aux infrarouges)

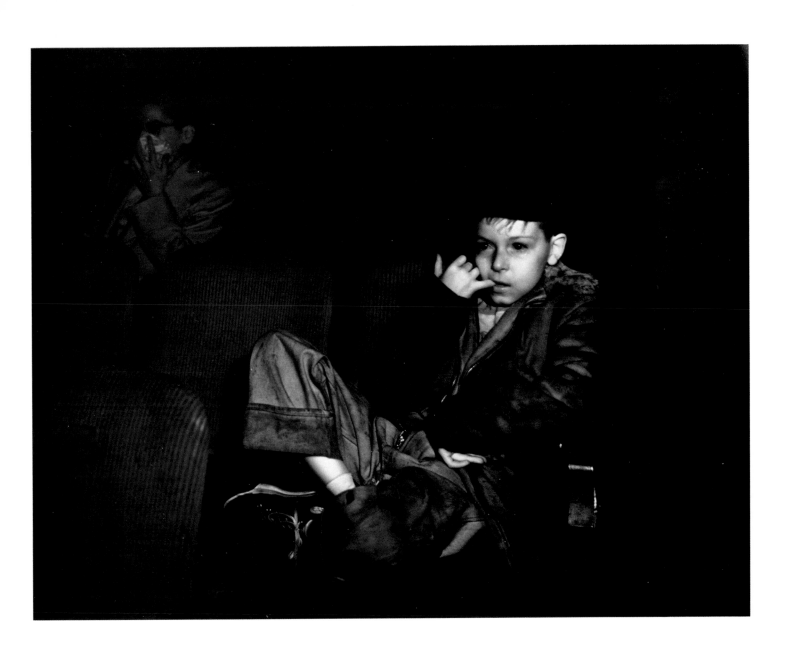

Kindervorstellung, ca. 1940 (Infrarot-Aufnahme)
Children's performance (infrared-photography)
Représentation pour enfants (photographie aux infrarouges)

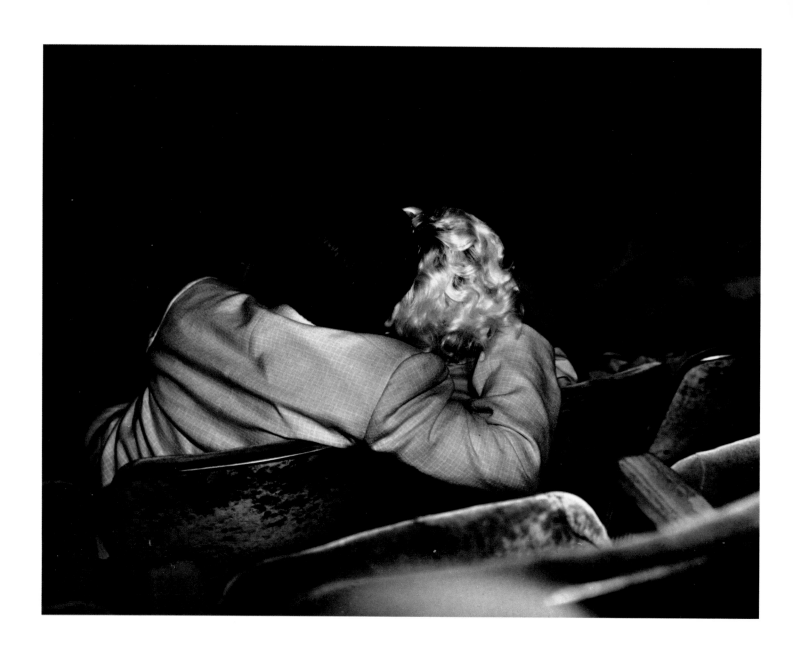

Liebespaar im Kino (Infrarot-Aufnahme)
Lovers at the movies (infrared-photography)
Couple d'amoureux au cinéma (photographie aux infrarouges)

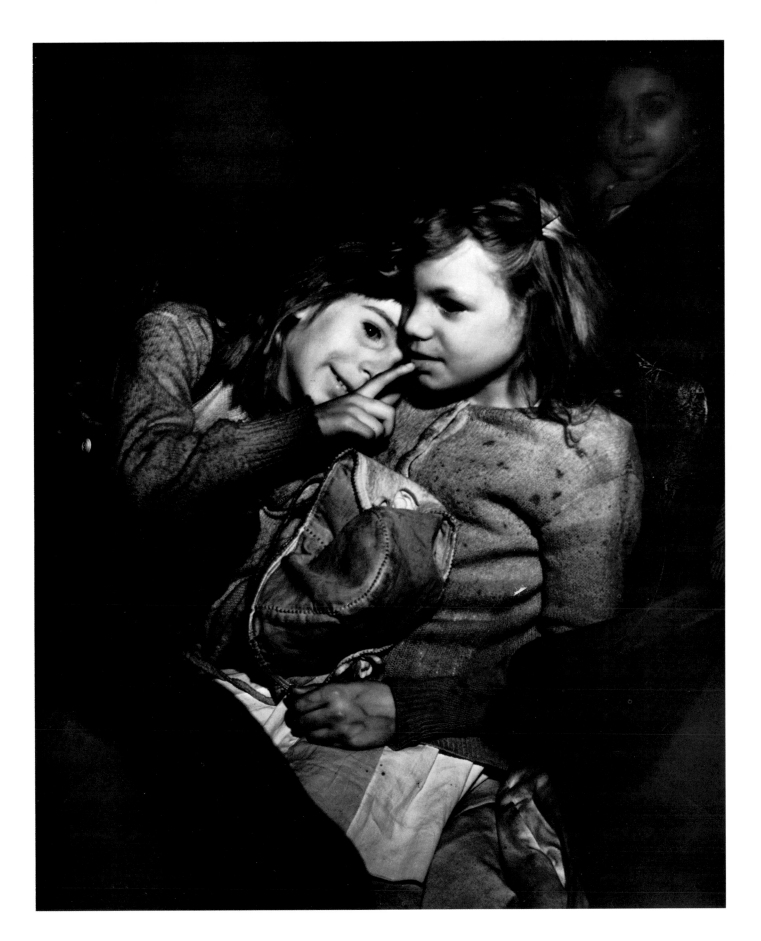

Kindervorstellung, ca. 1940 (Infrarot-Aufnahme)
Children's performance (infrared-photography)
Représentation pour enfants (photographie aux infrarouges)

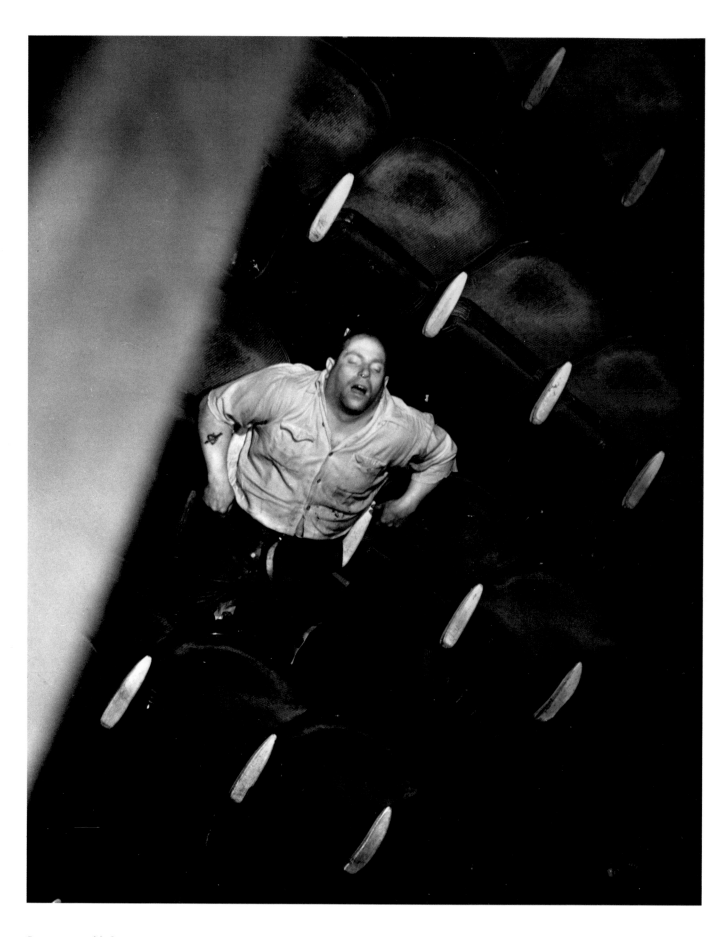

Programmschluß
The show is over
Fin de programme

Programmschluß
The show is over
Fin de programme

Kinder
Children
Enfants

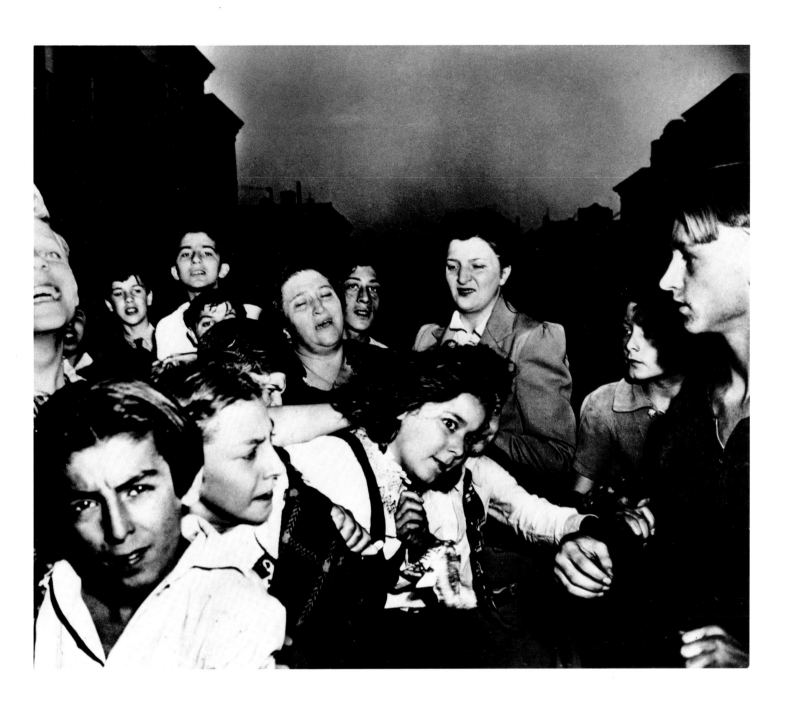

Ihr erster Mord, ca. 1936
Their first murder
Leur premier crime

177

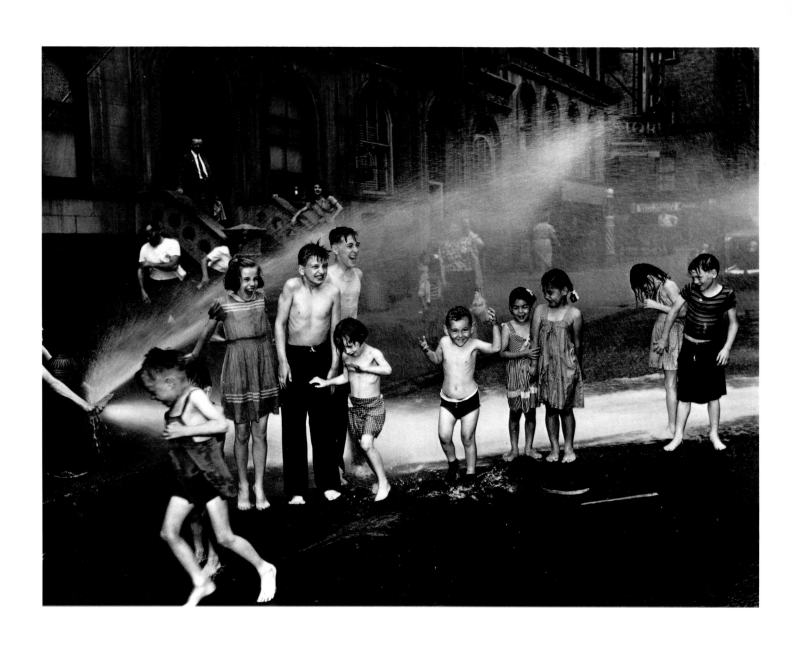

Sommer in der Lower East Side . . .
Summer on Lower East Side . . .
Eté à Lower East Side . . .

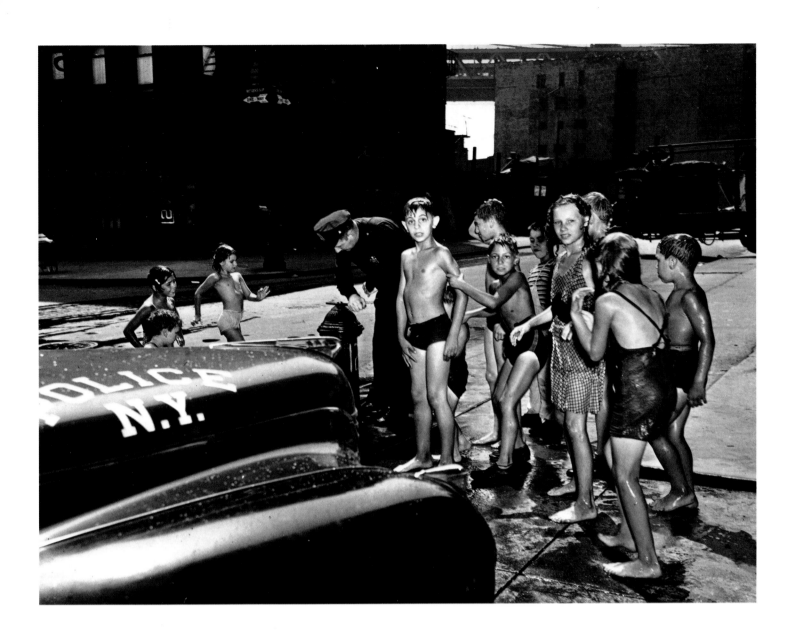

. . . ein Polizist beendet das Vergnügen, 1937
. . . a cop stops the fun
. . . un policier met fin au jeu

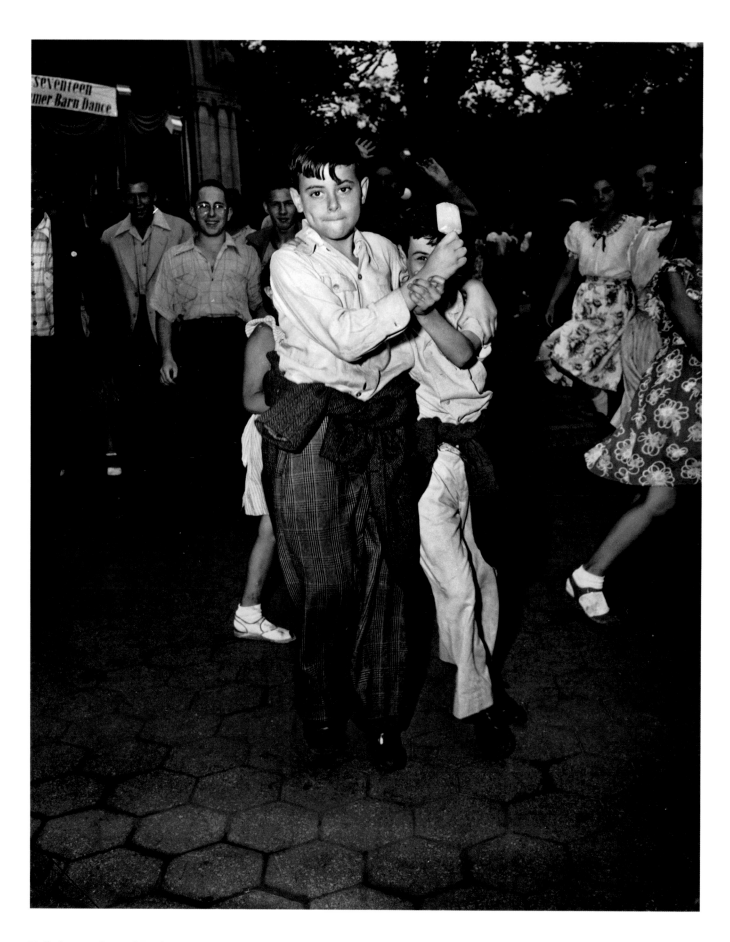

Volksfest im Central Park, 1938
Festival in Central Park
Fête populaire à Central Park

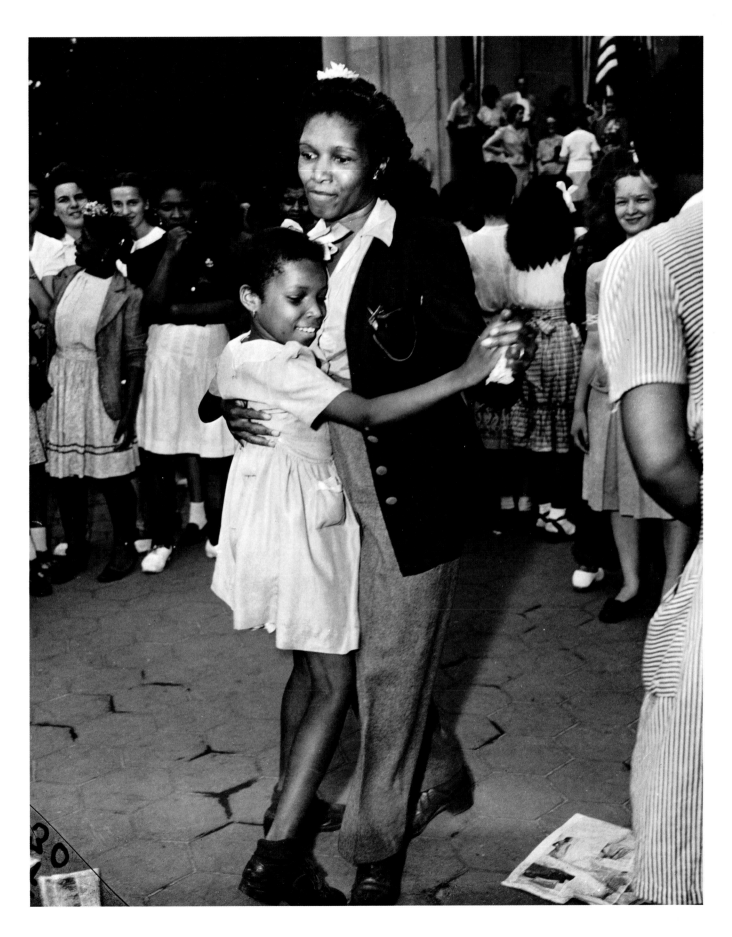

Volksfest im Central Park, 1938
Festival in Central Park
Fête populaire à Central Park

181

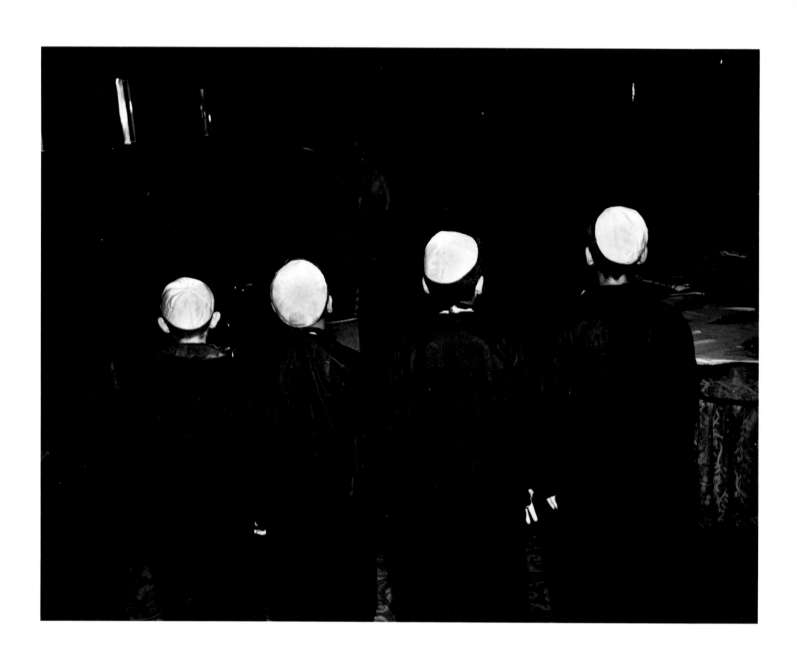

Bar Mitzvah
Bar Mitzvah
Bar Mitzvah

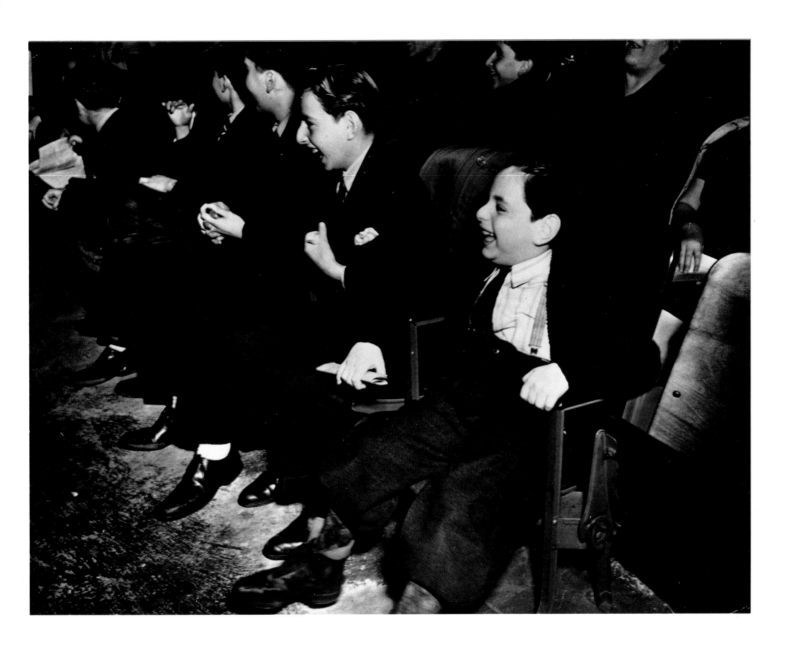

Bar Mitzvah
Bar Mitzvah
Bar Mitzvah

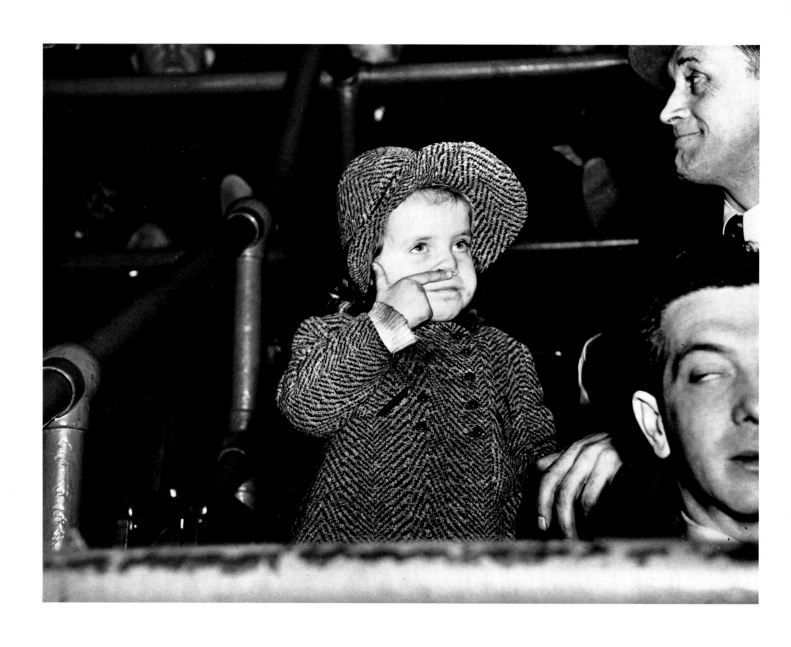

Kind im Zuschauerraum
Child in the audience
Enfant dans la salle de spectacle

184

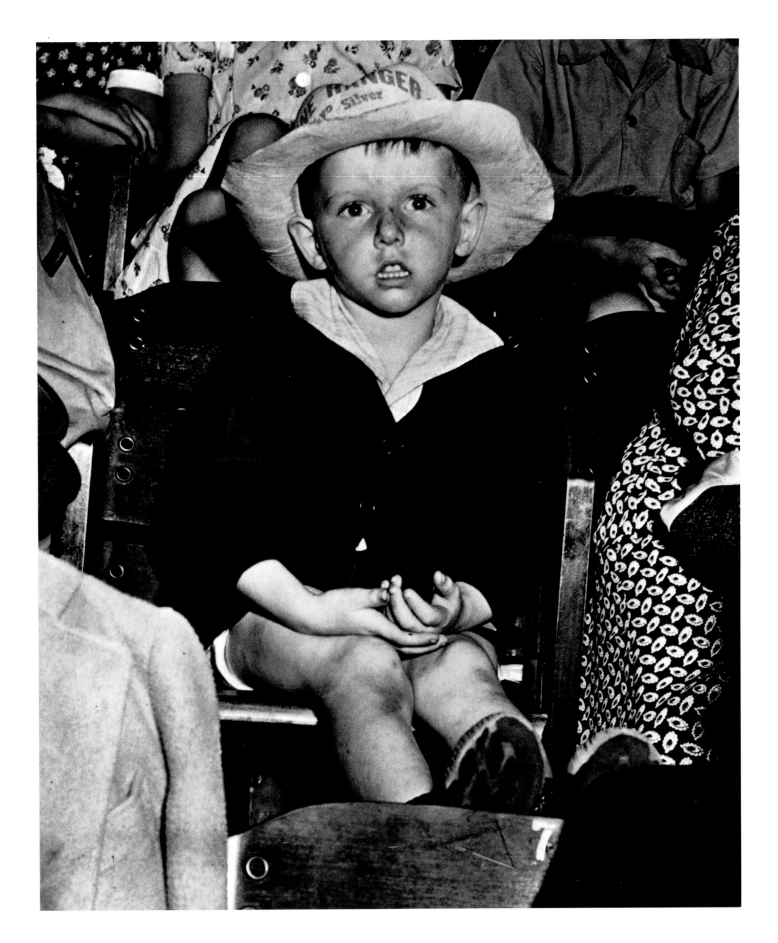

Kind im Zuschauerraum
Child in the audience
Enfant dans la salle de spectacle

185

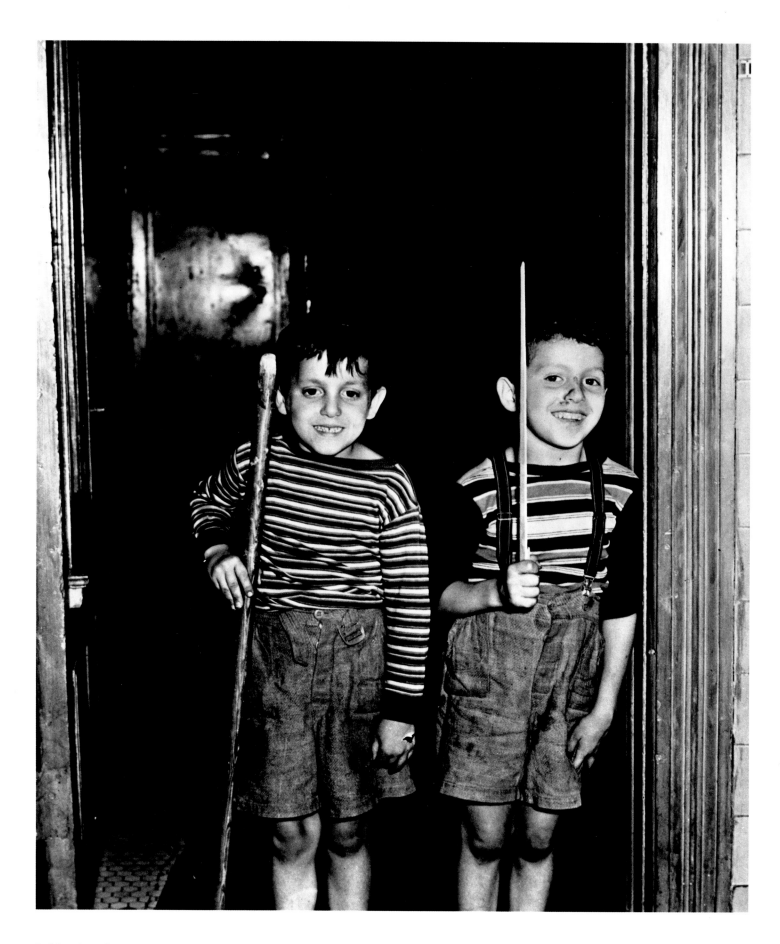

Soldatenspiel
Playing soldiers
Jouant aux soldats

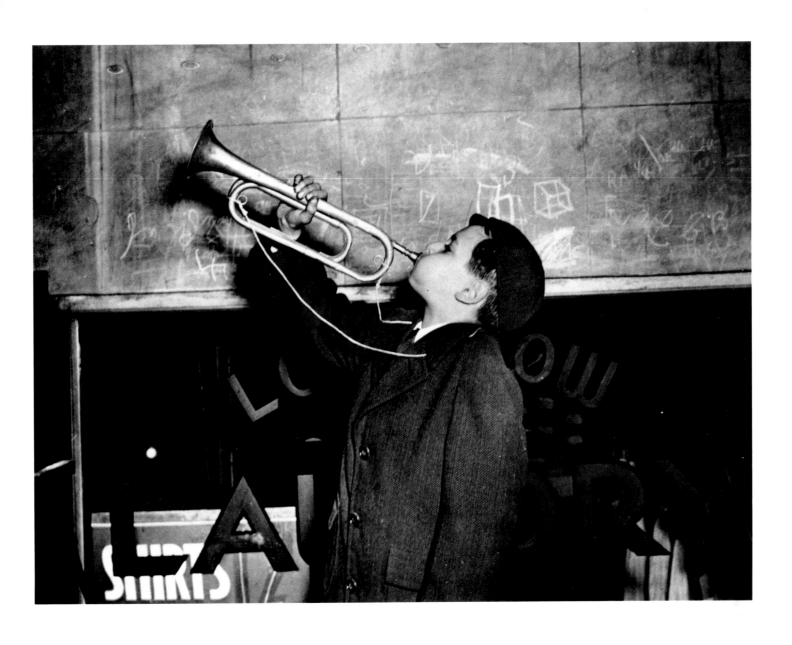

Kleiner Posaunist
The little trombonist
Le petit joueur de trombone

187

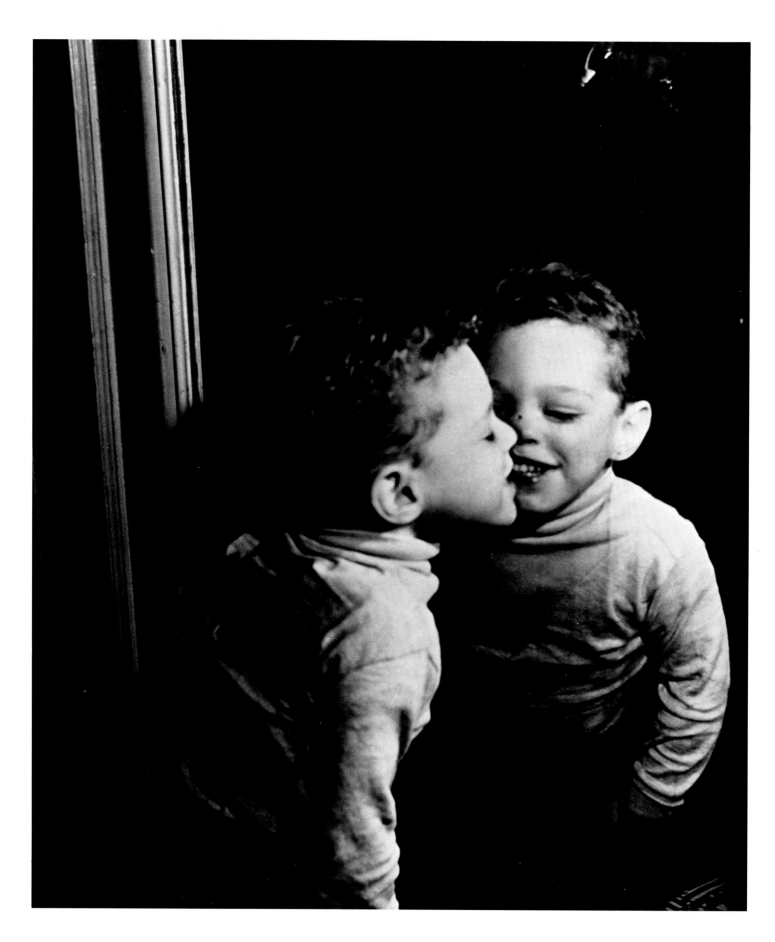

Das Spiegelbild
The reflection
L'image dans le miroir

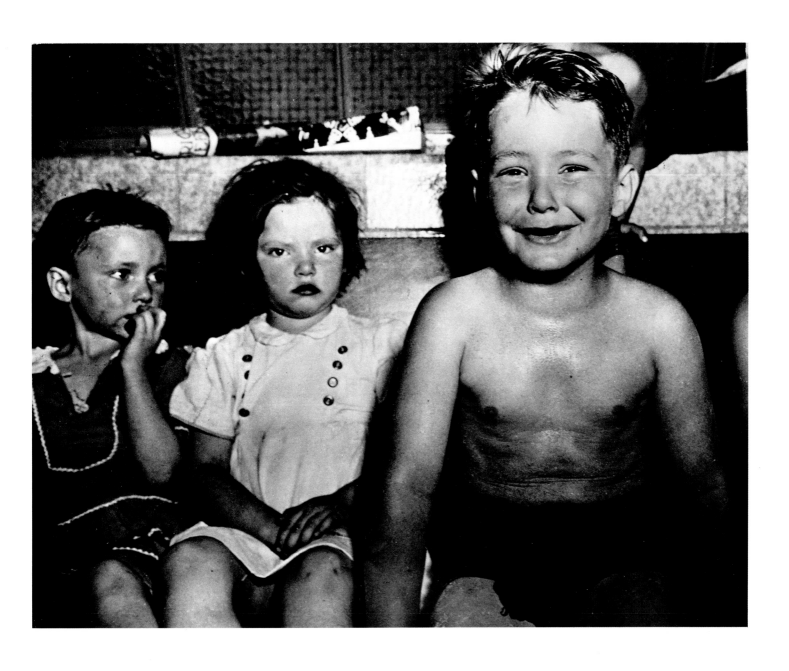

Kinder in der Badeanstalt
Children at the swimming pool
Enfants à la piscine

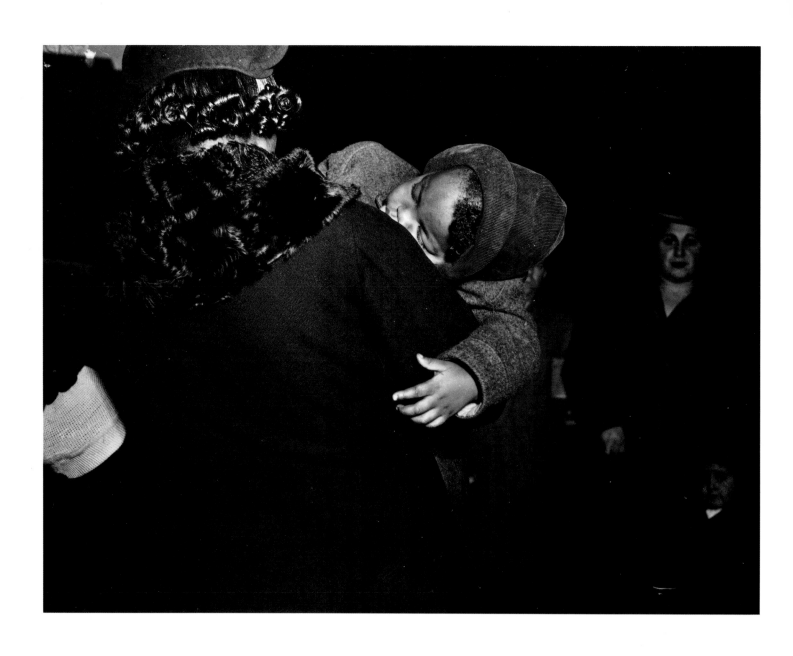

Mutter und Kind in Harlem
Mother and child in Harlem
Mère et enfant à Harlem

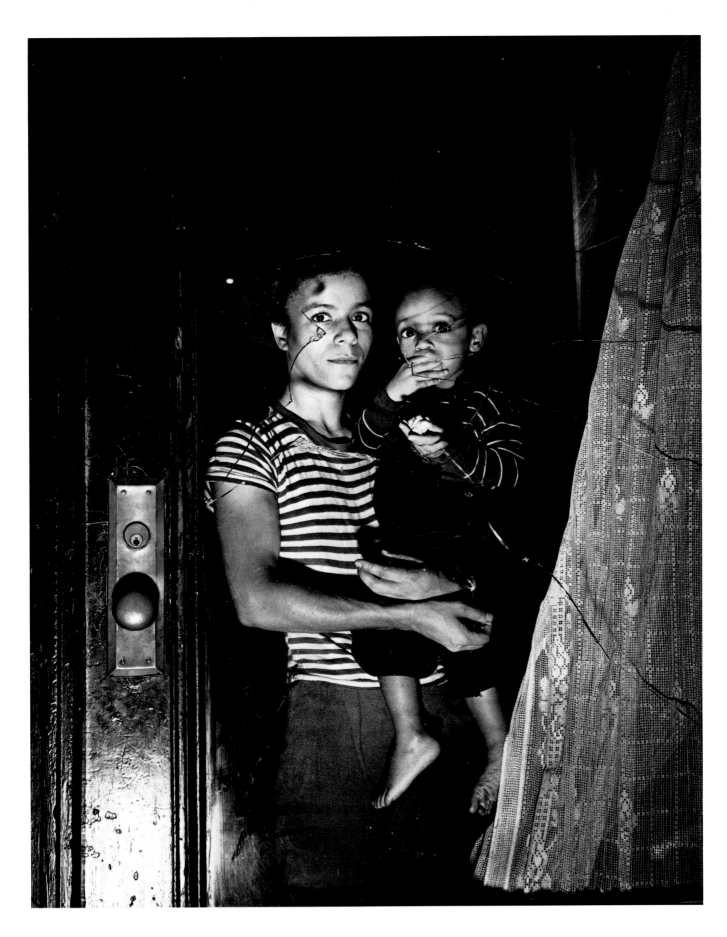

Mutter und Kind in Harlem, 1939
Mother and child in Harlem
Mère et enfant à Harlem

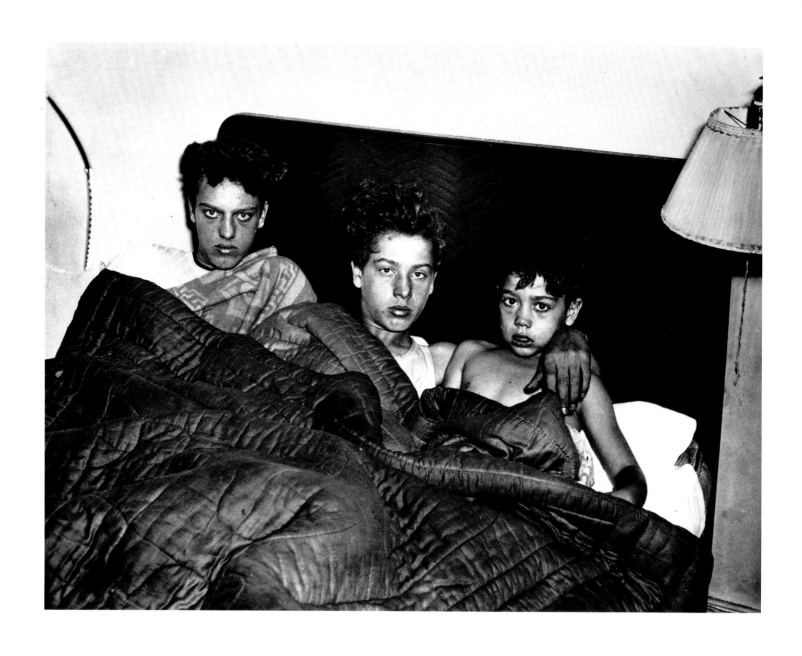

Zu dritt in einem Bett
Three in a bed
A trois dans un lit

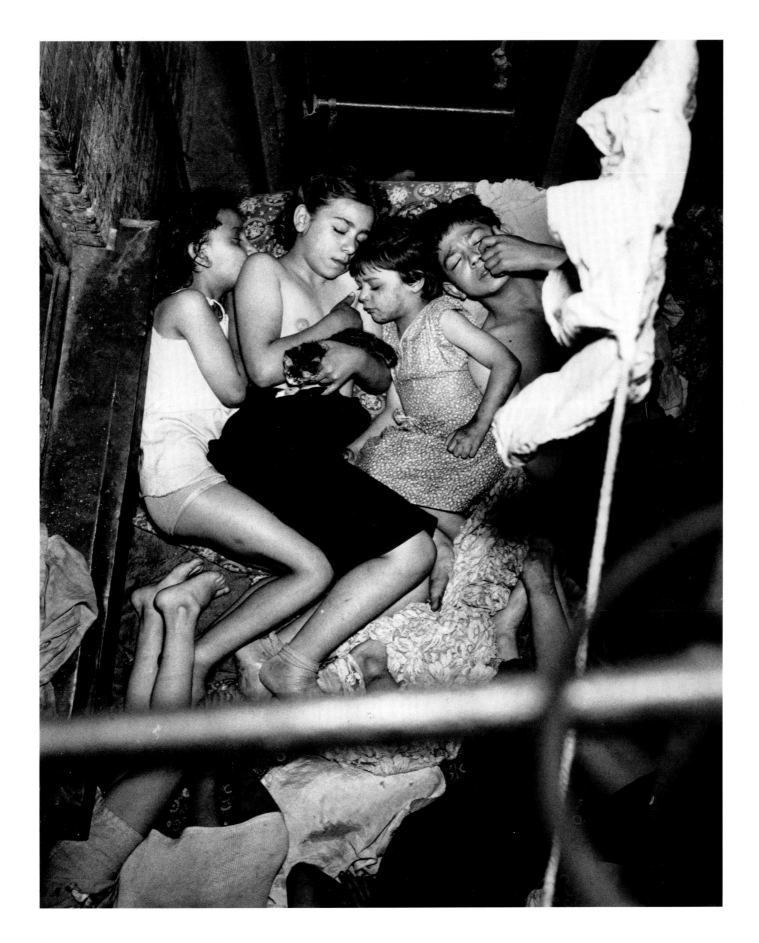

Kinder auf der Feuertreppe, 1938
Children on the fire-escape
Enfants dans la cage d'incendie

193

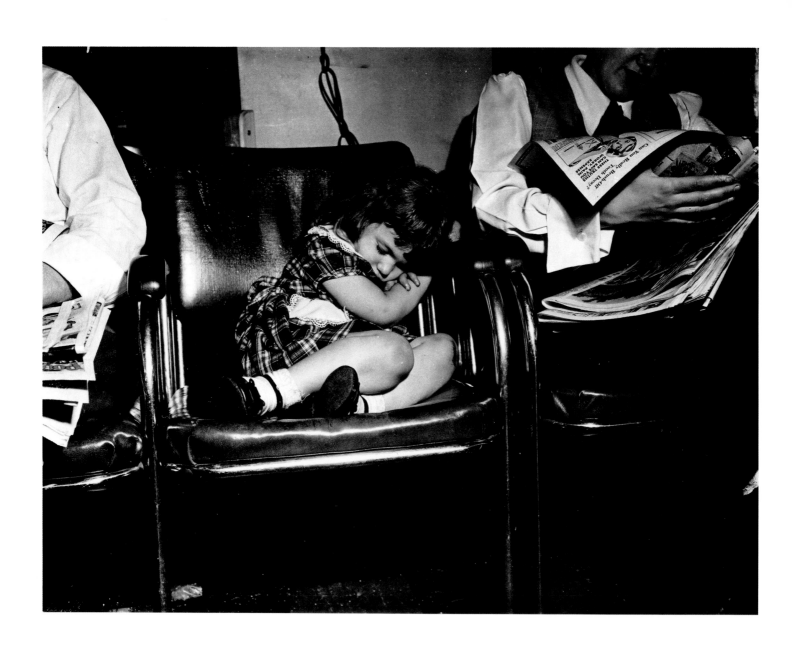

Eingeschlafenes Kind
Child — fallen asleep
Enfant endormi

In der Telefonzelle eingeschlafen
Fallen asleep in a phone-booth
Il s'est endormi dans la cabine téléphonique

195

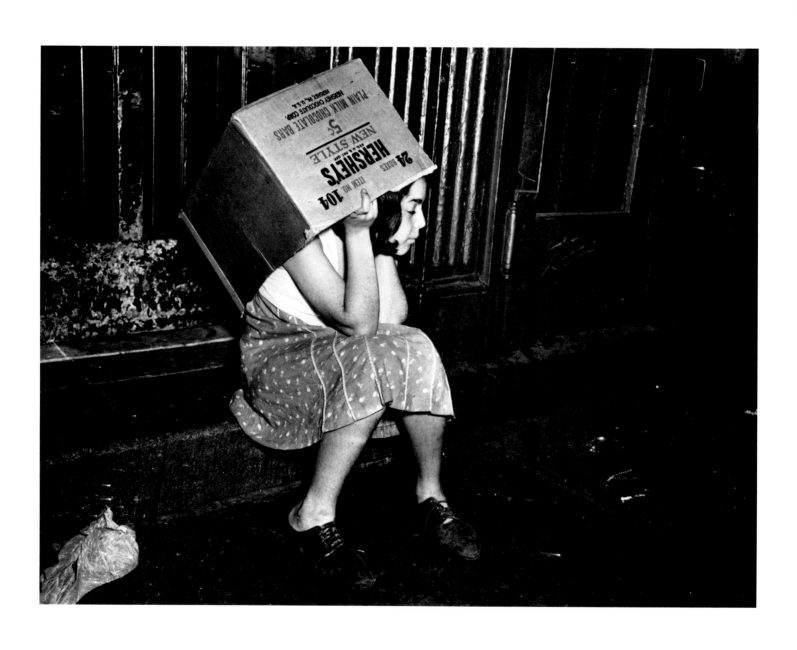

Schlafendes Mädchen
Sleeping girl
Fillette dormant

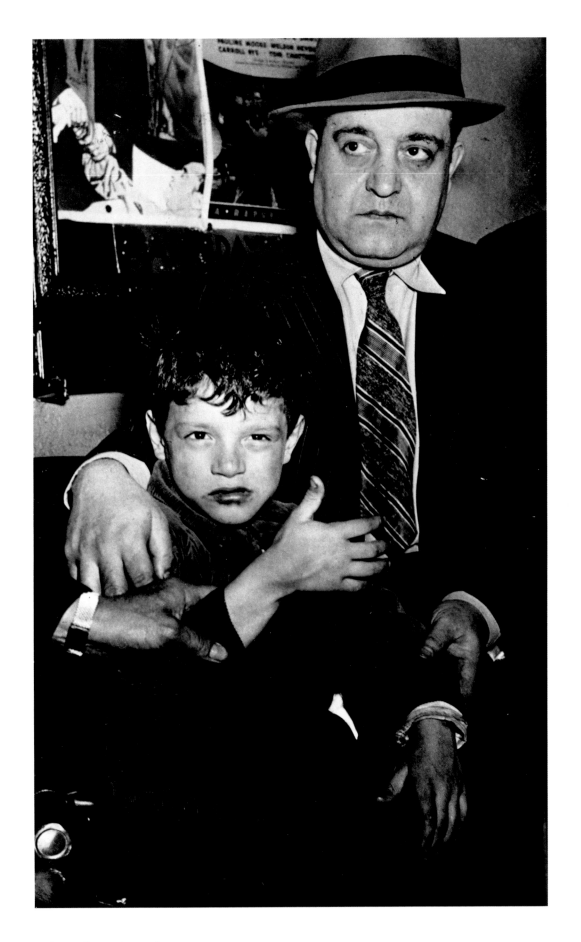

Aufgegriffener Ausreißer
Picked-up runaway
Fuyard attrapé

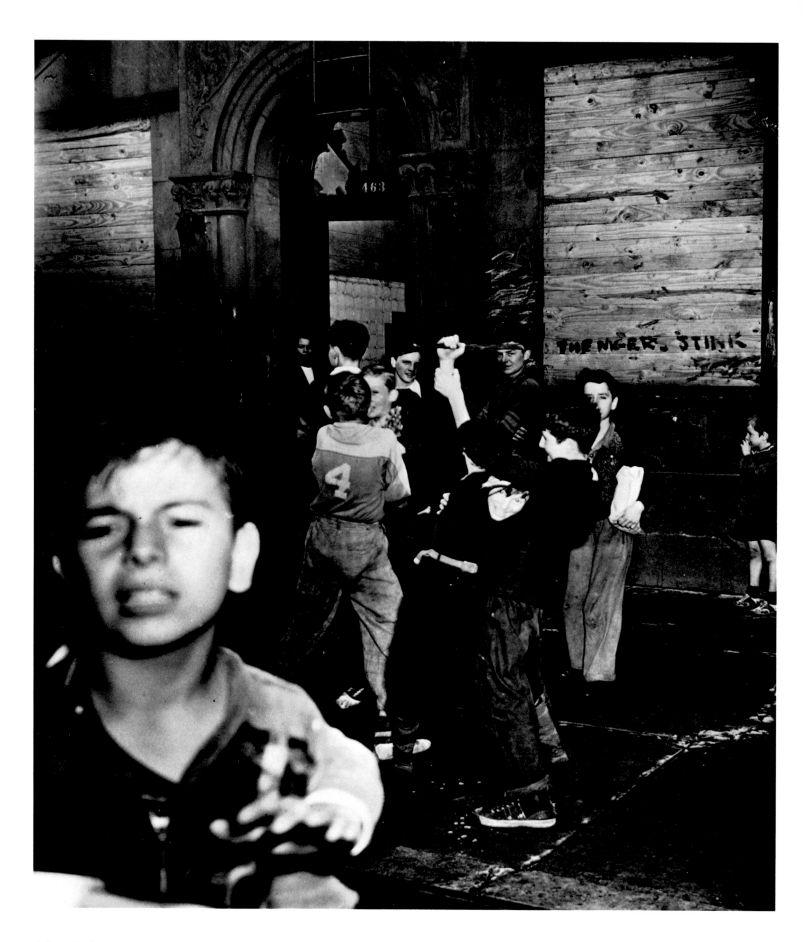

Schulschluß
School is over
Fin de l'école

198

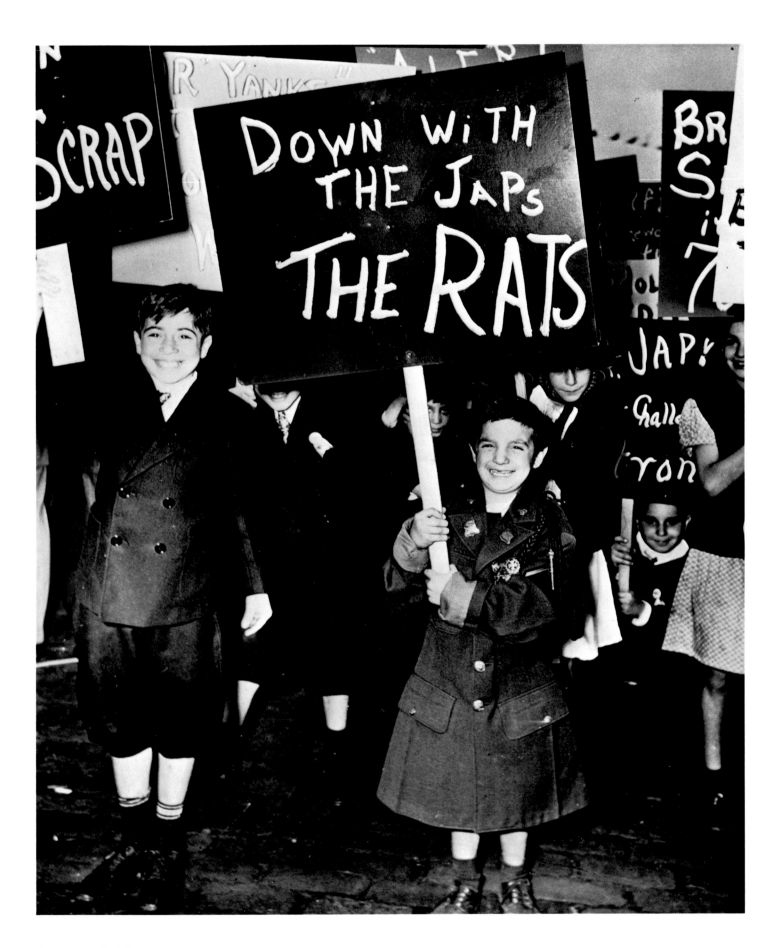

Antijapanischer Demonstrationszug
Anti-Japanese demonstration
Manifestation antijaponaise

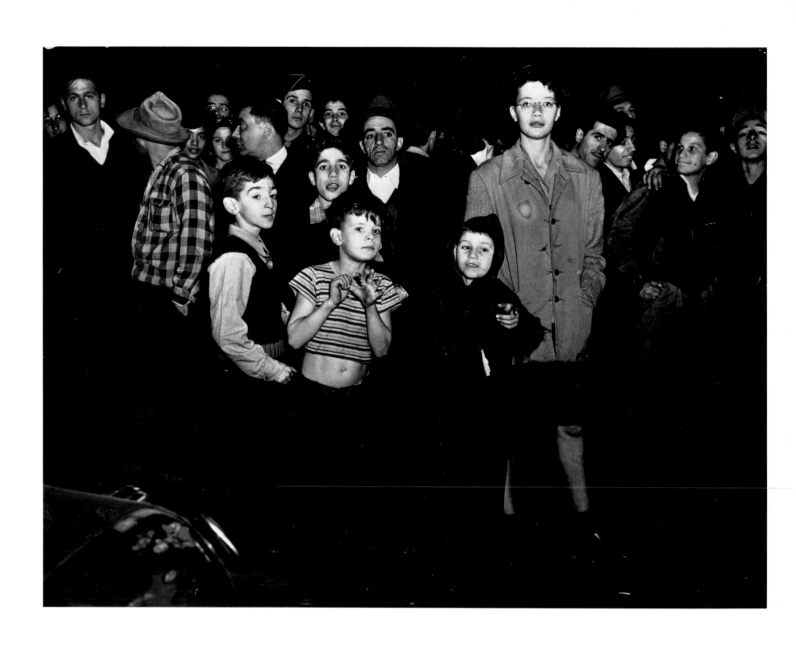

Zuschauer bei einem Feuer
Watching a fire
Spectateurs, pendant un incendie

200

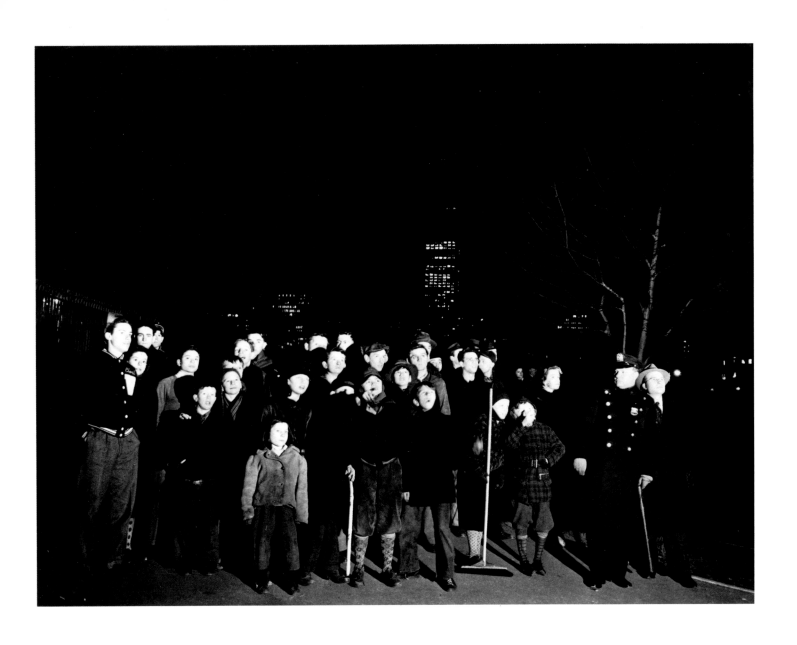

Zuschauer bei einem Feuer
Watching a fire
Spectateurs, pendant un incendie

Zirkus
Circus
Cirque

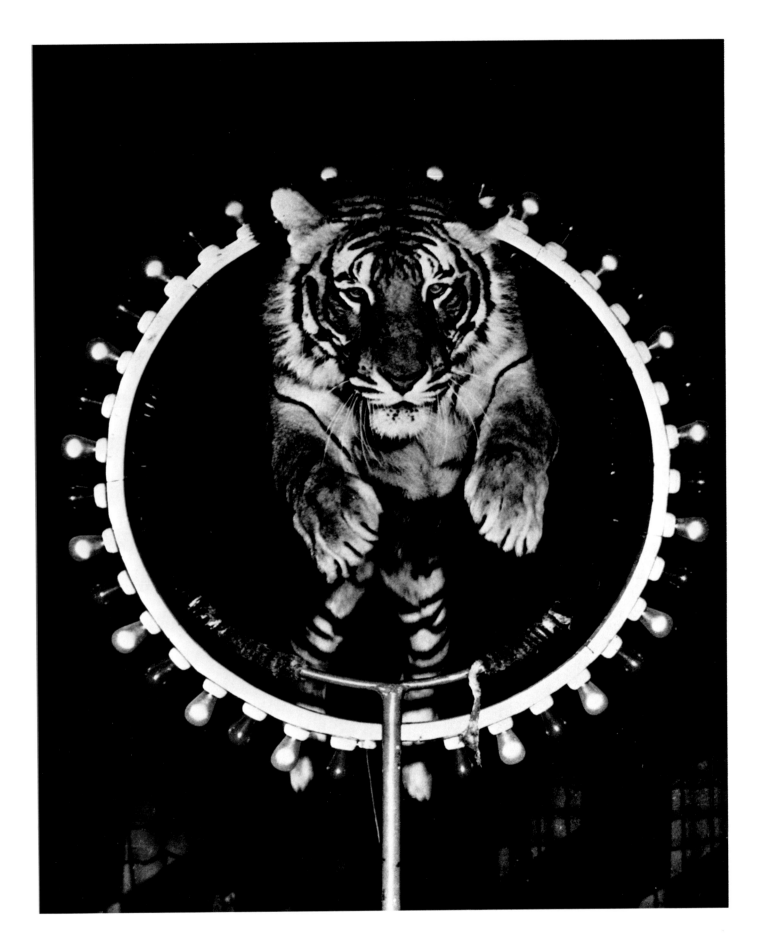

Der Tigersprung
The tiger jumps through the hoop
Le saut du tigre

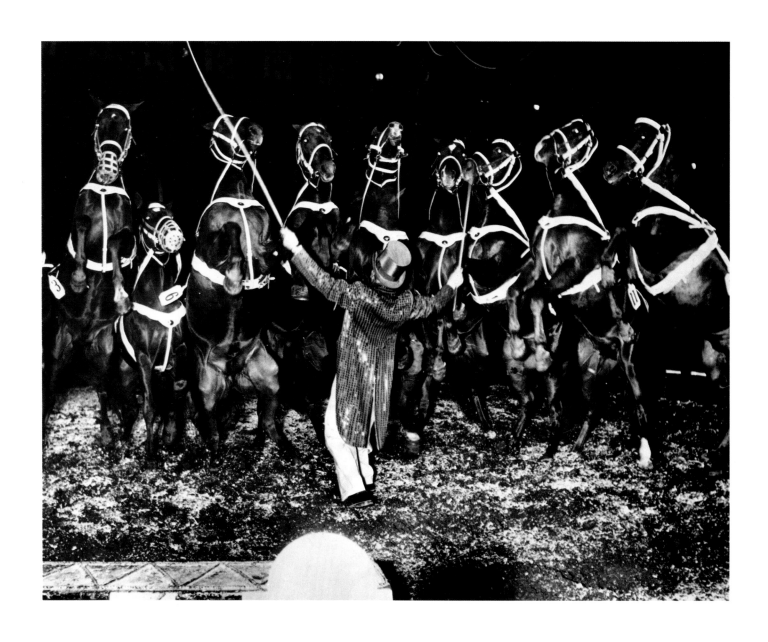

Pferdedressur
Horse trainer
Dressage de chevaux

Pferdedressur
Horse trainer
Dressage de chevaux

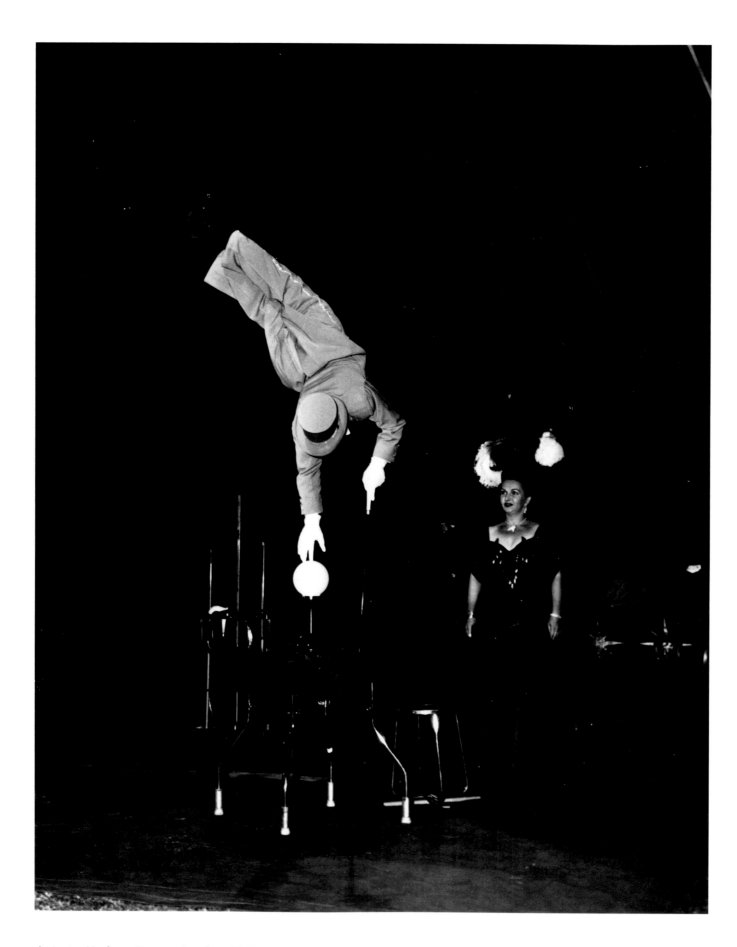

Artist im Madison Square Garden, 1958
Circus performer in Madison Square Garden
Artiste à Madison Square Garden

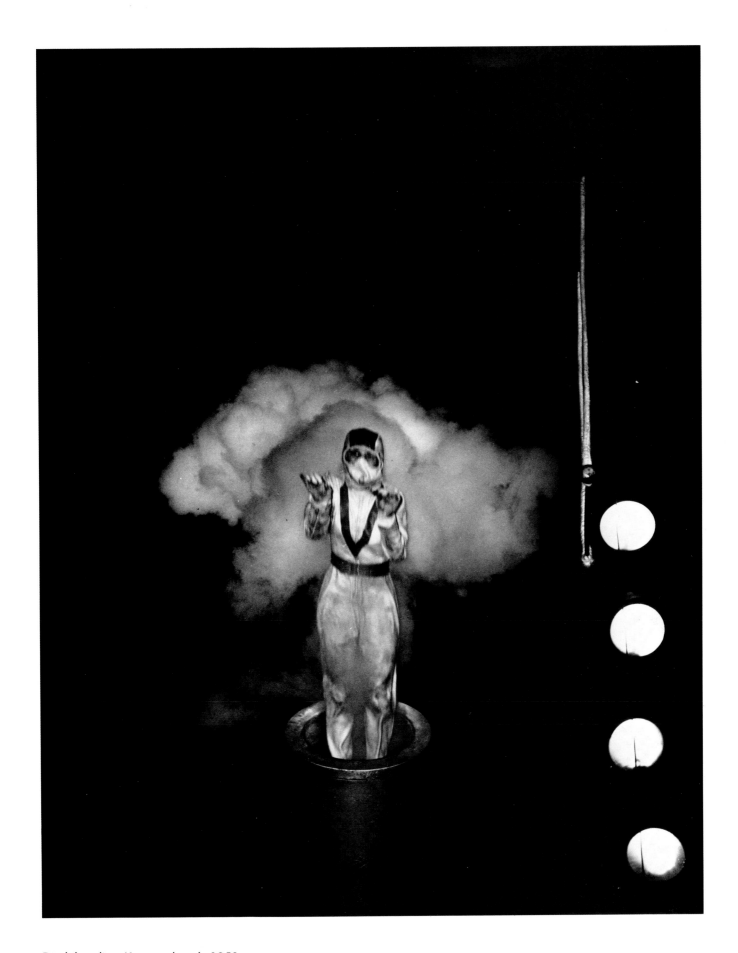

Die lebendige Kanonenkugel, 1952
The human cannon-ball
Le boulet de canon vivant

206

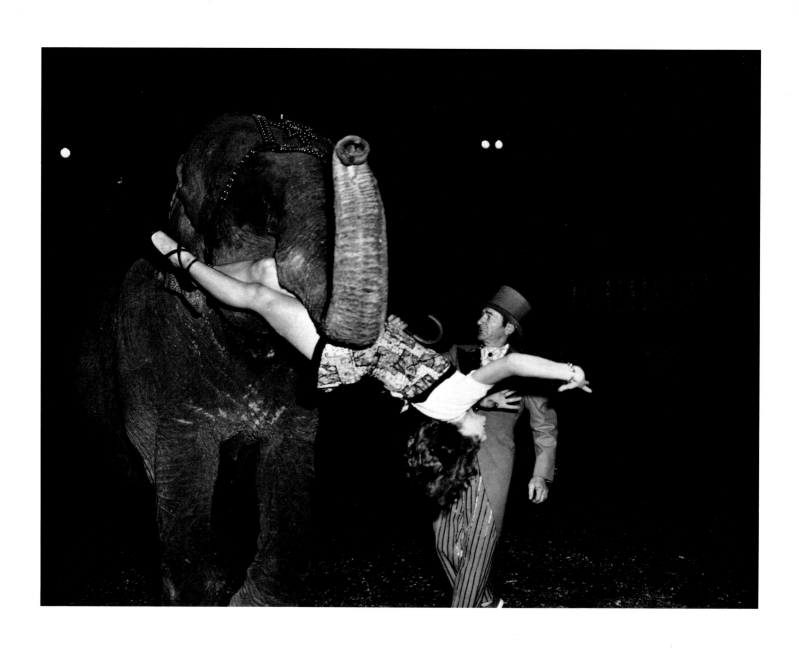

Elefanten-Nummer im Madison Square Garden, 1956
The elephant-number in Madison Square Garden
Numéro d'éléphants à Madison Square Garden

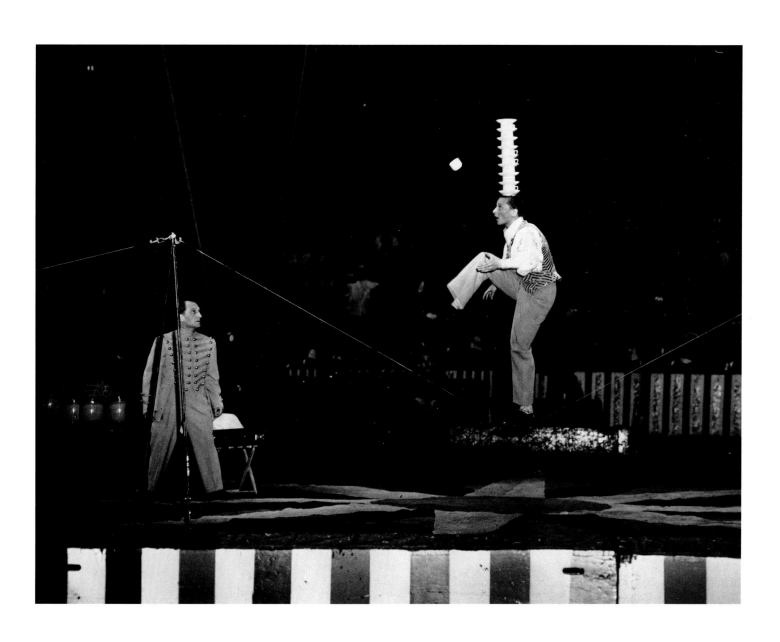

Balance-Akt auf dem Seil
Tightrope walking
Equilibre sur la corde

208

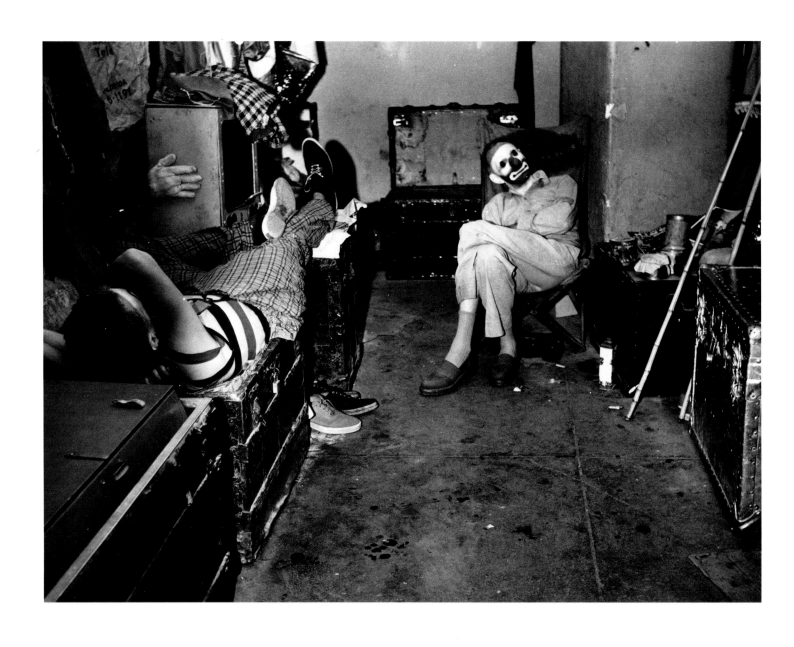

Clowns in der Garderobe, 1944
Clowns in the dressing-room
Clowns au vestiaire

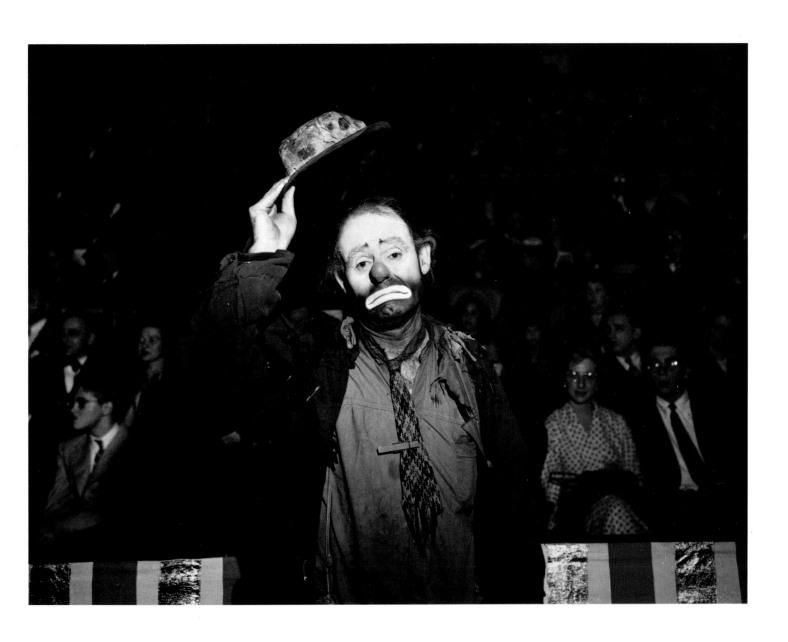

Der Clown Emmett Kelly, 1955
Emmet Kelly
Le clown Emmet Kelly

210

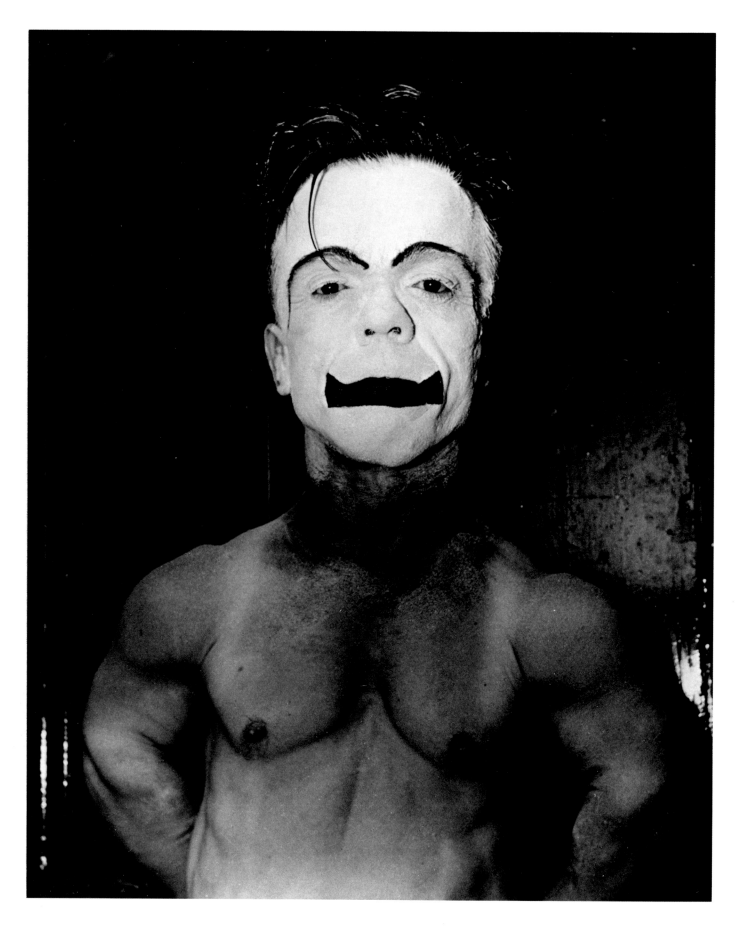

Clown-Portrait
Portrait of a clown
Portrait de clown

211

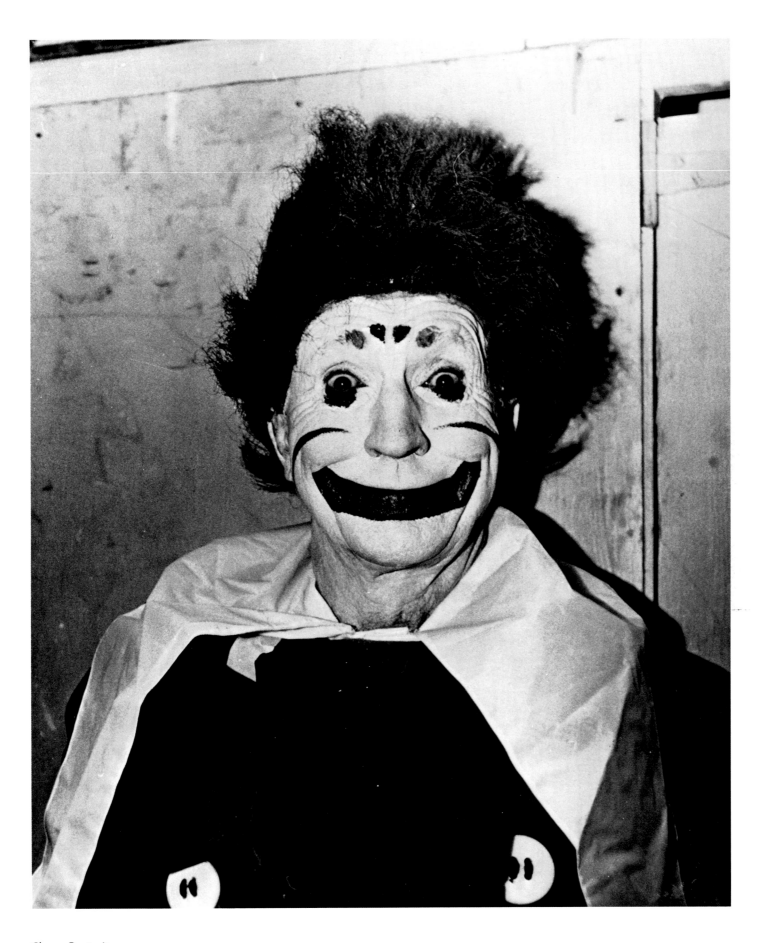

Clown-Portrait
Portrait of a clown
Portrait de clown

212

Society
Society
Société

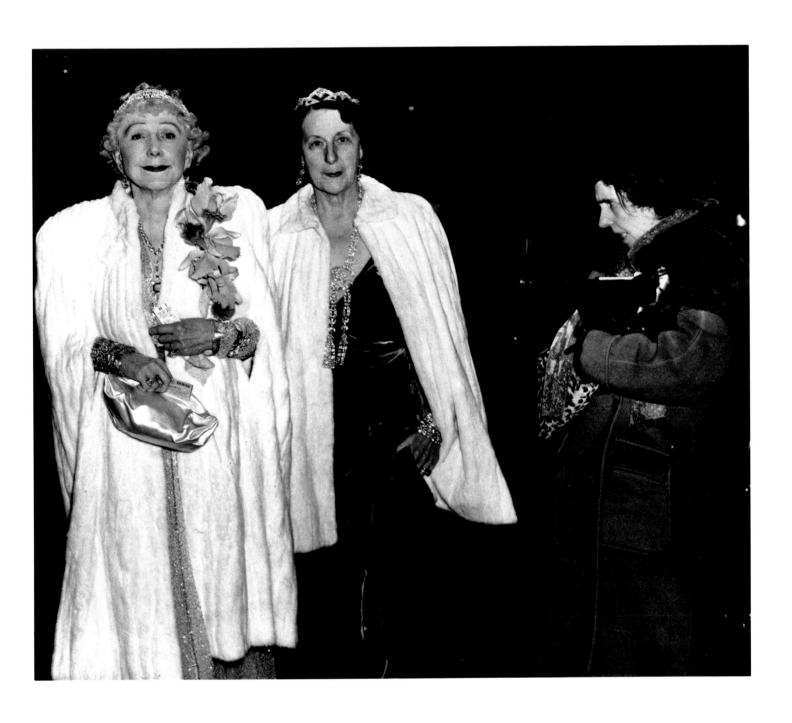

Kritik an zwei Besucherinnen der Metropolitan Opera, 1943
The Critic
Critique de deux abonnées du Metropolitan Opera

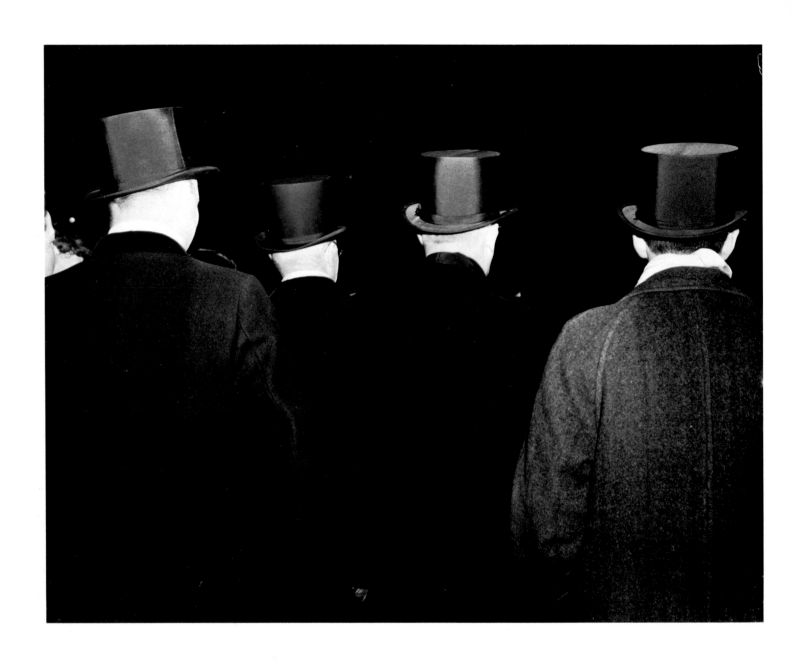

Zylinderhüte vor der Met, 1943
Top-hats at the Met
Chapeaux hauts de forme davant le Met

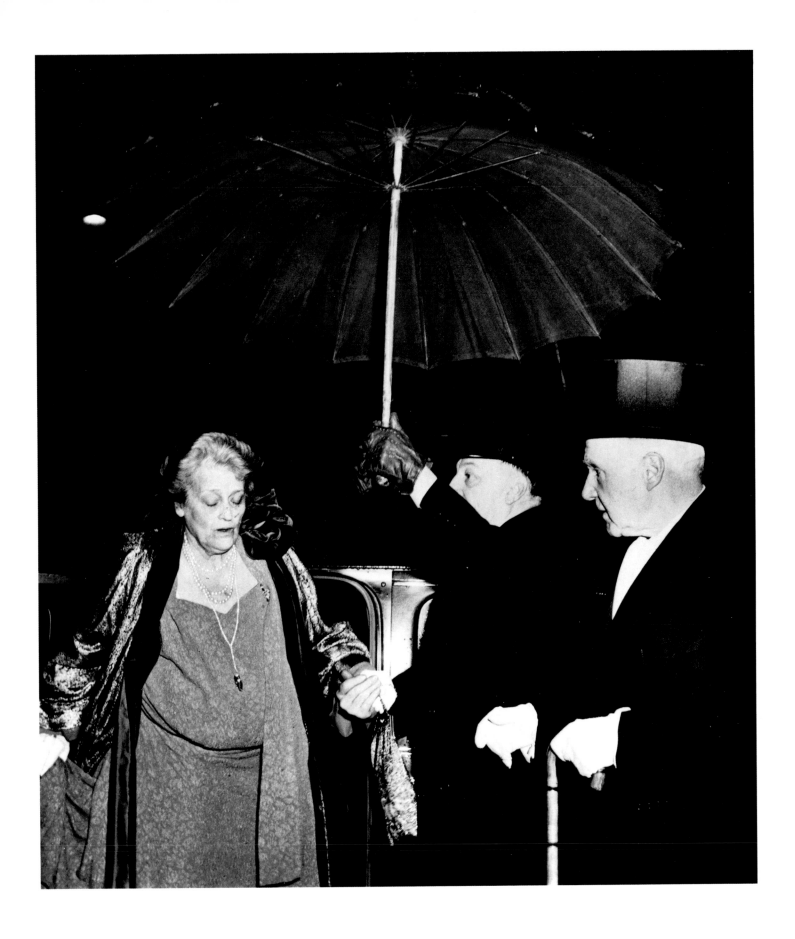

Ankunft vor der Met, 1943
Arriving at the Met
Arrivée devant le Met

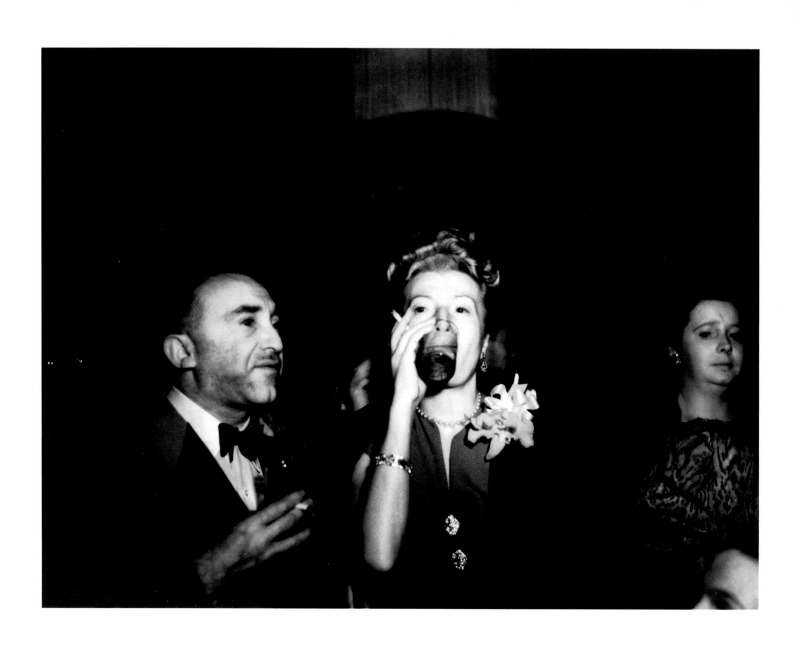

Premierenpublikum in der Met, 1943
First-nighters at the Met
Public de première au Met

216

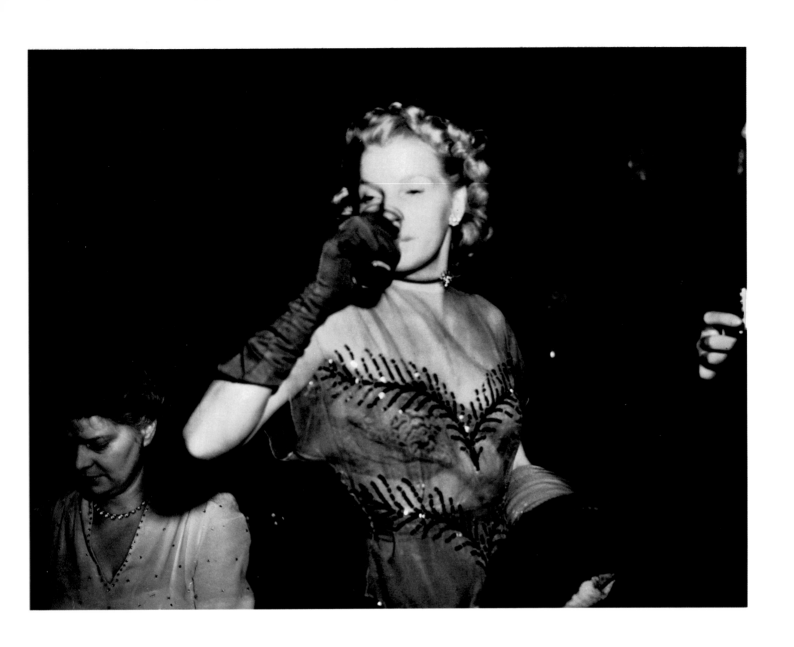

Premierenpublikum in der Met, 1943
First-nighters at the Met
Public de première au Met

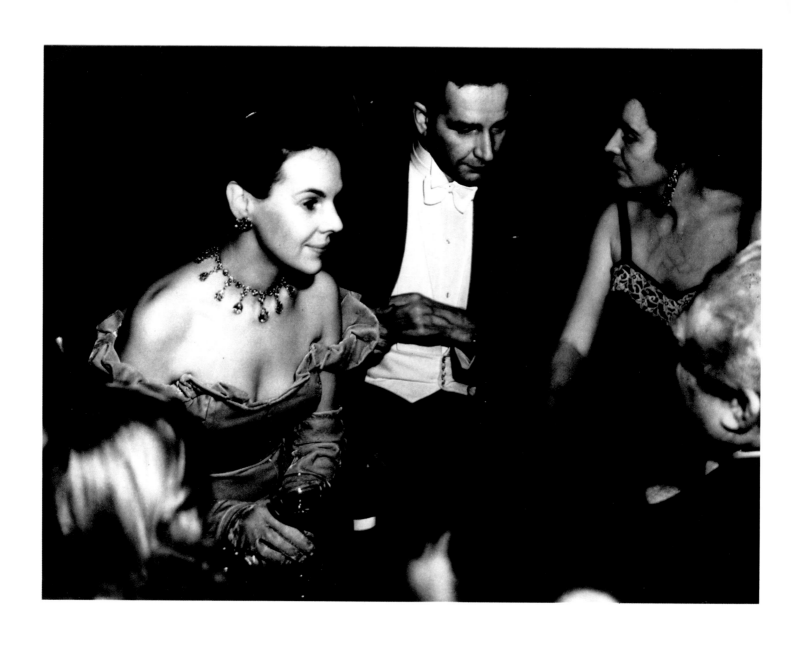

Im Foyer der Met, 1943
The Met foyer
Au foyer du Met

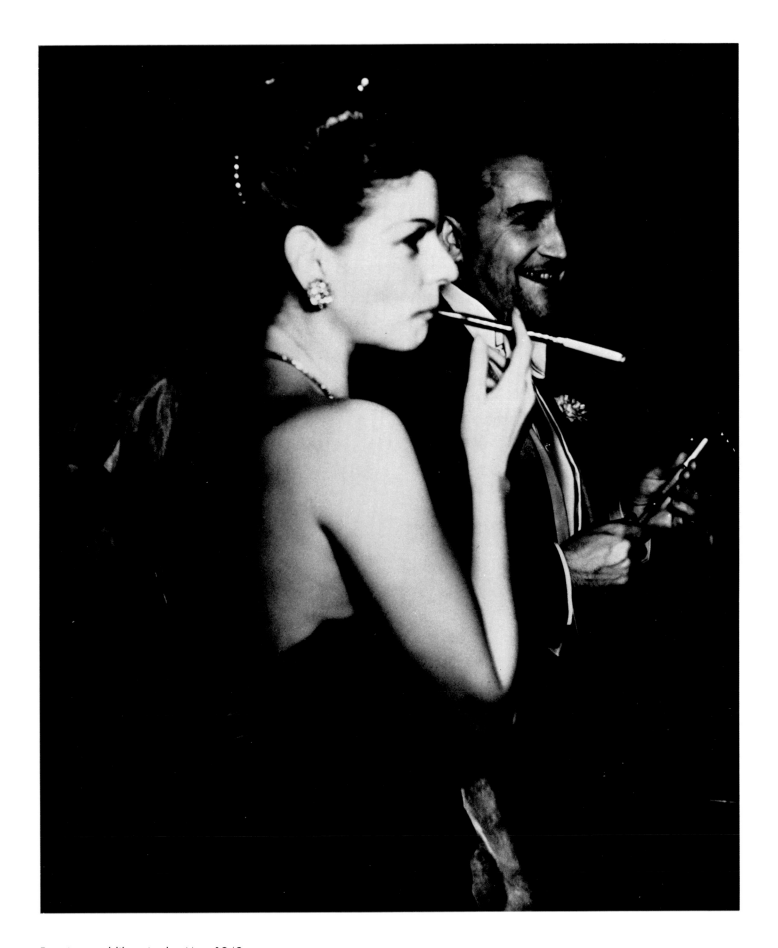

Premierenpublikum in der Met, 1943
First-nighters at the Met
Public de première au Met

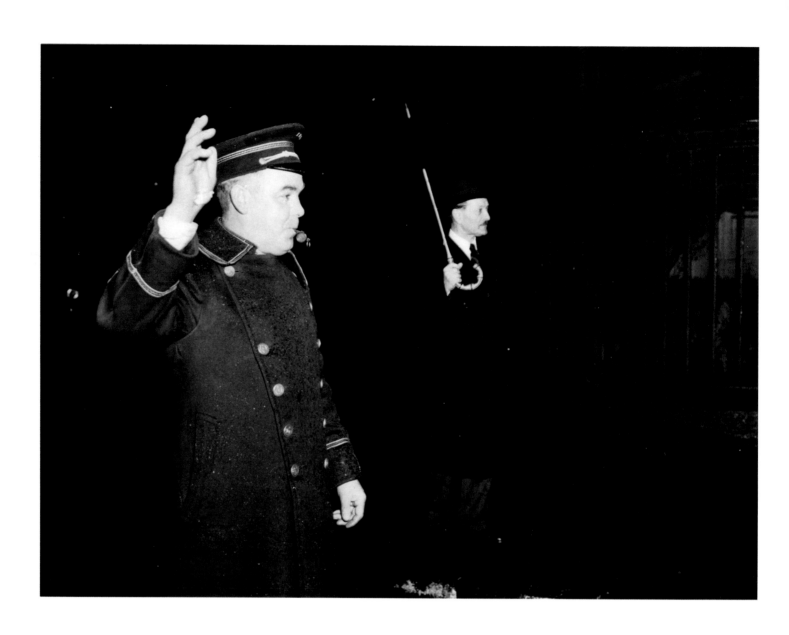

Portier, 1945
Doorman
Portier

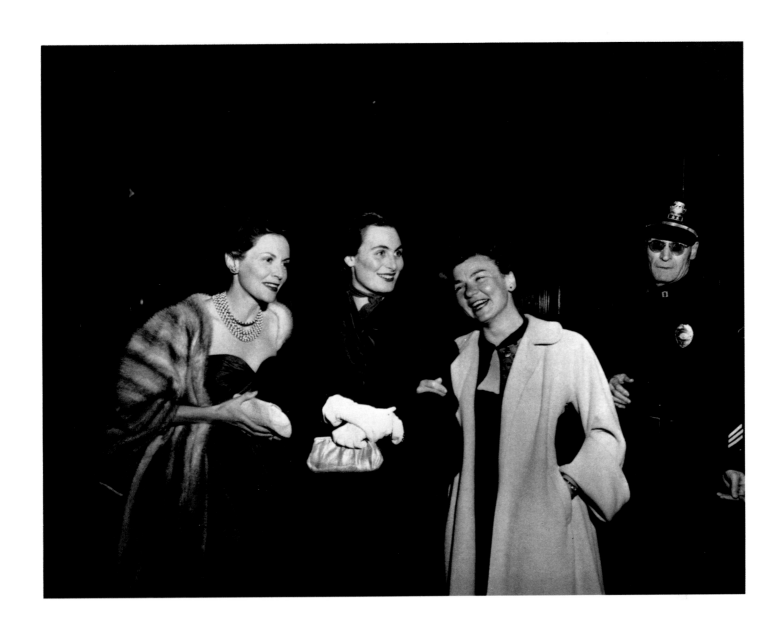

Auf dem Weg in die Oper
Going to the opera
Sur le chemin de l'opéra

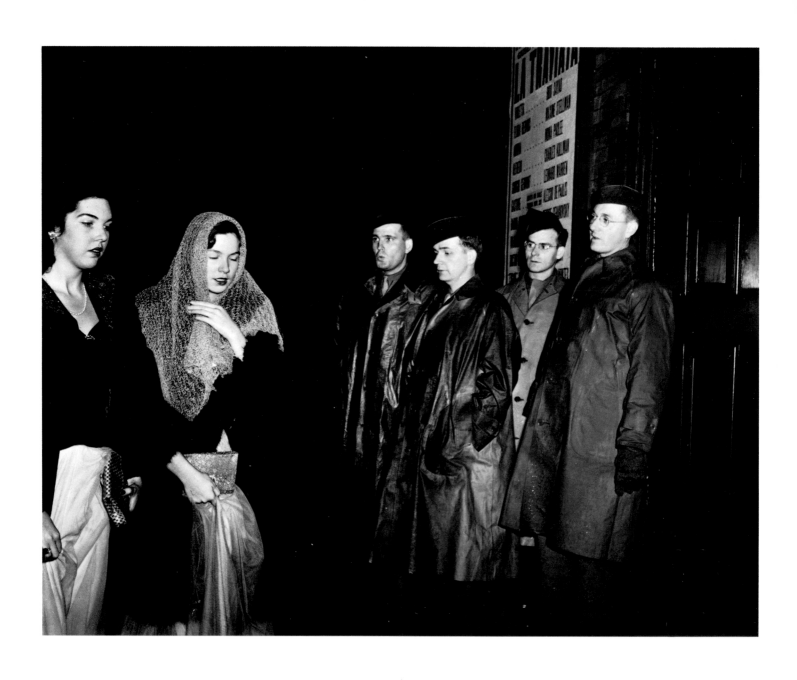

Auf dem Weg in die Oper
Going to the opera
Sur le chemin de l'opéra

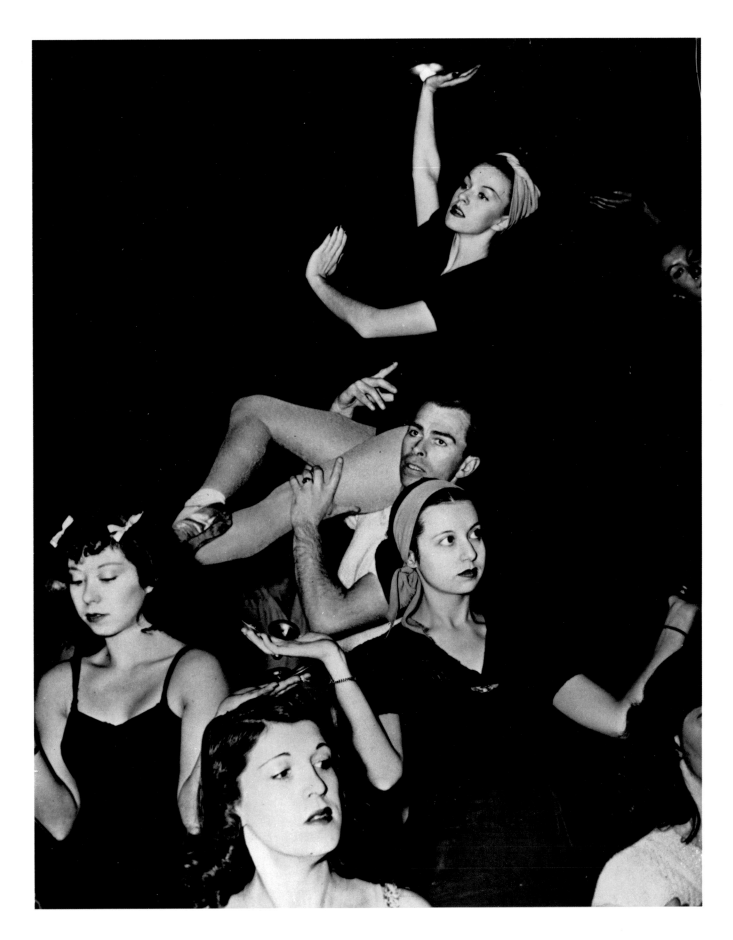

Ballettprobe
Ballet-rehearsal
Répétition de ballet

223

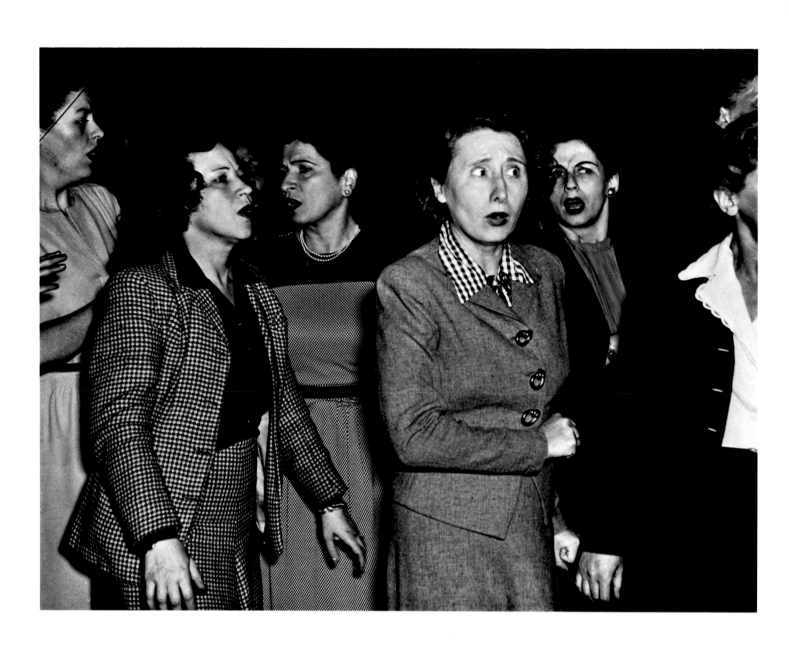

Sängerinnen der Metropolitan Opera bei der Probe, 1943
Singers rehearsing at the Met
Chanteuses du Metropolitan Opera à la répétition

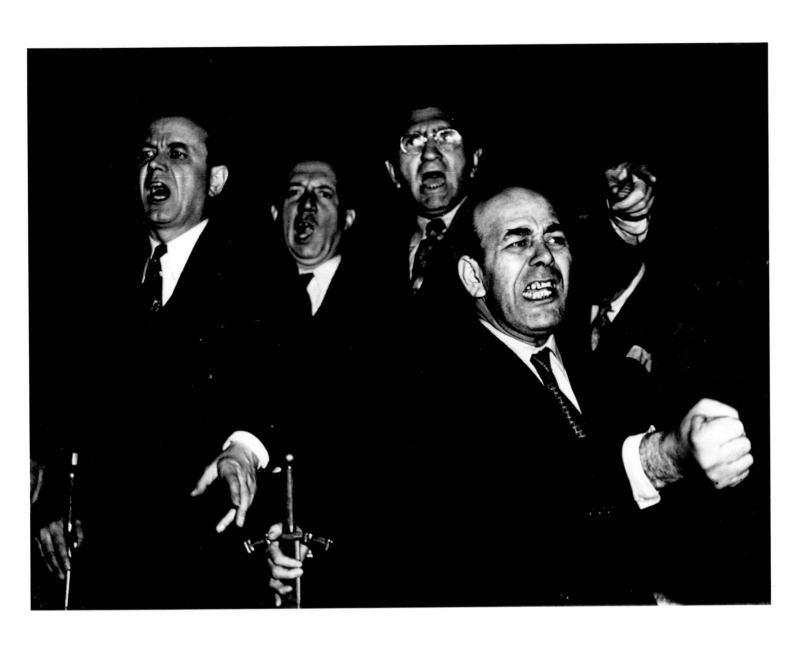

Sänger der Metropolitan Opera bei der Probe, 1943
Singers rehearsing at the Met
Chanteurs du Metropolitan Opera a la répétition

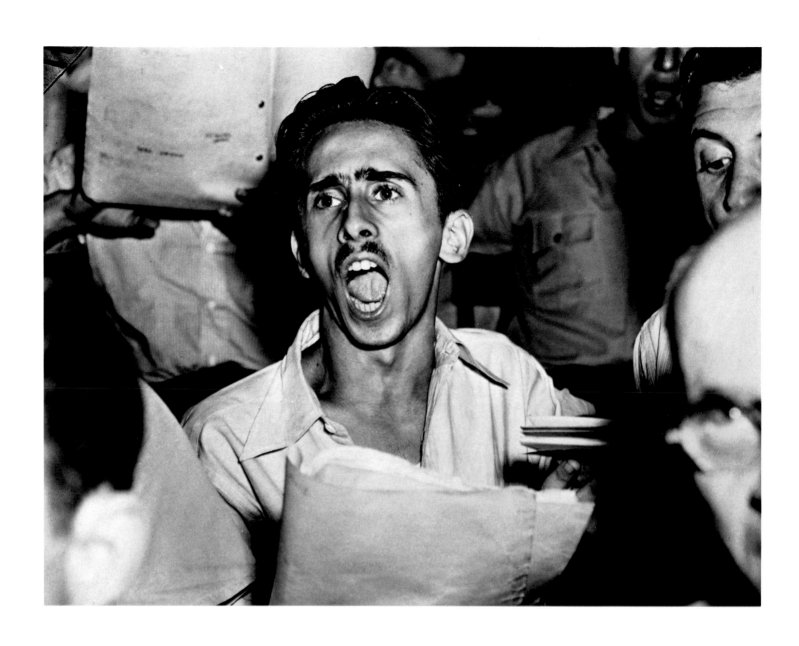

Chorprobe I
Choir rehearsal I
Répétition du choeur I

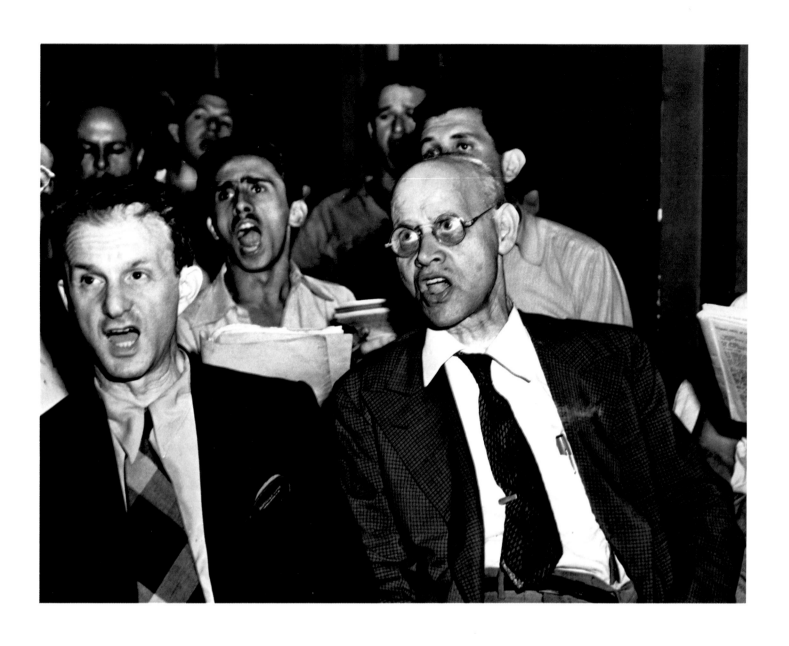

Chorprobe II
Choir rehearsal II
Répétition du choeur II

Musiker
Musicians
Musiciens

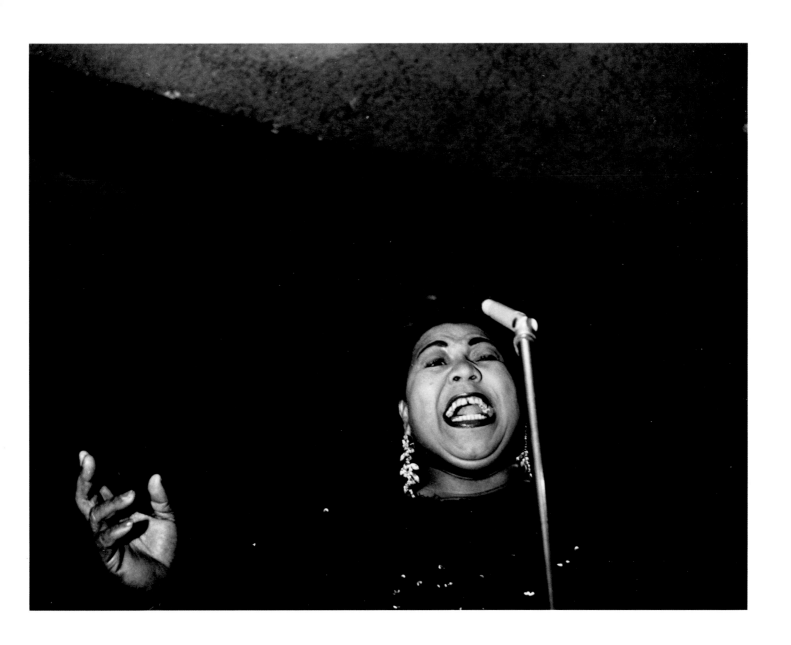

Sängerin
Singer
Chanteuse

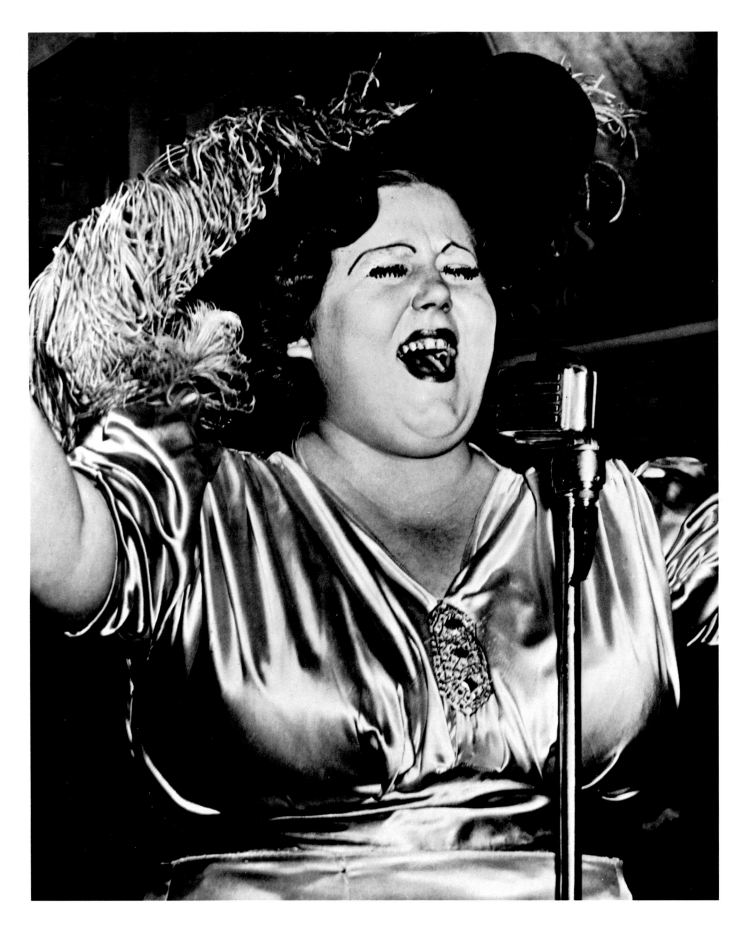

Norma bei Sammy's in der Bowery, ca. 1945
Norma at Sammy's in the Bowery
Norma chez Sammy à la Bowery

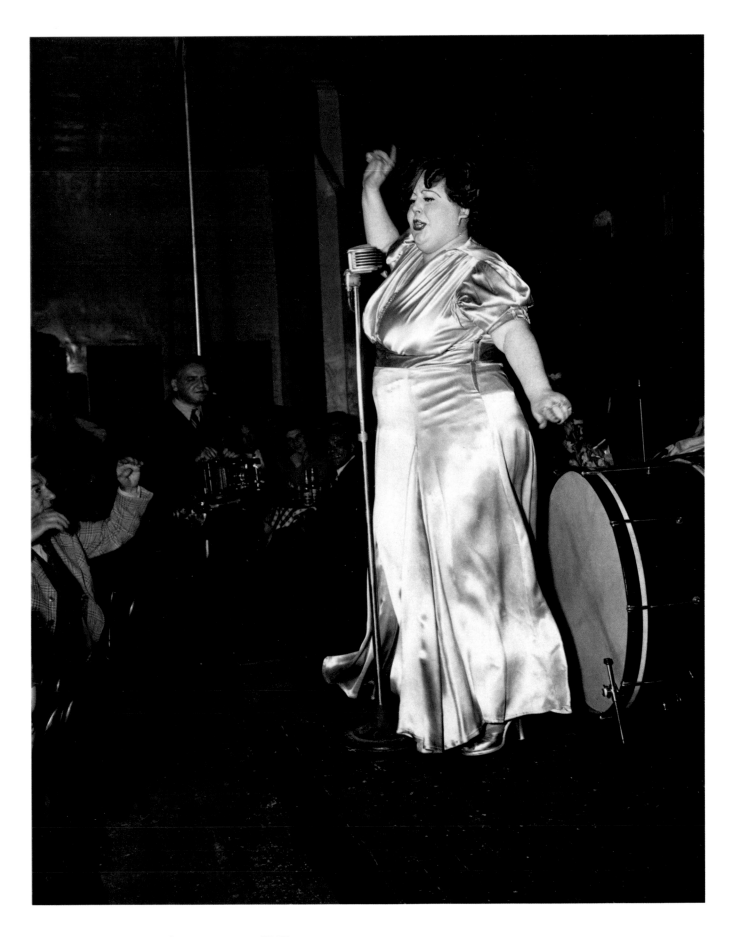

Norma bei Sammy's in der Bowery, ca. 1945
Norma at Sammy's in the Bowery
Norma chez Sammy à la Bowery

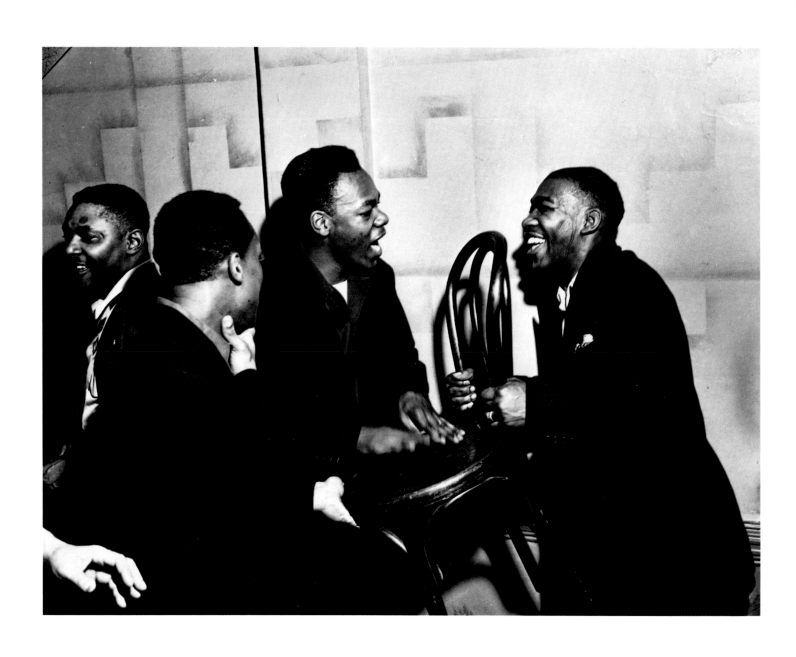

Musikbegeisterte
Music enthusiasts
Enthousiasmés par la musique

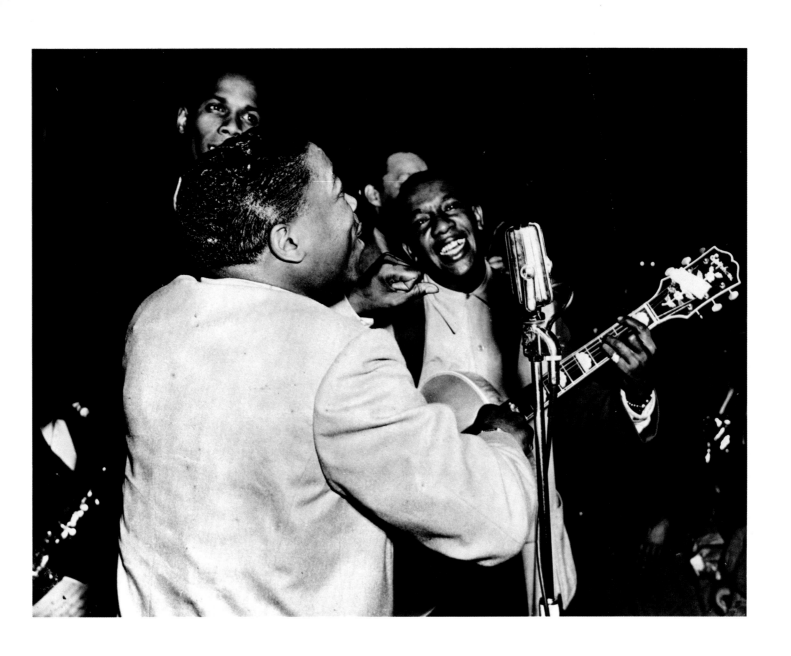

Jazzer in einem Nachtclub
Jazz in a night-club
Joueurs de jazz dans un night club

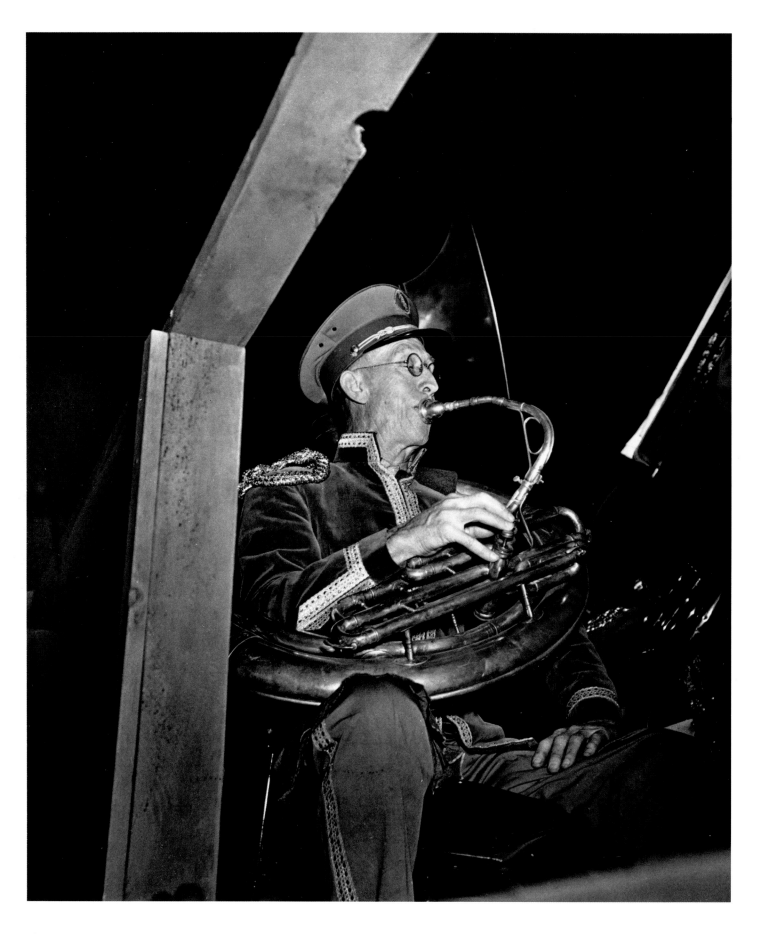

Bläser
Tuba-player
Joueur de tuba

233

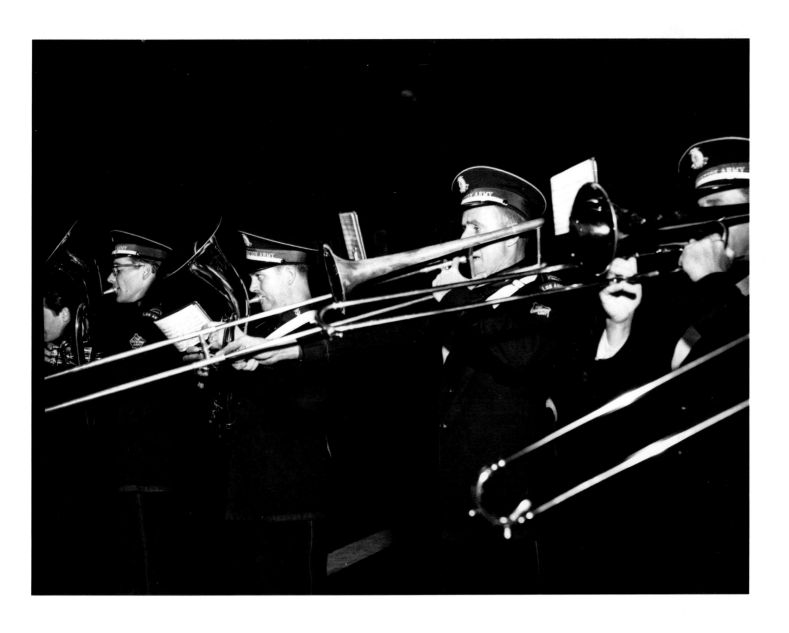

Blaskapelle der Heilsarmee
Salvation army brassband
Cuivres de l'armée du salut

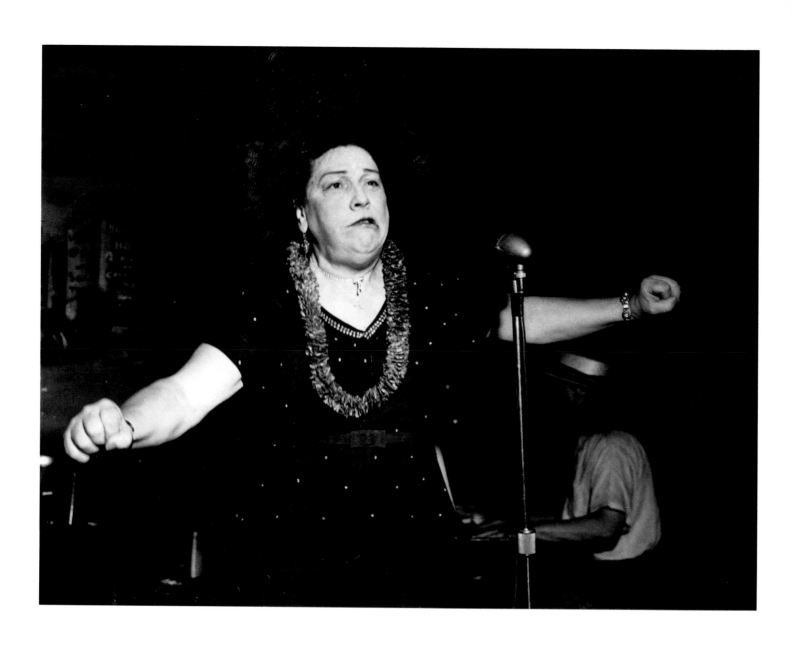

Bei Sammy's in der Bowery
At Sammy's in the Bowery
Chez Sammy à la Bowery

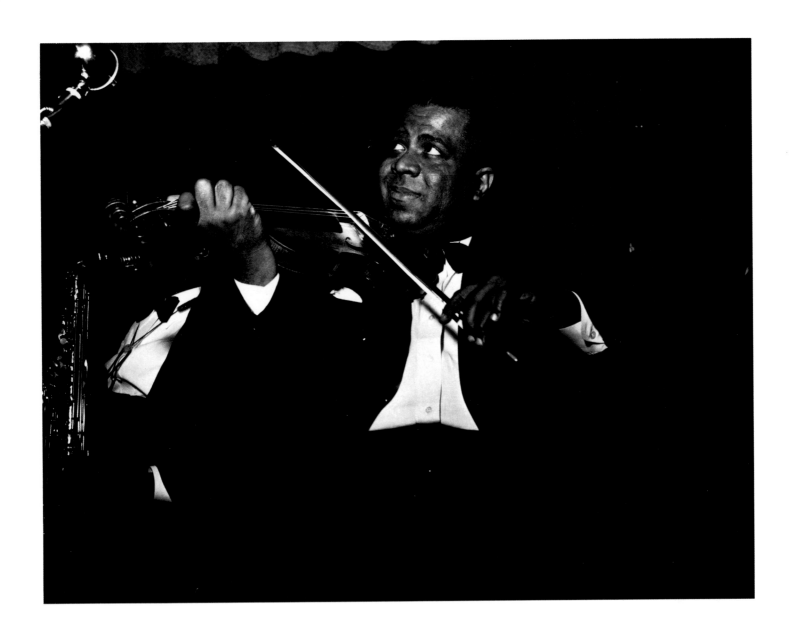

Geiger
Fiddler
Violoniste

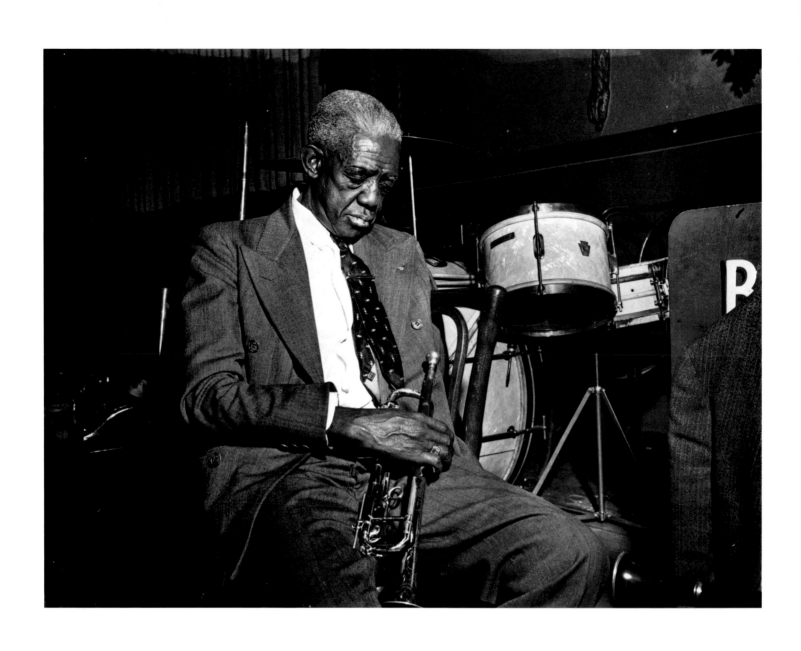

Bunk Johnson im Stuyvesant Casino, 1946
Bunk Johnson in Stuyvesant Casino
Bunk Johnson au Stuyvesant Casino

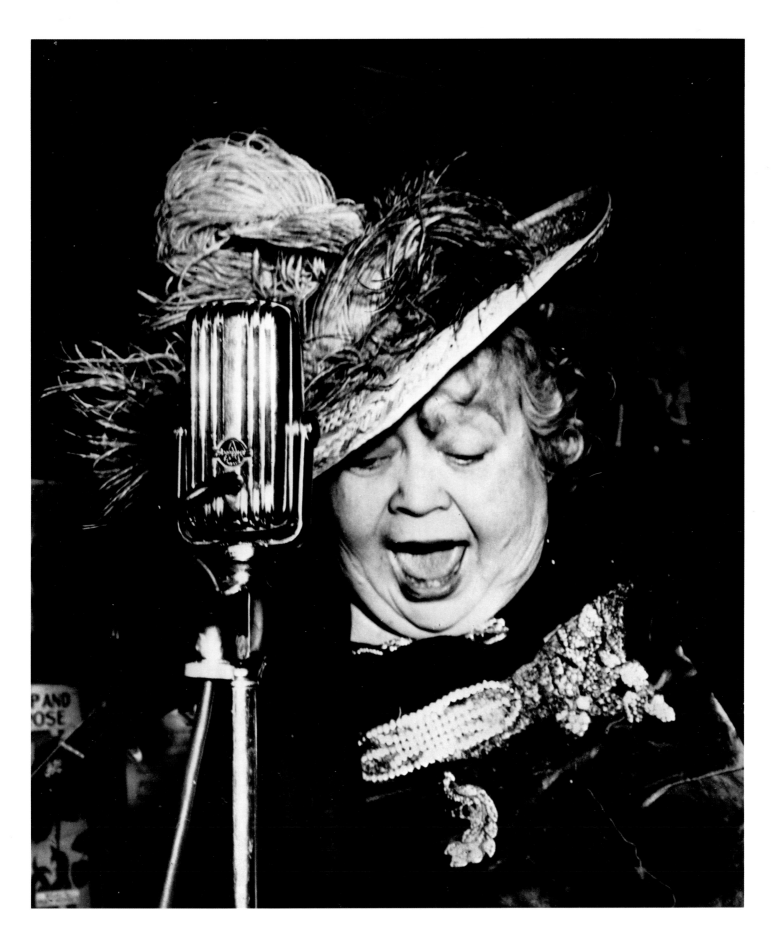

Sängerin bei Sammy's in der Bowery, ca. 1944
Singer at Sammy's in the Bowery
Chanteuse chez Sammy à la Bowery

Bars
Bars
Bars

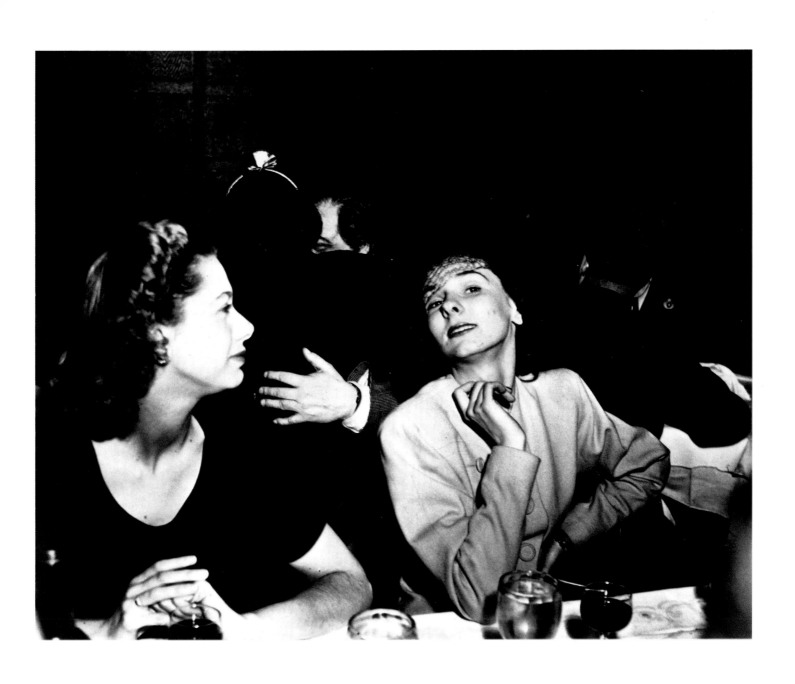

Frauen im Restaurant, ca. 1943
Women in a restaurant
Femmes au restaurant

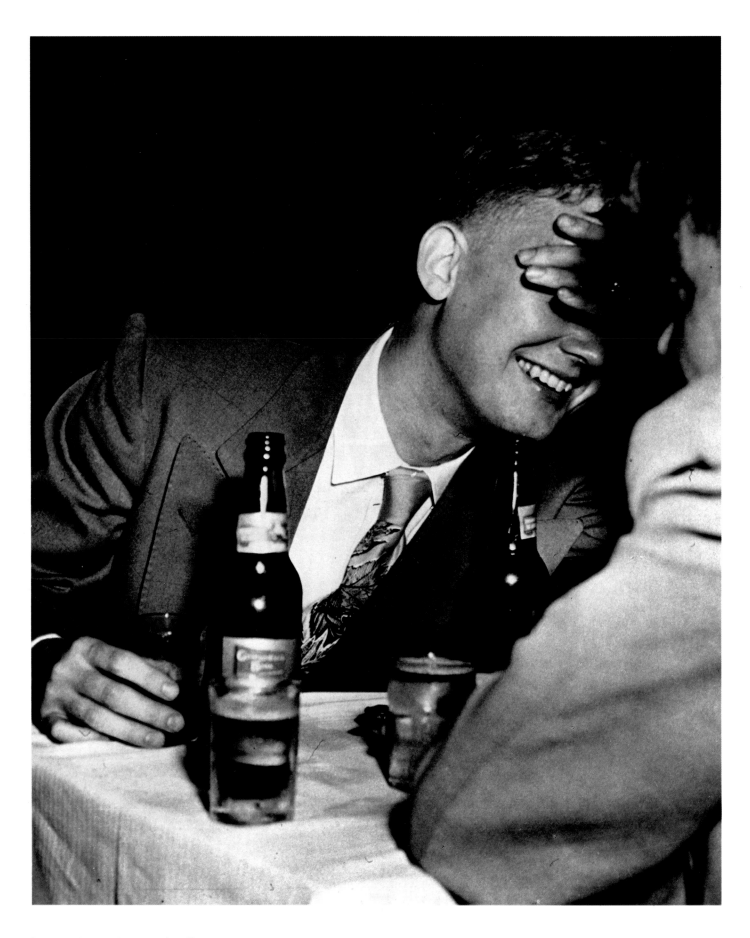

In einer Bar in Greenwich Village
A Greenwich Village bar
Dans un bar à Greenwich Village

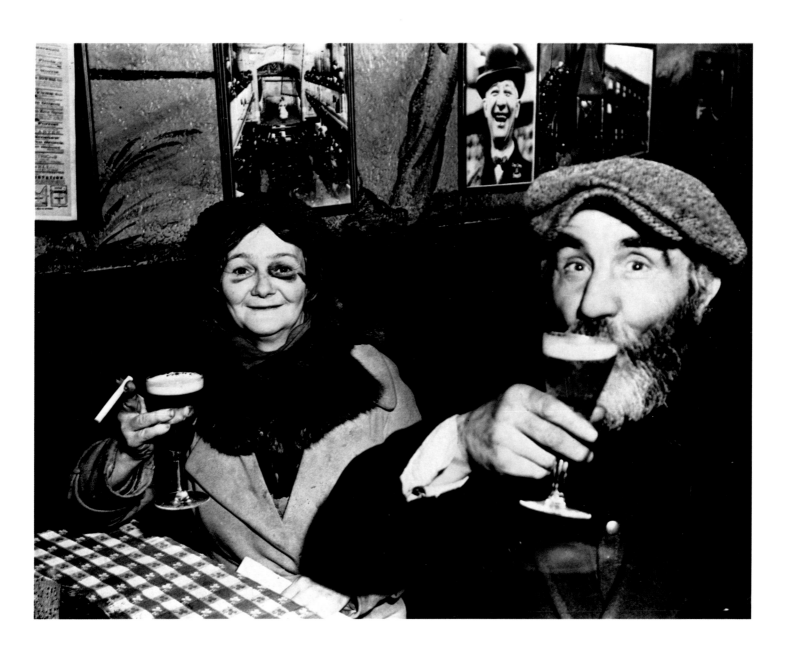

Paar in einer Bowery-Bar
Couple in a Bowery bar
Couple au bar de la Bowery

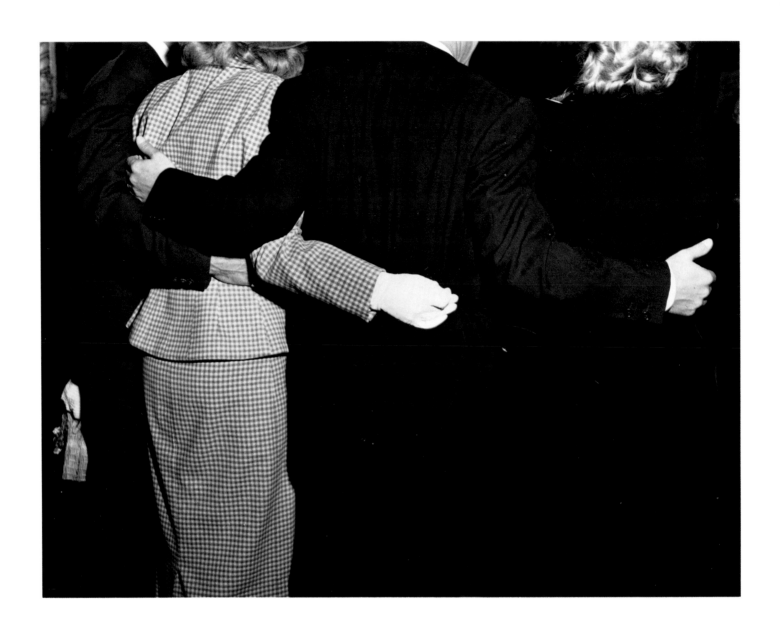

An der Bar
At the bar
Au bar

An der Bar
At the bar
Au bar

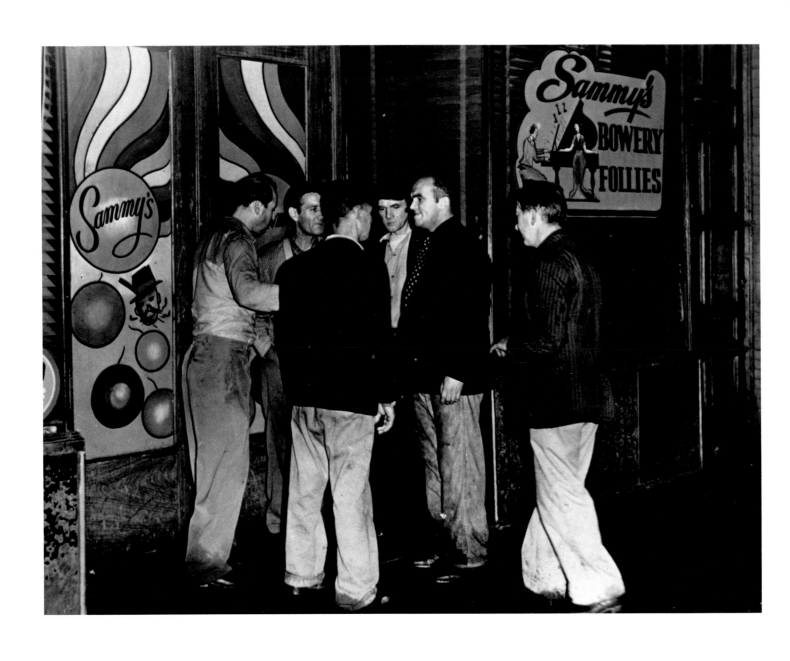

Vor Sammy's in der Bowery
In front of Sammy's in the Bowery
Devant chez Sammy, à la Bowery

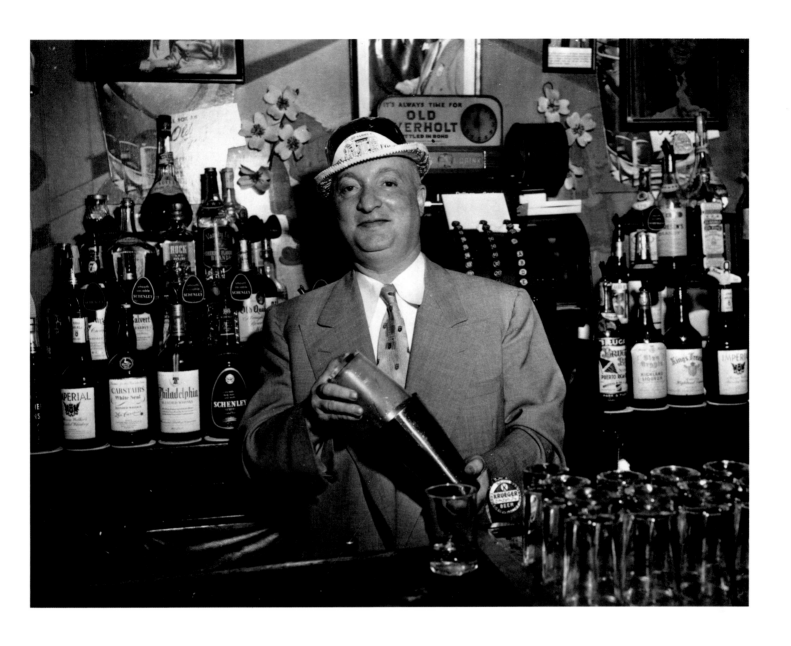

Sammy
Sammy
Sammy

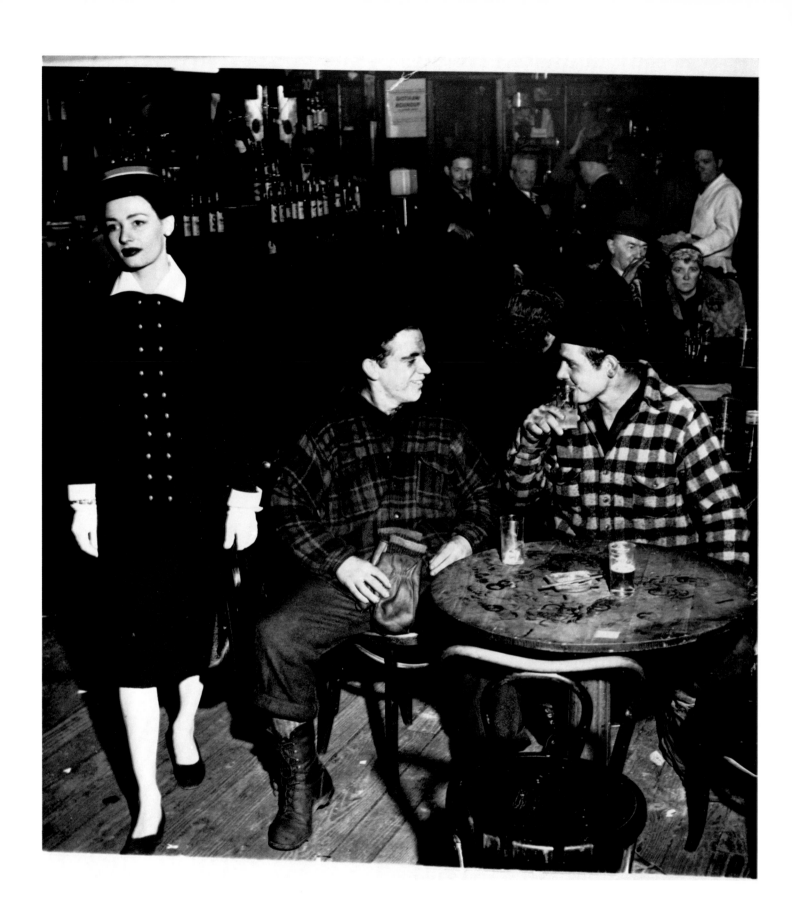

In einer Bar in der City I
In a city bar I
Dans un bar à la city I

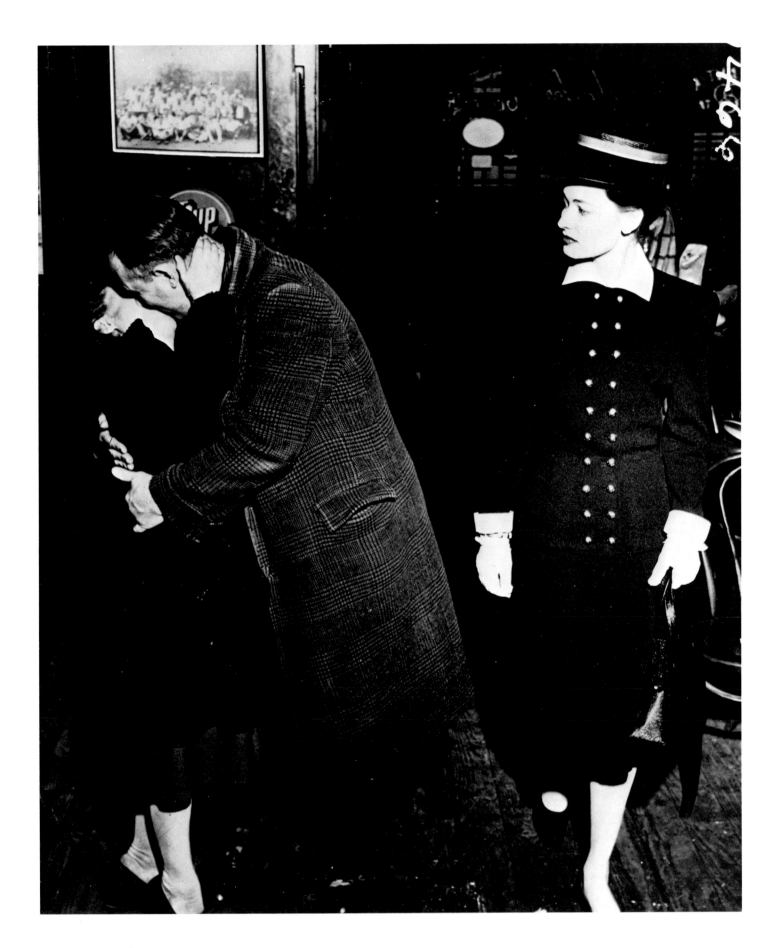

In einer Bar in der City II, ca. 1942
In a city bar II
Dans un bar à la city II

247

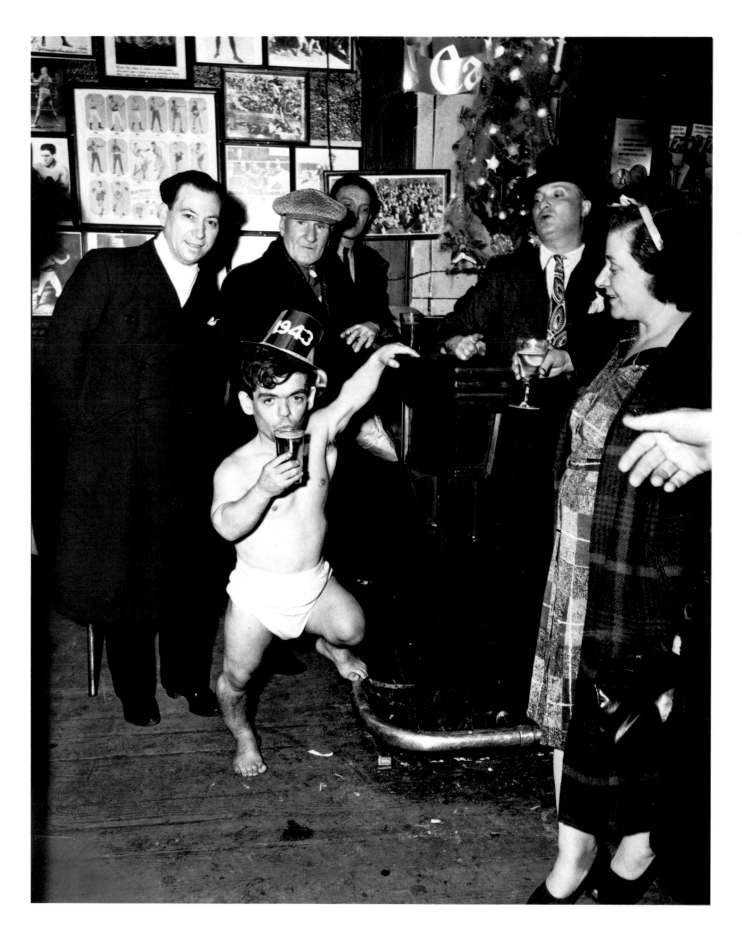

Neujahr bei Sammy's in der Bowery, 1943
New Year's eve at Sammy's in the Bowery
Nouvel an chez Sammy à la Bowery

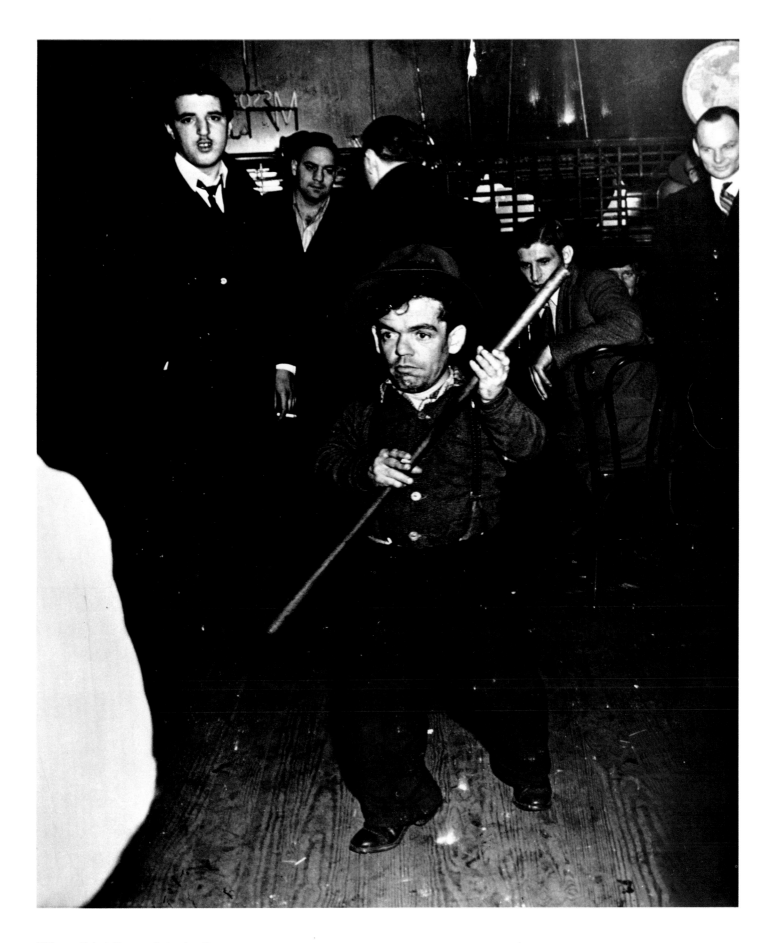

"Shorty" bei Sammy's in der Bowery
"Shorty" at Sammy's in the Bowery
"Shorty" chez Sammy à la Bowery

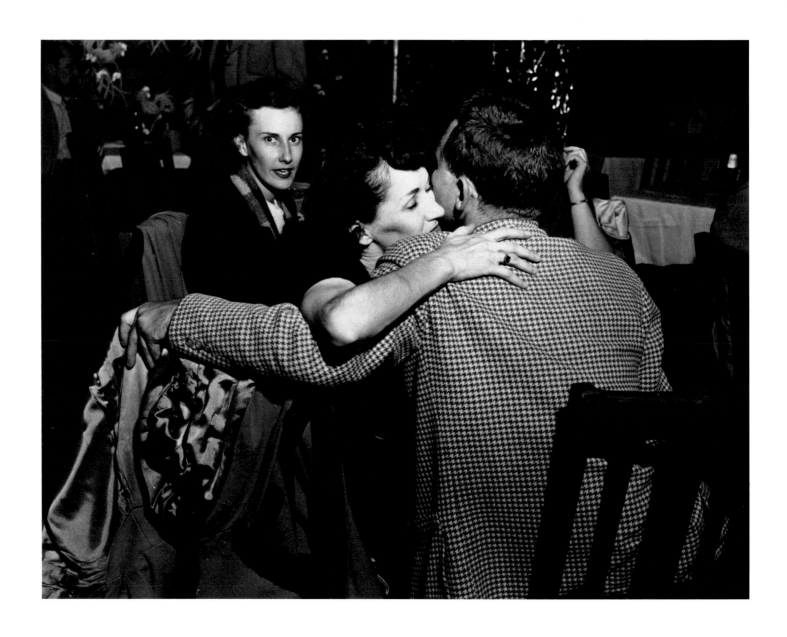

In einem Club
At a Club
Dans un club

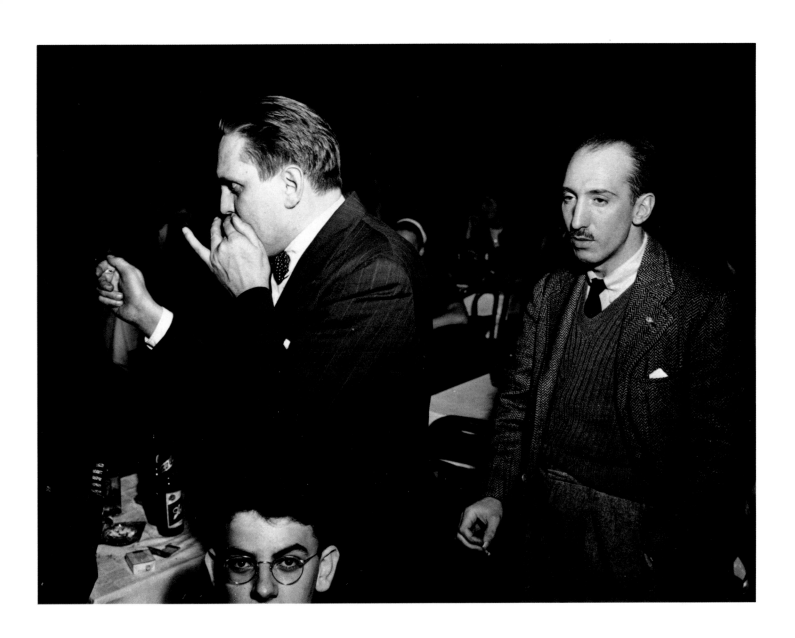

In einem Club
At a Club
Dans un club

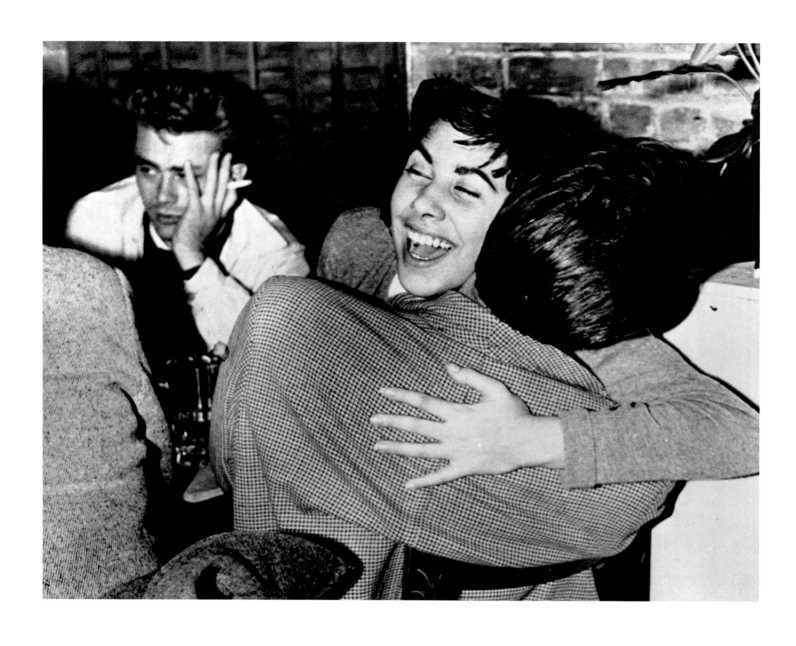

James Dean in einer Village-Bar
James Dean at a Village-bar
James Dean dans un bar du Village

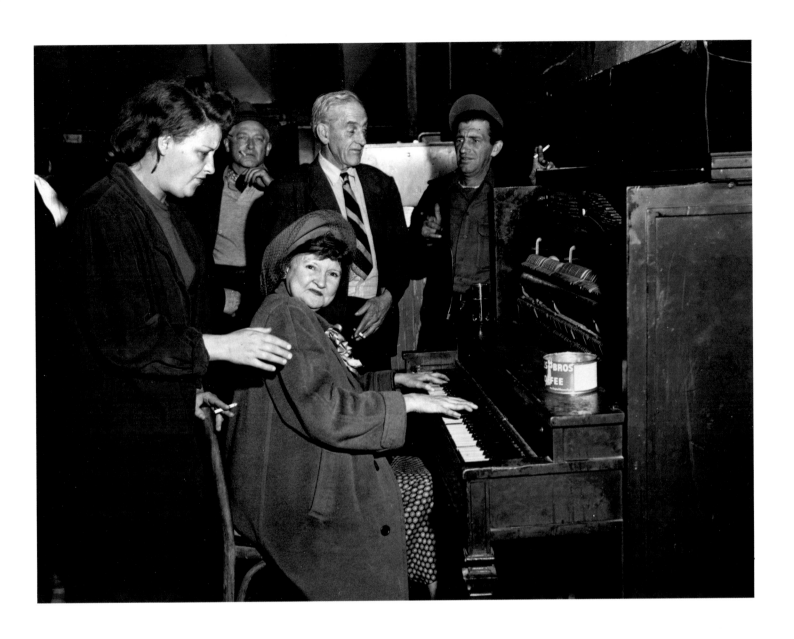

Eine kleine Nachtmusik
A little night music
Une petite musique de nuit

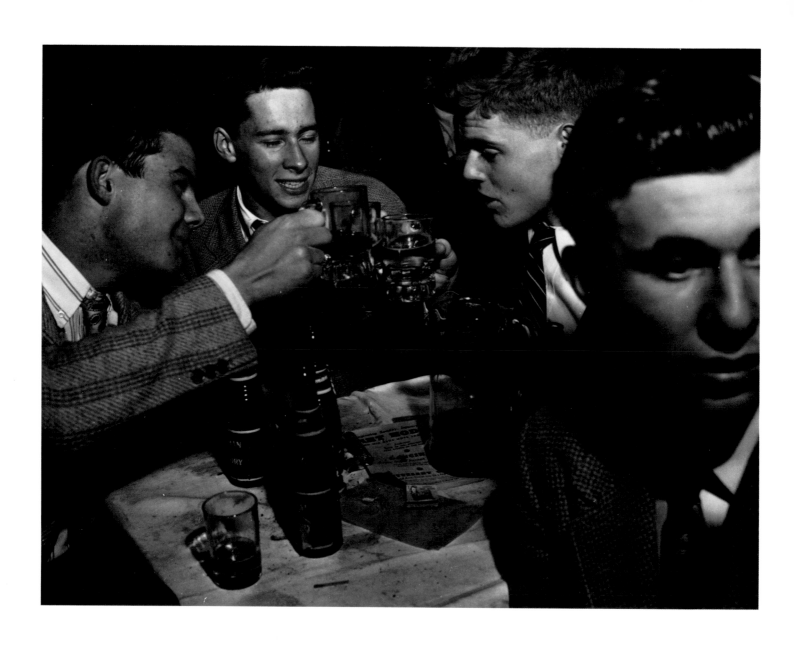

In einer Village-Bar
At a Village-bar
Dans un bar du Village

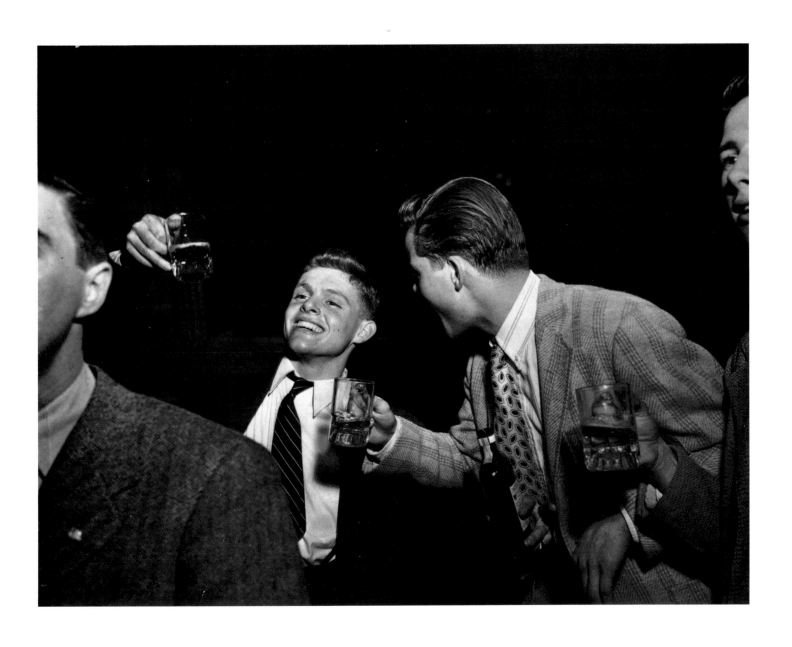

In einer Village-Bar
At a Village-bar
Dans un bar du Village

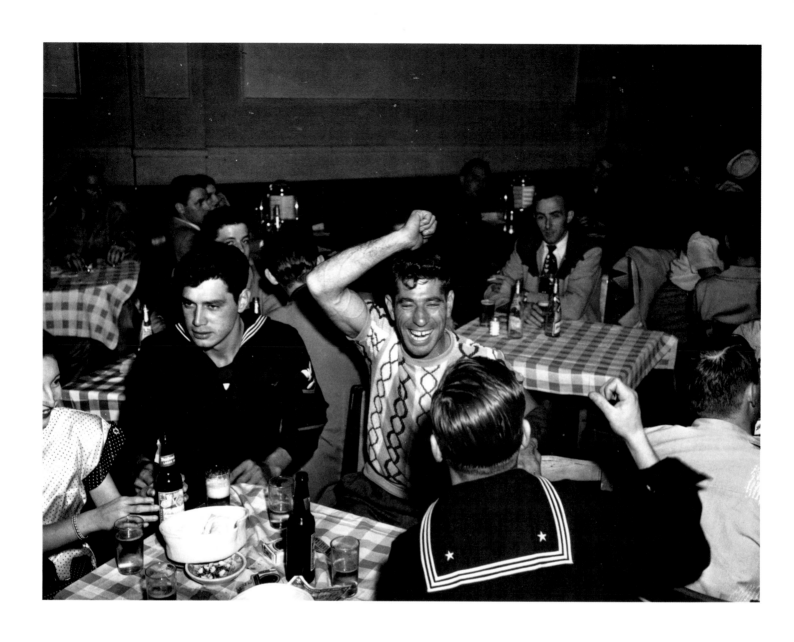

Kneipe
Pub
Troquet

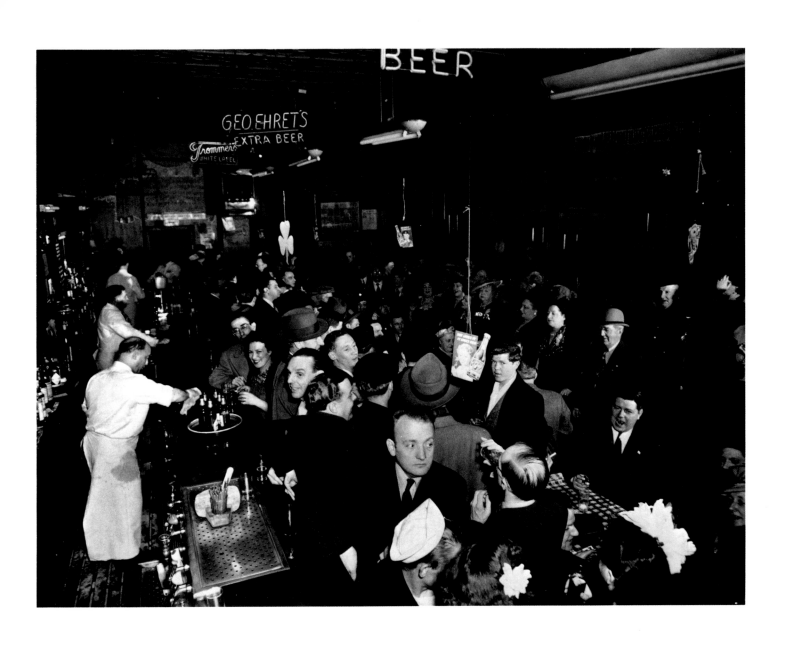

Bei Sammy's in der Bowery
At Sammy's in the Bowery
Chez Sammy à la Bowery

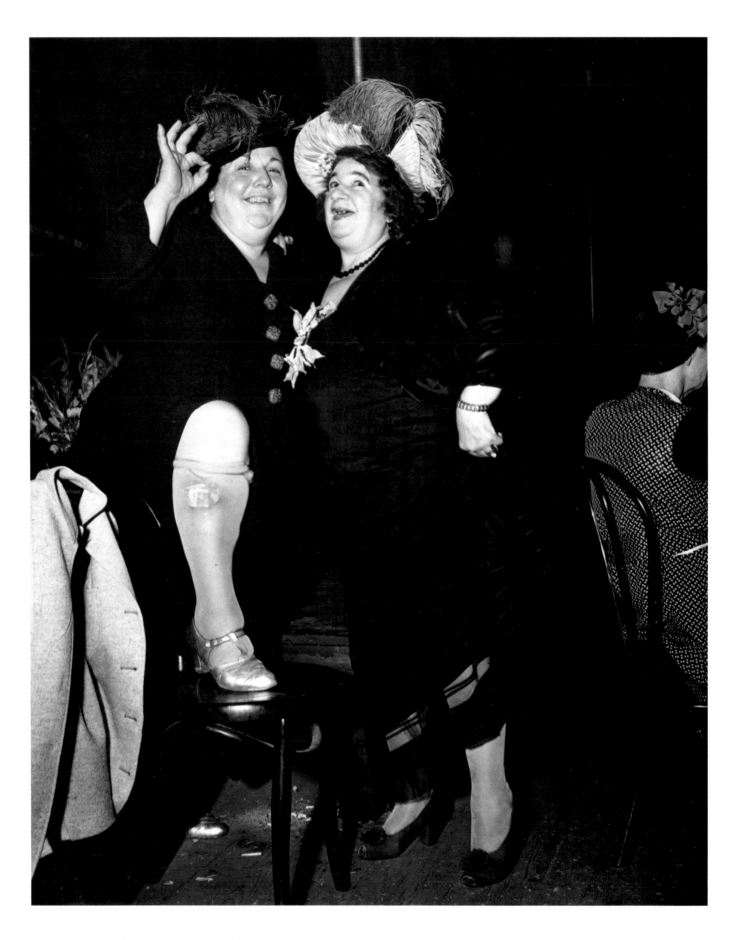

Bei Sammy's in der Bowery, ca. 1944
At Sammy's in the Bowery
Chez Sammy à la Bowery

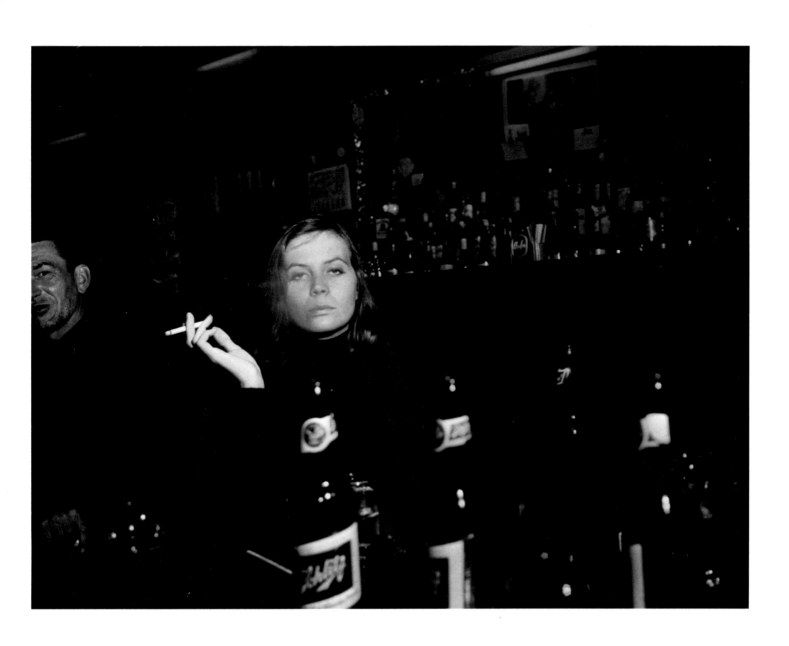

Village-Bar
Village-bar
Bar du Village

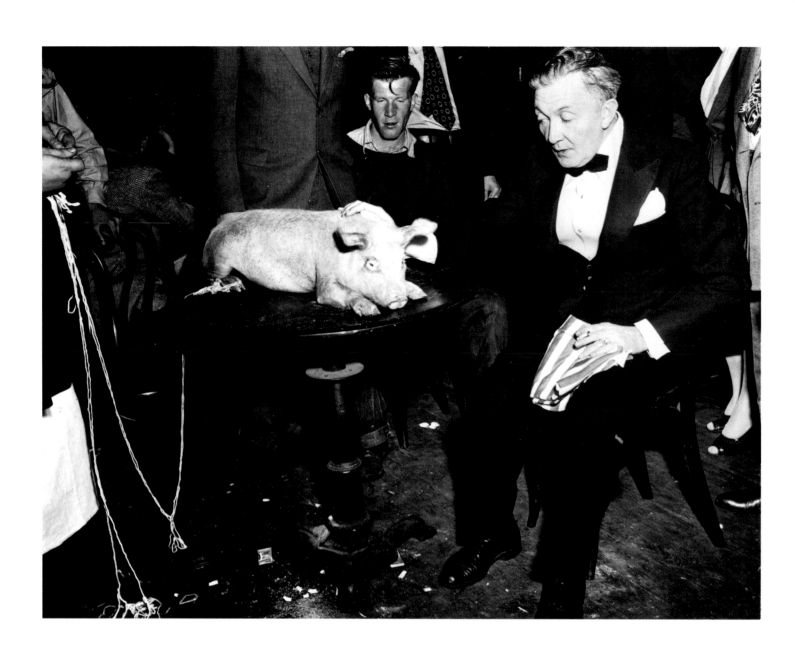

Neujahr bei Sammy's in der Bowery, 1947
New Year's eve at Sammy's in the Bowery
Nouvel an chez Sammy à la Bowery

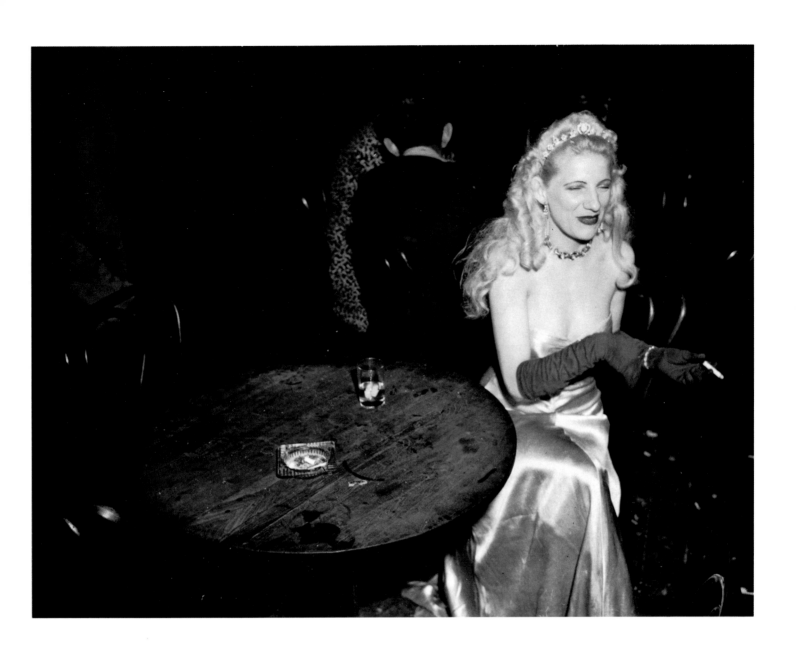

Bei Sammy's in der Bowery, 1943
At Sammy's in the Bowery
Chez Sammy à la Bowery

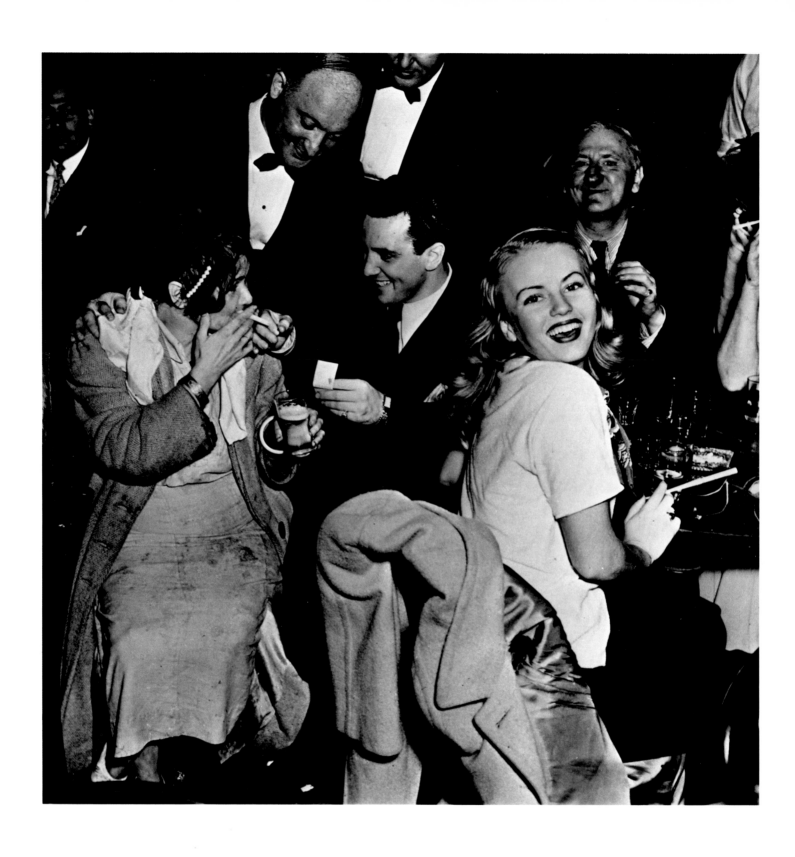

Sammy (links im Hintergrund) und Gäste
Sammy (in the background, left) and guests
Sammy (à gauche, au fond) et les hôtes

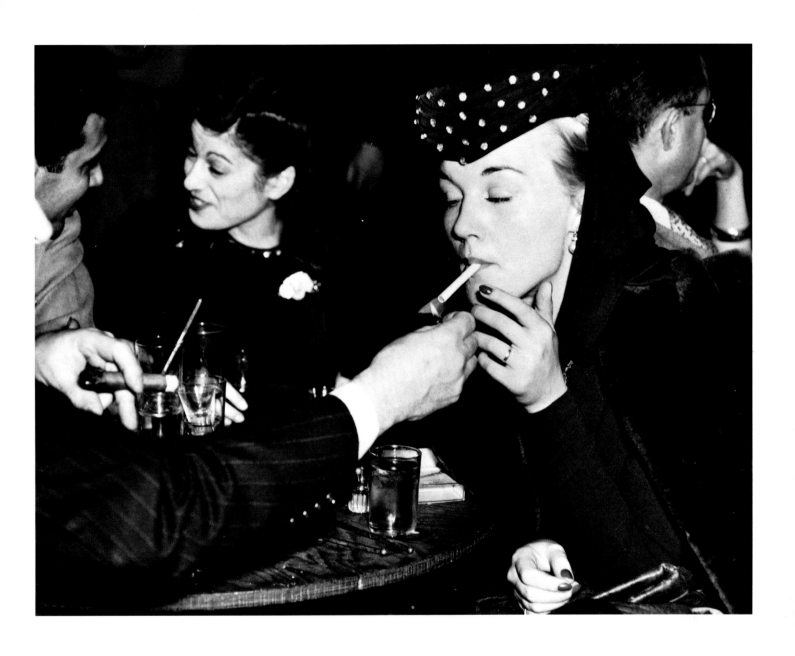

Bei Sammy's in der Bowery
At Sammy's in the Bowery
Chez Sammy à la Bowery

Soldaten
Soldiers
Soldats

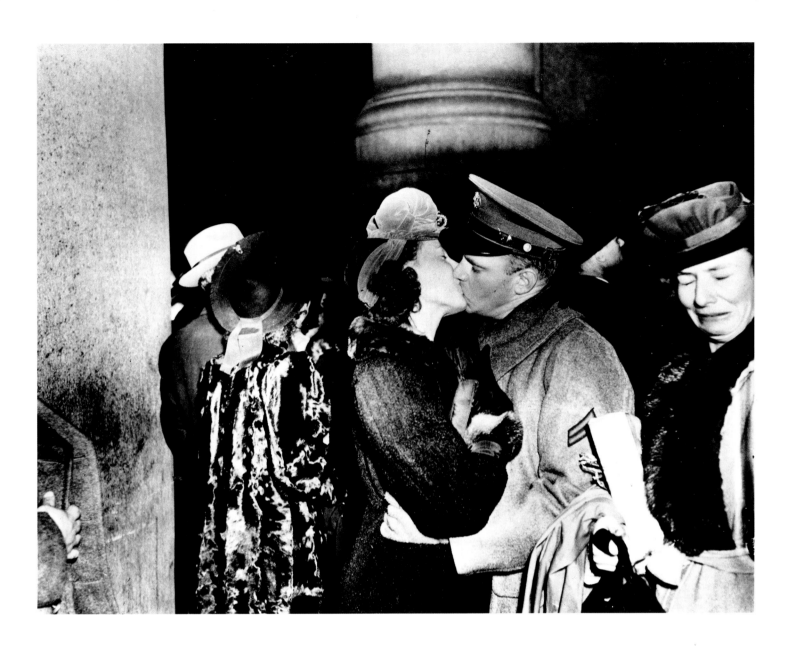

Soldatenabschied, ca. 1942
Soldiers farewell
Adieux des soldats

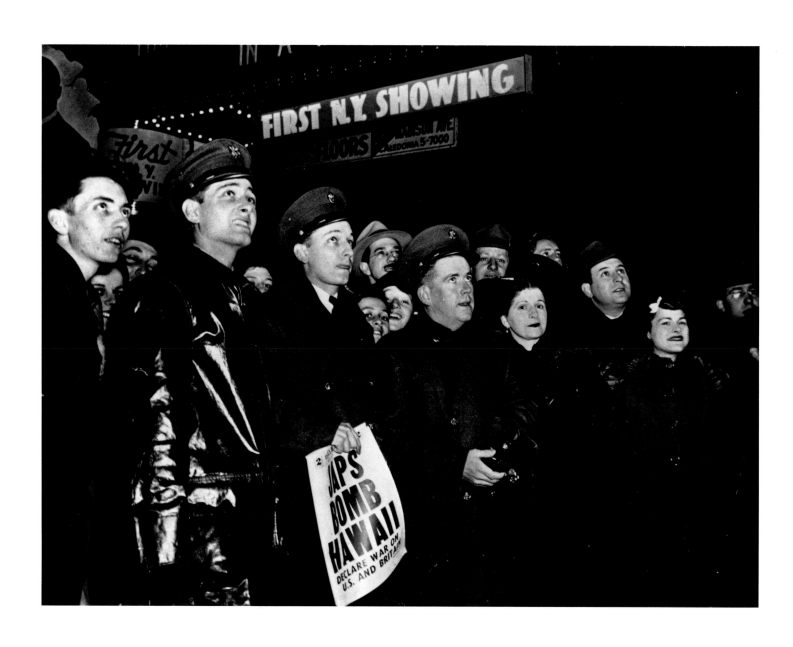

Soldatenabschied
Soldiers farewell
Adieux des soldats

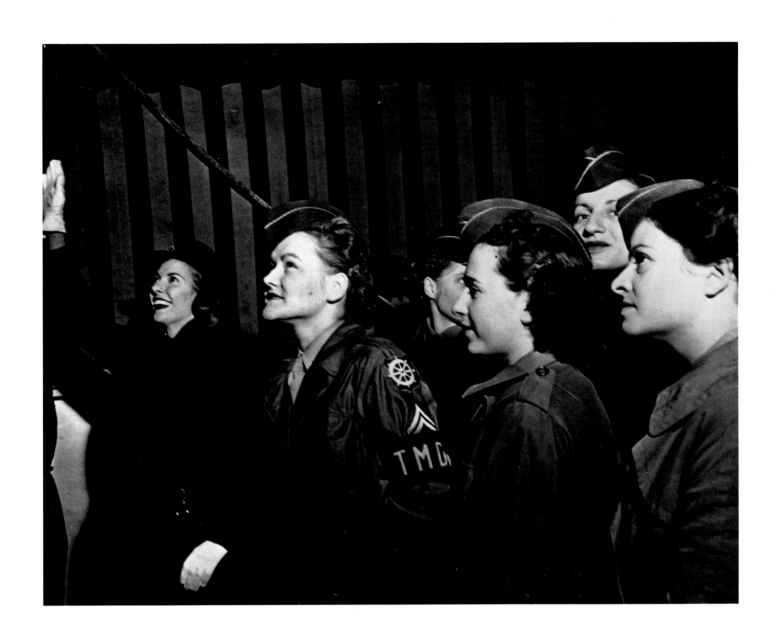

Soldatenabschied
Soldiers farewell
Adieux des soldats

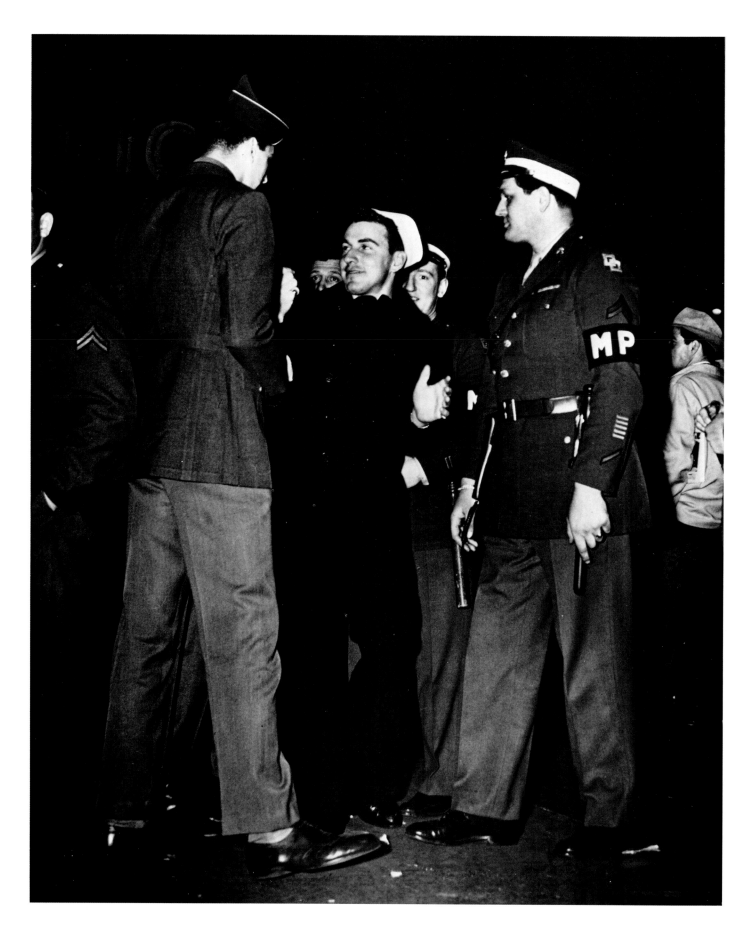

MP greift ein
The M.P. takes action
MP intervient

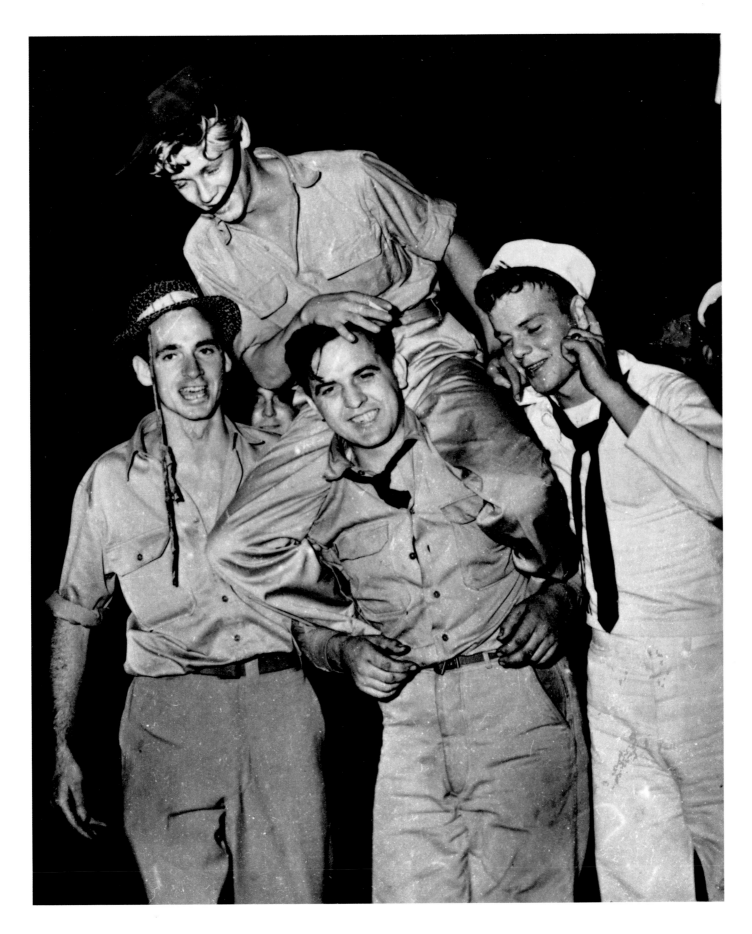

Soldaten
Soldiers
Soldats

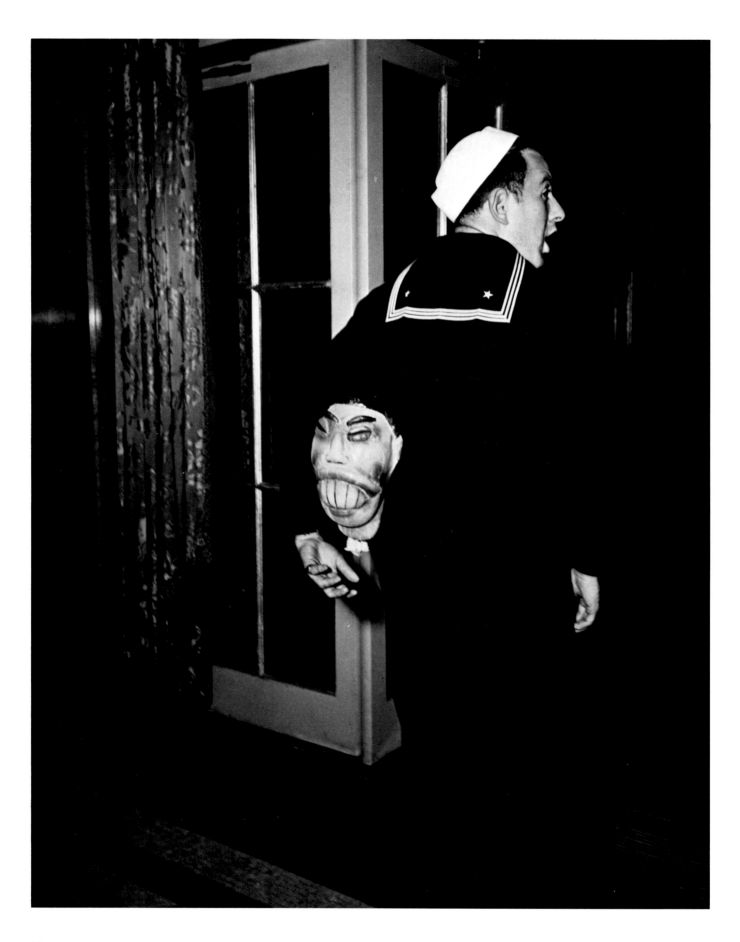

Matrose
Sailor
Matelot

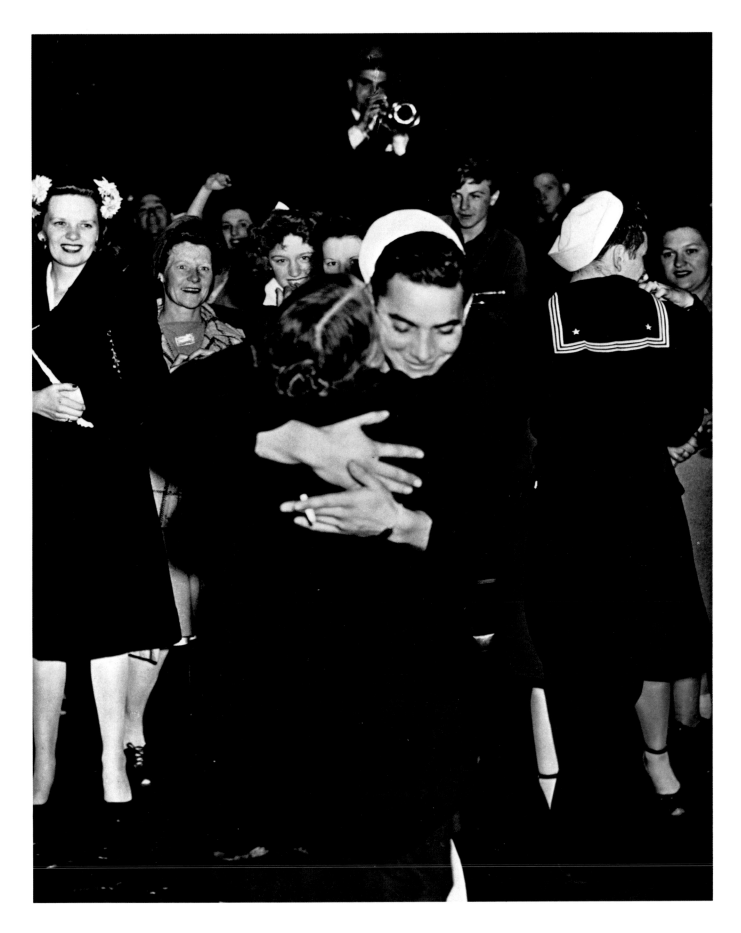

Siegesfeier
Victory celebration
Fête de la victoire

Victory-Europe Day, 1945
Victory-Europe Day
Jour de la victoire de l'Europe

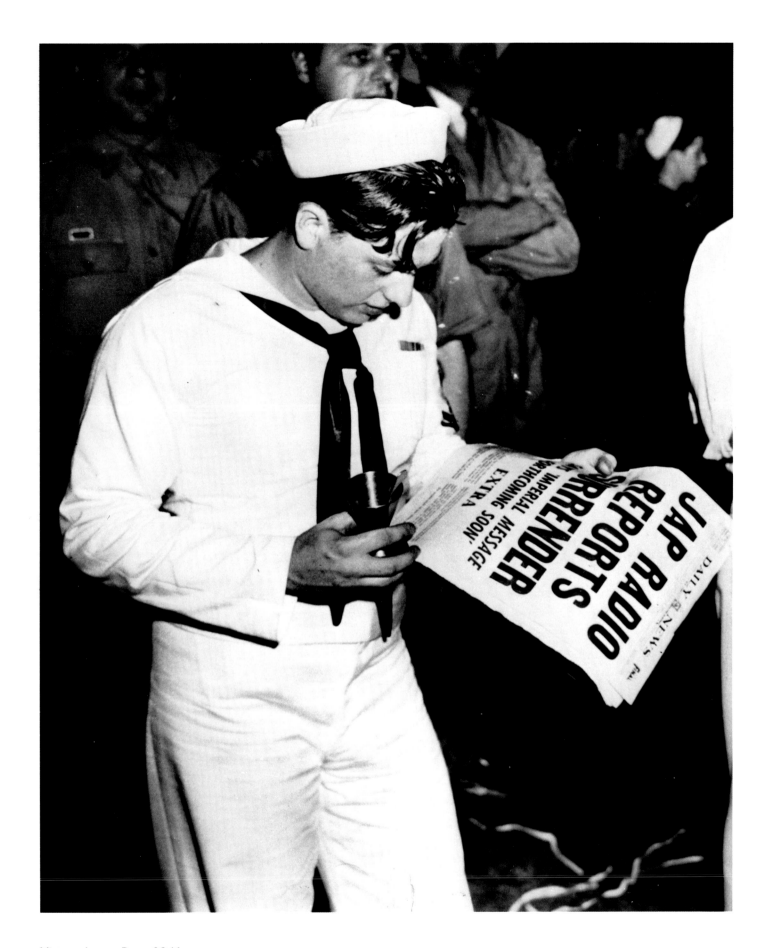

Victory-Japan Day, 1946
Victory-Japan Day
Jour de la victoire du Japon

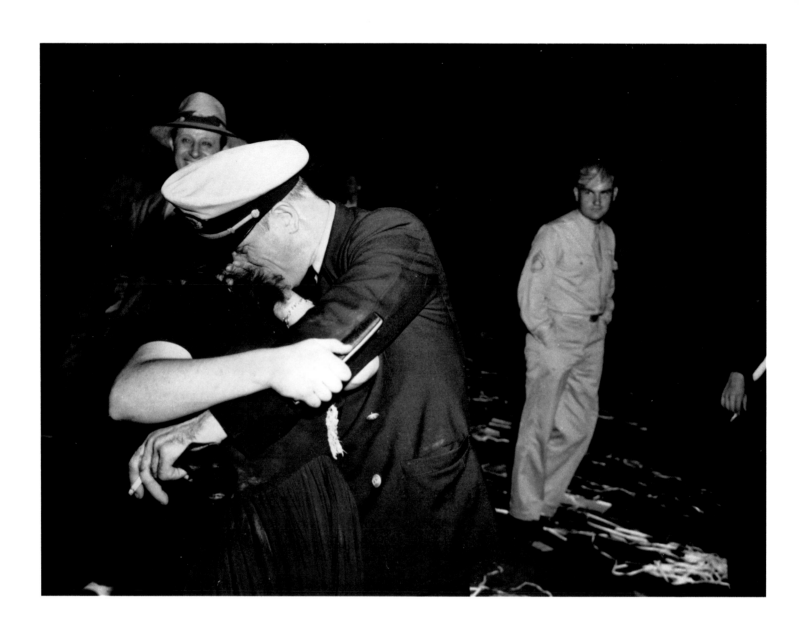

Siegesfeier, 1945
Victory celebration
Fête de la victoire

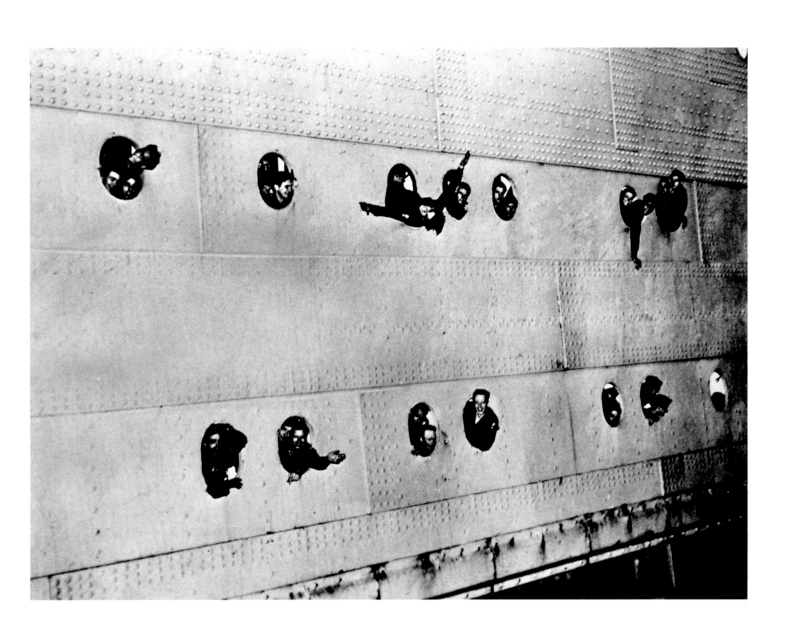

Siegesfeier, 1945
Victory celebration
Fête de la victoire

274

Publikum
Audience
Public

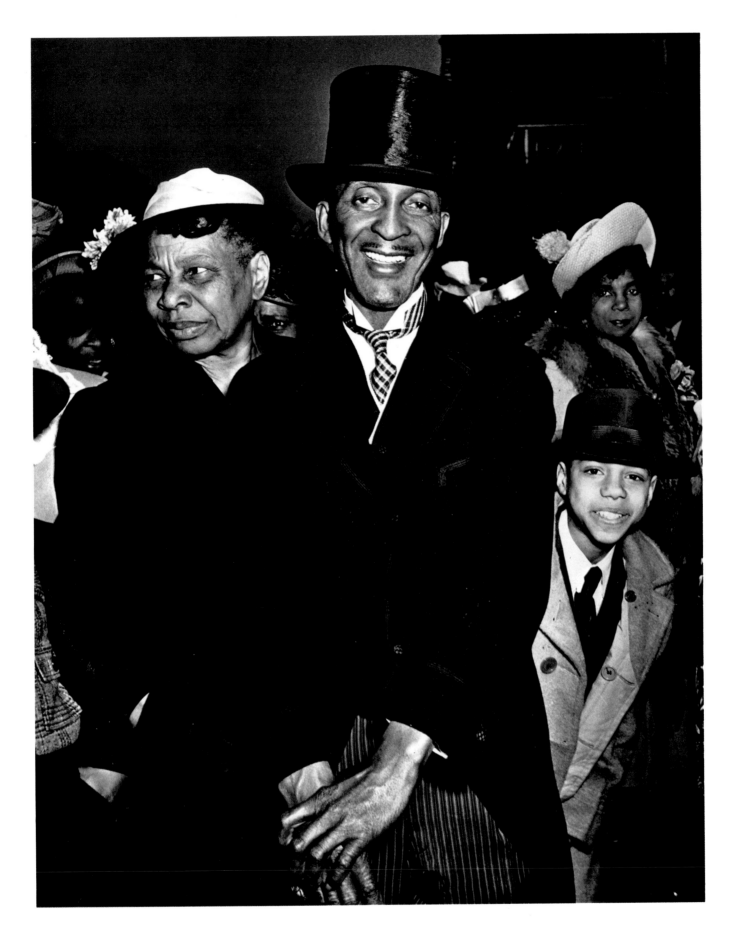

Ostersonntag in Harlem, 1940
Easter Sunday in Harlem
Dimanche de Pâques à Harlem

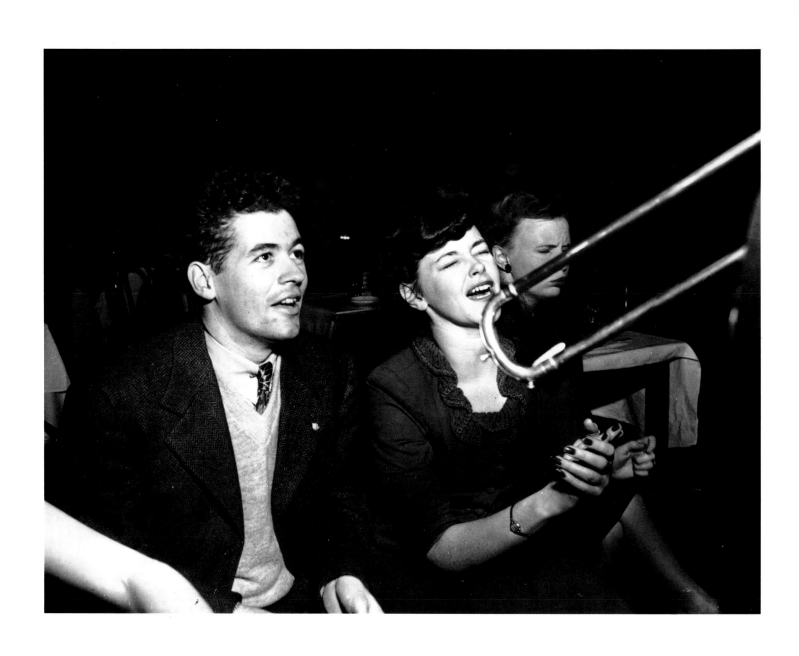

Im Stuyvesant Casino, 1946
At the Stuyvesant Casino
Au Stuyvesant Casino

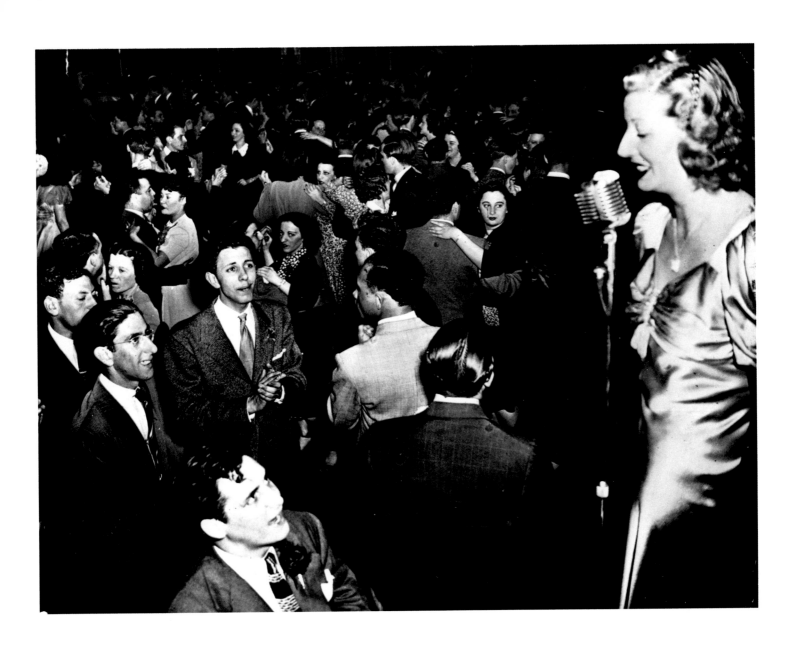

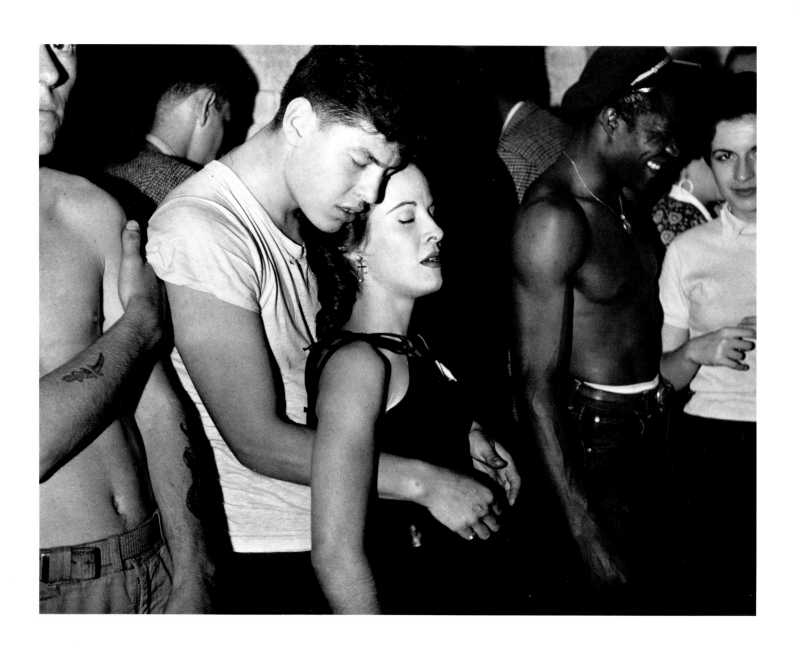

Versunken in Musik
Absorbed in Music
Plongés dans la musique

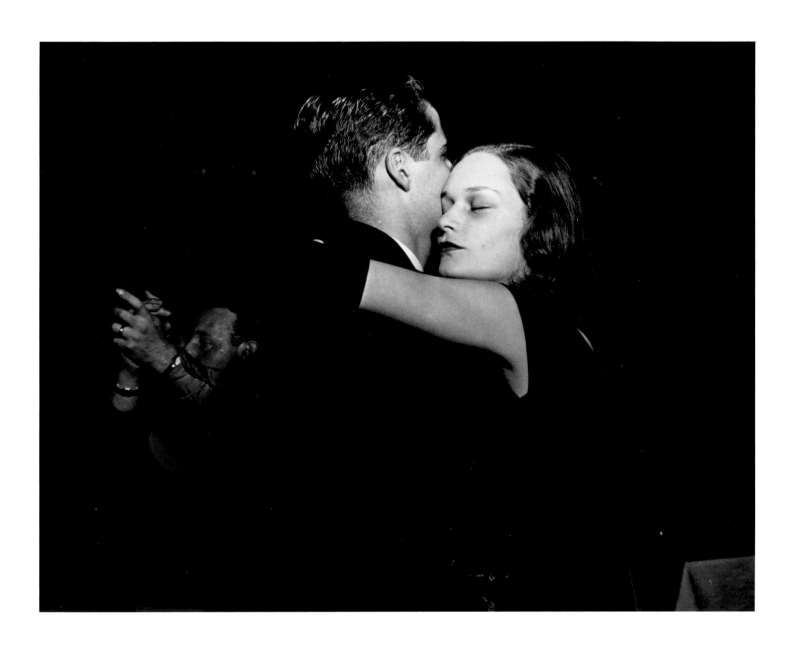

Tanzendes Paar
Dancing couple
Couple de danseurs

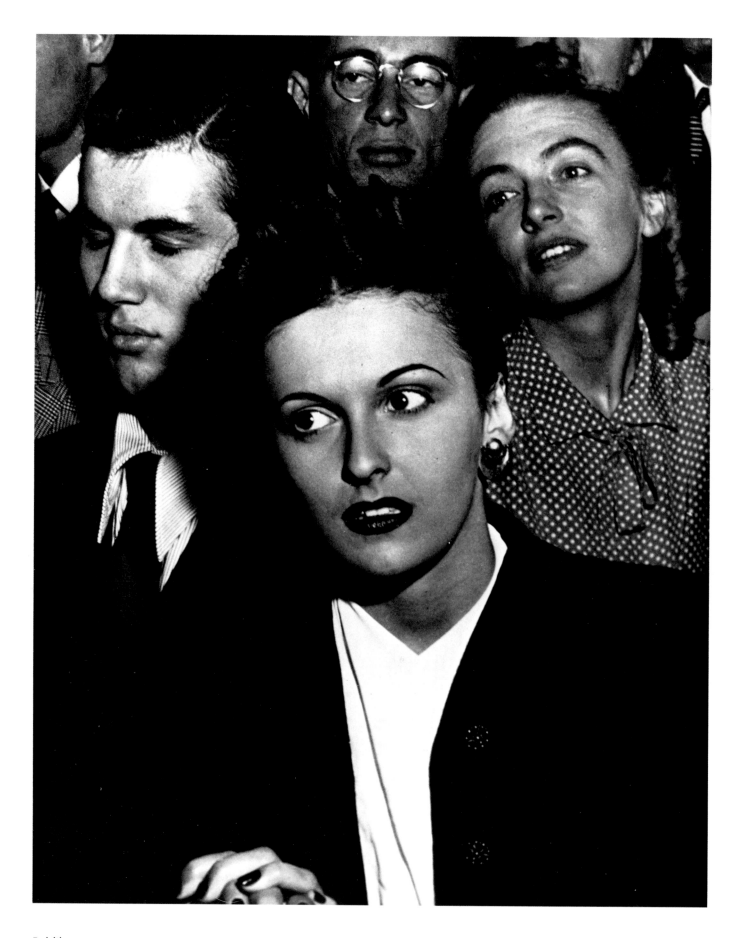

Publikum
Audience
Public

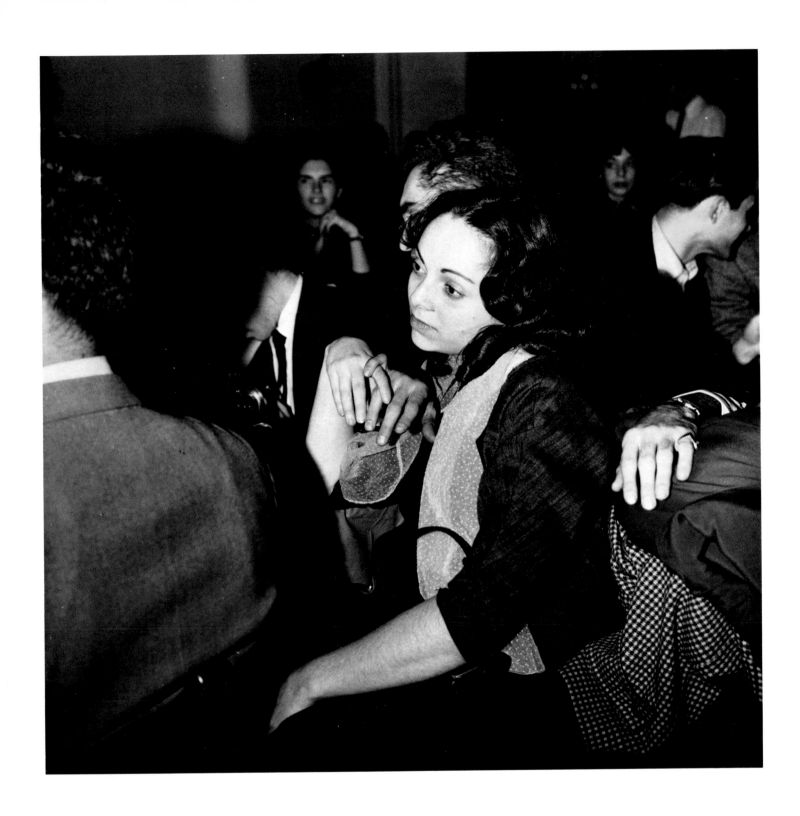

In einer Bar
At a bar
Dans un bar

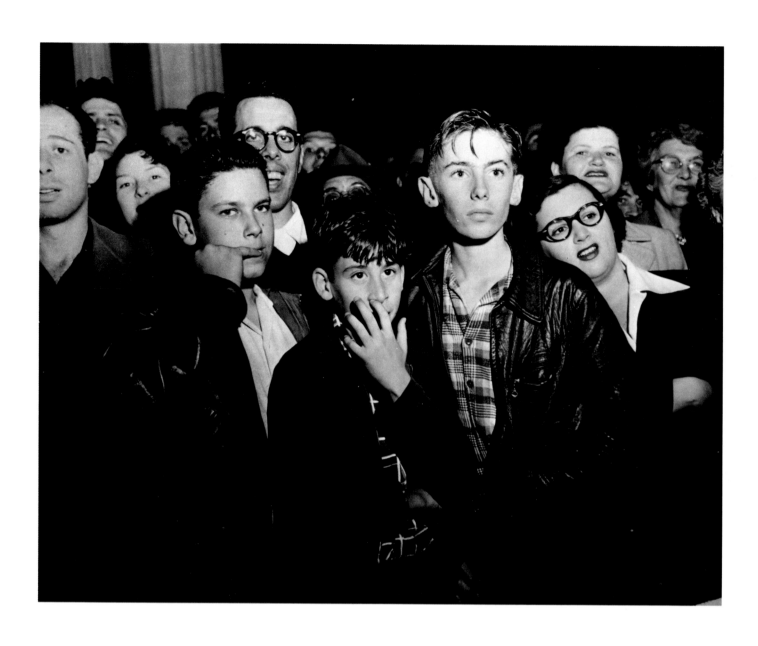

Publikum, 1949
Audience
Public

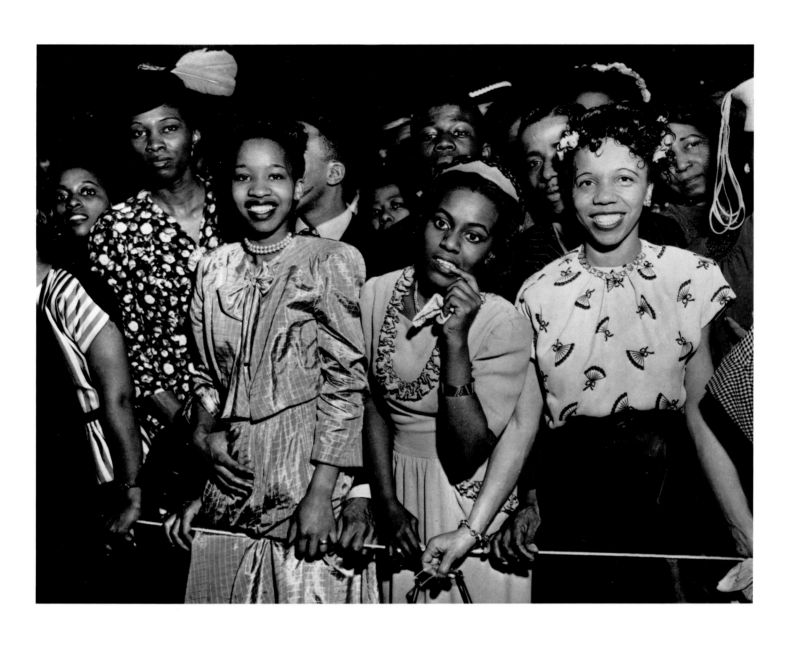

Konzertpublikum in Harlem, 1948
Harlem concert-audience
Public de concert à Harlem

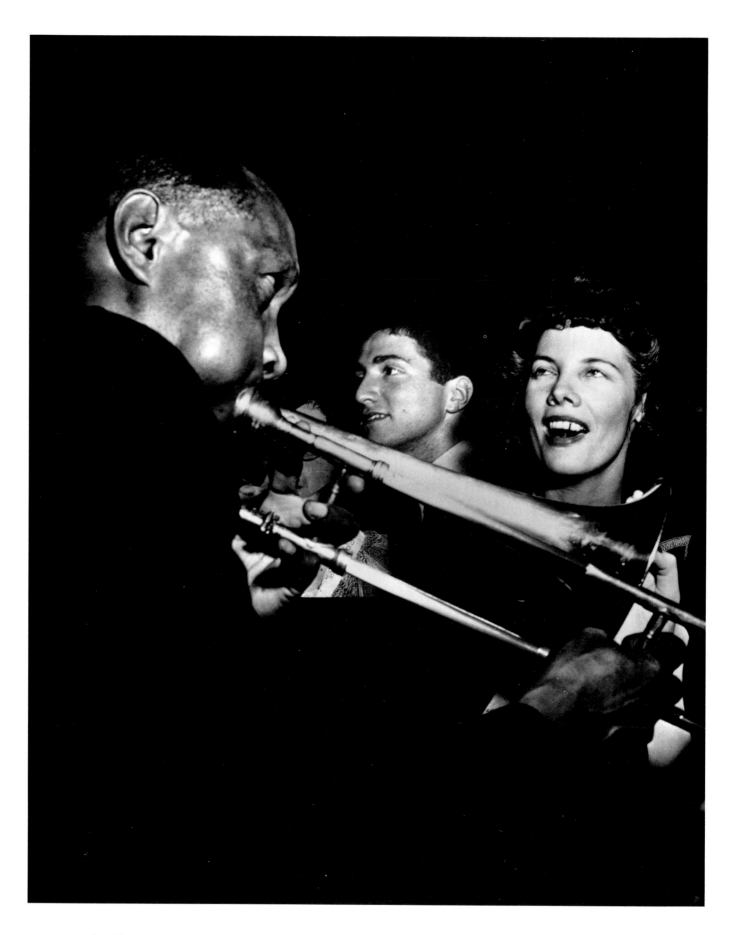

In Greenwich Village
In Greenwich Village
A Greenwich Village

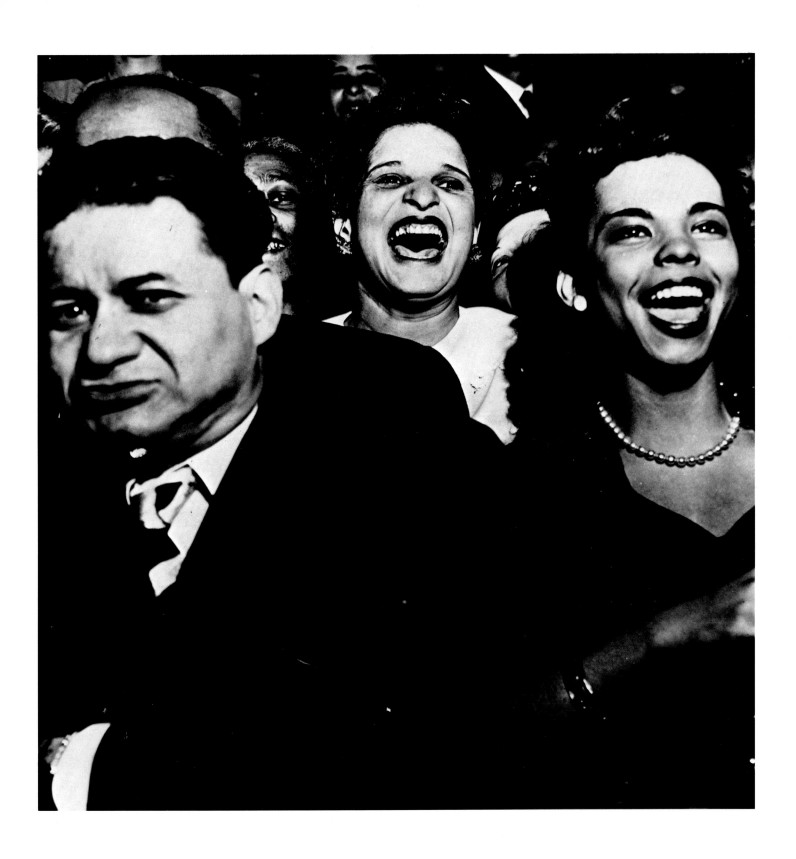

Konzertpublikum in Harlem
Harlem concert-audience
Public de concert à Harlem

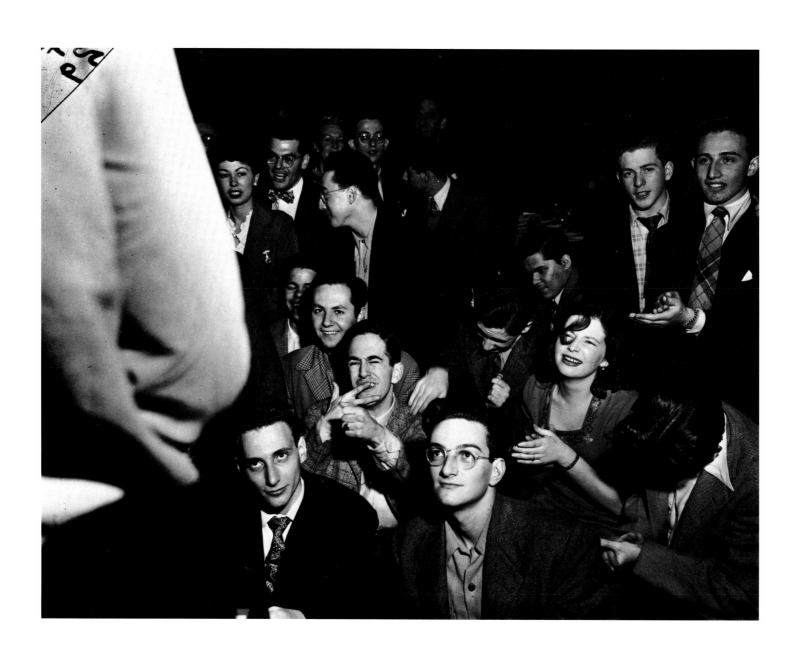

In einem Jazzclub in Greenwich Village
At a jazz-club in Greenwich Village
Dans un club de jazz à Greenwich Village

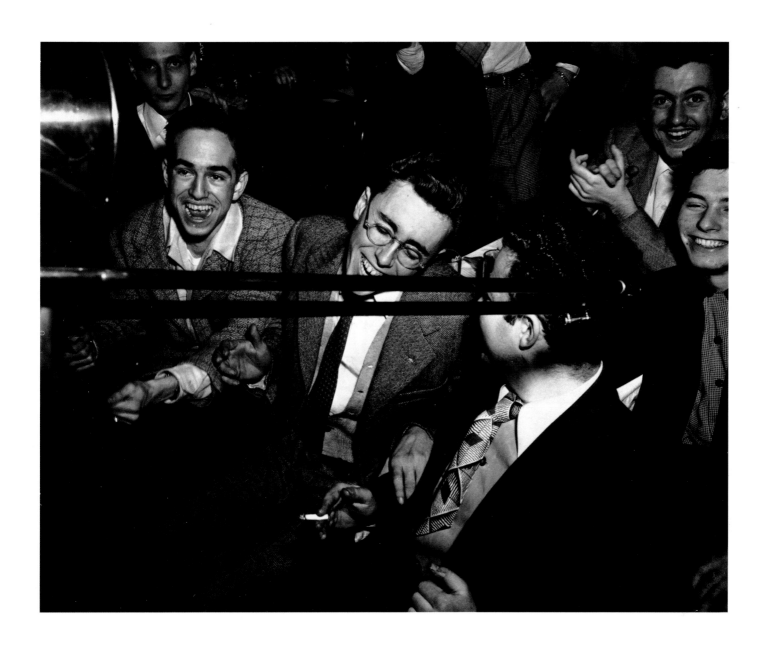

In einem Jazzclub in Greenwich Village
At a jazz-club in Greenwich Village
Dans un club de jazz à Greenwich Village

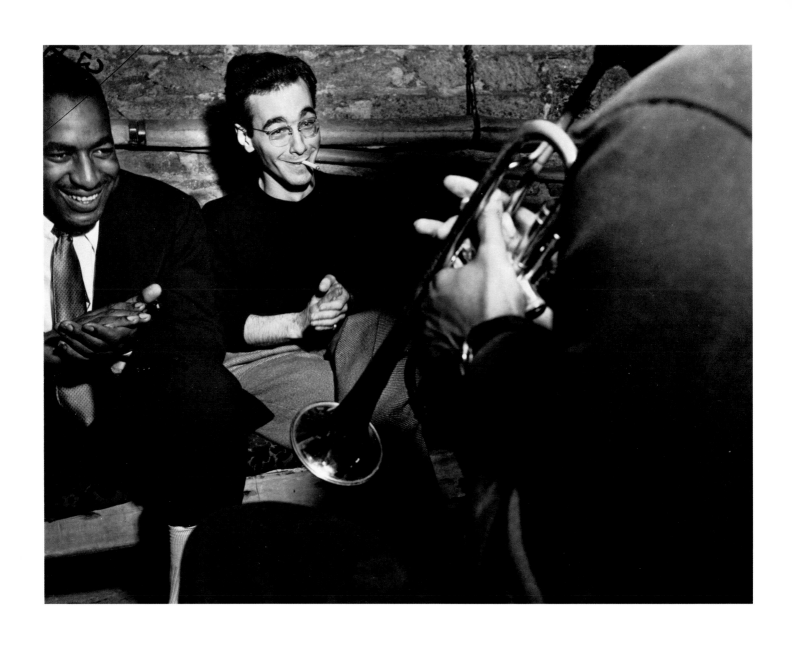

Jam Session in einer Kellerbar
Jamsession at a cellar-bar
Séance de jazz dans un caveau

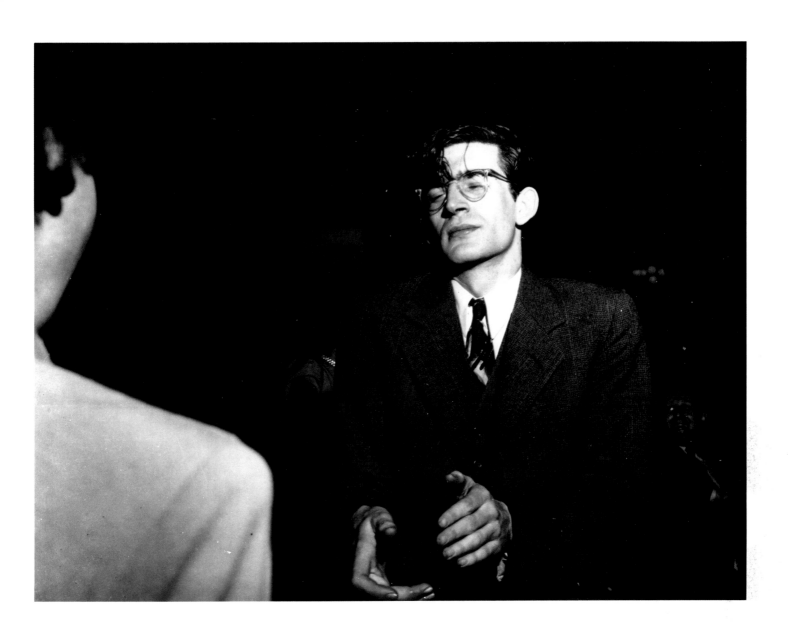

In einem Jazzclub in Greenwich Village
At a jazz-club in Greenwich Village
Dans un club de jazz à Greenwich Village

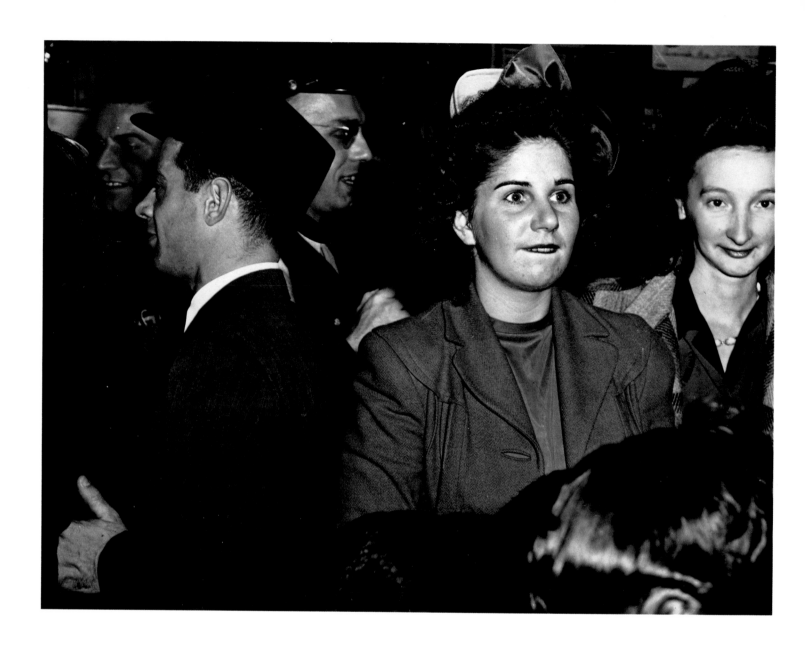

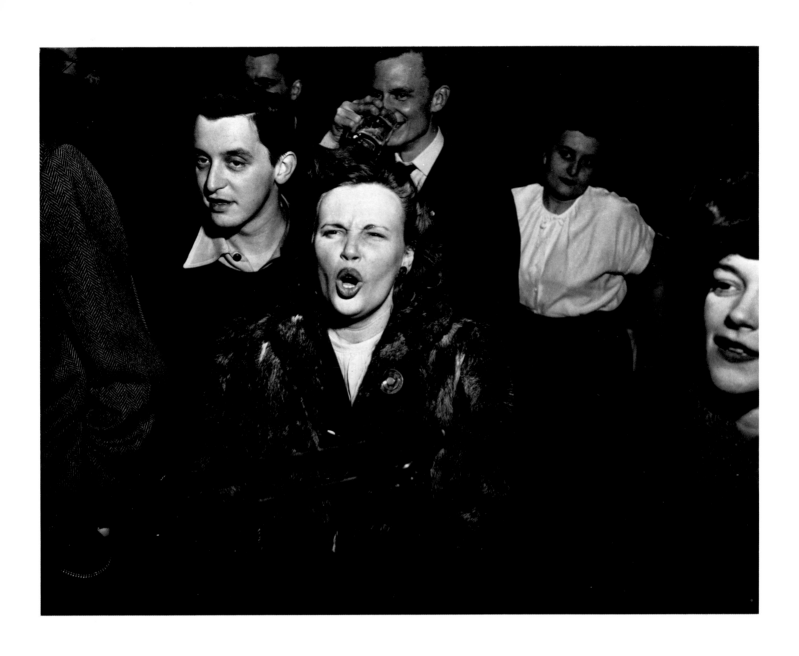

In einem Jazzclub, 1948
At a jazz-club
Dans un club de jazz

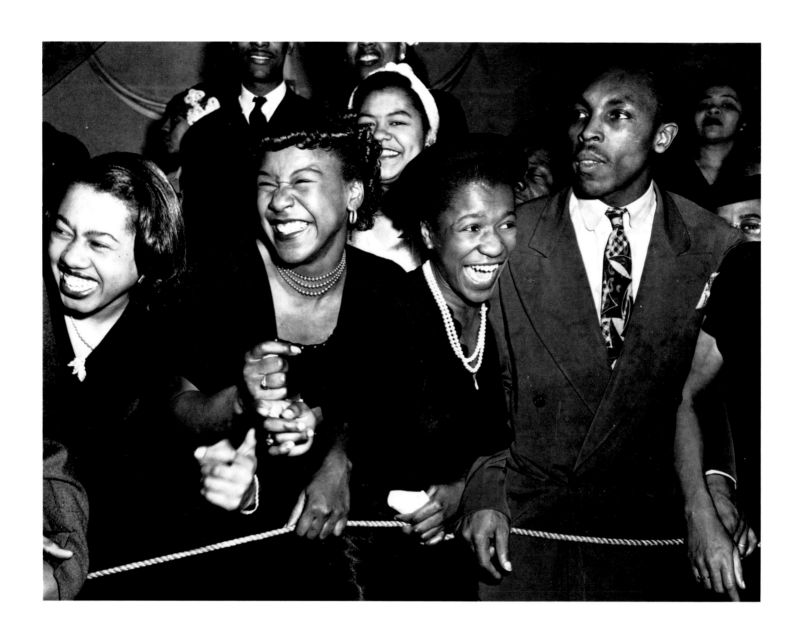

Konzertpublikum in Harlem
Harlem concert-audience
Public de concert à Harlem

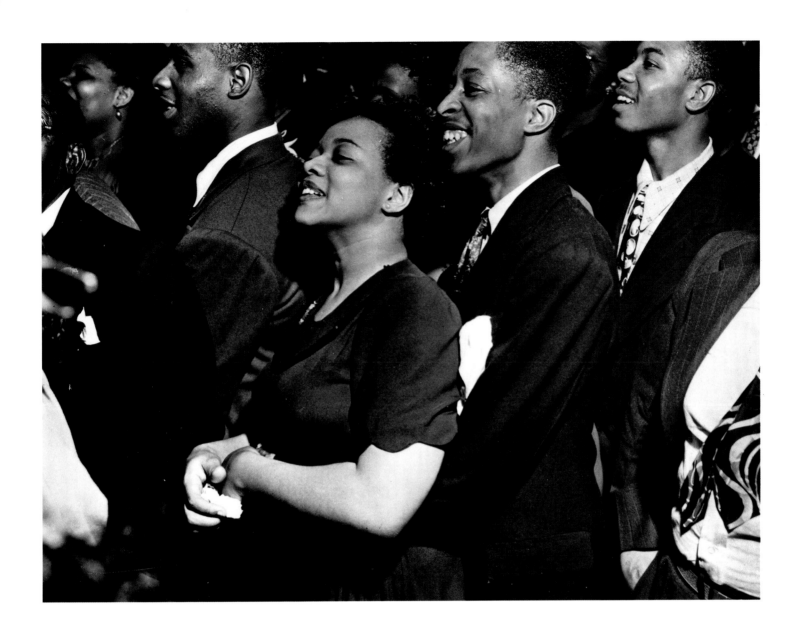

Konzertpublikum in Harlem
Harlem concert-audience
Public de concert à Harlem

293

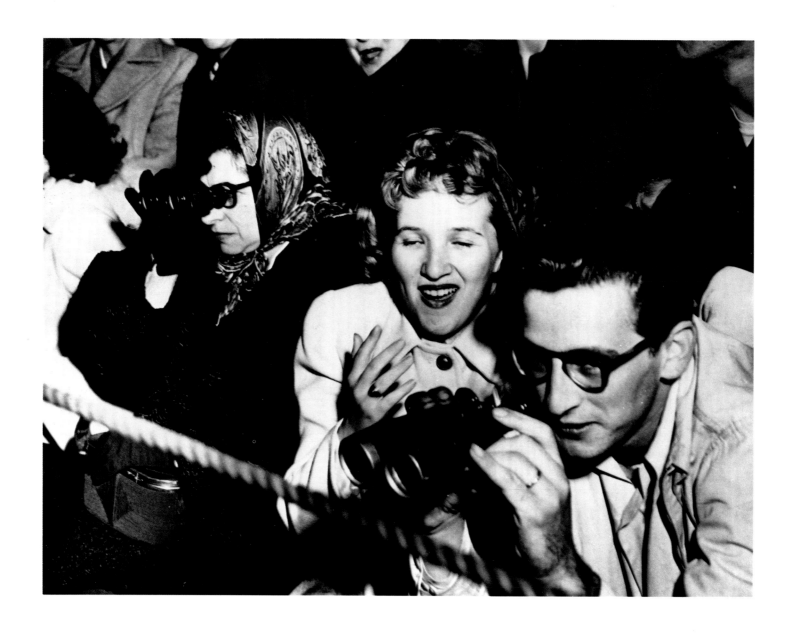

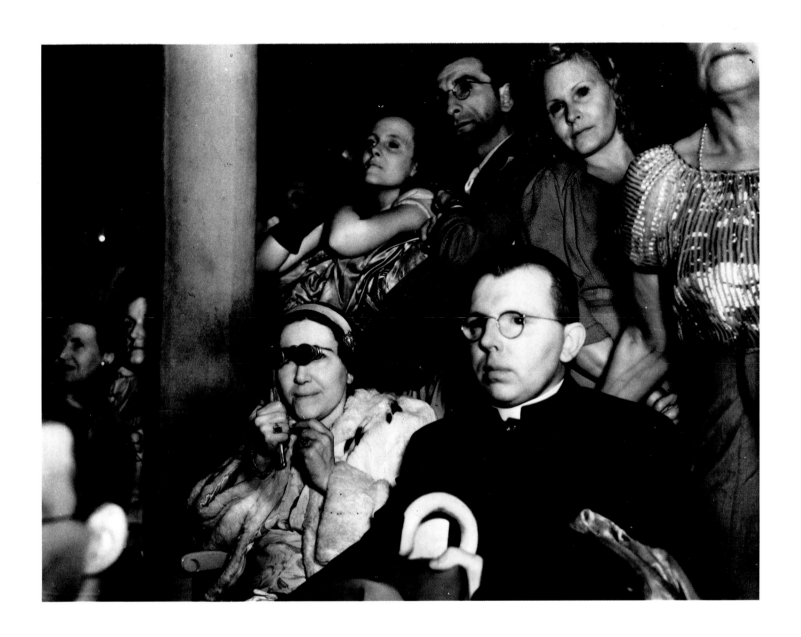

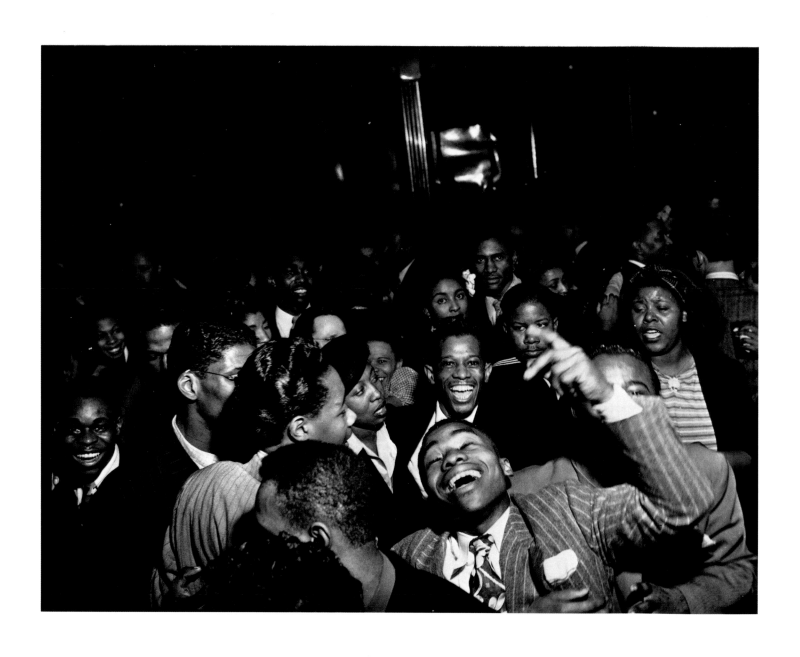

In einem Jazzclub in Harlem
At a jazz-club in Harlem
Dans un club de jazz de Harlem

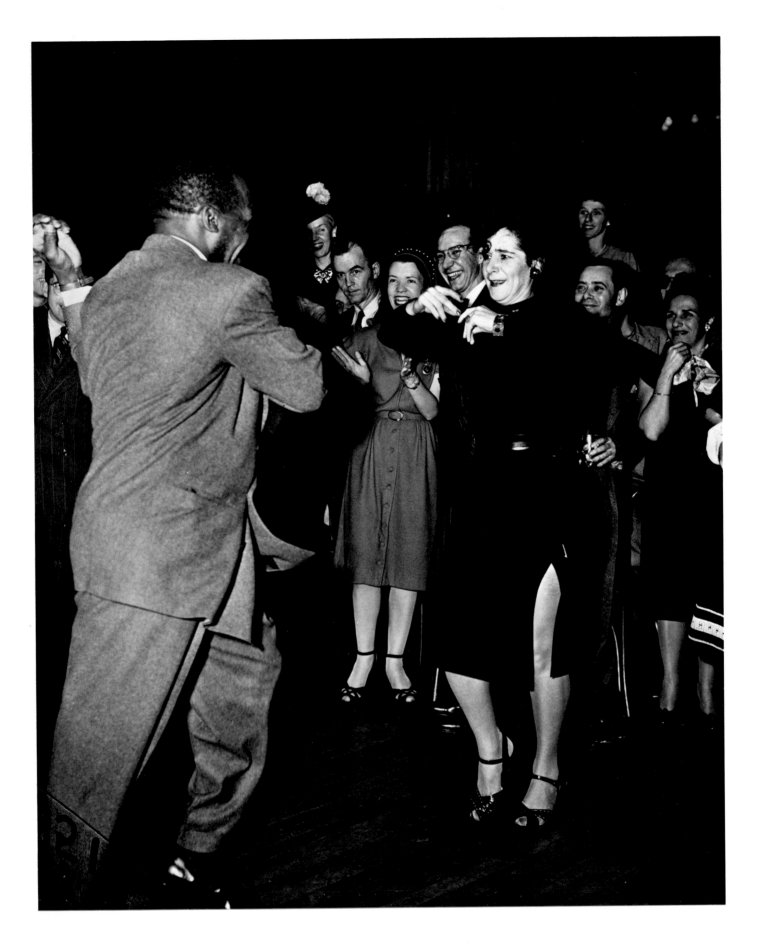

Tanzendes Paar
Dancing couple
Couple dansant

Stripperinnen
Strippers
Stripteaseuses

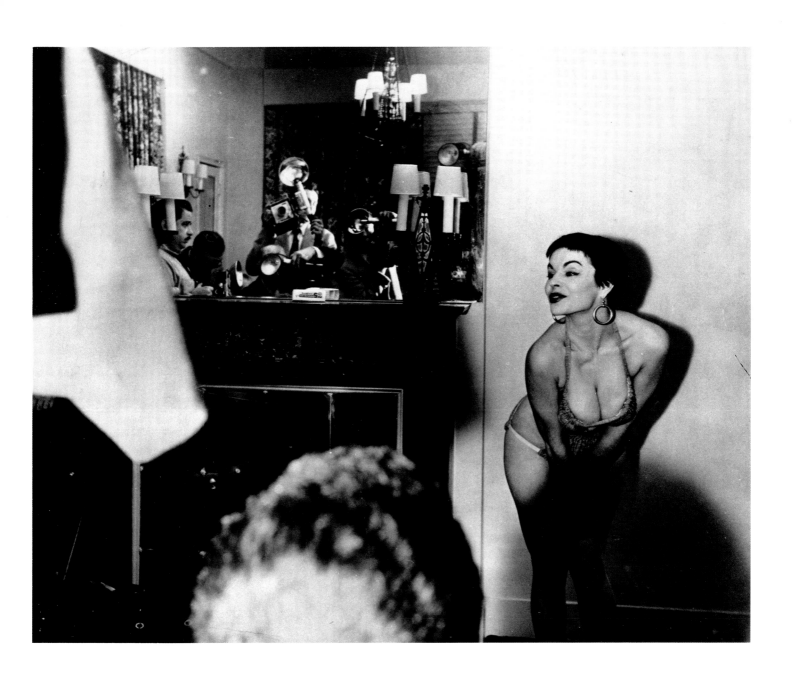

Nachtclub-Tänzerin posiert für Pressephotographen
A stripper posing for the pressphotographers
Danseuse de night club qui pose pour les photographes

298

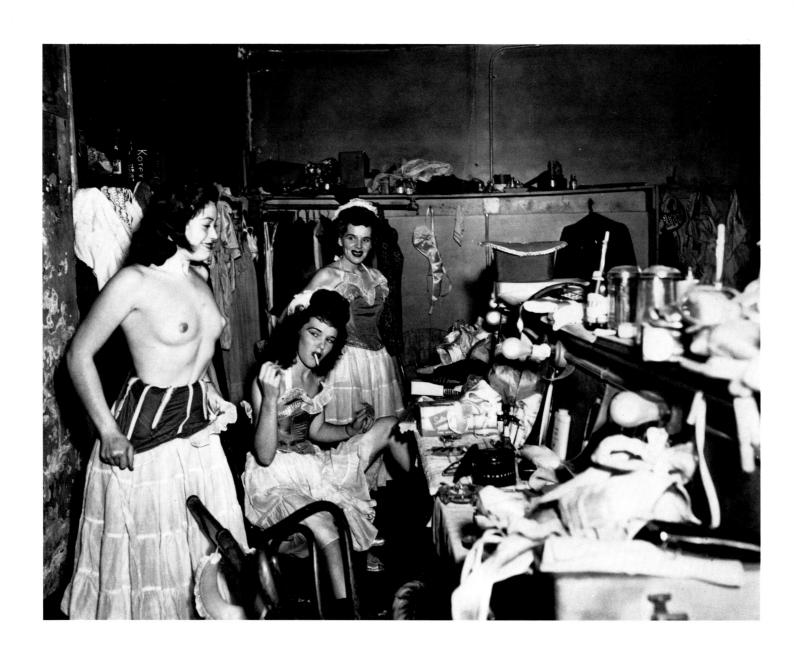

In der Garderobe
In the dressingroom
Au vestiaire

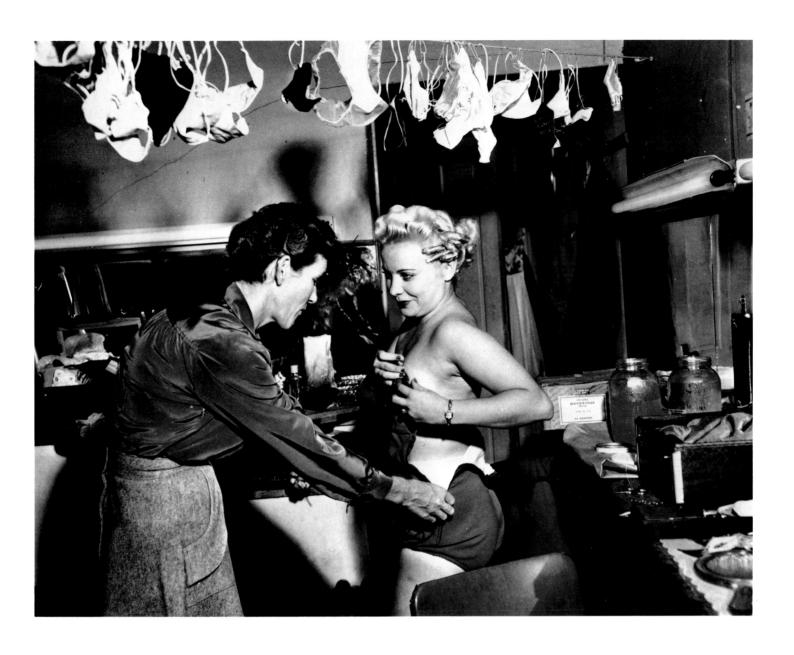

In der Garderobe
In the dressingroom
Au vestiaire

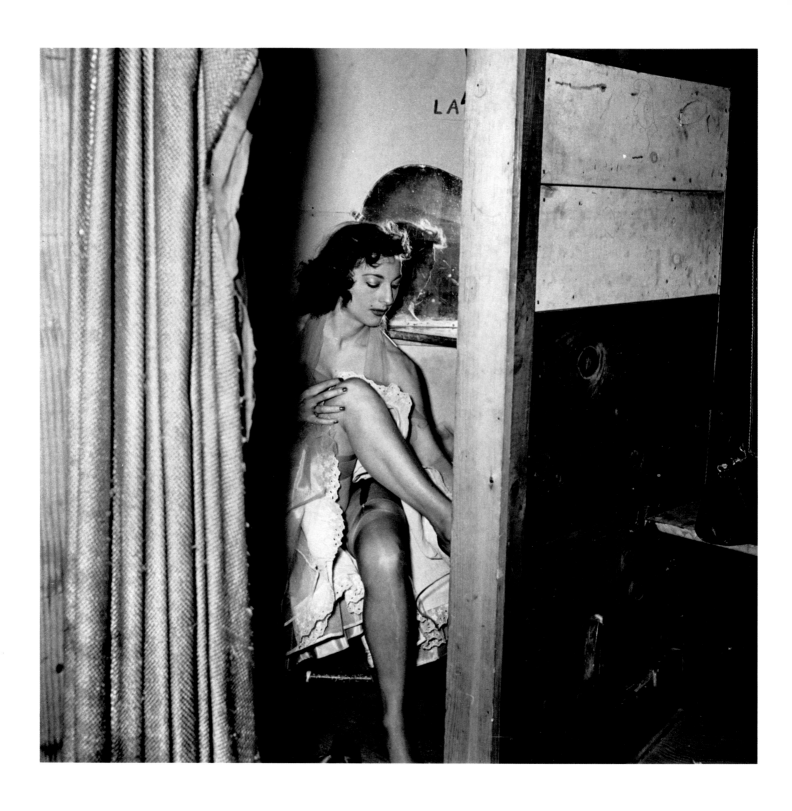

In der Garderobe
In the dressingroom
Au vestiaire

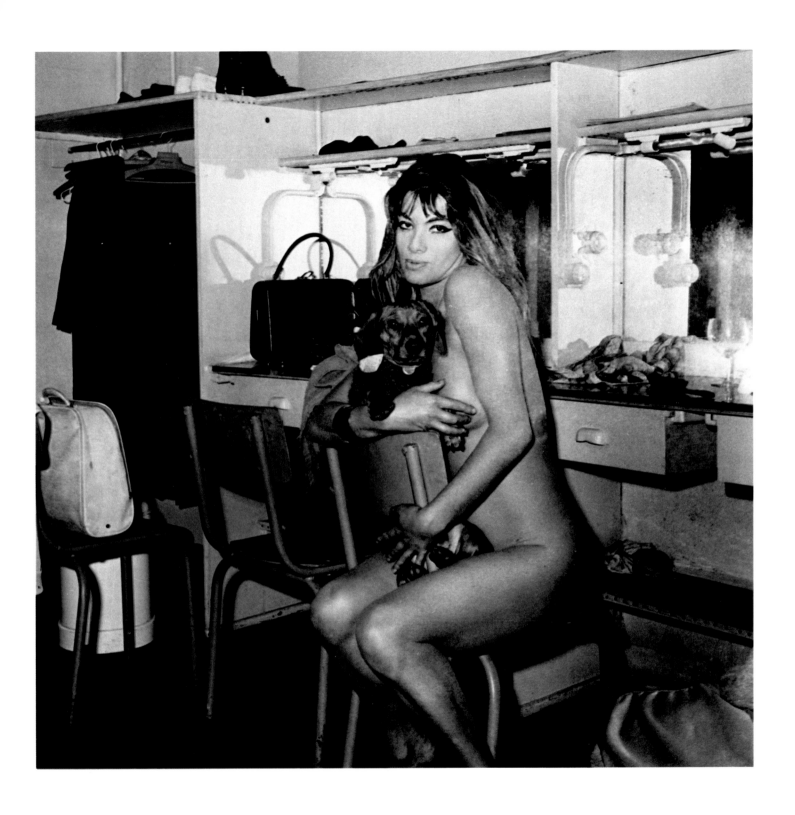

In der Garderobe
In the dressingroom
Au vestiaire

301

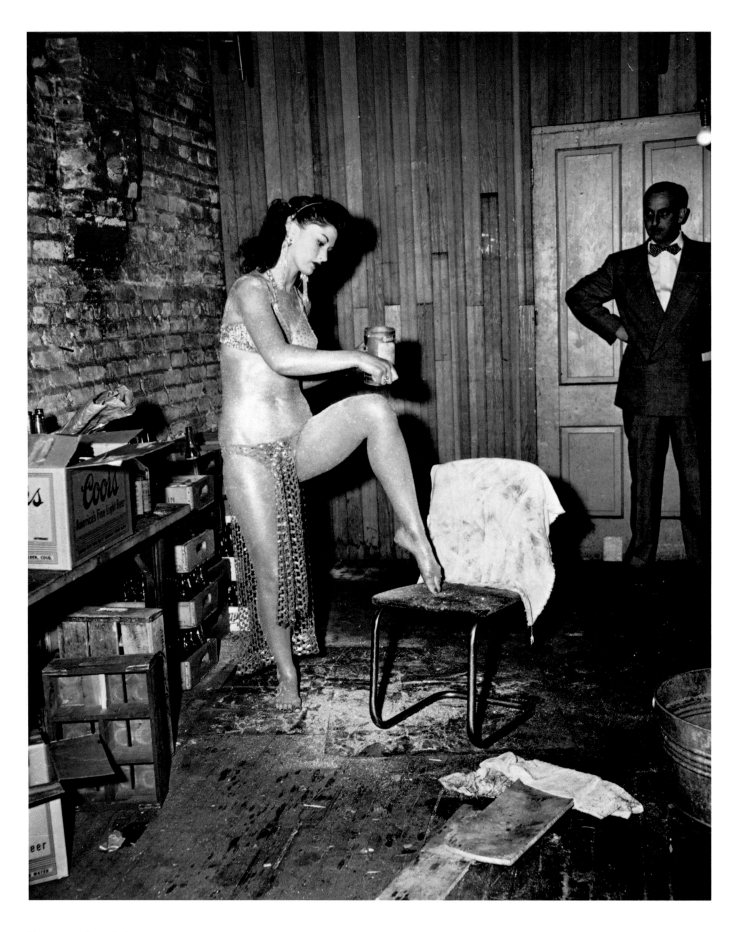

Kurz vor dem Auftritt
The show's going to start any minute
Peu de temps avant l'entrée en scène

303

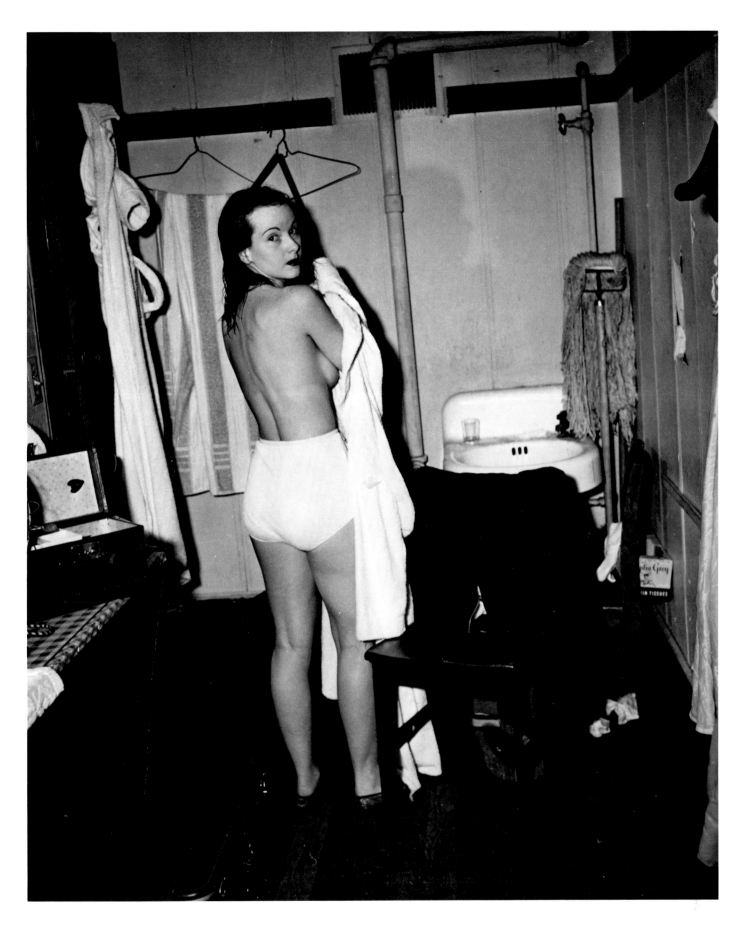

In der Garderobe
In the dressingroom
Au vestiaire

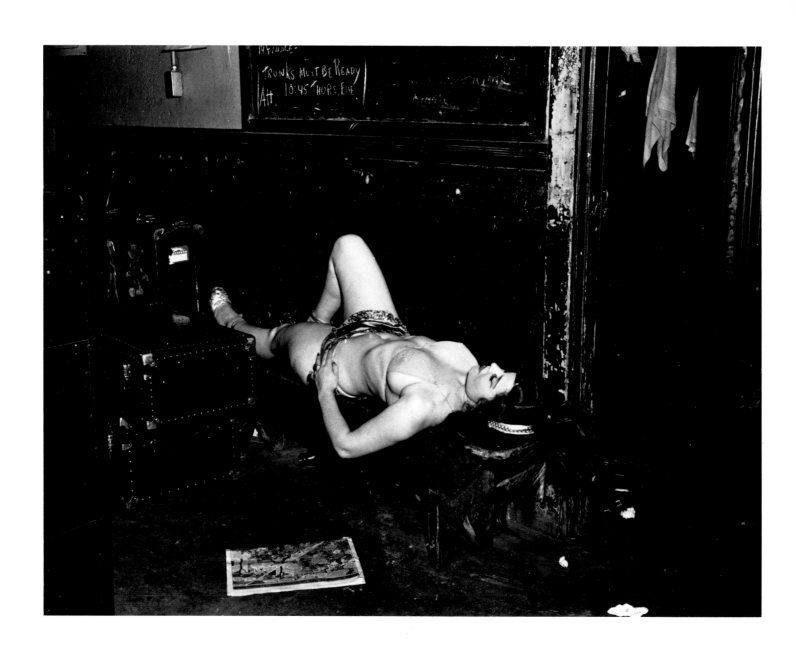

Zwischen den Auftritten
Between performances
Entre les entrées en scène

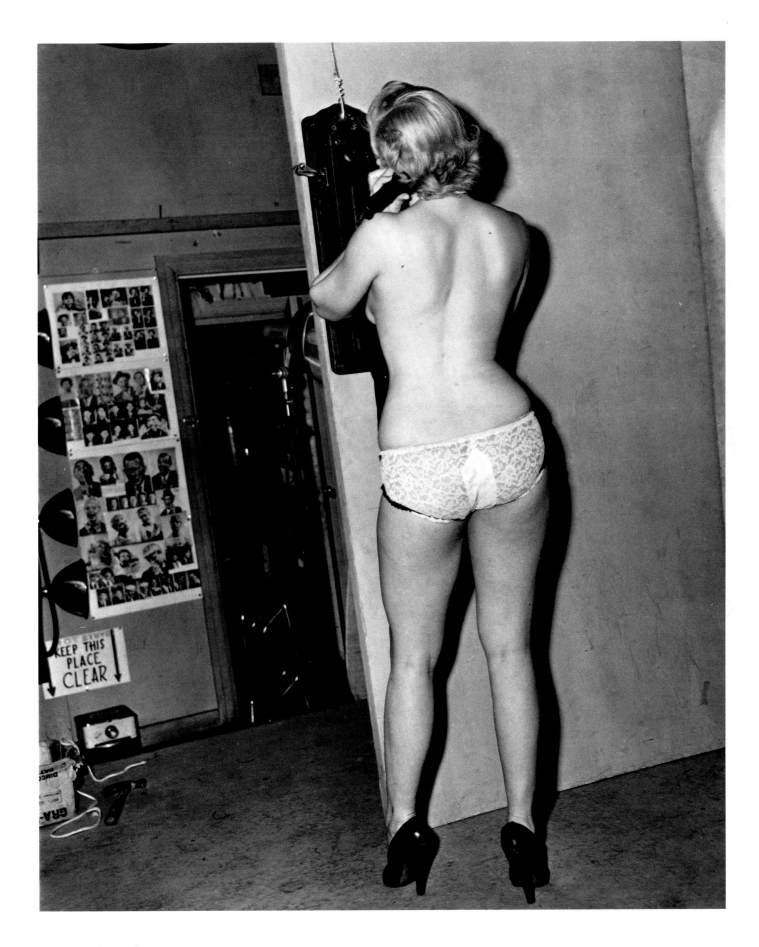

Zwischen den Auftritten
Between performances
Entre les entrées en scène

Berühmte
Socialites
Stars et notabilités

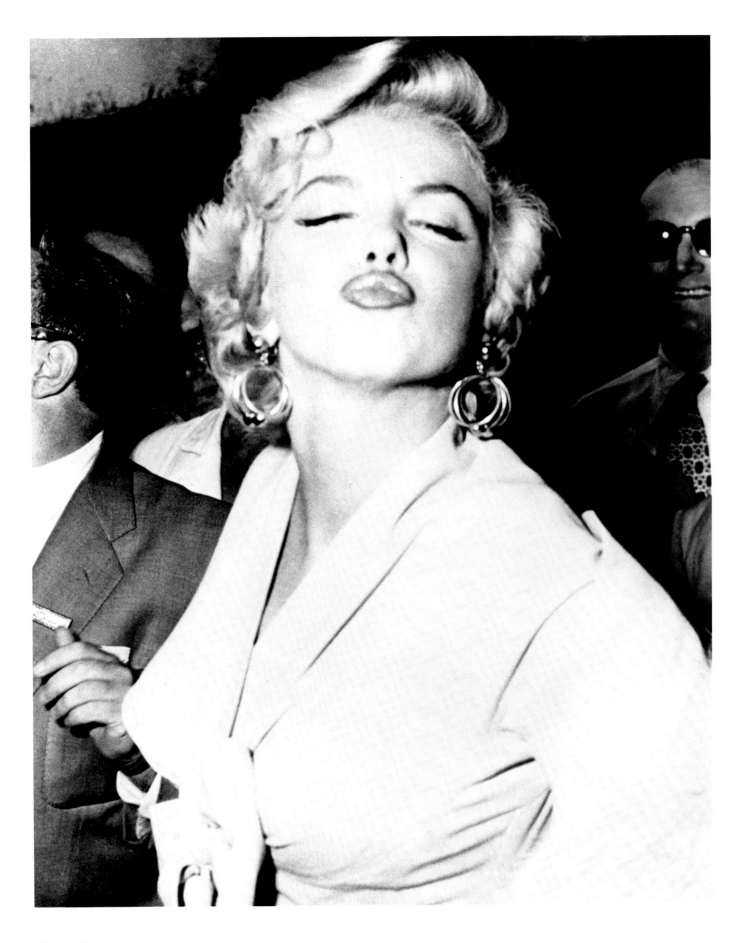

Marilyn Monroe
Marilyn Monroe
Marilyn Monroe

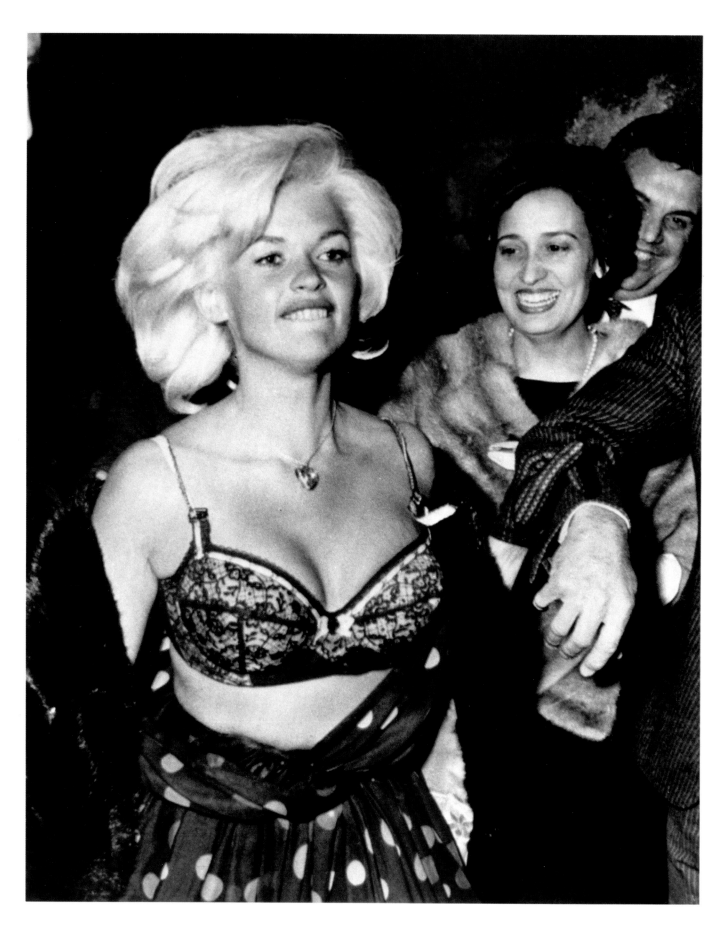

Jane Mansfield
Jane Mansfield
Jane Mansfield

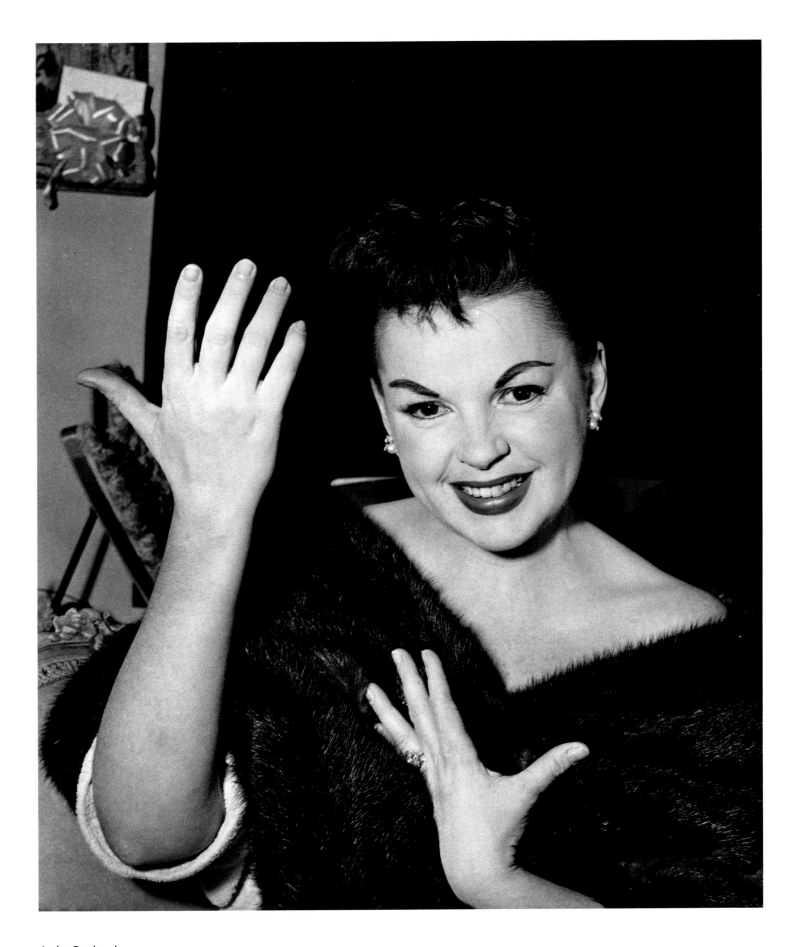

Judy Garland
Judy Garland
Judy Garland

Eartha Kitt
Eartha Kitt
Eartha Kitt

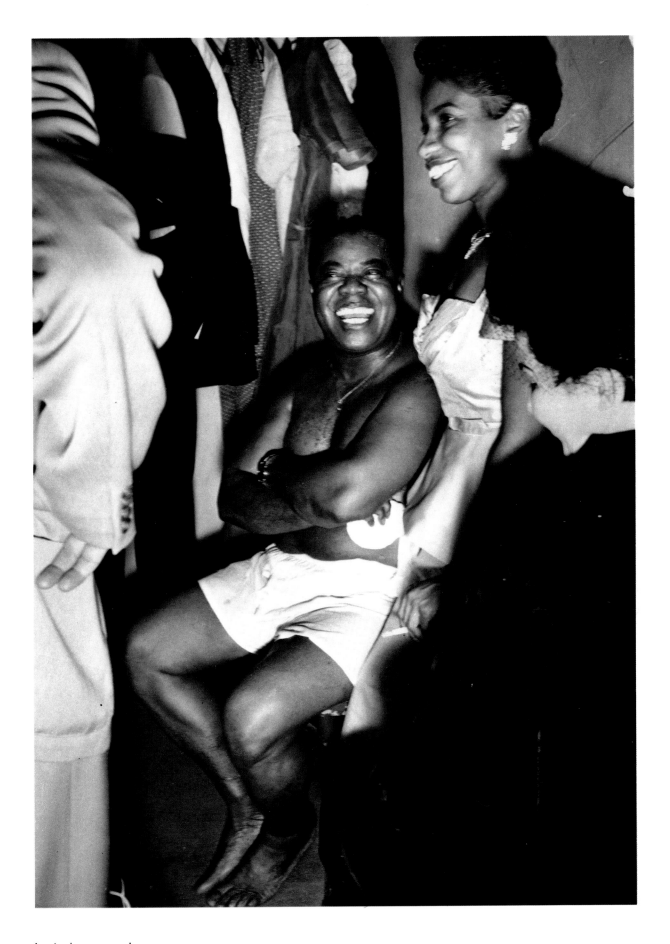

Louis Armstrong I
Louis Armstrong I
Louis Armstrong I

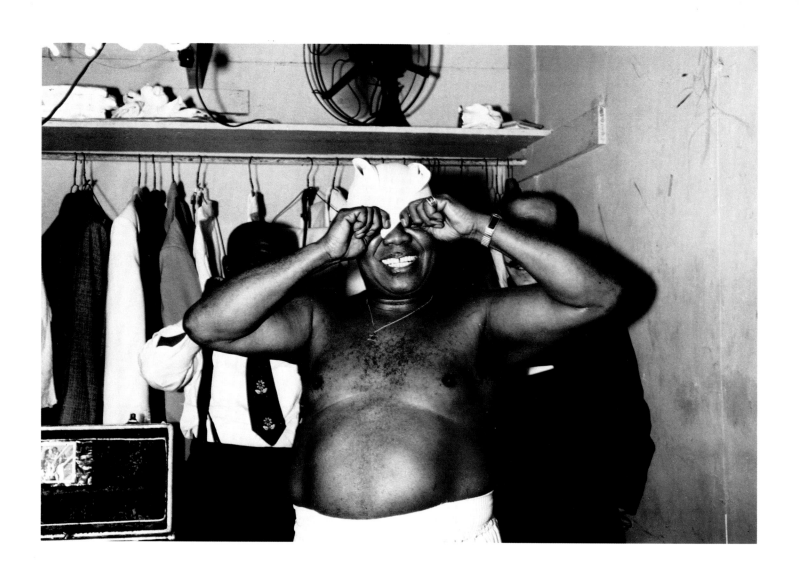

Louis Armstrong II
Louis Armstrong II
Louis Armstrong II

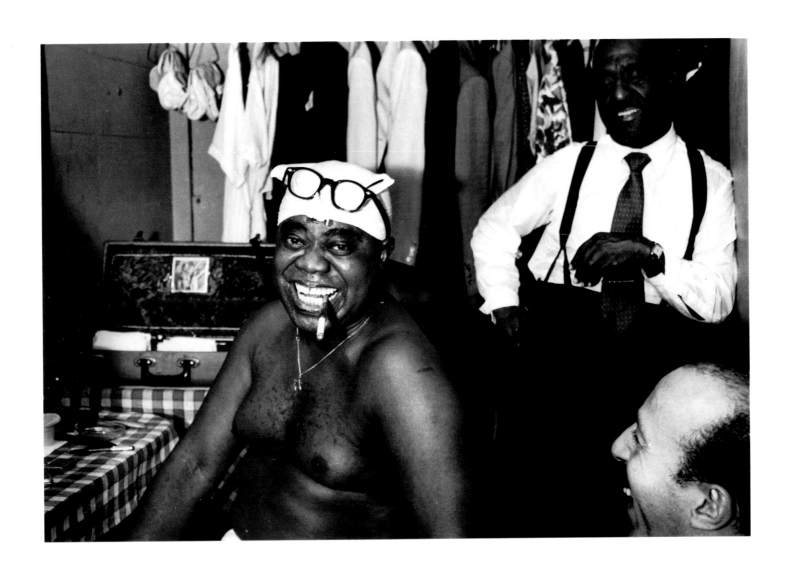

Louis Armstrong III
Louis Armstrong III
Louis Armstrong III

313

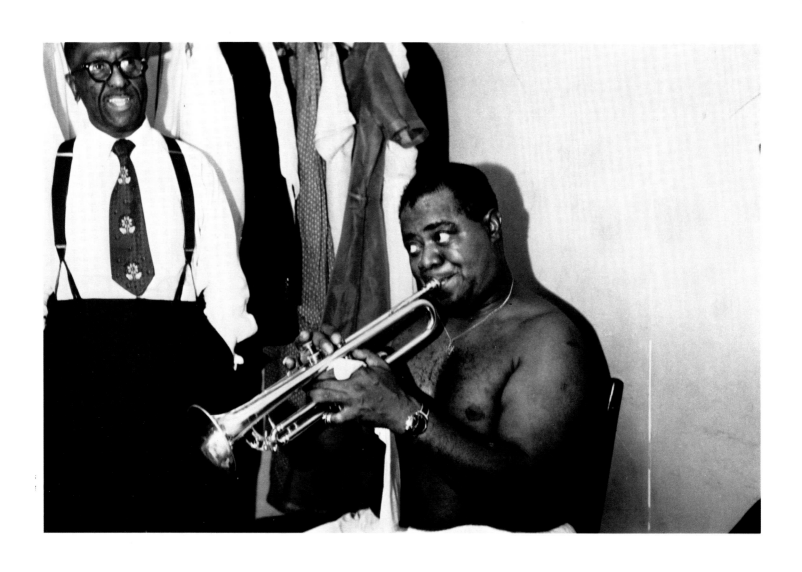

Louis Armstrong IV
Louis Armstrong IV
Louis Armstrong IV

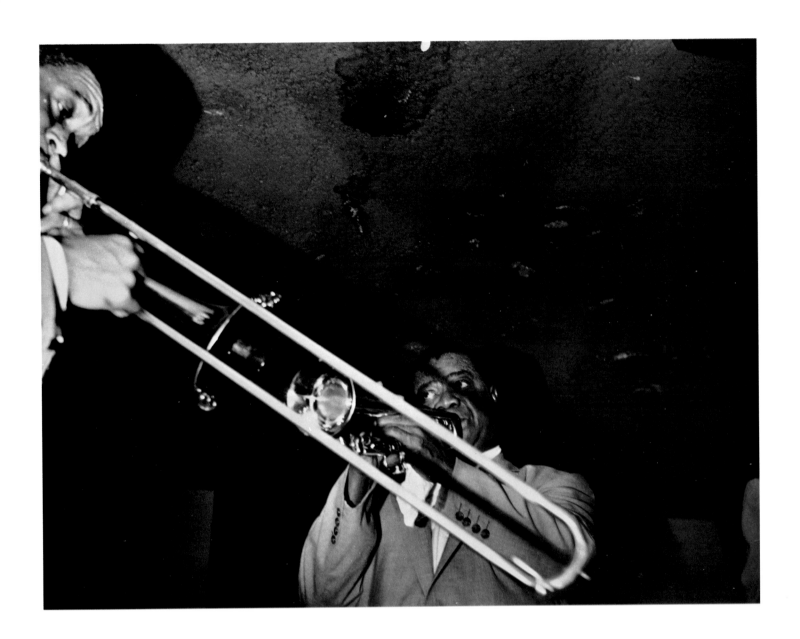

Louis Armstrong V
Louis Armstrong V
Louis Armstrong V

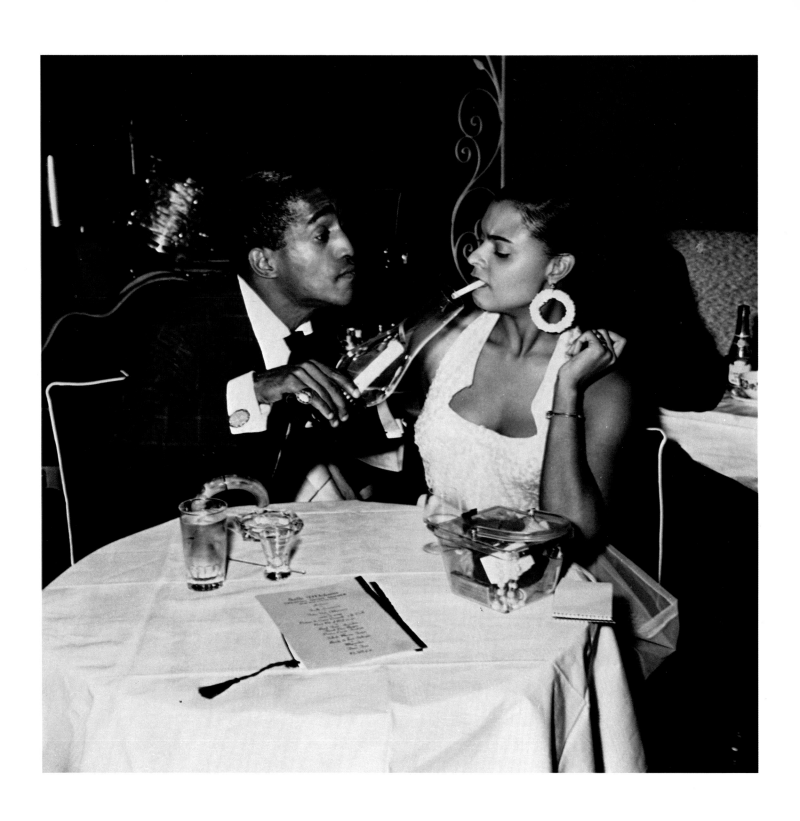

Sammy Davis Jr. mit Begleiterin
Sammy Davis Jr. and companion
Sammy Davis Jr. avec compagne

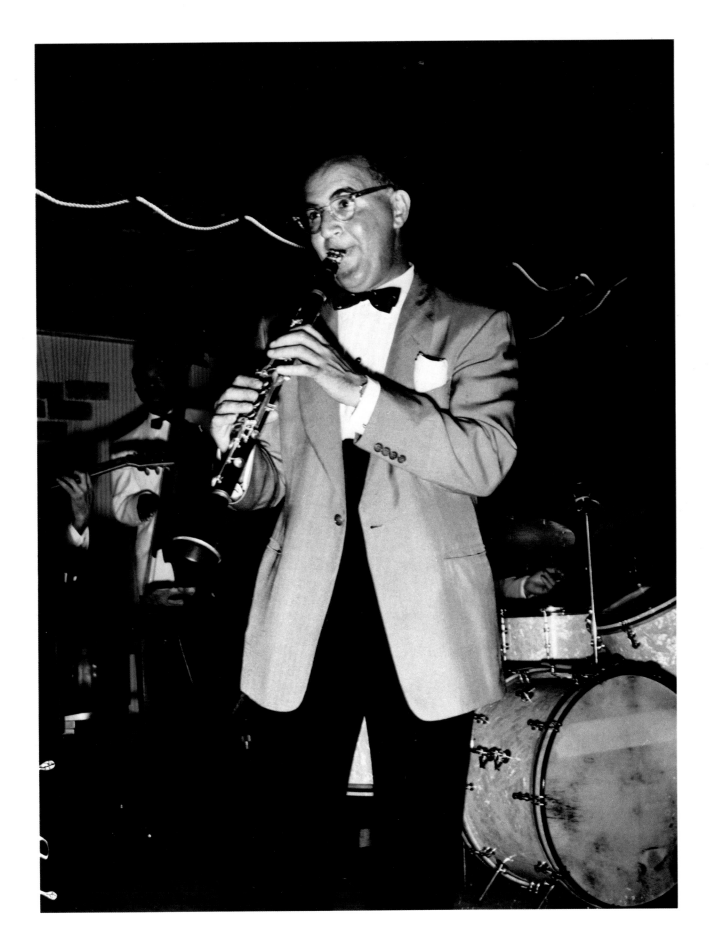

Benny Goodman
Benny Goodman
Benny Goodman

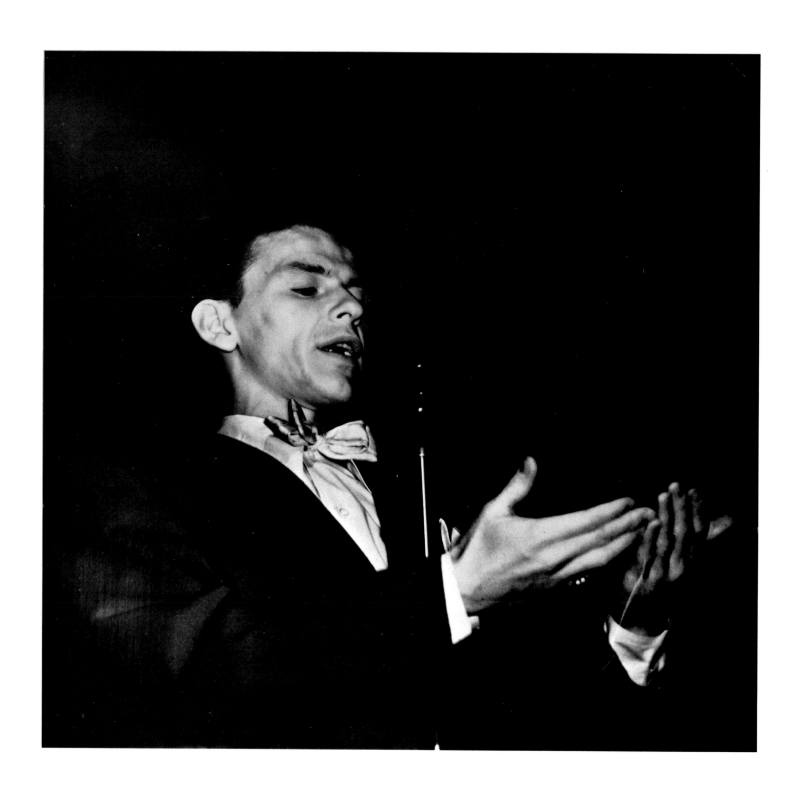

Frank Sinatra
Frank Sinatra
Frank Sinatra

318

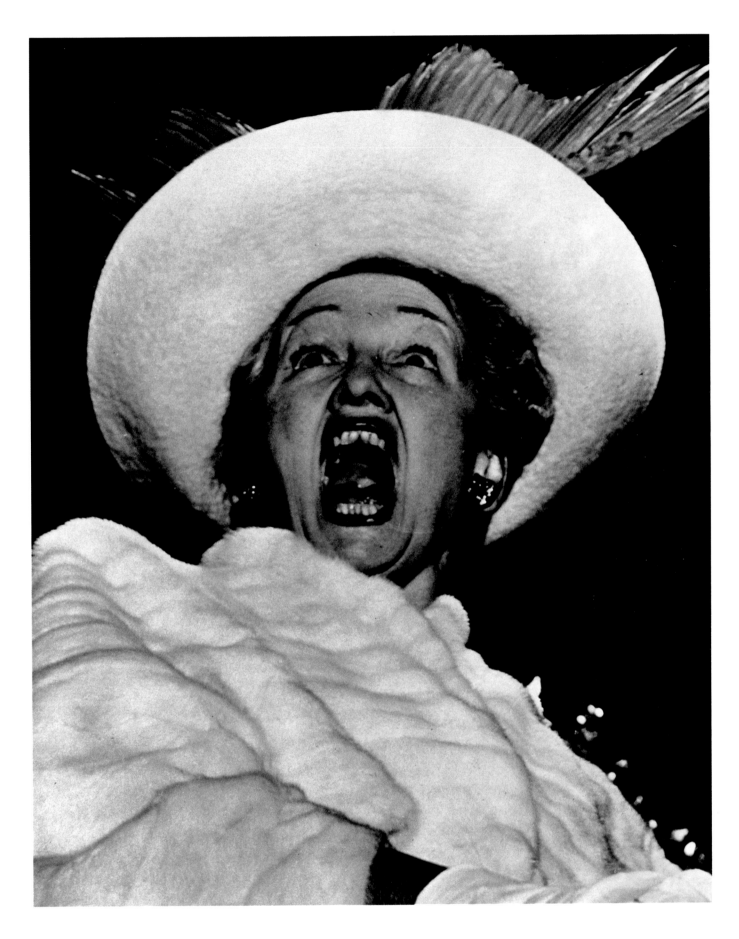

Hedda Hopper
Hedda Hopper
Hedda Hopper

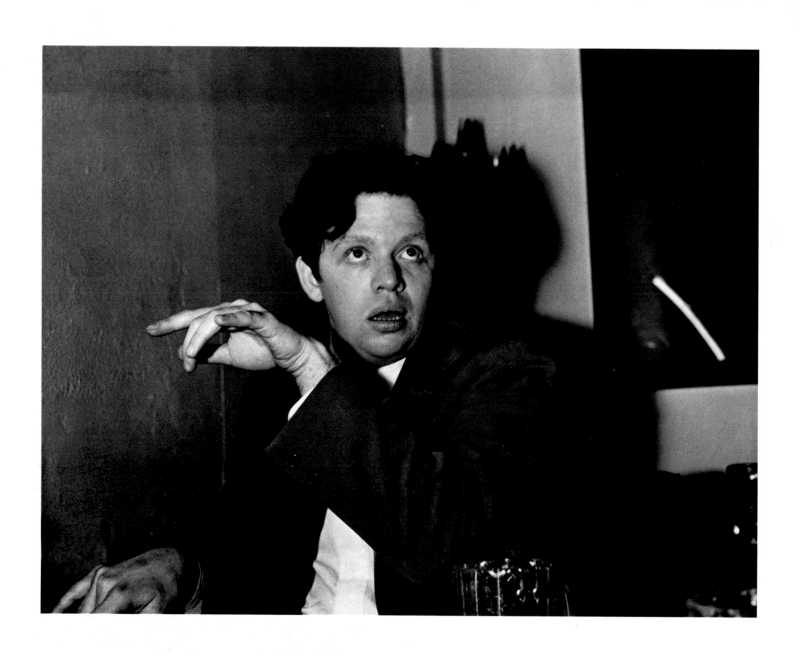

Dylan Thomas
Dylan Thomas
Dylan Thomas

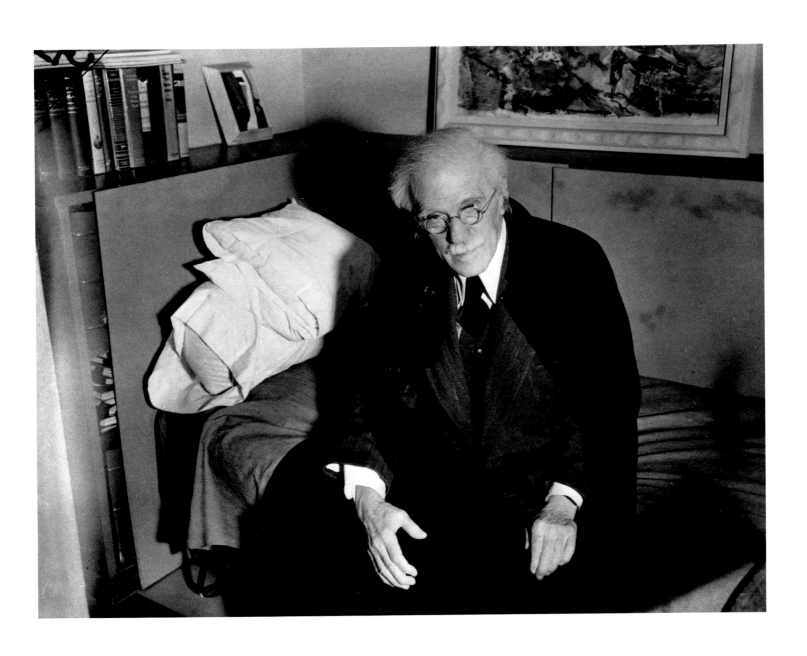

Alfred Stieglitz, ca. 1945
Alfred Stieglitz
Alfred Stieglitz

Andy Warhol
Andy Warhol
Andy Warhol

Jackie Kennedy
Jackie Kennedy
Jackie Kennedy

323

Herzog und Herzogin von Kent im Madison Square Garden
The duke and the duchesse of Kent in Madison Square Garden
Duc et Duchesse de Kent au Madison Square Garden

324

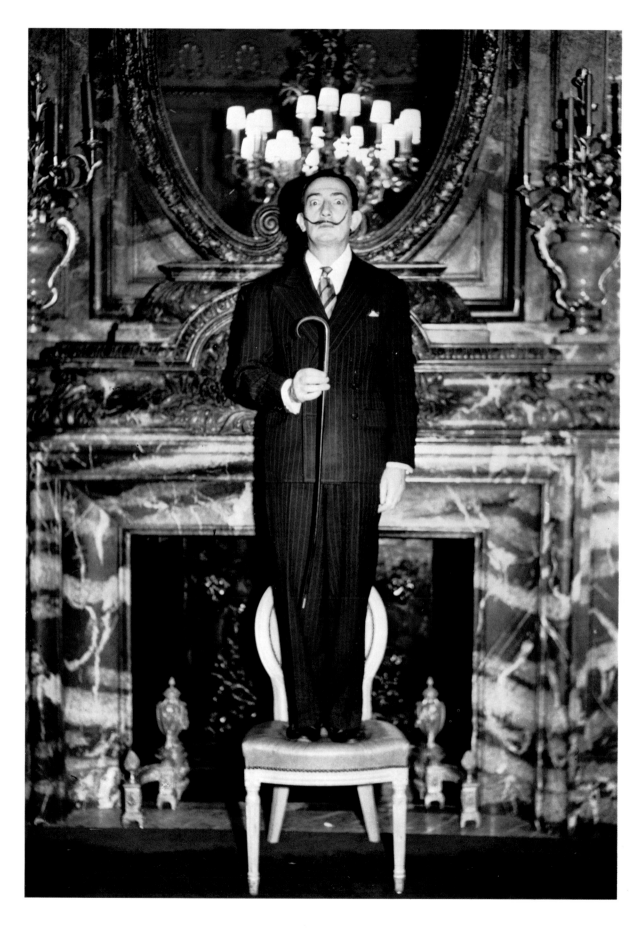

Salvador Dali
Salvador Dali
Salvador Dali

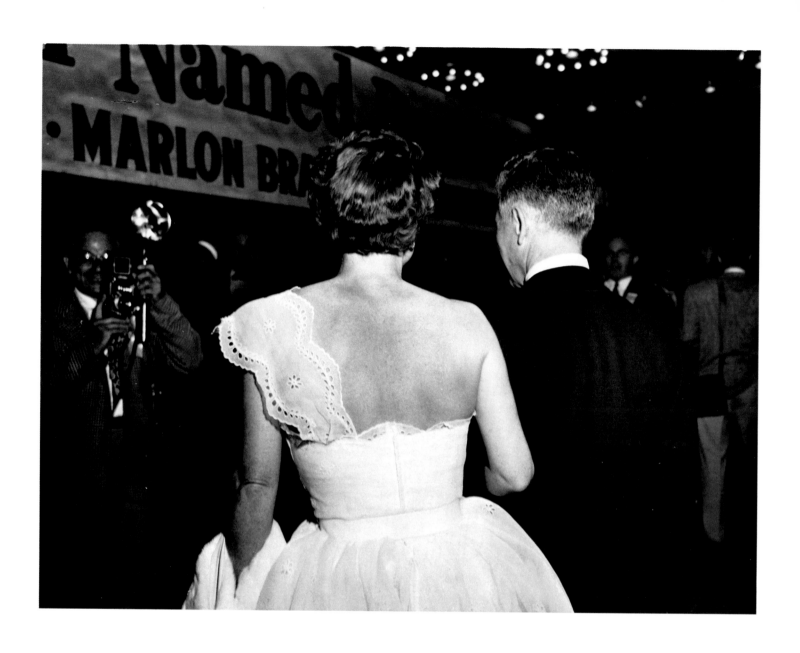

Filmpremiere von ''Endstation Sehnsucht''
The movie première of ''A Streetcar Named Desire''
Première du film ''Un tramway nommé désir''

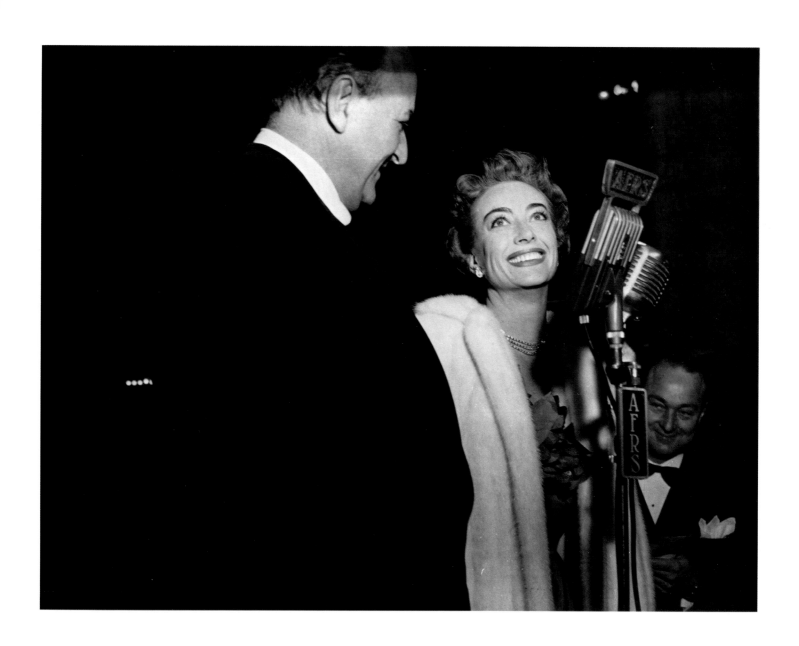

Joan Crawford
Joan Crawford
Joan Crawford

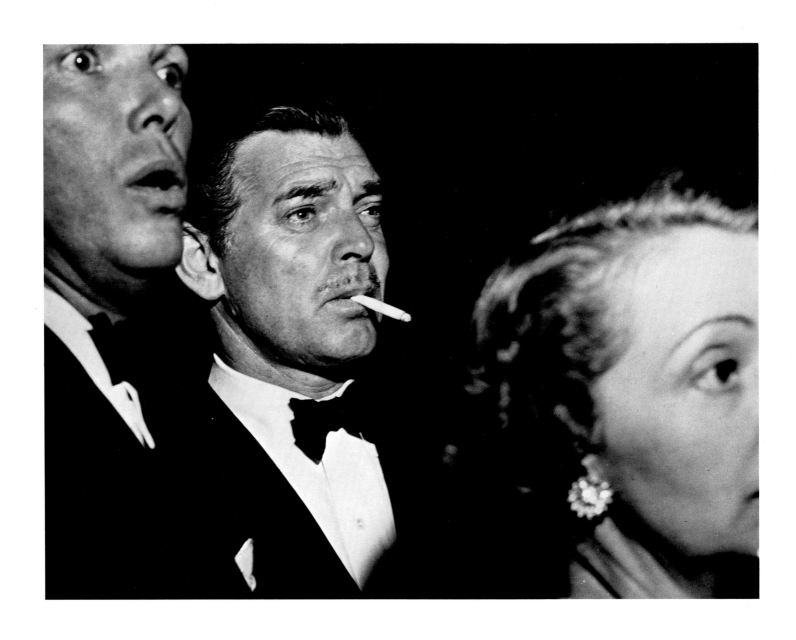

Clark Gable
Clark Gable
Clark Gable

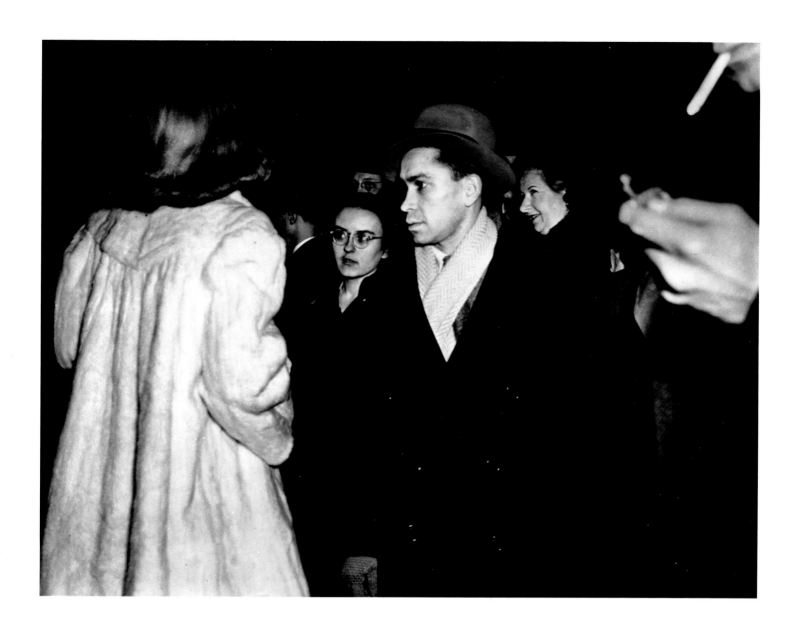

Bette Davis
Bette Davis
Bette Davis

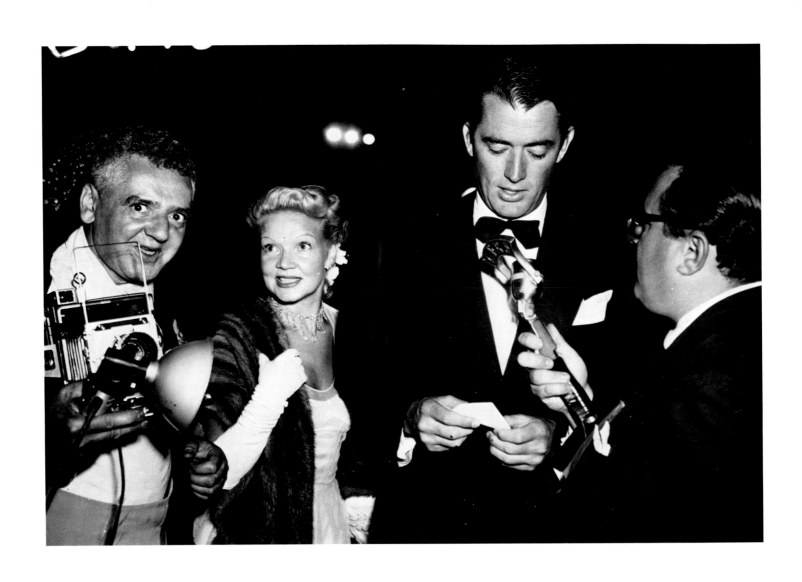

Gregory Peck mit Weegee
Gregory Peck and Weegee
Gregory Peck avec Weegee

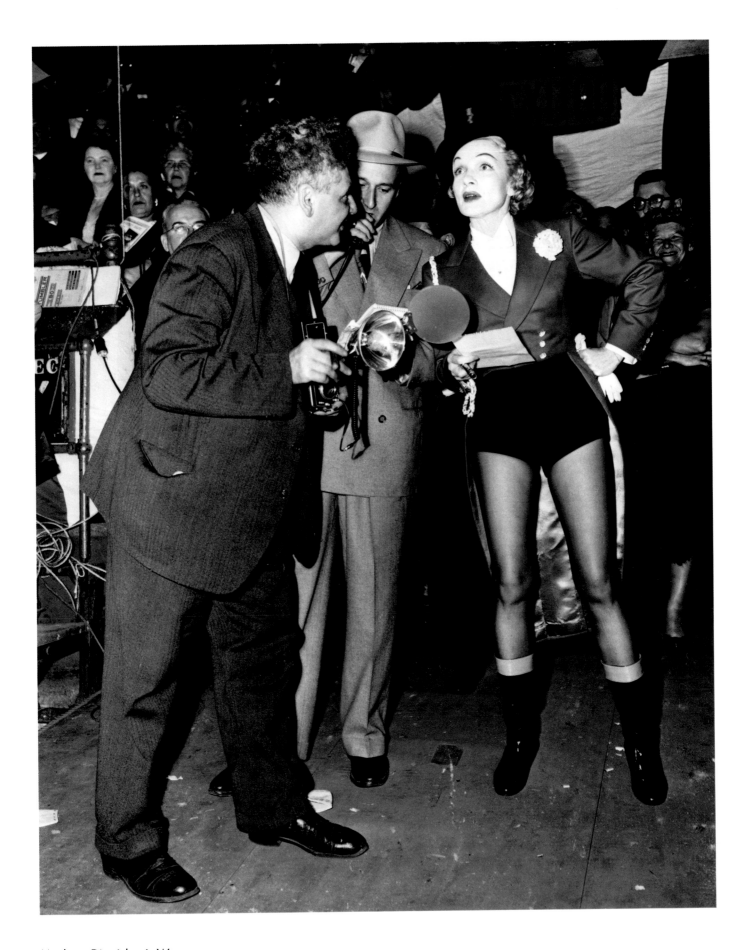

Marlene Dietrich mit Weegee
Marlene Dietrich and Weegee
Marlène Diétrich avec Weegee

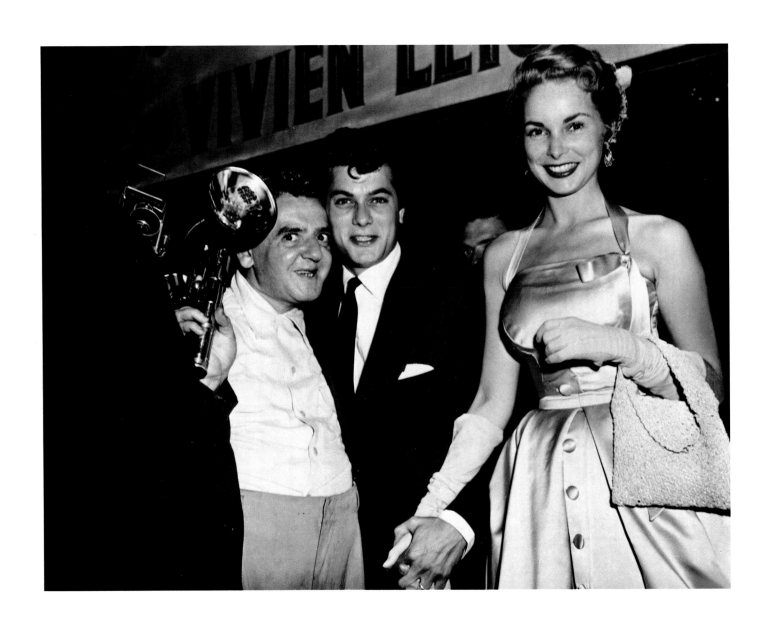

Tony Curtis mit Weegee
Tony Curtis and Weegee
Tony Curtis avec Weegee

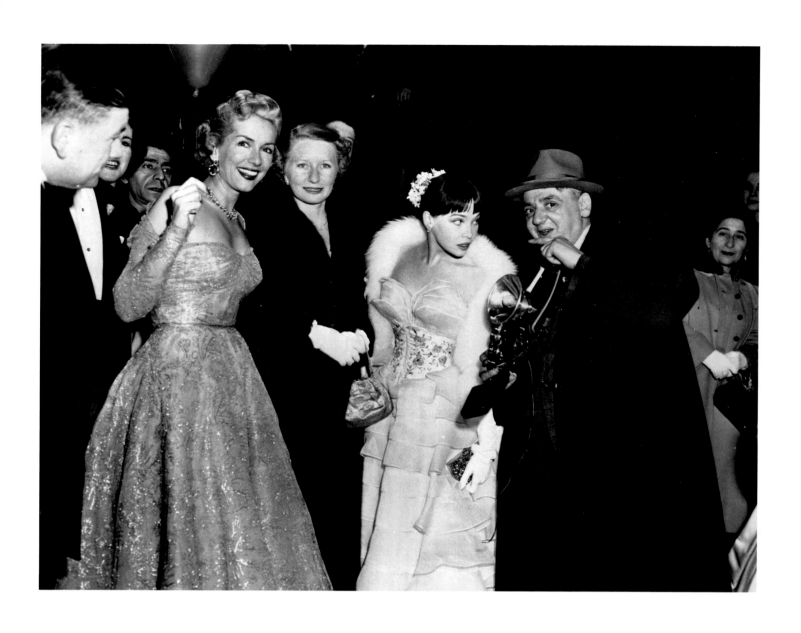

Leslie Caron mit Weegee
Leslie Caron and Weegee
Leslie Caron avec Weegee

Selbstportraits
Self-Portraits
Autoportraits

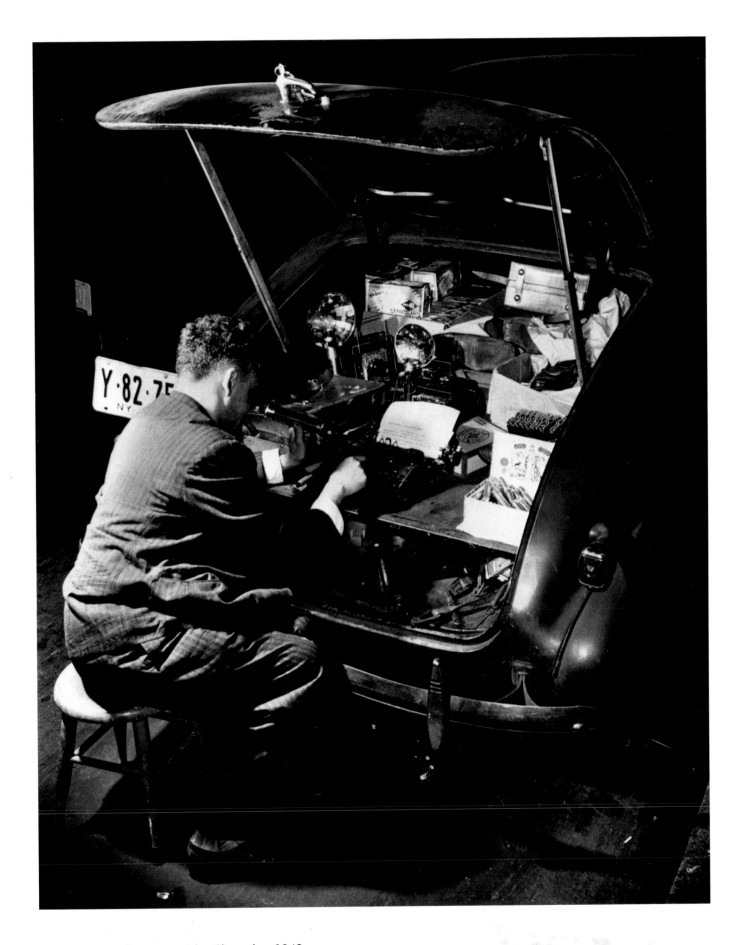

Weegee am Kofferraum seines Chevrolet, 1942
Weegee at the trunk of his Chevrolet
Weegee devant le coffre de sa Chevrolet

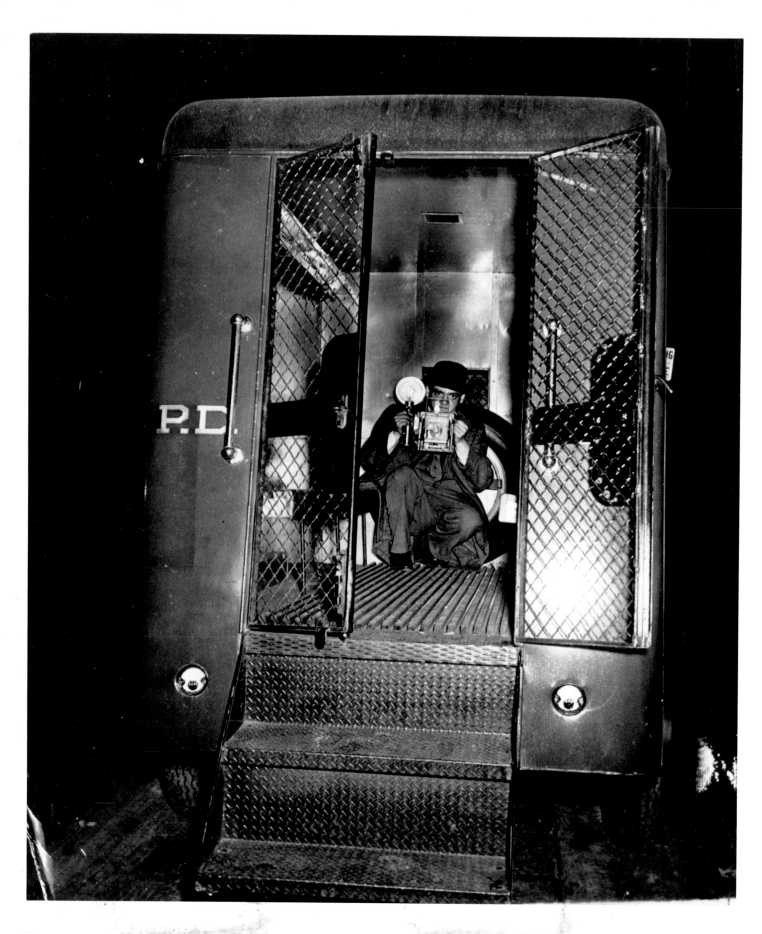

Weegee in der grünen Minna
Weegee in the paddy-wagon
Weegee dans le panier à salade